THE COMICS JOURNAL #290 (ISBN: 987-1-56097-936-4) May 2008. Published monthly in Jan, Feb, Apr, May, July, Aug, Oct, Nov by Fantagraphics Books, Inc., from the editorial and business offices at 7563 Lake City Way N.E., Seattle, WA 98115. *The Comics Journal* is copyright © 2008 by Fantagraphics Books, Inc. All images/photos/text © Their respective copyright holders. Unauthorized reproduction of any of its contents is prohibited by law. Periodicals postage paid at Seattle, WA, and at additional mailing offices. POSTMASTER: Please send address changes to The Comics Journal, 7563 Lake City Way N.E., Seattle, WA 98115. PRINTED IN SINGAPORE.

Cover art from *Win a Few, Lose a Few, Charlie Brown.* [©1974 United Feature Syndicate, Inc.] **Above:** From Matt Madden'

COMIC RELIEF
2138 UNIVERSITY AVE
BERKELEY, CA
94704-1026
510-843-5002
WWW.COMICRELIEF
.NET

LAUGHING OGRE
4258 N HIGH STREET
COLUMBUS, OH 43214-3048
TEL: 614-A-MR-OGRE

WWW.THELAUGHINGOGRE.COM

THE BEGUILING
601 MARKHAM ST.
TORONTO, ON
CANADA, M6G 2L7
416-533-9168
WWW.
BEGUILING.
COM

STRANGE ADVENTURES COMIC
BOOKSHOPS 5262 SACKVILLE ST.
HALIFAX, NOVA SCOTIA CANADA B3J 1K8
PH: 902-425-2140
WWW.STRANGEADVENTURES.COM

COMICOPIA
★★★★
464 COMMONWEALTH AVE.
BOSTON, MA 02215
617-266-4266
WWW.COMICOPIA.COM

JIM HANLEY'S UNIVERSE
4 W. 33RD ST.
NEW YORK, NY
10001-3302
212-268-7088

325 NEWDORP LANE
STATEN ISLAND, NY
10306
718-351-6299

WWW.JHUNIVERSE.COM

BIG PLANET COMICS
4908
FAIRMONT AVE
BETHESDA, MD
20814
301-654-6856

426
MAPLE AVE E.
VIENNA, VA
22180
703-242-9412

3145
DUMBARTON
AVE NW
WASHINGTON, DC
20007
202-342-1961

7315
BALTIMORE AVE
COLLEGE PARK, MD
20740
301-699-0498

WWW.BIGPLANETCOMICS.COM

ATOMIC BOOKS
1100 W. 36TH ST.
BALTMORE, MD 21211
410-662-4444

WWW.ATOMIC
BOOKS.COM

WWW.
CRIMINAL
.COM

CRIMINAL RECORDS
466 MORELAND AVE NE
ATLANTA, GA 30307
404-215-9511

ALTERNATE REALITY
4800 S. MARYLAND PKWY. D
LAS VEGAS, NV 89119
WWW.ALTERNATEREALITYCOMICS.NET

702-736-3673

The Comics Journal's Exclusive Guide to MoCCA 2008

Earlier this year, The Comics Journal *checked in with a number of MoCCA exhibitors to get the scoop on their plans for the show. Check out the online MoCCA preview section at TCJ. com for updates.*

AdHouse

AdHouse will present the *Skyscrapers of the Midwest* hardcover collection by Joshua W. Cotter, who will attend, as well as Jamie (*Aviary*) Tanner, Fred (*Johnny Hiro*) Chao, Joey (*The Ride Home*) Weiser and *Red Window* friend Scott Morse. www.adhousebooks.com

Alec Longstreth

New for MoCCA will be *Phase 7 #013*, a narrated trip through art history, focusing on depictions of everyday life. Also available, the entire catalog of *Phase 7* back issues as well as the new *Animal Alphabet* children's book. www.alec-longstreth.com

Bloomsbury

Mike Dawson will unveil his original graphic novel *Freddie & Me*, a 304-page autobiographical story about the author's lifelong obsession with the band Queen.

Bodega Distribution

Bodega plans to offer Dave Kiersh's introspective take on the fairy tale in his new book *Neverland*, and the second volume of the Eisner-nominated and Ignatz award-winning series *Mourning Star*, the post-apocalyptic epic by Kazimir Strzepek. Both artists will be in attendance. www.bodegadistribution.com

Candle Light Press

Presenting *Nightcrawlers* by Mike Ayers and Will Grant, the *Zoo Force: We Heart Libraries* edition by John Ira Thomas and Jeremy Smith, and *252Z: Law Of Monsters* by Carter Allen. www.candlelightpress.com

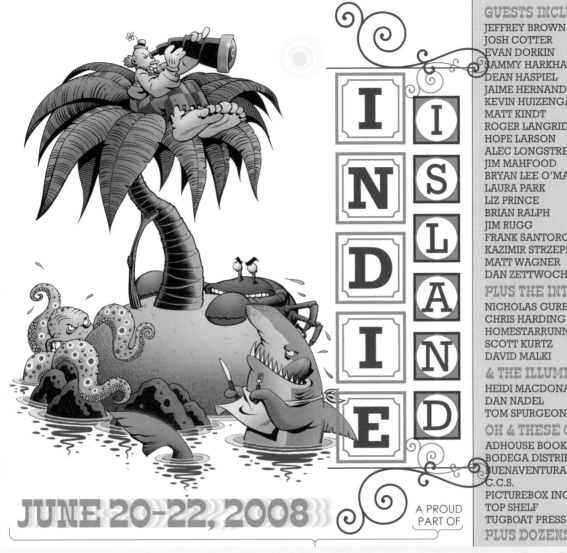

Corduroy High

Tyrone McCarthy will present the first collection of his self-published comic, *Tyne: Sour Times*, about a rookie assassin who's avenging her mentors death, along with McCarthy's other series, *Corduroy High* about sex, drugs & after-school high jinks. www.CorduroyHigh.com

Crossover Comics

Books will include the ongoing *Nisha* series, with issue #2.7 (April, 2008) as the latest edition. Robert Gavila will unveil the first set of the *Samame* series, in which cartoon kids act out the challenges faced by contemporary independent publishers. www.gavila.com/writer/Samame/Samame1.html

Damien Jay

Presenting a new issue of *Plates Are Cult* and the self-published books: *Pocket Party* and *The Tinderbox*. www.damienjay.com

Dinski

Will Dinski will display two Habitual Entertainment mini-comics at the MoCCA festival this year and will have the usual library of limited-edition handmade comics, artist books and prints. www.willdinski.com

Doomscape

Rev. Victor Giannini will present the 188-page Volume 1 of the skateboarders vs. ninjas vs. zombies comic series, *Skeight-fast Dyephun*, as well as the new line of "Reverend Doom" full-color posters, in what is rumored to be a specially constructed bamboo comic hut designed by Louis Peterson. www.doomescape.com

Drawn and Quarterly

Special guest Lynda Barry will unveil *What It Is*. Other debuts will include *Against Pain* by Ron Rege Jr., *Red Colored Elegy* by Seiichi Hayashi, *Good-Bye* by Yoshihiro Tatsumi and *Gentleman Jim* by Raymond Briggs. www.drawnandquarterly.com

Dumbrella

Andrew Bell will be on hand with his newly released book *Do Not Eat*, featuring 204 pages of the Creatures in my Head illustration, toys, paintings and six pull-out color postcards. www.creaturesinmyhead.com

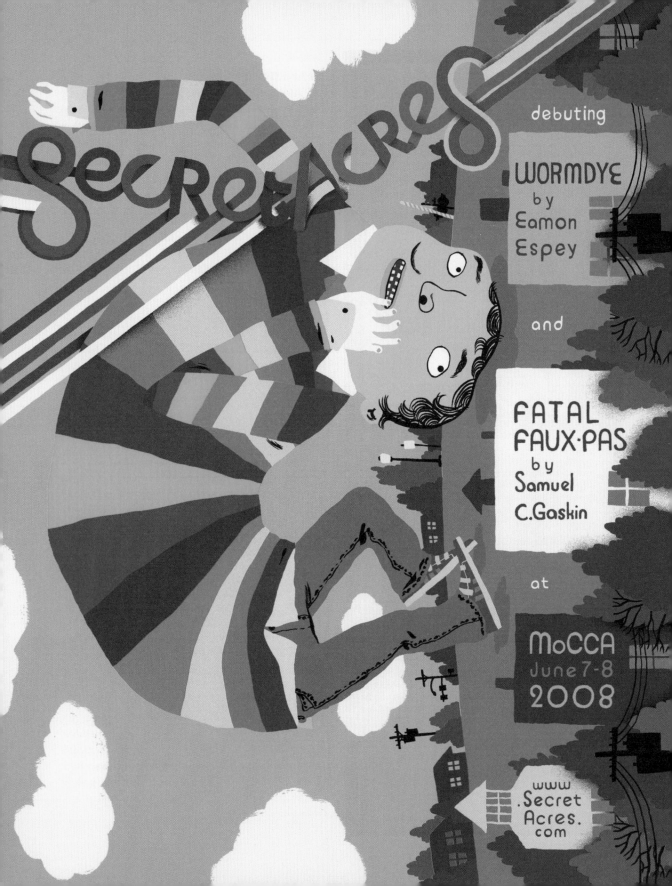

Evil Twin Comics

Fred Valente will present *Comic Book Comics* #2, which continues the saga of the comic-book industry in comic-book form, with stories about Simon & Kirby, funny books in WWII, the birth of romance comics and EC, all in Ryan and Fred's inimitable *Action Philosophers* style. www.fredvanlente.com

Fantagraphics Books

Jason will appear with his new book, *Pocket Full of Rain*. He will be the subject of an art show kicking off at Rocketship the night before MoCCA, as well. Dash Shaw and his *Bottomless Belly Button* also will be there. www.fantagraphics.com

First Second

Marketing associate Gina Gagliano told the *Journal*, "I think that the main book we want to emphasize at the MoCCA Art Fest is *Drawing Words and Writing Pictures*, the comics textbook by Jessica Abel and Matt Madden coming out this June. Jessica and Matt are both going to be at the festival." www.firstsecondbooks.com

Fred Harper

Fred Harper will feature silkscreen limited-edition B/W prints derived from his paintings of mechanical and figure combinations. B/W art from *Grave Digger* and the latest art from Wizards of the Coast will be on display. He'll also be signing Garbage Pail Kids cards and doing convention doodles. Listen for the cowbell! www.fredharper.com

Grogan

The debut of the Xeric Award-winning *Look Out Monsters*, a 32-page, tabloid-newspaper size, full-color book that explores a post 9/11 terror-inflicted mindscape. Also featuring *Nice Work*, the graphic novel about Sinatra stand-in Johnny Cat serialized at ModernTales.com, as well as original artwork for sale. www.geoffgrogan.com

Indiespinner Rack

Sneak peeks of the second volume of the Indie Spinner rack Anthology will be made available, along with last year's *Awesome Anthology*, which premiered at SPX and benefits a scholarship to the Center for Cartoon studies. Indiespinner Rack will also provide coverage of the event as the official podcast of MoCCA and recording every panel at the festival. www.indiespinnerrack.com

THE moon FELL on me

themoonfellonme.com

Tim Kelly

Autism Autumn is the third in the series of comics about the cartoonist raising his daughter Emily. The first two installments, *Spring time for Autism* and *Summer of Nove*, will also be available. *Autism Autumn* will make its debut at MoCCA. www.myspace.com/3635161

Ken Knudsen

Exhibiting: *My Monkey's Name Is Jennifer* trade paperback, and limited-run, conventions-only editions of *I Hate Zombies*, T-shirts and shot-glasses. www.comicspace.com/kenknudtsen

Kettle Drummer

Lance Hansen plans on having issue #1 of the new series *Hayseed* out in time for MoCCA: a collection of pantomime gag strips of varying lengths. www.kettledrummerbooks.com

Lunchbox Funnies

The all-ages collective will include Trade Loeffler, who will have Zip and Li'l Bit prints, postcards and a portfolio of original artwork, and Mike Maihack, who will have a new 12-page *Cow & Buffalo* comic that serves as a semi-sequel to the *Adventures in Sandwich Making* book published last year. Also in attendance: Dean Trippe (*Butterfly*), and Ryan Sias (*Silent Kimbly*). www.lunchboxfunnies.com

Lunchbreak Comics

Pat Lewis will be selling copies of the new hardcover *The Claws Come Out*, published by IDW as part of their creator-owned line of comics, along with his regular minis. www.lunchbreakcomics.com

Meathaus

The debut of *Meathaus: SOS*, full color, 272 pages, published by Nerdcore, featuring comics and art by Dash Shaw, Farel Dalrymple, Tomer and Asaf Hanuka, Jim Rugg and Brian Maruca, Ralph Bakshi, and many others. www.meathaus.com

Metrokitty

Cathy Leamy will present the latest issue of *Geraniums and Bacon*, plus a new short-story minicomic titled *Ladytrain*, with fellow creators from the Boston Comics Roundtable. www.metrokitty.com

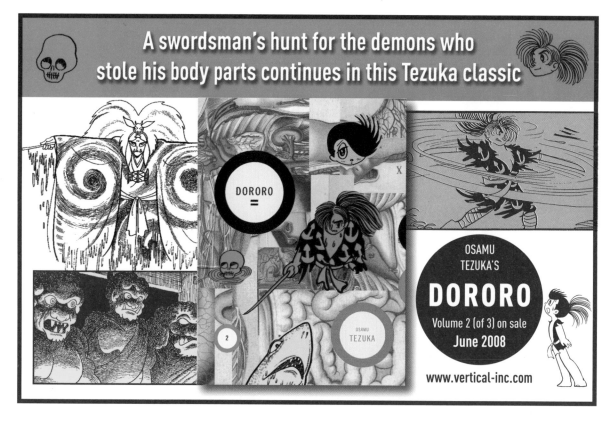

Mike Lariccia

Mike will offer the first part to his second graphic novel, *The Death of Black Mane and the Feared Self*, the follow-up to the Xeric Award-winning book *Black Mane*. www.michaellariccia.com

Molly Crabapple

"The Life and Death of Christopher Mott" is a limited-edition pamphlet from the universe of *Backstage*, describing the fate of an impertinent newspaper cartoonist.

Mr. Oblivious

In their first appearance at the MoCCA comics festival, co-creators Sam Girdich (writer) and Mark Gonyea (artist) will be on site with previous works, *The Haunting House, The Tall and the Dead, The Tuesday After* and their newest work, *Godless*. www.mroblivious.com

NBM

NBM will premier the *Bluesman* collected jacketed hardcover with new cover art by Pablo Callejo. Rob Vollmar will be in attendance to sign copies. MoCCA guest of honor Bill Plympton will be at the NBM booth as well. New books featured: the conclusion to *No Pasaran* by Vittorio Giardino, *Ordinary Victories* by Manu Larcenet and *Metronome*. www.nbmpub.com

New Radio

Writer Jad Ziade and artist Alex Cahill will be on hand for the debut of the 104-page second part of their four-part, sci-fi graphic-novel series, *Poison The Cure*, which Dave Sim called "… a nicely-layered introduction to Jad and Alex's world." www.newradiocomics.com

Picturebox

CF, Matthew Thurber, Gary Panter and Frank Santoro will all be in attendance. www.pictureboxinc.com

Secret Acres

Secret Acres will have advance copies of *Fatal Faux-Pas* and *Wormdye*, the respective debut books from Xeric-winner Samuel C. Gaskin and Eamon Espey, *Kramers Ergot* contributor and winner of City Paper's Best Comic. Both artists will be at the booth along with minis from Ignatz-winners Ken Dahl and Melanie Lewis, the *Best American Comics* selected *Turtle Keep It Steady* from Joe Lambert and lots more. www.secretacres.com

GEN CON
TRADE DAY — BUILDING YOUR BUSINESS

Get ahead in the game industry by attending Gen Con Trade Day.

If you're looking for a winning edge in the game business - or even expert advice for educational use - register now for the 2nd annual Gen Con Trade Day. This exciting event is jam-packed with seminars, mixers, and other programming designed to give you the knowledge and connections you need to succeed.

To register for Gen Con Trade Day and learn more about this unique event, go to: **www.gencon.com**

August 13-14, 2008
Indianapolis, IN

RETAILER LOUNGE SPONSOR

Who's invited?

- **Retailers** – See new releases first, meet game company reps, get trade-only access to special events and limited products, and learn to grow your business.
- **Licensing Professionals** – Enjoy exclusive networking opportunities with companies involved in rights deals.
- **Game Companies** – Network with major retailers, distributors, librarians, educators, press, and companies selling & acquiring game rights around the world.
- **Trade Press** – Get the inside scoop on the game industry, with special access to game publishers.
- **Librarians & Educators** – Learn to organize game events and how to use games in curriculum-based teaching.

stef lenk

stef lenk will present new episodes of *The Details*, a wordless graphic novel described as: "Girl goes into antique/toy shop, seduced by the mistaken prospect of tea seen in the window display. Girl investigates. Girl opens the Wrong book, opening a door to the Wrong people." www.steflenk.com

Toon Books

Exhibiting Spring '08 debut titles *Benny and Penny*, *Silly Lilly*, and *Otto's Orange Day*, with Jay Lynch and Frank Cammuso signing books, and a preview of Fall '08 titles by Art Spiegelman, Eleanor Davis, Lynch, and Dean Haspiel, with Spiegelman and Haspiel also on hand. www.toon-books.com

Top Shelf

Chris Staros reported at press time that Top Shelf will present *Too Cool to Be Forgotten* by Alex Robinson and *Johnny Boo (Book 1): The Best Little Ghost in the World* by James Kochalka. www.topshelfcomix.com

W. Rees

W. Rees will be bringing copies of *Obsession*, his new graphic novel. www.heavyproton.com

A Wave Blue World

A Wave Blue World will have all seven issues of its series, *Adrenaline*, as well as the new sketchbook/preview of the upcoming graphic novel *American Terrorist*. www.awaveblueworld.com

Willow Dawson

Willow Dawson will be present the fourth and final issue of *Violet Miranda: Girl Pirate* (kissmachine.org/violet). Along with *Violet* #4, she will bring issues #1-3, a selection of her art prints and some hand silk-screened t-shirts. www.willowdawson.com

Wondermark

David Malki will offer his new Dark Horse book *Wondermark: Beards of Our Forefathers* and the usual selection of his books, apparel, greeting cards and DVDs of spy-spoof film *Expendable*. Wondermark and Chris Yates Studios welcome *xkcd*'s Randall Munroe at their table. www.wondermark.com ∎

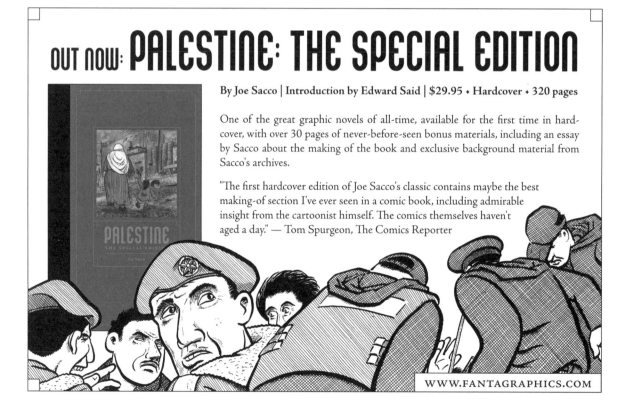

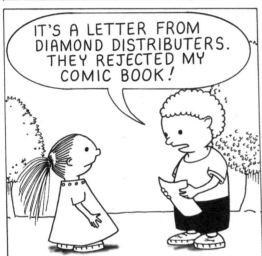

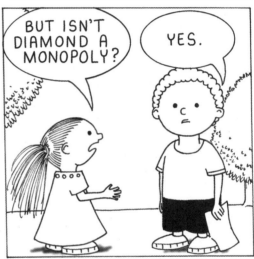

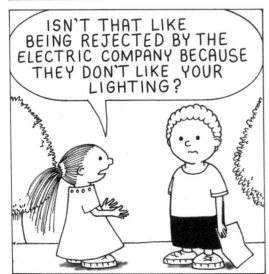

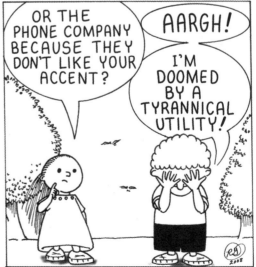

Jan. 9, 2008 – Mar. 13, 2008
by Greg Stump & staff

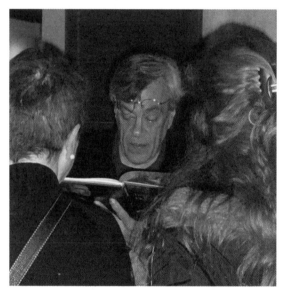

Muñoz signing comics, at the Argentinian comics exhibition: photo courtesy of Stephen Betts.

Angoulême 2008

Jan. 24-27: 2008 was a vintage year for the Angoulême Festival. After several lacklustre years, the Festival International de la Bande Desinée needed something of a revival, and under José Muñoz's Presidancy it certainly got it. This was the year that reminded regular attendees why they always exhort others to come to the festival. It is almost impossible to convey all that was great about this festival without reference to what didn't work last year. But perhaps the greatest symbol of the difference between this year and last is provided by two enduring images of the Presidents for those festivals. Last year a video did the rounds of the President, Lewis Trondheim, performing an impromptu striptease during a publisher's dinner, to the shocked delight of his fellow diners; by contrast, this year's enduring image is of Muñoz sitting at a drawing desk on stage in the Théâtre d'Angoulême, drawing a night scene with a brush and ink, projected for the enthralled auditorium to see, while accompanied by the elegant and passionate voice of Argentinian singer Haydée Alba. Like the rest of his festival, Muñoz's Concert de Dessin (as such combinations of live music and drawing are termed) was perfectly judged. Of course, Muñoz cannot take credit for everything good about the festival. For the last couple of years the normal layout of the festival was severely disrupted by construction work on a brand new mall in the town center, leading to some publishers boycotting last year's festival due to their having been located a bus-ride (or steep rainy walk) out of the center of town. This year the layout of the festival returned, more or less, to its normal configuration, with a few reconfigurations to accommodate the new mall. In fact, the tent which held the independent publishers was considerably larger and had been rechristened the "New World". Everyone was happy — almost.

The expansion of the independent publishers' space left no space for the small-press, which traditionally would have shared the same tent, as well as something of the same sensibility. They were displaced to a smaller tent, tucked behind the large publishers tent, with whom they have less in common. This caused the publishers of *Turkey* #16 — the winner of Best Fanzine in this year's prizes — to make a statement during their acceptance speech criticizing the organisers of the festival for their ghettoization of the small press.

Exhibitions: The exhibitions were much more impressive than in recent years — for one thing, The Imaginary Museums of Comics exhibit was finally retired from the CN-

BDI (The National Centre for International Comics) after five years. Its removal made way for two exhibitions related to Muñoz, (compare to 2007, when there was no Trondheim exhibition at all). The first was devoted to Muñoz's work, and showcased original pages of art from his entire career. It was held in a black, circular room, with the simply framed artwork evenly spaced all around. Discrete South American music played in the background, and in the center of the room were two pairs of shoes — a man's and a woman's — arranged as if dancing together in a circle of sand, adjacent to an abandoned accordion. The sparse setting created atmosphere and let the artwork speak for itself. Connected to that, the second Muñoz-related exhibition was devoted to the comics of Argentinia from the 30s to the present day, which Muñoz himself curated. This was a very large, imaginatively realized exhibition — it was dark and atmospheric, unifying it with the exhibition of Muñoz's work, but the various rooms evoked a more gritty South America. It served to demonstrate the breadth of material from Argentina, and illustrate Muñoz's influences from his home country. In addition to those, the CNBDI also had a good collection of Ben Katchor's work, including some of his watercolored pages from Metropolis magazine. This was timed to match Katchor's award from Angoulême's art school.

An exhibition of work by the Italian cartoonist Sergio Toppi illustrated how European comics' aesthetic sensibilities have changed. A couple of decades ago, Toppi's style would have been instantly recognizeable as a classic European style, but now those highly detailed, realistic renderings of fantastic worlds have given way to cartoonish, representational depictions of realistic worlds, typical of Sfar and Trondheim.

No report from Angoulême 2008 should fail to mention the Smurfs, celebrating their 50th anniversary. Large displays devoted to the small blue creatures sprung up on smurf legs all over the town. The installations, containing games, historical information and vinyl figurines, were a big hit with people discovering — and many rediscovering — their inner Smurf.

The Essentials: The climax of the festival, as ever, was the ceremony for the annual awards, "The Essentials", which Muñoz's Concert de Dessin kicked off beautifully. His long-term collaborator, Carlos Sampayo, perhaps most familiar as writer of the *Alack Sinner* series, joined him on stage to warm and lengthy applause from the audience. The top prize for best book is now called the Fauve d'Or after the new mascot of the festival, a black and white cat

The Comics Journal
http://www.tcj.com

Publisher: Fantagraphics Books

Editor in Chief: Gary Groth

Managing Editor: Michael Dean

Art Director: Adam Grano

Scanmaster: Paul Baresh

Assistant Editor: Kristy Valenti

Online Editor: Dirk Deppey

Interns: Eric Buckler, Michael Litven, Sam Schultz

Columnists:
Bart Beaty, Tom Crippen, R. Fiore, Steven Grant, R.C. Harvey, Daniel Holloway, Rich Kreiner, John Lent, Tim O'Neil, Donald Phelps, Bill Randall, Kenneth Smith

Contributing Writers:
Simon Abrams, Jack Baney, Noah Berlatsky, Bill Blackbeard, Robert Boyd, Christopher Brayshaw, Ian Brill, Gabriel Carras, Michael Catron, Gregory Cwiklik, Alan David Doane, Austin English, Ron Evry, Craig Fischer, Jared Gardner, Paul Gravett, David Groenewegen, Charles Hatfield, Jeet Heer, John F. Kelly, Megan Kelso, Tim Kreider, Chris Lanier, Bob Levin, Ana Merino, Chris Mautner, Ng Suat Tong, Jim Ottaviani, Leonard Rifas, Trina Robbins, Larry Rodman, Robert Sandiford, Seth, Bill Sherman, Whit Spurgeon, Frank Stack, Greg Stump, Matthew Surridge, Rob Vollmar, Dylan Williams, Kristian Williams, Kent Worcester

Proofreader: Rusty McGuffin

Transcriptionists: Carol Gnojewski, Kristy Valenti

Advertising: Matt Silvie

Publicity: Eric Reynolds

Circulation: Jason T. Miles

"We've got nothing but time."
— Eskimo & Sons

For advertising information, e-mail Matt Silvie: silvie @fantagraphics.com.

Contributions: *The Comics Journal* is always interested in receiving contributions — news and feature articles, essays, photos, cartoons and reviews. We're especially interested in taking on news correspondents and photographers in the United States and abroad. While we can't print everything we receive, we give all contributions careful consideration, and we try to reply to submissions within six weeks. Internet inquiries are preferred, but those without online access are asked to send a self-addressed stamped envelope and address all contributions and requests for Writers' and/or Editorial Guidelines to: Managing Editor, The Comics Journal, 7563 Lake City Way N.E., Seattle, WA 98115.

The Comics Journal *welcomes all comments and criticism. Send letters to Blood & Thunder, 7563 Lake City Way N.E., Seattle, WA 98115. E-Mail: tcjnews@tcj.com*

called Fauve, created by Trondheim. This year the prize went, somewhat unexpectedly, to *Là où vont nos pères,* the French edition of *The Arrival* by Shaun Tan. The Moomins collection published by Le Petit Lézard won the Heritage Essential, and the Essential Newcomer prize was awarded to *L'éléphant* by Isabelle Pralong. The public voted for *Kiki de Montparnasse* by Catel & Bocquet to win the public prize, and a jury of 9-14 year-olds chose *Sillage — tome 10: Retour de flammes* by Philippe Buchet and Jean-David Morvan as the Young Essential. The other Essentials winners were *Exit Wounds* by Rutu Modan, *Trois Ombres* by Cyril Pedrosa, *RG* by Frederik Peeters and Pierre Dragon, *La Marie En Platique* by Pascal Rabate and David Prudhomme and *Ma Maman Est En Amérique* by Jean Regnaud and Emile Bravo.

Rutu Modan is a frequent attendee of the Angoulême Festival, and should be familiar to readers of *The Comcs Journal* as part of the Israeli comics collective Actus Tragicus. In her acceptance speech she said that she first came to the festival 12 years ago, and that it had changed her life forever. This year, for the first time in several years, you could understand why.

— Stephen Betts

Editor Bob Callahan dies

Jan. 28: Bob Callahan, a writer and editor whose work for major publishers presaged the graphic-novel boom in this decade, died in late January. No exact date or cause of death was immediately made public for Callahan, who edited notable collections of comics and prose as a figure of influence in the San Francisco literary circles. The best known of his recent efforts was likely *The New Smithsonian Book of Comic Book Stories from Crumb to Clowes*, but Callahan also served as the editor of the Neon Lit line, which featured adaptations of Paul Auster's *City of Glass* (by David Mazzucchelli) and the writer's own collaboration on *Perdita Durango*. He later worked with the underground artist Spain for the serial *Dark Hotel*, which ran on Salon.com.

Gus Arriola, Ambassador Extraordinaire, Dies at 90

Feb. 2: Gus Arriola, creator of the celebrated comic strip *Gordo*, died Feb. 2 at 9:30 a.m. in his home in Carmel, Calif. At the age of 90, plagued by Parkinson's disease, fading health and a growing cancer, he had declined further chemotherapy and for the last couple of weeks was under hospice care. His wife of 65 years, Mary Frances, was with him

Gordo, published in U.S. newspapers for 44 years (1941-1985), was the most visible ethnic comic strip in America and its creator the most visible American of Mexi-

can descent working as a syndicated cartoonist. At its peak *Gordo* appeared in 270 newspapers and was the more widely circulated and longer-running of only two comic strips with a Mexican milieu. (The other was *Little Pedro,* a Sunday pantomime strip, by William de la Torre, which ran from about 1948 until 1955. It was offered by a small syndicate and never had very great circulation.)

Gordo's other distinction is that it was a stylistic tour de force, a triumph of design in cartooning. Arriola is revered (and envied) by other cartoonists and admirers of cartooning for the sheer quality of the art in the strip. Cartoonists generally would agree with Malcolm Whyte, founder of the San Francisco Museum of Comic Art, who told Wyatt Buchanan at the *San Francisco Chronicle*, "Arriola's Sunday strips were a tour de force of rich, vibrant color, lovely line work and dazzling artwork — stunning pieces of art."

And all of that is true. But what is seldom realized is how gifted a storyteller Arriola was. Most of his reputation rests on the "design quality" of the strip during its last three decades, when Gus was cracking jokes in the strip rather than telling stories. That's what most people remember.

But before 1960, the strip was a thorough-going storytelling strip, week after week, month after month, year after year; and Arriola's humorous yarns were tantalizingly intricate, tiny details complicating a tangled skein until, at last, the cartoonist unraveled the mess by tying all the loose ends into a single tidy knot to end the tale. And many of the narrative details were entirely pictorial, little insights into personality conveyed with body language, say. Arriola was more than a master designer: He was also a master storyteller in his chosen medium.

In the beginning, *Gordo* retailed the humorous adventures and amorous preoccupations of a portly Mexican bean farmer, Gordo Salazar Lopez, his perspicacious pint-sized nephew Pepito, the menagerie of their farm animals (Senor Dog, Poosy Gato, Cochito the Pig, and Popo —Popocatepetl — the gamecock), and the other citizens of their village. Among the latter were Juan Pablo Jones, a short fellow with a large nose and moustache and absolutely no desire to work; "the Poet," Paris Juarez Keats Garcia, who shared Juan Pablo's ambition.

The strip had an unusual and interrupted history. Launched as a daily-only feature November 24, 1941, it was briefly discontinued on October 28, 1942, when Arriola entered the Army. On May 2, 1943, Arriola started the strip again, this time only on Sundays. After the War, he resumed doing the dailies on June 24, 1946, and *Gordo* remained a

From *Gordo the Lover* by Gus Arriola. [©1972 United Feature Syndicate Inc.]

seven-day strip until it ceased on March 2, 1985. Except for a brief 12-18-month period in the late 1940s, Arriola produced the strip single-handedly with only his wife as a sounding board for gag and story ideas. The run of the strip brackets almost 44 years, and Arriola's seven-day servitude embraced 38 continuous, unassisted years. At the time of Arriola's retirement, no one had matched his record; subsequently, only Schulz surpassed it.

More by accident than by deliberate intention, *Gordo* evolved a cultural ambassadorial function, representing life in Mexico to its American audience. At first, Arriola's depiction of his characters perpetuated the stereotypical imagery of Mexicans found in American popular culture and in Hollywood, where Arriola worked in animation after graduating from Manual Arts High School in Los Angeles in 1935. Eventually, however, Arriola realized his comic strip was one of the few mass circulation vehicles in the United States that portrayed Mexicans, and he began in the 1950s taking pains to reflect accurately the culture south of the border.

Arriola was born in 1917 into a Mexican family and culture: his father, raised on a hacienda in the Mexican state of Sonora, had come to the U.S. in the 1890s, settling in Florence, Arizona (as Gus usually said, "the northern part of Mexico now known as Arizona"). The family moved to Los Angeles when Gus was 8. As a child, he spoke only Spanish; he said he learned English by reading the funnies in the newspaper..

He won awards and accolades for his efforts. The National Cartoonists Society named *Gordo* the best humor comic strip in 1957 and again in 1965. Also in 1957, the Artists

Club of San Francisco recognized "his pioneering in bringing design and color to a new high in the field of newspaper comic strips." In 1983, he was named Citizen of the Year in Monterey's Parade of Nations, and in 1999, he received the Charles M. Schulz Award (the Sparky) from the San Francisco Museum of Comic Art for lifetime achievement. In 2007, he was awarded an honorary doctorate by California State University — Monterey Bay. A week before his death, Arriola was honored again for lifetime achievement, this time by the Arts Council of Monterey County.

Arriola matched his literary achievement and quiet crusading with graphic wizardry. A supremely inventive stylist, he changed the way he drew twice during the run of the strip. He had graduated into newspaper syndication from the animation department of MGM, to which he had migrated after a year in the Mintz shop, and he rendered the strip at first with MGM visual mannerisms. By the late 1940s, however, he had nearly achieved pictorial realism. Then in the 1950s, he suddenly — virtually overnight (literally, over a weekend) — streamlined his style, adopting a bolder line and a simplified technique better suited to transforming his pictures with decorative patterns, shapes and textures. For the next three decades, he took the comic strip medium in exciting new directions with stunning fiestas of color and design unusual for a comic strip.

Since the late 1950s, Arriola lived in Carmel, California, an artists colony, and several cartoonists are numbered among its denizens. Regularly, once a week on Tuesdays ("Toons-day"), he met for coffee at a local shop with other cartoonists in the area: Dedini, Hank Ketcham, Dennis Re-

nault (retired editoonist of the *Sacramento Bee)*, Bill Bates, and other writers and at least one poet.

Arriola is survived by his wife and a granddaughter. His only child, a son, Carlin, died after an automobile accident in 1980.

— R.C. Harvey, author of *Accidental Ambassador Gordo: The Comic Strip Art of Gus Arriola*

Kart faces more heart in Turkey

Feb. 5: Musa Kart, who was one of many writers and artists sued by Turkish Prime Minister Erdogan for commentaries that ridiculed the politician, is under fire once again in the country for his work. And this time the cartoonist could face imprisonment rather than just a financial penalty.

Kart was charged in January with insulting the President Abdullah Guh for a cartoon that was published in November; another cartoonist, Zafer Timucin, faces similar charges. Both artists, who could receive a maximum sentence of five years, were published by the daily paper *Cumuhuriyet.* Kart was fined previously for his anthropomorphic treatment of Erdogan, although that verdict was overturned on appeal by a court that said humorous critiques should be given a wider berth in instances of supposed insults to leaders.

Steve Gerber, Marvel Innovator of the 1970s, Dies at 60

Feb. 10: Steve Gerber died of complications from idiopathic pulmonary fibrosis, a disease that fills the lungs with scar tissue. He was 60. Gerber had been rushed to the hospital the month before and was waiting to be assigned lungs for transplant. He occasionally blogged from his Las Vegas hospital bed, including a post that described the suspense over whether a spot found on one of his lungs was cancer or a viral infection; cancer would have ruled him out as a transplant candidate. The spot was indeed a virus, but the resulting pneumonia proved too much for Gerber's body to survive.

As a comics writer, Gerber turned out some of Marvel's most interesting scripts of the 1970s. He then went to the mat with Marvel for the rights to his most famous creation, Howard the Duck. He was the first comics creator to act on the example set by the Siegel and Shuster furor of the mid-1970s. Fans and fellow professionals rallied behind him, most notably when Jack Kirby volunteered to draw *Destroyer Duck,* a series that Gerber wrote and Eclipse Comics published to raise money for Gerber's court battle. In the end Marvel kept the rights, but Gerber extracted what appears to have been a lucrative settlement. "It's no secret how

Howard's first appearance in *Adventure Into Fear #19* (December 1973), written by Steve Gerber and drawn by Val Mayerick. [©2006 Marvel Characters, Inc.]

mad I was during and before the lawsuit," Gerber said in 1985. "The terms of the settlement are such that I am no longer angry." Marvel made sure to include nondisclosure language, so Gerber couldn't say much more than that. Still, the industry had watched as its reigning giant got a bloody nose from someone the company used to pay $23 a page. In effect, Gerber had fought his way to the same basic bargain that has underlain industry dealings since the 1980s: more money and credit for creators, but character rights stay with the company.

Gerber is survived by his daughter, Samantha Voll; by his mother, Bernice Gerber; by his brothers, Jon and Michael; by his sister, Lisa Bedell; and by his wife, Margo Macleod, from whom he was separated. He was born on Sept. 20, 1947, in St. Louis, graduated from University City High School in 1965, and received a communications BA in 1969 from St. Louis University. The biggest part of his comics career took place between 1972, when Gerber joined Marvel as an associate editor, and 1978, when the *Howard the Duck* newspaper strip was taken from him and he announced his intention to sue Marvel. In the decades afterward and up to his death, he occasionally returned to comics for miniseries or story arcs, and he created several news series. But chiefly he earned

his living as a writer and story editor on Saturday-morning cartoon shows. These included *Thundarr the Barbarian* for Ruby-Spears Productions, *G.I. Joe: A Real American Hero* for Marvel Productions and Sunbow Productions, and *The New Batman/Superman Adventures* for Warner Brothers.

— Tom Crippen

A full report on Steve Gerber's life and death will appear next issue.

Republication of Danish Mohammed caricature re-ignites controversy

Feb. 18: Several European publications reprinted one of the 12 infamous drawings of Muhammad in the wake of news in February that police in Denmark had foiled a plot to assassinate the artist behind one of the most volatile cartoons. Three individuals were arrested and charged with the conspiracy to kill Kurt Westergaard, the artist whose drawing of Muhammad with a bomb-shaped turban was perhaps the most visible of the cartoons published by the daily paper *Jyllands-Posten* in 2005. In the course of reporting on the news of the alleged plot, many papers printed Westergaard's cartoon – leading to another round of outrage and protests among Muslims in multiple countries.

Around the same time as the latest round of controversy, another one of the 12 artists who contributed Mohammed-themed cartoons to *Jyllands-Posten*, Eric Sorenson, died at the age of 89. Sorenson was a longtime contributor to the paper, serving as a staff artist for three decades and publishing his first art for the paper in 1938. Sorenson's most visible creation did not actually contain a depiction of Mohammed, which is forbidden under Islamic doctrine — rather, the artist chose a more symbolic visual combined with text that critiqued the religion's treatment of women.

Steve Whitaker dies at 52

Feb. 22: Steve Whitaker, a longtime fixture of the British comics scene best known in America for his coloring work on *V for Vendetta*, died on Feb. 22 at the age of 52 after reportedly suffering a stroke. Whitaker was a talented and wide-ranging figure in the UK who earned a degree in painting at the Chelsea School of Art and later got jobs coloring for major publishers like Marvel and DC in addition to outfits like Tundra and Valiant. (According to the writer Neil Gaiman, Whitaker was tapped to be the regular colorist for on *The Sandman* but was such a perfectionist that the job was awarded to another, more prompt freelancer.) Al-though his work on Alan Moore's *V for Vendetta* was admiringly cited in the wake of his death, his colleagues also noted Whitaker's presence in the comics community as a respected scholar and mentor to other artists. His book entitled "A Unique A-Z Directory of Cartooning Techniques, Including Guidance on How to Use Them," was released in 1993 and reprinted by David & Charles in 2002.

Two new projects from Sim

Feb. 25: Dave Sim, who concluded his long-running epic *Cerebus* four years ago, has two new projects in front of comics fans this year. One is the fashion satire *Glamourpuss*; the other is *Judenhass*, a project that Sim plans to release in May as a 56-page comic book during the 60th anniversary of the founding of Israel. *Judenhass* is described in a released statement as "a personal reflection on The Holocaust," that, due to its subject matter, the artists will not be actively promoting. Several comics figures, including Joe Kubert and Neil Gaiman, have given the project high praise as an affecting work. An excerpt can be viewed online at judenhass.com.

Major prizes handed out this spring for editorial cartooning

March 7: Major awards in the field of editorial cartooning were announced this spring, with different winners for each prize. Steve Kelly of the New Orleans *Times-Picayune* was named the recipient of this year's National Journalism Award for editorial cartooning. The award comes with a $10,000 stipend. Kelly beat out two other finalists for the honor, Mike Lester of the *Rome News-Tribune* and Michael Ramirez of *Investor's Business Daily*; the latter was named this year's winner of the John Fischetti Award for editorial cartooning. Meanwhile, the National Headliner Awards were announced in early March by The Press Club of Atlantic City, N.J., with cartoonist Mike Peters taking the top honors in his field. Peters, who won the Pulitzer for editorial cartoons in 1981, is on staff at the *Dayton Daily News* and is the creator of the daily strip *Mother Goose and Grimm*. Additionally, *The Herblock Prize* was given out to John Sherffius, who draws for the Copely News Service and the Boulder, Colo. publication *Camera*. He received the award March 18 at the annual ceremony held at the Library of Congress.

Webcomics honored at Megacon

March 8: The winners of the Web Cartoonists Choice Awards were announced at Orlando's Megacon March 8. Among the winners were Phil and Kaja Foglio, who took

home three of the honors, including the top prize. The complete list of winners is as follows:

Outstanding Comic
Girl Genius, Phil and Kaja Foglio

Outstanding Newcomer
Octopus Pie, Meredith Gran

Outstanding Artist
Tracy J Butler of *Lackadaisy*

Outstanding Writer
Kaja and Phil Foglio of *Girl Genius*

Outstanding Character Writing
Templar, Arizona, Spike

Outstanding Long Form Comic
The Order of the Stick, Rich Burlew

Outstanding Short Form Comic
Perry Bible Fellowship, Nicholas Gurewitch

Outstanding Single Panel Comic
XKCD, Randall Munroe

Outstanding Comedic Comic
Penny Arcade, Jerry Holkins and Mike Krahulik

Outstanding Dramatic Comic
Gunnerkrigg Court, Tom Siddell

Outstanding Layout
Copper, Kazu Kibuishi

Outstanding Use of Color
Dresden Codak, Aaron Diaz

Outstanding Black and White Art
Lackadaisy, Tracy J Butler

Outstanding Photographic Comic
A Softer World, Emily Horne and Joey Comeau

Outstanding Character Rendering
Lackadaisy, Tracy J Butler

Outstanding Environment Design
Girl Genius, Phil and Kaja Foglio

Outstanding Web Site Deisgn
Lackadaisy, Tracy J Butler

Outstanding Use of the Medium
Dresden Codak, Aaron Diaz

Dave Stevens, creator of The Rocketeer, dies at 52

Dave Stevens, the illustrator and comic-book artist known for creating The Rocketeer as well as for a distinctive retro style that he used in his depictions of glamourous pin-up girls, died on March 10 after a long battle with leukemia. He was 52.

A full obituary and a remembrance of Dave Stevens by Bill Stout will appear next issue.

Cold Cut renamed under new ownership

March 13: Cold Cut Distribution, the last small distributor that provides even the tiniest shred of Direct Market competition to industry mammoth Diamond, is now under the ownership of Rogue Wolf Entertainment and is being renamed Haven Distributors. Cold Cut specialized in reorders and small-press titles that retailers found to be slow or problematic orders from Diamond. The other last small distributor in the field, FM International, went out of business in 2006. "We see this company as a haven from short orders, from jumping through hoops to get listed, from getting buried in the back of a top-heavy catalog and from unrealistic expectations," said Rogue Wolf's Lance Stahlberg to *Publishers Weekly*.

Two Corrections for TCJ #289

We forgot to express our appreciation to Shaun Tan and Lothian Books / Hachette Australia for the use of the images that accompanied our interview with Mr. Tan. And we forgot that Greg Stump refuses to change his professional name despite our crediting his Datebook report in that issue to "Greg Stuff and Staff." The *Journal* regrets its faulty memory and Mr. Stump's obstinacy. ■

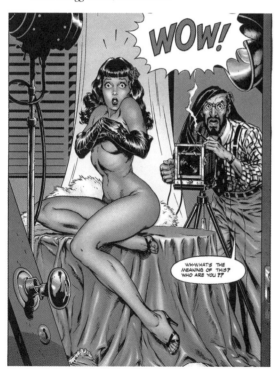

From *The Rocketeer: An Album* by Dave Stevens. [©1991 Dave Stevens]

I have put my genius to work and created a donut that actually prevents cavities.

get out!

I kid you not, little man.

What's the secret ingredient?

Fucking toothpaste..

I hope you are having fun reading a cartoon about a lonely, fat-pig, whose highlight of his weekend is doing laundry...

I would think you could find something more exciting to watch like a bank heist or a police chase.

Ewwwwww, spin cycle, now thats exciting!

Here, Let me spice it up a bit for ya.

I can see in your eyes that you are waiting for me to fall in love with you.

After I fall in love with you you will stick a rusty knife in my gut and bleed out my spleen like a fish

For six months I will fester in a dark hole of alcohol, depression and substance abuse!

Not this time you dirty wench!! Not this time, you dont!!

Nothing like a good game of frisbee to take your mind of the worries of modern life.

You said it, Chicken Man! And it is much cheaper than drinking or drugs!

zoom

You didnt buy any of that bullshit about drinking and drugs did you?

Nada

You think we can sell that frisbee for some meth?

The *Schulz and Peanuts* Roundtable

David Michaelis' *Schulz and Peanuts* is the most ambitious biography to date of the creator of what may be the most influential and beloved comic strip of the 20th century; it may be the most controversial biography of a cartoonist, as well.

Schulz and Peanuts appeared in early October. It received largely respectful reviews, most of which took Michaelis' story of Charles Schulz's life at face value and reiterated it uncritically — including those reviews that appeared in *The New York Times* and *The New Yorker*. Several reviews underscored Michaelis' conclusions that Schulz was a depressed or melancholic personality and a remote father and husband, but didn't question them. By the end of October, however, it was widely known, at least among cartooning circles, that the Schulz family was unhappy with much of the biography and disputed precisely those

most-talked-about assertions made in the book. Schulz's son Monte was particularly vocal about his — and the family's — dissatisfaction with Michaelis' portrait of his father, posting numerous messages on the Cartoon Brew website to that effect.

On Nov. 7, as part of his book tour, Michaelis appeared in Seattle, where I had the privilege of interviewing him about the book. We spoke at length about the gestation of the biography and his admiration for Schulz. I brought up the burgeoning controversy and read a couple of quotes by Monte Schulz, inviting him to respond. Michaelis replied that his biography was interpretive, conceded that it could be read as a "corrective" to Schulz's antiseptic public persona, and steadfastly defended the truthfulness of his portrait of Schulz.

Because *Schulz and Peanuts* is an important biography about one of the most important cartoonists who ever lived and brings up specific issues regarding Schulz, as well as broader issues about the latitude of a biographer, the difficulty of resolving competing truth claims, and the nature of biography itself, we decided to arrange a symposium on the book. We asked five historians and critics to, first, write a response to the book and, second, comment on each other's initial responses. Three participants are *Journal* contributors: Jeet Heer, R.C. Harvey and Kent Worcester. (R. Fiore's essay, insightful as it is about Schulz, did not discuss the book itself, and appears in his column on page 208.) The fourth is Monte Schulz. In the course of a conversation with me on the subject, Monte was sufficiently impassioned that I encouraged him to consolidate his numerous message-board posts into a coherent argument that we could publish as part of the roundtable. He did more than that by writing both an argument and an alternative portrait of his father. I would like to have participated myself but, as the publisher of *The Complete Peanuts*, felt I lacked the objectivity (or the appropriate subjectivity). We are happy to publish any response Michaelis would care to make or respect his disinclination to do so. He was invited to participate in this issue by responding to the two rounds of argumentation or in any other way he felt comfortable, but he declined, saying he preferred to let the book speak for itself. Clearly, it had a lot to say, for good or ill, judging from the critical conversation it has provoked.

—GG

Jacket designed by Chip Kidd.

Regarding *Schulz and Peanuts*
by Monte Schulz

I must admit I'm not a big fan of biography. This is not to say I don't read them, because now and then I'm drawn to the story of writers I admire, such as Virginia Spencer Carr's biography of Carson McCullers, or A. Scott Berg's book on Maxwell Perkins, and Arthur Mizener's biography, *The Far Side of Paradise,* one of the early examinations of F. Scott Fitzgerald's life. I've read Joseph Blotner's book on Faulkner, and Moreau's biography of James Agee, and even *Shade Of The Raintree,* Larry Lockridge's memoir of his father. So, while I am not indisposed to appreciating biography, it's not something I seek out all that often.

For that reason, the idea of a biography on my father was not, for me, a huge priority, even after he died. Perhaps it was because I presumed his story had already been told in 50 years of comic strips, or maybe because the only part of his life that mattered to me were the years I knew him as my father. In any case, when David Michaelis approached us with the idea of writing Dad's life, I was fairly neutral to the idea. What interested me in evaluating David's pitch was how well he wrote, not necessarily what he intended to write. I supposed he would try to say, as others had, that Dad was melancholy and morose and hated to travel. And if that were to be the direction of the book, I'd have to say no. Yet not only was I impressed by what I read in his biography of N.C. Wyeth, his artful language and literary sensibility, but by David himself, who came across as thoughtful and engaging, fun to talk to and be with; I even nicknamed him "Pudge." He even confided to me how the genesis of doing the biography on my father came from a conversation with the Kennedy kids, former schoolmates of his. When asked how he had intended to follow his biography of N.C. Wyeth, David told them he was leaning toward a book on their grandfather, Joe Kennedy, an idea they rejected out of hand, arguing that he ought to write about Charles M. Schulz. Although his *Wyeth*

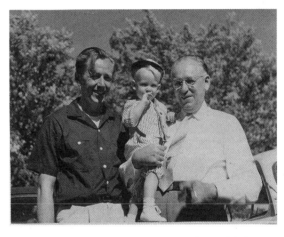

Charles, Monte and Carl Schulz: photo courtesy of Monte Schulz.

editor at Knopf favored the Kennedy biography, David became convinced that telling my father's life — a Midwestern story — was what interested him best, and so that's what he proposed to us several months after Dad's death.

It's important to bear in mind that David and I had a good and constant relationship over the years he researched and wrote my father's biography. We visited with the rest of my family in Minneapolis and St. Paul the year after Dad's death, traveling from Roselawn cemetery in St. Paul, where Dad's mother was buried, three miles east to my grandfather's plot at Forest Lawn. We drove to the houses where Dad lived as a boy, the apartment he shared with his mother and father above Grandpa's barbershop on Selby and Snelling, and onto Minnehaha Parkway where our family lived before coming west to California in 1958. David was invited into our lives to record what we knew was important about Dad and our time with him, sharing, as we traveled about, anecdotes and observations we were sure would be recorded

into David's definitive biography on Charles M. Schulz's life and art.

After Minnesota, I flew into Washington D.C. to take part in Katie Couric's colon cancer benefit. David met me at National Airport and I stayed the night at his Georgetown mansion where we did our first interview about my life with Charles M. Schulz. He and his wife, Clara, were very gracious hosts. A year later, I came back to Washington to take part in a ceremony awarding Dad the Congressional Gold Medal and had dinner with David, my friend (and Dad's) Robert Short (*The Gospel According to Peanuts*), and the former president of Dad's company, Warren Lockhart. That evening, I discovered that David was more religious than I'd expected, something that bore out in the first draft of his manuscript years later with a discussion of my father's own faith regarding the Church Of God and his professing late in life of an inclination toward secular humanism.

It's important to understand how often David and I spoke during the period he researched and wrote this biography. I considered us to be good friends, and I presume he did, too. Nor were all our communications limited to a discussion of Dad and his life. Indeed, few people in my life were more supportive of my own work than was David and I owe him quite a lot for that. Likewise, we shared a good correspondence regarding his own difficulties, both personal and professional, and I felt a deep and abiding empathy for that path which led him to our family. He had, after all, lost his own mother fairly recently and felt her absence as much I missed Dad. I found David over the years to be considerate and gracious, unusually insightful on artistic and personal matters, and genuinely forthcoming in expounding on his own triumphs and failures. We commiserated often and that's what made our friendship so worthwhile to me — beyond the ultimate purpose of his biography-writing and his presence in my life. The practical result of our relationship was my constant and energetic cheerleading of his efforts in dealing with my family. Initially, Mom had no interest in talking to him; neither did my older sister Meredith, nor my Aunt Ruth. My mother believed David was simply cashing in on the publicity surrounding Dad's death and wanted no part of that. I spent four years urging them to speak with him, because I believed in David's book and the importance of the project. Moreover, I was utterly convinced, as was my stepmother, Jeannie, that David Michaelis was clearly the best person to tell this story, both from a literary perspective and his own sensibilities, as I perceived them during those years.

We kept up a steady correspondence both by telephone and e-mail, so I felt confident in what sort of biography David intended to write. Also, I closed each phone call by reminding him that the mythology of my father's depression was not only false but also done to death by journalists and his first biographer, Rita Grimsley Johnson. Knowing my father over any reasonable period of time would disabuse someone of the idea that he was melancholy or withdrawn. Quite the opposite, in fact. Most people who knew him found Dad quite engaging and full of enthusiasm for life and its many facets, both wonderful and troubling. He understood as well as anyone that we live in a difficult world whose contradictions test our faith in goodness and love and reverence for all things bearable. Yet, life still must be lived and appreciated for what it offers. Doing that, while trying to exist through tragedy and sorrow and disappointment, makes some of us heroes, and lends a glow to our minor triumphs. This understanding lies at the heart of *Peanuts* and is what perhaps made it unique in American culture. My father summoned his genius from many places when he drew those funny pictures. Knowing him personally gave some insight into where his ideas originated, but did not fully explain how and why he wrote. I imagined that David knew this to be

The cover image to Robert L. Short's *The Gospel According to Peanuts*.
[©1956 United Feature Syndicate, Inc.]

fundamental. Indeed, once by e-mail he wrote:

Monte, I know, I know: your father didn't draw from life; and I'm not looking for a one-to-one match-up here; and the reader probably can't finally understand art any better by knowing the conditions of the life of the artist — ideally, art has to be understood on its own terms.

At the time, I could not fail to appreciate how wise David was to point out how dangerous and faulty it can be to attempt to make those direct correlations between the life of the artist and what he or she puts out for the world to see. I thought he articulated this basic truth quite eloquently; I don't recall us ever revisiting this issue. Most of our discussions were like that, as I'll show later on: We addressed some aspect of my father's life and art, his past or present, hashed it out between us, and then moved on. In our personal correspondence, David Michaelis was wonderfully even handed and artful with his prose and insights.

Our expectations for this book were that it would reveal my father's life in its totality, as far as that would be possible. There was a review of one of David's early essays on my father that commented on what could be missing from his biography, something that drew my attention immediately.

Michaelis clearly knows the facts, and he offers useful comments about Schulz's personality and art. One hopes that he'll find joy and perhaps even ecstasy in Schulz's life and that he'll tell us about that side, too, along with the dark, morose side.

I sent this to David to see his response, adding, "Good point, and I trust that you will. It's not something you and I have spent a lot of time on, but I do have much to say about the clear and obvious joys and enthusiasms Dad experienced before my eyes."

He wrote back with the sort of reassurance I'd come to expect from him. Because David Michaelis, in the years I knew him, was one of the most thoughtful writers I'd ever met: generous with his perspectives on life and art, how we live and ought to live, and more importantly, inquisitive about the strangeness of being a writer. Essentially, David and I had a six-year conversation about how best to decode what a life reveals, and this dialogue had a grace to it that impresses more now even than it did back then. He wrote:

"Monte,

A very, very good point. That balance — that roundedness — is of course what I'm aiming for, and I would very much appreciate any (even a single quintessential example) recollection you have of a moment or moments in which your father's joy was clear and present (maybe outside of during sports, which I have heard much about from his hockey teammates). I don't have to tell you that the more the strip and its themes became part of his mythology, the more he himself, when he spoke about his own life, chose restraint or melancholy as an alternative to expressing enthusiasm or releasing anger or revealing any of half a dozen more subtle or complicated emotions that would have been difficult to present to the outside world. So please, do let me know about real joy as you saw him experiencing it in his real, private life."

And, of course, I saw this as a ready and vital opportunity to have my say, once and for all, about what made my father smile. Too often over the years, all I read about him was how melancholy he was, how depressed and detached, how the humor in his comic strip masked somehow, or was a surrogate for, the deep and abiding sadness that inhabited his true self. Which was nonsense. So I sent David this long e-mail trying to explain how that whole paradigm of thought regarding Dad's true struggle was false and misleading, how it ignored the greater part of Dad's life, how it left out all of us who shared years of smiles and laughter with him, and was careening toward a caricature of my father that would haunt his image in the decades to come unless somehow, while we were still alive, we took these opportunities to correct that stupendous error.

David,

Joy has its own rainbow. I've given quite a lot of thought about your question regarding Dad and his joys, and the more I've thought about it, the angrier I've become. Because for years now, most of what I've heard about my dad is how melancholy, morose, sad, and depressed he was. I don't care who tells you that. It's just not true. I don't deny that he had those moments where he was overwhelmed by an abiding sadness that arose of deep remembrances, or fears, or worries. And maybe his were more profound than those of the average person. So what? Isn't that true of any true artist or thinking person on this earth? Anyone who seems happy all the time must be either an imbecile or constantly medicated. They can't be trusted. Dad, on the

other hand, loved life, and saw both the beauty and tragedy therein. He was incredibly successful in his career and beloved by millions, yet, like many of us, his life was not perfect, his joy incomplete. Where was his mother? Gone all those years. Why couldn't she be there with him and his dad to share his accomplishments, guide him through his crises, mend his wounds, and heal his fears? His victories were incomplete. Such is life. But, good grief, his joys! Wow, David, he LOVED to be with his friends! From my earliest memories of our family being deluged on holidays or summer weekends or any other excuse to entertain, I can remember Dad wearing a huge grin of enthusiasm when he had friends there to the house. Whether playing softball, or Ping-Pong, or tennis, or shooting pool, or just sitting around telling jokes, he just beamed and beamed. He was such a fun Dad to have. That day he tried to fly the kite was no Charlie Brown nightmare, but a lark that made the day for all of us. And he loved his cars, and drove with a smile every time. We'd go for a ride, whether to town or off to school, and he'd tell me all about driving and what the car could do. They were not just for his transportation. He adored them! And he loved to talk about books, dozens of books, and all kinds of books, be they fiction or nonfiction, poetry or theology. He loved reading. He wore a grin of satisfaction when he talked about reading and all he'd learned and all there was yet to learn. That's why, I presume, he was so happy that I, too, discovered books, so that he'd have someone in the family to share his enthusiasm. And he loved the ice show, just being there during rehearsals and the performances, meeting the skaters, sharing his ideas, seeing them implemented, watching the crowd appreciate what he gave them each Christmas season. He loved that show, and his joy was evident each day

at the rink. Of course, he loved to draw! I'd come into the studio some days and he'd greet me with a huge smile and a chuckle and show me the gag he'd drawn that afternoon. No one ever pursued that profession with more joy and enthusiasm than he did. Do you possibly believe that anyone who was basically depressed all the time could have sat at his drawing board for fifty years and made millions of people laugh? That's ridiculous! Oh yeah, the clown weeps beneath the greasepaint grin. Sure. Maybe we need to talk about this on the phone one day, but I tell you here and now, Dad's joys were in movies and golf and trips with his friends, (Listen to the story of the time he and Lee and the gang went down the Rogue River humming Ommmmmm through the rapids, and I defy you not to see that joy he was feeling), teaching me to throw the knuckleball, or Jill to ride a bike, or Craig to drive a car. They were in a bowl of tapioca pudding or a tuna sandwich at his table at his ice rink with his friends joining him for lunch. A depressive Dad is not fun to be with, and each one of us will tell you that our dad was wonderful company at every stage of our lives, and I believe his friends will tell you the same. No one is always sunny and up. Dad's heart drifted into dark realms because of a sadness he could never conquer. Even if my book sells tomorrow, the whole thing, and makes me rich and famous, I'll never get over his death, and my boys will know that in their dad and wonder why I don't smile all the time, and why I seem morose now and then, and why I have fears they lack, but I also make them laugh and they see me smile and see my joy much more than not, as I saw it in my dad. Don't let anyone tell you the contrary because it's at best a point of view, and at worst, a shameful lie. And if you spend five years writing a book about how Charles M. Schulz was at heart a sad and melancholy

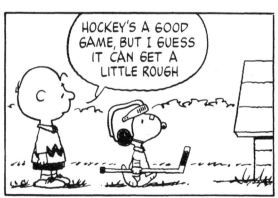
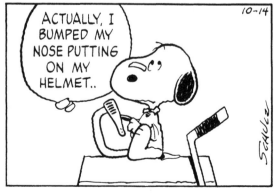

Peanuts strip from Oct. 14, 1983. [©1984 United Feature Syndicate, Inc.]

person, I'll feel you needed another five years to look with better eyes."

What David wrote in response to my articulating of Dad's joy was, I thought back then, sufficient to assuage any fears I had of his book jumping the track. In hindsight, I realize I was the one who ought to have looked with better eyes, because his emphasis was not mine, and I can see now how he missed my point almost entirely. But I did not recognize it back then.

> *Monte,*
>
> *Thanks for your memories of your father in happy times. I appreciate each of those, as well as the larger point you're making, and I understand your concern. I'm sure you must know that my aim for this book is to tell the most complete, fully rounded account of your father's life. I've always appreciated your candor, and I was glad in this case to hear you articulate what sounded exactly right to me: that your father had his joys and yet his joy was incomplete. I can't think of a better way to express that side of his life.*

Still, it would be a mistake to suggest that at any time during David's writing of his book I doubted what he would write. On the contrary, perhaps more than anyone in the family, I believed in him as a writer and a person of great integrity and fidelity to the process and importance of biography. Neither, aside from that paragraph above, was there anything in our ongoing correspondence to give me any cause to worry. In fact, he wrote:

> *I love this work, I love your Dad, his life, his art, and the more time I spend in this the more I understand that famous remark of Kierkegaard's about how, although life is lived forwards, it must be understood backwards. You have to know the end of the story first. Then, only by going back to the beginning and grasping the strangeness and beliefs and uncertainties of the time in which a person lived and the choices he made during the pull and play of life's alternatives can you begin to understand who he really was. This process, especially with your dad, has also made clearer than ever Katharine Hepburn's famous remark: "Nobody can ever know everything about anybody."*

And it was just that dignity of purpose and commitment to his subject that reinforced our friendship and cemented my faith in David as an artist and biographer. You can see

This photo of Charles Schulz is courtesy of Monte Schulz.

how he seems to place his own ego in proper proportion to his subject. Although each of us who writes anything of value reveals ourselves somewhere in our work, that temptation to allow our own point of view to infect how we see our characters, whether fictional or real, must be sublimated to the final integrity of the piece itself. Like anyone, David Michaelis has opinions, many deeply felt. The loss of his own mother gave David insight into the lifelong sorrow Dad felt. That empathy, I firmly believed, could only strengthen David's biography. His understanding of his own flaws should have led him to a greater appreciation of the struggles my father underwent throughout his life and career. Those painful vulnerabilities that both David and I shared fed nicely into our discussion of Dad's. The basic trust that needs to develop between a biographer and those closest to his subject can only thrive in an atmosphere of empathy and honesty. So I did my best to be as forthcoming as possible in all our conversations and correspondence, telling him much more about myself, for example, than I ever needed to in an effort to let him see how much of who I am today came out of my relationship with my father, and, in turn, give him a clearer picture of who Charles M. Schulz was as a parent. I sent him

From *Peanuts Classics: Kiss Her, You Blockhead!* [©1982 United Feature Syndicate, Inc.]

this short piece I was asked to write about that part of my relationship with Dad and how baseball figured into it:

When I was maybe four years old, my dad dressed me up in a baseball uniform and posed me in our family's backyard with a bat and ball. More than forty years later, just before he passed away, we played catch one autumn afternoon in my own backyard. So many of my dearest memories of my dad, involve our shared love of baseball. He took me out of school when I was ten years old to see the sixth game of the 1962 World Series between the San Francisco Giants and the New York Yankees. We used to drive down to Candlestick Park to see doubleheaders on Saturday afternoons, just the two of us. One morning he was invited by the Giants to a breakfast at the ballpark and brought me with him where I was able to meet the legendary Casey Stengel and Willie Mays. We watched Willie McCovey hit three home runs in one game against the New York Mets, and saw all three Alou brothers in the Giants' outfield together at the same time. My dad taught me how to throw a curve and a knuckleball. With him in the dugout cheering me on, that curveball won a Bronco League baseball tournament game when I was twelve years old. We spent hours on the front lawn competing with each other in wiffle ball games. There is a Peanuts *strip where Charlie Brown is pitching a golf ball into some cement steps, imagining himself on the mound in a big game. Even then he suffers a home run rebounding over his head. Dad taught me that game and I played it for years out in our driveway when he was working and couldn't come out to play. I had heroes in the major leagues. He had his own from a team in St. Paul where he grew up. In his studio was a small baseball bat signed by one of those players from*

Dad's childhood — Ollie Beama. That bat belongs to me now, and whenever I pick it up, I am reminded once more of that enduring sport which bound us together, father and son, forever.

Sending David this little essay lay at the heart of why he and I had our dialogue: my attempt to let him see how big a part of my life was my father, not only when I was a young boy, but really later on, even to the night he passed away. Dad and I spoke constantly on many topics of many sorts, and that father/son bond never wavered from beginning to end. So while I knew that others had different relationships with my father, I saw it as my role in this biographical process to show a facet of Dad's personality and temperament that remained vibrant. And I think I did, in fact, communicate that to David. But maybe I ought to have gleaned some hint that he had decided to pursue another direction. Over and over, during those years, he reiterated a belief that some day I ought to write about my dad and myself, how we lived, what we shared and meant to each other.

Another subject for another time: I know that you are not interested now, but I hope that eventually you will find your way into a serious piece of writing about yourself and your father — whether memoir or fiction isn't important; I feel certain that you would do something of real value in either form. For yourself, you might also lay to rest that suspicion you spoke of — that, for you, any writing or publishing having to do with him is an un-accomplishment. My guess is, it would be a tremendous victory, personally and professionally, if you could see yourself and him in real terms, which, of course, are his terms at the start, as they have to be in every father-son relationship; but, which, in

the very act of writing, you would make your own."

Ironically, though, I never felt doing so was necessary, especially since David was certainly going to tell my story for me. Why else had I been telling him so much about my life with Dad and showing him our letters, going over the photo albums, explaining how we each felt about certain events in our life? We had many exchanges like that over the years, and I did try as best I could to offer David a window into our lives all those years ago. They were, after all, many of the best times our family knew, and those memories were precious to us, so sharing them with a biographer was an act of courage, but also something I think each of us enjoyed doing. Revisiting a past that is long dead can be traumatic and melancholy, yet also invigorating in the sense of remembering smiles we forgot, a laughter whose echo has disappeared. So our hopes for David's biography were rooted in that sensibility, a calling card to our halcyon days, a gift of remembrance. In exchange, we handed over notes from forgotten scrapbooks, to show David the abiding love we held for our father. This one was from Craig to my dad:

> *Happy Father's Day to My Dad!*
> *I am sorry I do not have a present to give you*
> *But I will get one. — Craig*

And this from Amy:

> *Happy Birthday Dear Father, Greatest of all Fathers*
> *Without Whom I Couldn't Survive! I Love you!*

He also asked about personal histories, and we tried as best we could to provide him with the most honest accounts possible. It was not a case of describing both happy times and sad, the good and the bad. We each understood that life provides choices and not all our decisions are glad and golden. Mom and Dad did not agree on everything, to say the least, nor did we agree with all of their decisions. There were squabbles, as in any family. But maybe in our occasional unhappiness, we trusted the direction we were sent, and somehow found advantages to be had where there appeared to be none. These, too, were made clear to David: why Mom and Dad did what they did, and how we dealt with their complicated choices. I suppose I believed that if I were to fully illuminate the root causes of various trying situations for David, there would be less chance for him to arrive at faulty interpretations. Because he had no first-hand

knowledge of our lives at Coffee Lane, nor any reliable witnesses outside of our family to rely upon, I knew somehow that clarity was essential in guiding his telling of our story.

My freshman year, I had 3 A's and 3 B's, so it was a shock when Dad approached me during the winter to suggest I wasn't doing well, and maybe I ought to go away to a great school. I had no idea what he was talking about, because my grades were great and I was doing well. He came back again and again, and I just knew something was going on, and the private school issue had already been settled without my input. And the next year, off we went, Craig and I, with no real knowledge of why we'd been sent. Well, Meredith had been sent, too, off to Switzerland (she'd already spent one year at a girls' school called the Katherine Bronson School near Ross, I think). It wasn't until maybe five or six years later that I found out why I'd been sent off. Mom believed that Meredith was hanging out with the wrong people at Analy High and was doing drugs (which she maintains to this day that she was not — then!), and needed to be removed from that situation. So that Meredith would not feel punished or picked on, Mom decided Craig and I also needed to be sent off. Dad was crushed and angry, but went along with the plan. No, I do not believe in any way that Mom and Dad were in agreement about sending us away. He hated to see us go and it was Dad who drove us down there. We stopped at the Madonna Inn in San Luis Obispo the night before driving on to Cate, and Dad took us to see Rio Bravo *at the drive-in theater across the highway from the Inn. I always associate that movie with that trip. On our holiday trips back home, we flew from SB to SF, and were taken to the SB airport by Sue Broadwell, who later became Dad's secretary. She was attending UCSB at the time, and works now at the Museum. You could ask her about this, if you like. I do not recall Mom ever coming down to Cate School, and I doubt she did. So Dad had to do the tough job, leaving us off, and picking us up at year's end. And, again, I believe Dad was the one who always spoke to me about going away to Cate, not Mom. You might ask Craig about his experience in all this. It'd be interesting. Did Dad talk to him? I don't know, but I will tell you this: When I was at UCSB and Craig came down to visit once, I drove him up to the Cate School for a walk around and when we were driving off again, he said, "I'll never forgive Mom for sending me here." Interesting, huh? And he had lots of friends there, more than I did. But apparently his*

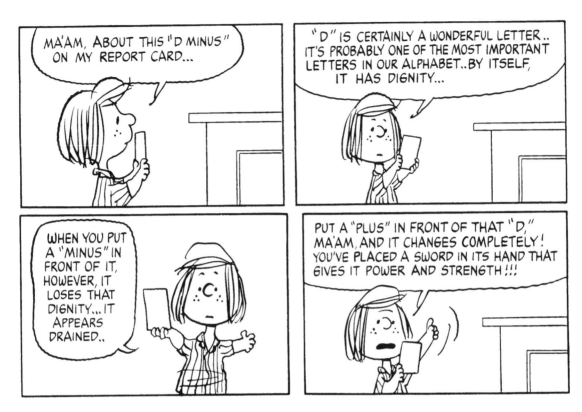

From *Peanuts Classics: Kiss Her, You Blockhead!* [©1982 United Feature Syndicate, Inc.]

academics were weak, and ultimately, seeing the year-end letters from Cate for both of us, they didn't think he should return; They did believe I should, and I wish I had. Yes, I'm sure Dad cried when we said good-bye, or held it back if he didn't. He seemed sad, as I was, too.

These exchanges would have been stillborn had David not received them with such sympathetic recognition. And don't imagine these correspondences provided some emotional exorcism. They did not. However trying those days away from home were back then, I assured David that, in fact, I regard that year at the Cate School as immensely beneficial, and, in fact, I was sure to tell him how I attend every reunion for my class of that year with great enthusiasm. Again, David needed to hear these stories to better appreciate the directions our family went as we grew. Honesty in my dialogue with David required these inclusions, and I believe he appreciated that.

Monte,
Thanks exceedingly for taking the trouble to go into the

belly of that beast and with real style answer every question I asked and even those I hadn't formulated; and I'm very glad we ended up discussing this in detail at this stage, because although I am still in 1946, with Staff Sgt. Schulz returning from war to the muddy brown-brick buildings of the Selby-Snelling intersection, far, far away from the "garden air" and "smooth winds" of Coffee Lane, the dots you've helped me connect make real sense to me now. That said, I also want to add on a personal note, how sad much of what you wrote made me — for you, for your father, for Craig. If a biographer needs regular doses of empathy to understand his subject(s), this is the necessary medicine. I can only hope it lifts some of the baggage from your grip; and I thank you for braving the past in behalf of your Dad and the book. I am writing about his life first and foremost, of course, but understanding the lives around his as they developed alongside his (and not seeing them merely as fixed or static figures, as biographies so often do with secondary and tertiary characters) is incredibly important to see how his choices developed out of and from the lives of those close to him, esp, of course, his family. I loved Rio

Bravo, *by the way, but I doubt I'll ever be able to see it again without thinking of you three exiles, marooned there in the drive-in.*

We did not hire David Michaelis to write this biography, but we certainly did much more than simply cooperate; we helped him do the work. All a family can ask of any biographer who has been invited to tell the story of a life is that the writer be honest and generous, thoughtful and human, because none of us are lacking in faults, nor are any of our flaws absent in others, even in the biographer himself. Despite everything that followed, I can look back on my correspondence with David during his research and writing and agree that never did my opinion of him change. I believed his sensibility and passion for my father's story was more than adequate to that good task. It seems to me that treating an artistic venture (as this was) with skepticism dooms it all along. Nobody ought to be fooled by the presence of a writer in his midst, yet being hopeful and credulous has its place, as well. Why agree to be helpful, and then offer a distrustful hand? David engendered my trust through a long and mutually enriching correspondence. He wrote to me with dignity and respect. I could not help but admire him.

So I start every morning at my desk with a mantra of my own about being entrusted with the life of a human being: You start with a baby, you discover a man, and end with dust. Be gentle.
Yrs,
David

Finally, of course, David reached the end of his long journey with my father's life and his biography. Having spent 10 years of my own on an epic novel of the Jazz Age, I appreciated his steadfast patience and determination to see that last page written, and I think I looked forward to the completion of his manuscript nearly as much as he did. So I wrote him a brief congratulatory e-mail acknowledging his hard-won accomplishment:

Finishing to where you are now is a great achievement. Editing is always easier than creating. Good for you! Although I doubt you'll need anything else from me, I'll be here if you call.
Wishing you good fortune,
Monte

And David wrote back, elegantly generous as ever, clearly understanding that my support for his book had always been unconditional and enthusiastic.

Thanks for every good wish. I really appreciate that, and especially because it means a lot to me, coming from you, when I know that you know what it means to have given a great deal of oneself to a book over a long stretch of years. At any rate, I certainly will need something more from you; namely, candor. I count on you, as I always have, for nothing more and nothing less than what Thomas Wolfe sought from his first and best reader Max Perkins: "the straight plain truth."
Meantime, wishing you good fortune in return.
Yrs always, David

We saw each other a couple of months before he finished the biography, and I drove him out to Occidental near the Russian River for supper, then shot baskets with him for an hour or so up at Jeannie's guest house where he had been staying for a few days. We spoke by telephone once more when the book was done and ready to be mailed to Jeannie and me. I gave a last few words of assurance, writer to writer, regarding my unconditional support for his book and wished him happy holidays. David sent me the manuscript a few days before Christmas, and I read it in bed after returning from a family celebration on Christmas Eve. I was still reading at 4 in the morning. Once I completed my reading and organized my thoughts about the manuscript, I wrote to David.

I finished the book yesterday evening, so, of course, we ought to talk, but you must know I am extremely disappointed in how this project turned out. Actually, I'm horrified. It upset me so much I never got to sleep at all after Christmas Eve; I just stayed in bed until the boys woke and went down to see what Santa brought them. We're driving to SB tomorrow, so you and I couldn't talk, anyhow, until Thursday, but since virtually nothing of what I told you about Dad went into your biography, I'm not sure that we'd have a lot to discuss. If six years of conversations could essentially be ignored while you fulfilled your thesis, what difference could another hour or two make? I will tell you that there are a great many factual errors in the book of many sorts, and I'm not inclined to tell you what they are. Truthfully, for all the time we spent together, and on the phone, I feel deceived, and, I believe, so will a great many other people. But, again, I'm still mostly amenable to

talking about this.

I heard back from him almost immediately.

Dear Monte,

I am genuinely sorry that the manuscript has disappointed and upset you, especially sorry to have placed a burden on you and your family at Christmas. I'll call you in a few hours to talk this through. I'd like to respond immediately to how you are feeling.

David

But it was already too late for me. What I'd read in that manuscript was so far from what we'd talked about all those years that I had no hope of reaching any reasonable rapprochement with him. It was January now, and I understood that the bound galleys of the biography needed to be ready by May or June, which really gave him little time to make anything but the most perfunctory changes to the manuscript. Moreover, I reasoned that if he had spent the previous two years writing what I found to be so shockingly false and distasteful, how could I possibly expect him to change the entire manuscript, all 800 pages, in a month or two? In fact, I believed what he needed to do involved more than simple editing. Virtually nothing of what I had told him over the years about my relationship with Dad was represented in the manuscript I had just read.

David,

Your book is so fundamentally false in its portrayal of my father, so narrow in its description of his character, and so deceitfully uninterested in telling his life story (as opposed to your moralizing psychological analysis of him, which is not 'biography'), that I have neither the desire, nor any intention whatsoever, of revealing any of the many, many factual errors in this manuscript. I am so astounded and shocked that you would devote six years of your life to writing this kind of book (which you repeatedly assured me did not interest you), I've come to the conclusion that you either had no genuine passion in telling his life story, or that you became bored halfway through, and decided a salacious account of his love life and the size of his bank account, would be more interesting than anything else. And, make no mistake, it's not so much what you wrote that I find objectionable, but all that you left out — unquestionably the larger story of his life. Also, having written a long book myself that required voluminous research, I was ap-

palled how careless and lazy yours turned out to be, how unintellectual and amateurish. Therefore, I will be more than satisfied to see your book sail out of the harbor with dozens of loose planks below the waterline.

It is quite difficult to reread that e-mail now without seeing how abruptly mean-spirited and intransigent it was. There is none of the give and take David and I had offered each other over the years, no room for negotiation or compromise. He had requested criticism and suggestions, and I replied with the former, but none of the latter. Certainly, I feel somewhat uneasy with that note now, a year later, particularly without his manuscript in front of me, because his own work provided the motivation and anger, which inspired that amazingly snarky e-mail. So I am of two minds regarding what I wrote, just as I am ambivalent about David Michaelis himself. How our correspondence could have degenerated so rapidly really does astound me today, but then so did his first draft of the biography. And you simply cannot understand what prompted me to write such a nasty note without following me through the manuscript. One led irrevocably to the other. And both distress me still. And, naturally, there are two books to talk about: that stunning first draft, and the one HarperCollins published in October. They are similar (the final being somewhat shorter), yet I feel the need to offer a couple of differences in order to illustrate what astonished me so much in my initial reading. Since we were not shown the final version until September of '07, there was no sense in making a loud noise about the book until we had seen it. Complaining about parts of the book David had already cut was only useful in showing what he had desired to write, not what HarperCollins planned to offer to the public. Every writer makes cuts, and I would certainly not comment on sloppy writing or first-draft eccentricities. What writer lacks such things? Nonetheless, there are two examples I believe need to be aired in the context of what seemed at such variance with that book we were so convinced David was writing. I'll show them in their proper context.

There are, essentially, three major problems with *Schulz and Peanuts*. The biography has a number of factual errors throughout, some minor, some reflective of larger issues, all easily corrected. Yet none of them are really excusable when David Michaelis had such constant access to those of us willing to respond to the smallest questions at any time. That he let so many mistakes creep into the book is surprising, and disappointing, too, given how carefully he was doing his

 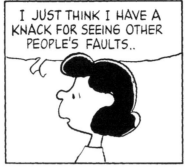 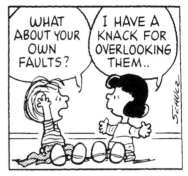

From *Being a Dog is a Full-Time Job: a Peanuts Collection*. [©1994 United Feature Syndicate, Inc.]

research. But these mistakes do exist and I will point some of them out as we move through the book. Then, there are factual errors of interpretation and these are more serious because they influence the reader's opinion of certain areas of my father's story. In other words, David presents specific information, whether in his own narrative or by quoting someone, that is erroneous or misleading. These mistakes are certainly deliberate, because they direct the story he is trying to tell, and lead the reader away from the truth of a given situation or point of view. Another aspect of this turns on whom David quotes to illuminate some moment of Dad's life or personality, or even our family's life at a given moment in time. Choosing to quote one person to the exclusion of another can easily direct the narrative somewhere it ought not to go. Which brings me to the largest problem in this biography: omissions. As I wrote to David in that final e-mail, what he left out of the biography was without doubt the larger part of my father's life, and by doing so he did a great disservice to his readers who were then left with David Michaelis' version of Dad's life, not that of those of us who actually lived with, or alongside of, Charles M. Schulz. And although David has argued that the biography was already too long and needed to be edited down, which is true of any long volume, what he left in very conveniently suited his own themes and beliefs in this book, while much of what he left out would have contradicted his point of view. So these many great omissions were conscious, deliberate cuts by David to create a book that is, in places, flatly untrue and deceitful in a very obvious and unfair manner. I will illustrate them as I go along, explaining that most of what I know to be left out occurs in the part of the book where I am alive and old enough to be aware of what was going on in my father's life. What my essay cannot be is a page-by-page analysis of the biography. I have no desire to write something

longer than David's book, so by necessity I can only jump about here and there, trying to illuminate parts of the biography that are problematic to me, and have been to others.

To begin, what's odd about this biography is how heavily David attaches it to Orson Welles' *Citizen Kane*. His contention that, like Charles Foster Kane who "got everything he wanted, and then lost it," my father succeeded beyond his wildest dreams, but struggled to love and be loved. According to David, my father felt alone all his life. I presume that David believed my father adored this movie because it resonated with themes in Dad's own life. Yet, really, Dad told me that he thought *Citizen Kane* was the greatest movie ever made because of the cinematography, its innovations and artistic achievement. He never made one mention of its astonishing insights, or any connection to his own life. And it is also true that my father spoke just as often about *Beau Geste* as his favorite movie, even using it now and then in the strip. In any case, I think David creates a thesis and a theme right off the top in his book of dubious merit. It's more his invention than anything else. Just as the issue of whether Dad struggled to love and be loved and felt alone all his life is part of David's imagination, and has to be regarded as an unknowable fact since none of us close to Dad over those many, many years believe David's thesis to be true at all. Of course, one might also wonder why David feels it necessary to explain my father's life analogically when he has already at hand the incredible story of a little boy who is given the name of a comic-strip character practically at birth — "Sparky," after Sparkplug in *Barney Google* — then grows up to become the most famous cartoonist of the 20th century and dies the night before his final strip appears in the newspapers.

I do know that Dad was forever fond of his mother and her memory, and how both she and his father supported his desire to be a cartoonist. His constant affection for her certainly mitigated the happiness he experienced later in life with the success of *Peanuts* and the wonder of having his own children — none of whom would ever know his mother. A simple question I asked my father once maybe 10 years ago was paraphrased (incorrectly) by David to illustrate incompleteness in Dad's joy. I had asked, if he could go back to any time of his life where he was happiest, when would that be? (Again, David rephrased this as asking at which point in history he would return to, but that was not my question at all.) I initiated his answer by explaining that for me it would be that wonderful summer of 1958 when we moved out to California with Uncle Bus and Aunt Marion, and all the family was young and still alive. Dad told me that, for him, it would be those years he lived with his mother and father in the apartment above the barbershop on Snelling. An interesting answer, because that meant he was happiest before he had sold his strip or had a family of his own. Yet I found that answer quite satisfying; and, of course, later on, it explained how his mother's death truly did affect him. But then, who among us, having known loss, would not trade some measure of professional success to be young again or see the smile of a beloved relative? Life is necessarily defined by loss, and if we lead good lives, our loss will be felt by those we leave behind. And I surely feel my father's absence every day of my own life.

David's description of my father's extended family — Halversons, Borgens, Swansons — seems also curiously demeaning, particularly when he says they behaved "brainlessly, living from moment to moment, sometimes like wild men," as if the poverty and alcoholism of those people, that rural branch of Scandinavian culture in the troubled era of Prohibition and Depression, were unique. If the point he wants to make is that Dad's comfortable city life made visiting his relatives out on the farm that much more difficult, well, such a scenario would doubtless be repeated among many families in any part of this nation at any time. And if David wants to draw a portrait of my father as the artist among the buffoons, once again, parallels to other unique individuals in a trying culture are not going to be tough to find. Maybe David's issue derives from an East Coast-Midwest difference, or perhaps he is trying to sympathize with my father's early difficulties in getting close to people. Either way, it feels cruel to pick on rural people who had little means and little hope of raising themselves above the circumstances of their lives. That my father eventually knew fame and fortune certainly had nothing to do with his extended relatives, whether for good or bad. His own parents were rooted in a particularly loving sensibility that allowed their only child the time and opportunity to discover a talent that lay within him. He loved them most dearly for that, a refrain he passed on to me and others in our family many, many times over the years.

It is just this sort of judgmental, editorializing point of view that characterizes much of the biography. Rather than simply stating what people said or did, David seems to feel obligated to offer his take on things, too often putting a slant on events that he could not possibly derive factually from what was there. An example of this is a little story my father told me during a taped interview I did with him maybe 20 years ago, the transcript of which I shared with David during his research. This anecdote David uses could only have come from my interview with Dad for two reasons: first, because Dad was the only participant in the adventure still alive at the time he told me about it; and secondly, because David uses three quotations in his version, all of which came directly from my interview. The story goes like this: On a driving excursion to Las Vegas with his father and mother, Uncles Cy and Monroe and Aunt Ella, Dad said:

We stopped to get gas and buy something to drink and they sat around drinking beer and the next thing I know — I have no recollection of how long we were there — but I

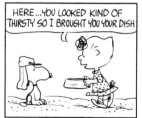

Snoopy plays Beau Geste in the April 16, 1966 strip, collected in *The Complete Peanuts 1965-1966*. [©2007 United Feature Syndicate, Inc.]

From *Being a Dog is a Full-Time Job: a Peanuts Collection.* [©1994 United Feature Syndicate, Inc.]

know they were there long enough that so that Cy and Monroe were feeling pretty good. They were not staggering drunk, but they had certainly had too much to drink and I remember him telling the guy who ran the place — apparently there was nobody else around — telling the guy that he was a barber. I don't know how it happened, but the next thing I knew he had the guy sitting down in the chair and was giving him a shampoo with a bottle of beer. I remember that distinctly. In the meantime, Ella and my mother had probably been looking for a ladies room or something like that, but they found a box that had a whole bunch of bottles of vanilla extract. What they were going to do with all this vanilla, I don't know. I suppose they used it in their cooking, but they thought they had really found something and they stole this box with all these bottles of vanilla in it and put it in the back of the car, and finally we left. It was night by the time we left and we were heading down the road and we pulled over, I suppose to go to the bathroom or something. Everybody got out and the next thing I knew, Cy and Monroe were wrestling in the middle of the road. They were always getting into some kind of fights. They were kind of tumbling around and wrestling in the middle of the road and Ella and my mother had opened up the box and they discovered that these bottles of vanilla were all empty, and they were so disappointed because all they had done was stolen a box of empty bottles. So, they proceeded to do something which gave me great delight. They stood on the side of the road and they started throwing those empty bottles out into the desert into the dark and you could hear them when they would hit a rock now and then and break and I thought this was great sport.

Whereas David acknowledges that Dad "registered only the facts of the matter," David himself makes inferences that are clever, but nowhere present in the text. For instance, he says that Dad's "mother and the grown-ups in charge of him were inebriated to the point of risking the law or an ugly incident on those appalling roads." So where does Dad say that his father or mother were drunk? He suggests that Cy and Monroe were "feeling pretty good," but not necessarily anyone else. By saying that Dad "took no account of the extract's alcohol content" as a reason for Dena and Ella wanting to steal the box of vanilla bottles, David infers that as a reason for the theft, and faults Dad for not holding his mother accountable. How can David know that's why they stole the vanilla? In fact, according to Pat Swanson, Dena was basically a teetotaler and would never have drunk beer to the point of being tipsy. Further, David says that "Carl seems not to have been along been along that day," but that's not necessarily true. If David assumes that Carl was not present because Dad doesn't assign him any role in the mischief, well, he does say in a sentence leading up to the story that he didn't know whether Frenchy was along or not, either. In any case, Carl was not much of a drinker, and I just assumed, hearing the story, that he had not taken part in the drinking to the extent that Cy and Monroe had. Even a biographer can embellish scenes for dramatic effect, but only a novelist

Photo courtesy Monte Schulz.

can invent what happens. Regarding the theft of the "shipping case" of vanilla bottles, David writes, "While one sister kept watch, the other sneaked the whole case in the back of one of the cars." Nowhere in Dad's story is that box referred to as a shipping case, and nowhere is there any mention of either sister "keeping watch" while the other put the "case" into the back of the car. Moreover, once they had stopped to go to the bathroom on the side of the road and the scrap begins with Cy and Monroe, David writes that Dena and Ella "tiptoed behind one of the cars … to sample their private stock." Since they're not cooking out there in the desert, we can assume David has already decided the vanilla bottles were stolen for their liquor content. He even says they "uncapped the bottles and put them to their lips." Where does Dad say any of that? He does not. That entire part of the scene is a figment of David's imagination. He goes even further by writing that Dena "trumped idiot frustration" as she and her sister pitched the empty bottles out into the desert,

all "two dozen dead soldiers." How does David know how many bottles there were? My father makes no mention of it. I presume David investigated how many bottles would be in a case of vanilla extract, but since Dad only mentions a "box" of bottles, why would we assume they came out of a shipping case? The point here is that David begins with a brief anecdote, reads his own interpretation into that story, and then alters the facts of the story to further his interpretation. All of that is fine and good for fiction and his version has a lyrical elegance to it. But that is not biography, not truthful, nor at all honest. What he has done in this scene is present characterizations of people through their actions, but whose actions he has fictionalized, and interpretations of those actions he has judged for the reader, the sum of which creates a false and immensely damaging portrait of those people from a fairly small and innocuous event. And this is just one example of how the biography was constructed and written, and one is left to ponder how many of the dozens of stories within the biography have been equally distorted and rendered to suit David's point of view. Even later on when David writes about life at the Schulz household in my father's childhood, he claims that conversation "was not practiced at home." How can he know that? David writes that, "No one spoke about himself." Again, that is something unknowable to David, if not to everyone outside of that particular family, yet David describes it as a fact. Yet it is not. Because even Dad's own memory of events in his youth must be tainted by that youth and lack of understanding, the biographer can know even less.

David paints a picture of my father's family life — and his place in it as a child with a singular gift — in strangely contradictory terms. On one hand, he suggests that studying the comics as a schoolboy in St. Paul was considered "crackbrained and probably self-destructive, and drawing cartoons was all but degenerate," and if comics were for children, "then people like Carl and Dena Schulz and their neighbors would naturally have wanted to wash their hands of them as soon as possible." Yet he also indicates that Dena relaxed the household rule against using the dining room table for drawing, although "she must also have been afraid of his strange, singular dream." Even though in her family's world, "drawing was not man's work, nothing to put food on the table," she and Carl did take my father to an exhibition of comic strip art, and never forced him to give up his dream in favor of seeking a regular job in the city. Whether or not they understood him, in truth, they did allow him to choose his path in the world.

Another oddity in the biography is the description of Dad as a lonely child, friendless and solitary, "doodling indoors or playing backyard games." I say odd, because no sooner does David finish this portrait, but we are told that Dad organized the boys in his neighborhood into a baseball team, and that he commanded the team, either from behind the plate or on the mound. What David never explains is how that came to be, how that only child, withdrawn and keeping to himself with comics and drawing, became the leader in sandlot sports. How did that happen? We never hear a good explanation, except that Dad complained of being bullied, and joining a neighbor gang of athletes offered protection. And David switches his interest in that section of the book to a curious issue of whether or not Carl ever watched his son compete in sports, how he wasn't one to play catch with my father, and how Dad didn't remember either parent witnessing the no-hitter he pitched one afternoon, nor the championship his team won. Instead, David attributes agoraphobia, rather than an oppressive work schedule, to Carl's absence at my dad's sporting events, which is, again, completely unknowable.

Similarly, David makes a lot of Carl and Dena's apparent apathy to my father's poor grades early on, noting that when Dad failed arithmetic in seventh grade, and then algebra, Latin and English in eighth, "no one said anything at home." David writes that Carl "chalked up poor marks to a lack of curiosity, a rather conspicuous trait of his own. 'If Sparky were interested in knowing something, he'd know it … Why, when he was ten or eleven, he could draw every president right out of the air without copying, and in order, too. And it would look just like them. That's how good he knew his presidents.'" This is important to think about because in Dad's final year of high school, "thirteen out of sixteen grades recorded in four courses of the final four marking periods of senior year are A or better." So while David shows a legitimate curiosity about Carl and Dena's attitude toward my father's study habits, he fails to ask how Dad managed to flunk all those classes. If he were a poor student, how did he happen to do so well later on? Why doesn't that interest David? He seems ambivalent himself about the kind and de-

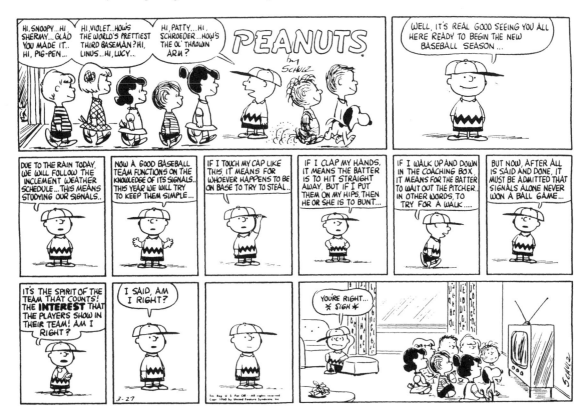

March 27, 1960 strip. [©2004 United Feature Syndicate, Inc.]

gree of support Carl and Dena offered their exceptional son, even though they had no real way of knowing the success he would eventually become. Whether or not his parents were pessimistic or hopeful, whether his teachers encouraged or discouraged him, however Dad compared himself to his peers or professional artists, his mother and father did, in fact, provide a nurturing environment for my father to make of himself whatever he could. If David seems to find that confusing, it is factual nonetheless.

As I said earlier, knowing what is and is not truthful in David's biography of my father is problematic, given that I was not there in my father's life until 1952. So, with the exception of many things we spoke about at length when Dad and I were together, large parts of his life remain mysteries to me. His cousin Pat Swanson has been extremely forthcoming in her remembrances and how they compare to what David supposedly dug up, as was Sherman Plepler in denying David's assertion that Dena Schulz was "cool to the world." So, when asked how much of the biographical is truthful or problematic, I usually reply by saying that I can only comment on that part which occurs when I was alive and aware of what was going on around me. Yet, with all the errors I saw in that section of the book, there always remained the suspicion that the other part of the book must also be shaky in its facts and assertions. And, sure enough, that turns out to be true where David writes about Dad's army experience.

The following is a brief analysis of that part of Dad's life written by one of his fellow veterans of Company B, Art Lynch. Rather than editing it, I decided to let Art tell his own story.

During World War II, I served with Sparky Schulz in Company B, 8th Armored Battalion of the 20th Armored Division. For many years, I was the editor of our Army Company newsletter, Parade Rest. *To provide information for the newsletter, I acquired copies of 4 diaries from men of Company B and 4 diaries from men of other units in the 20th Armored Division, contemporaneously recording our wartime activities. I made two trips to The National Archives at Suitland, Maryland, to gather a file of pertinent documents and I made several trips to France and Germany, during which I visited many of the places we had been during the war. I have been in contact with my Army buddies over the years. We have exchanged scores of letters and have had numerous conversations in which we compared and/or corrected recollections. When one of*

my sons requested that I write my recollections of WWII, I combined much of my research in the form of a letter to him.

In early 2001, Mrs. Jeannie Schulz asked me to cooperate with David Michaelis who was writing Sparky's biography. Over a period of time, I sent Michaelis a mass of data from the collection I listed above. I also supplemented this data with many emails and letters. In justice, I must say that Michaelis was very gracious in his thanks, commending me for the quality of my data and commented that he had benefited greatly from my work. When the book was published in October, 2007, I bought a copy and compared the applicable text to the documents I provided. In short, the author was extremely careless with facts. And he employed a literary genre of "Mix to Match" to support a fictionalized vision of the life of Charles Schulz. He used actual facts but mixed dates, places, circumstances, countries and years.

I was particularly disturbed by the spin he put to a story I told about an accidental shooting in which Sparky was involved. Sparky had told me the story in October, 1996. At the time, I wondered if he was telling me as the editor of the newsletter, Parade Rest — *or just sharing a war story with a fellow Company B veteran. I believe it was the latter. I made notes of the conversation at the time, but didn't relate the story to anyone until after Sparky died. When Jeannie Schulz asked me to cooperate with Michaelis, I discussed the accidental shooting incident with her and let her decide if I should tell Michaelis. She assented and on May 2, 2004, I sent a letter to Michaelis, in which I wrote:*

"Shortly after Company 'B' entered Salzburg, Austria (Either May 4th or May 5th, 1945) Sparky was rummaging through a German Army warehouse and found some pistols. About that time, an American Army officer entered the warehouse and proceeded to scold Sparky for being there. But then, the officer and Sparky recognized each other. Sparky, in his capacity as Information NCO, had worked with that particular officer. The officer told him he could take one pistol.

"Later, Sparky and another man in his squad, Private Bill Stearns (now deceased), were sitting on the porch of a house. Sparky was occupying himself examining the newly acquired pistol. There was an American Army medic (identifiable by the circle and cross on his helmet) across the street. Sparky was unaware that there was a live round

in the pistol chamber. Sparky said very slowly: 'I aimed very carefully at that helmet and pulled the trigger very slowly.' Then he continued with the words coming faster: 'I don't remember hearing the sound of the shot but felt the pistol recoil.' Fortunately the bullet just grazed the medic's cheek."

"As he said this, Sparky brushed his cheek with the tips of his fingers. I don't remember whether he used his right or left hand so I don't know whether it was the medic's right or left cheek.

"Sparky said the medic and a sergeant who was with him apparently had no business being in the area. After expressing their anger at Sparky, they quickly left. It was the last Sparky saw or heard of them.

"Sparky concluded — and I don't recall the exact words, but it was essentially — 'I've often thought how my life might have changed if that bullet had hit a few inches away.'"

In his own inimitable and confusing way Michaelis reported this incident on pages 148 and 149. But it is buried under his spin, some of which includes factual errors and ignores a pertinent fact. The following are the exact words that Michaelis used on pages 148 and 149 to record the shooting incident. (My comments are parenthesized.)

"By the time the convoy forded the Salzach River to enter what had been Austria on the afternoon of May 4, men in various squads of Bravo Company had recorded in their diaries uncovering 'all types of German weapons' in a Nazi ordnance depot. 'Got plenty of pistols and souvenirs here,' noted one GI."

(Comment: Three men from another platoon of Sparky's Army Company had recorded: "Discovered big German quartermaster and ordnance depot. All types of German weapons found — not even assembled." The quartermaster and ordnance depot found near Altenmarkt, Germany, was an assembly plant for large weaponry, not hand guns. And Michaelis marries that statement to the next, "'Got plenty of pistols and souvenirs here.' noted one GI." That is a complete distortion of fact! The quote is accurate, but Michaelis played his Mix To Match game. That GI was talking about a different country, a different date and different circumstances. On May 5, 1945, the German Army of the South surrendered. Outposts were set up to intercept German Field Marshall von Kesselring and to disarm any German soldiers coming through. One soldier assigned to man one of the outposts in the night of May 6-7, 1945,

wrote in his diary that Kesselring "… never showed up. Got plenty of pistols and souvenirs here." So, the incident happened in Austria, not Germany. It happened on May 6-7, 1945, not prior to the afternoon of May 4th. And the pistols and souvenirs were mostly weapons taken from the German soldiers coming through the outpost.)

Back to the page 148 text: "On May 5, scavenging through a Wehrmacht quartermaster depot in Salzburg, Sparky came upon a cache of weapons from which he could at last claim a trophy."

(This isn't too bad. But let's place things in historical prospective. In war, the weapon inventory of the enemy army is fair game. This is especially so when the enemy's arms are better than yours. Many American soldiers preferred the German "potato masher" grenades to our "pineapple" grenade; the German Schmeisser sub-machine gun, nicknamed "burp gun," was much better than our Thompson M3 sub-machine gun, "grease gun." And the German pistols, the Lugar and P-38 were superior to anything we had in our inventory. Any of us would love to come "upon a cache of" German pistols.)

On Page 148, 3rd paragraph, the author says, "'Everyone seemed to have acquired pistols… of every make and caliber', a man in Schulz's company later wrote. Another remembered May 5, 1945 — only three days shy of VE Day and in no serious contact with the enemy — as among the scariest he spent overseas. In the Eight Armored Battalion's Bravo Company alone, no fewer than four men managed to shoot either comrades or themselves."

Sounds very dramatic, but it didn't happen that way. Michaelis is quoting (but distorting) a letter I sent to my son, detailing my service in the Army. I wrote: "Everyone seemed to have acquired pistols; they were of every make and caliber. Some of the guns were mishandled. … I know of one incident where a guy in our Company wounded a soldier in another outfit; and at least three incidents were men in our Company wounded themselves or were wounded by one of their buddies." The first incident was, of course, the incident with Sparky that happened on May 5th. The other three happened over the next three weeks — not on that scariest of days, May 5th.

Page 149: Michaelis wrote: "Across the street, the medic from another platoon was talking to a sergeant."

The medic was not from another platoon in our company, or indeed, from the 20th Armored Division. He was from another outfit completely, the 3rd Infantry Division, that took over occupation duties of Salzburg that after-

JUNE 6, 1944, "TO REMEMBER"

Collected in *Around the World in 45 Years*. [©1994 United Feature Syndicate, Inc.]

noon. And, Michaelis completely ignored the paragraph that ended, "It was the last Sparky saw or heard of them."

The factual errors supported the spin he used in his conclusion and the ignored paragraph would have contradicted his spin. Michaelis's version was: "The bullet, to his horror, 'grazed the medic's cheek' but luckily did no serious harm. But this did not free Schulz from an unending burden of guilt, if anything, it intensified it. He had held a man's life in his hands — a comrade's — and could easily have killed him without purpose or meaning."

To support his guilt theory, Michaelis, in his next paragraph, suggests that Sparky acknowledged this "unending burden of guilt" by speaking through one of *Peanuts* characters: "Twelve years later, Linus, in a philosophical mode, addressed the question of accountability: 'Why do I do stupid things? Why don't I think? What's the matter with me? Where's my sense of responsibility?' . . . Enough said; I let the reader judge."

Besides his propensity for spin, the author is careless with facts. I can speak only of the errors about which I am knowledgeable, more specifically, those on pages 143 through 152. For simplicity, I list the errors in the order in which they appear without giving weight to their respective seriousness:

Page 143, bottom paragraph. The author relates that Sparky spent time "at the Chateau de Malvoisine — the Castle of the Bad Neighbor Woman." That should be Chateau du Mal Voisin — Castle of the Bad Neighbor. The chateau was featured in two of Schulz's films. One can

read the story line of the first, Bon Voyage, Charlie Brown (and Don't Come Back!!) *at Wikipedia online. The second film,* What Have We Learned, Charlie Brown? *is also briefly described on Wikipedia.*

Page 144, center paragraph: The author wrote that when they arrived at the Chateau, Schulz's squad was assigned an open shed for living quarters. Then: "Under timbers and a tiled roof, the air was frigid, the dirt hard. … " So far, so good; but then the author continued: "nor did the morning offer more to eat than a frozen hunk of local but days-old brown bread."

Absolute fiction! Michaelis was given copies of four diaries written by men in Schulz's Army Company. One, written by Donley Swanson, a man in Sparky's platoon said that after they arrived at 11 P.M., "We opened up a K-ration, ate that up and were told we could sleep in the morning." Memo: A K-Ration was a ready-to-eat emergency meal packaged in a waxed paper box. Google "K-Ration" for complete details. Swanson's entry for the next morning: "February 20, 1945 we started cleaning up our personal equipment this morning and got out 10-in-1 rations."

Memo: The 10-in-1 was the preferred field ration. It was a large corrugated box that contained three meals for ten men. It held cans of bacon, butter, dehydrated potatoes, eggs, canned pork or beef, plus chocolate bars, powdered coffee, salt, sugar and accessory items such as cigarettes, matches, a quarter-sized can opener, dubbed a P-38, toilet paper and water purification tablets. The only reference

to French bread was by a man from another Platoon in the Company. He wrote: "The French bread, though tough and costing 20 francs per loaf, tasted good while the rations were short."

Page 144, 2nd paragraph, speaking of the time he was billeted at a Château in France, Sparky "came across a man in his squad, the rural Floridian Frank Dieffenwierth, outside the chateau, sketching the vine-covered castle wall and gate post."

Again — fiction! When I was editor of Parade Rest, our Army Company newsletter, I received a copy of that sketch. Before publishing the sketch in the newsletter, I sought to determine who drew it. On January 6, 1987, I wrote Sparky enclosing a copy of the sketch and inquired whether he drew it. He wrote back, in a letter dated January 9, 1987 saying that he did not draw the picture. He remembered going out into the field one day and seeing a fellow making a drawing. They talked about it for a few minutes, but Sparky didn't remember who he was. He would certainly recall if it had been Dieffenwierth, who was in his squad.

On April 6, 2001, I sent Michaelis copies of my 1/6/87 letter and Sparky's 1/9/87 reply… Incidentally, it was later determined that our company mail clerk drew the sketch.

Page 145, 2nd paragraph, the author speaks of the names soldiers gave their squad halftracks in Europe, the "vehicles dubbed Salty Baldy, Sidownbud, Snowballs N All, Big Surprise, Stardust, and (Schulz's own) Sparky." Michaelis was given a copy of the July, 1987 B Company newsletter, Parade Rest, which reported: "While at Camp Campbell, the Company B vehicles had names beginning with the letter B. Some names selected by the drivers were: Bloody Bucket, Bucket of Bolts, Beats Me, Berlin Blitz, Big Surprise, Beatuprec. In Europe, the vehicles had names beginning with the letter S, such as: Sidownbud (which had been Big Surprise at Camp Campbell), Sugar, Snowballs N All, Salty Baldy, Stardust."

Page 146, paragraph 3. The author says: "There was no eye contact with the enemy until, on April 29 . … " Several documents that were provided to Michaelis showed that Sparky's task force was ambushed at Dorfkemmaethen on April 25.

Page 146, bottom paragraph, the author says: "Barreling toward the Amper, the First Platoon, farthest forward, had advanced nearly to the end of the road." How do you barrel through a massive traffic jam? In the previous paragraph, he had correctly reported that after the Americans seized one bridge across the Amper River, four American Army divisions tied up in a spectacular traffic jam.

Page 151: "On July 27, Sparky sailed for home on an

Joyce with Nona and Dale Hale: photo courtesy of Monte Schulz.

overcrowded troopship, tying up in New York harbor eleven days later, Tuesday, August 7, 1945. Newsboys greeted the troops on the gangplank, bawling "EXTRA! EXTRA! Read all about it!" The United States had exploded an "atomic bomb"over the city of Hiroshima, ... As the world held its breath waiting for Japan's unconditional surrender, Sparky took two nights of liberty in New York City." Per several documents provided to Michaelis, the troopship sailed on July 28 and arrived in New York on August 6, 1945, the same day the first atomic bomb was dropped. The newspapers did not report the news until the following morning. Upon arriving in New York, Sparky along with his entire unit boarded a train for Camp Shanks, New York, a processing center. There, the men were given physical exams, issued summer-weight uniforms and waited while paperwork separated the men into geographical groups. Each group was sent on separate troop trains to their respective geographical area. No one was given leave. Therefore, Sparky could not possibly have spent two nights of liberty in New York City.

Page 152: After landing in New York, Sparky traveled to St. Paul. The author continued: "Walking into the Family Barber Shop, he set down his duffel. Carl was working on a customer. 'Well,' Sparky announced, 'that's it'. His father went on cutting hair."

Sounds pretty cold! But that unemotional homecoming

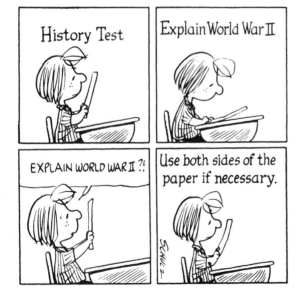

From *Peanuts Classics: Don't Hassle Me with Your Sighs, Chuck*. [©1976 United Feature Syndicate, Inc.]

did not happen on Sparky's return from Europe in August 1945. The story was lifted from Rheta Grimsley Johnson's book, *Good Grief, page 55* in which she says that after Sparky was discharged from the Army (in January, 1946): "Schulz returned to St. Paul a civilian, took the streetcar to his father's barber-shop, walked in and in Schulz-family fashion said simply, "Well, that's it."

This is a different situation. By January 1946, the war was over. Sparky had been home for a thirty day recuperation furlough in August-September, a forty-five day "convenience of the government" furlough in November — extending into December. Unlike his trip home in August, he had not been in harm's way and was now discharged. He walked into the barbershop to tell his father that he was out of the Army, but in a way that would not involve a customer in family matters. What better way was there to communicate that message from son to father than to say "Well, that's it."

Page 152: The author spends a half-page dwelling on the lack of parades or celebration over the war's end, scenes of subtle forms of reserve repeated on Main Streets all over the country. Evidently, Michaelis never saw the very famous LIFE magazine cover for the issue following the Japanese surrender — the one with the sailor kissing the nurse on Times Square. That was the scene repeated all over the country. I was there and I know how happy everyone was — and how they showed it. Sparky, and the rest of Company B of the 8th Armored Infantry Battalion did participate in a parade — at Los Angeles in the autumn of 1945. It was the Saturday that U.C.L.A played Oregon. All the services participated in the parade, the Army, Navy and Marines. For whatever reason, Company B was one of the units selected to represent the Army. We rode the 150 miles from Camp Cook, California to the Los Angeles area in trucks, camped in a schoolyard in Santa Monica — and on the given day — marched through the downtown streets of Los Angeles. As trained infantry, we were proud of our marching skill. Smartly attired in dress uniforms and accompanied by an army band, we marched, in arrow straight rows and in perfect step. The crowds roared their approval. That night, the participating servicemen received complementary tickets to the U.C.L.A. vs. Oregon football game. Sitting across from the student section, we watched the students switching colored squares to show the animation of a bear (The U.C.L.A. Bruins) shoot a duck (The Oregon Ducks).

In a letter to Michaelis dated April 6, 2001, I enclosed

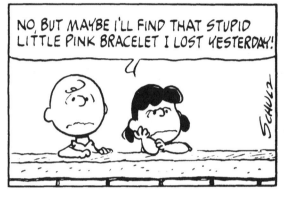

From *Peanuts Classics: Don't Hassle Me with Your Sighs, Chuck.* [©1976 United Feature Syndicate, Inc.]

a copy of the May 1989 issue of Parade Rest, *which included information about that parade.*

Some of these errors are trivial. But serious or trivial, all these errors were found in only the ten pages of text that I analyzed. Extrapolating over the entire 566 pages of text, there are certainly hundreds and perhaps thousands of factual errors — negating the many conclusions the author makes.

In addition to the factual errors, the author has a problem separating the present from the past. He assumes that what is today, always was!

Item: On page 146, the author states the 20th Armored Division crossed the E-5 Autobahn. A WWII map (entitled Reichsautobahnen) of the German autobahns, shows that they did not use numbered references back then. In addition, it shows that the Köln (Cologne) to Frankfurt Autobahn was not complete from Bonn to Frankfurt, the area where the 20th crossed the Rhine.

Item: He frequently referred to Company B as Bravo Company. The so-called NATO alphabet — Alpha, Bravo etc. was not instituted until sometime in the 1950's. During WWII, the US Phonetic Alphabet used for radio and telephone communications only was Able, Baker, Charlie, Dog, etc. But in normal communication, it was always Company B. (As in The Andrews Sisters classic song, "The Boogie-Woogie Bugle Boy of Company B.")

Item: He refers to the 20th Armored Division as The Liberators. This nickname wasn't used until the 1970's, after the 20th Armored Division Association was formed. According the March 18, 1944, issue of the Camp Campbell newspaper, RETREAT TO TAPS, *the WWII nickname was 'ARMORAIDERS.'*

What is most intriguing in Art Lynch's piece is not only how many errors there were, but also how easily David could have avoided them had he shown that section of the manuscript to Art during the editing process. Why he failed to do so is somewhat of a mystery, although I would argue that he needed to show the book to all of us much earlier if he truly wanted to avoid some of the mistakes that are present in the book — that scene with the vanilla bottles, among others. And, as Art suggests in his analysis, it seems simple to extrap-

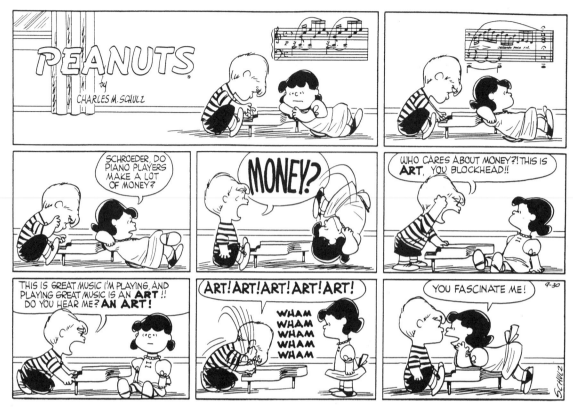

The Sept. 30, 1956 strip, collected in *The Complete Peanuts 1955-1956*. [©2004 United Feature Syndicate, Inc.]

olate how much of his biography is not factual from what we can verify in what we already know to be untrue. What kind of book did David Michaelis really desire to write? Since he stands by the one Harper Collins published, we can only assume it is that one with the yellow dust jacket. Whether it is more novel than biography is open to debate, but much of it is indisputably fiction.

I have no memory of the year we lived in Colorado Springs, and it would be peculiar if I did, since 1952 was the year I was born. I was named after my father and his Uncle Monroe, whose nickname was "Monte." Why he was named "Monte," not even my dad seemed to know. My birth name was Charles Monroe Schulz, Jr. David points out that I changed my legal name to Monte Charles Schulz, but that was really only on my driver's license and I did it because at the bank, and during grad school, too many people who didn't know me personally kept calling me "Charles." So I simplified it for everyone. Like Dad, who never went by Charles with anyone close to him, I've used my nickname all my life.

Those *Peanuts* strips from the first two books, *Peanuts*, and *More Peanuts*, do remind me of my childhood in the best way. Even the modern post-War furniture in the rooms Dad drew resembles our homes back then. Our lives were much simpler and more modest than most people seem to imagine, given Dad's success and fame in later years. The home we inhabited in Minneapolis was nice, but not extravagant by any means. Although David describes the house at 112 West Minnehaha Pkwy. as looking "as tall as a cliff," not even family or old friends from that time remember it that way. Both Pat Swanson and Nona Hale said the house was "nice," but that was all. Showing them a photograph of it today did nothing to change that perspective. We lived in a nice house in a pleasant part of the city, and that was all. Indeed, one afternoon perhaps 10 years ago, touring Nevada City with me, I brought Dad to a grand old Victorian mansion where I asked him why he never lived in a house like that. He told me, "I just never saw myself living in that sort of place." That did not change even with our move to California in the summer of 1958.

It was somewhat true that Dad was induced away from Minnesota, and forced to leave his father behind, lamenting, "My dad and I were close and I know he was just destroyed when we left." What David ignores when he talks about my father's sadness back then is how many of Dad's family and close friends came with us. We traveled west in two cars; my brother Craig and I rode in the backseat of the Lincoln with Uncle Bus and Aunt Marion; Dad, Mom, Amy, Jill, Meredith and our golden retriever rode in the station wagon. Waiting for us on our new property, the Coffee Grounds, were Dale and Nona Hale. They had gone to California two weeks or so earlier to get things ready for us and were staying in the guest room of the stables. Dale, a graduate in Fine Arts, had met my father at Art Instruction, where they became good friends. When my parents decided to move west, Dad asked Dale to be come out and be his assistant. After we arrived, Nona and my mother made several shopping excursions down to San Francisco. For the first few weeks, Dad and Dale would drive into Sebastopol for pizza, and all four of them would play Hearts in the warm evenings as all of us adjusted to California, day by day. About six months later, Jim Sasseville and his wife came out, and they were followed perhaps a year after that by Tony Pocrnich — a fellow artist at Art Instruction. Jim started to work on a comic panel and Sunday page called *It's Only A Game*. Tony helped out in the office with correspondence and business-related issues. The whole gang socialized, shooting pool at lunchtime, batting the tennis ball about, playing Ping-Pong, and generally having a good time. As Dale remembers, "Nobody can say Sparky missed Minneapolis, because eventually he brought Minneapolis to him — except for the snow." Contrary to the deep lament David suggests Dad felt by being compelled to leave his Minneapolis, according to Dale, my father was, in fact, excited about having bought their new home outside of Sebastopol. Even before leaving, Dad and Mom had subscribed to the local newspaper, appreciating the better weather in California they were reading about, and getting a jump on what life was going to be like out West. Dale says Dad looked at it as an adventure. And so it was.

Inspired by Dale's '54 Corvette, Dad bought a Ford Thunderbird. He also built a brick barbecue, much like the one in our backyard on Minnehaha Parkway. That first summer seemed miraculous in so many ways. In the evening, cool summer breezes allowed us to sleep with the windows open, something we had never done in Minnesota because of the humidity and mosquitoes. We discovered blue-belly lizards, earwigs, potato bugs, garden slugs, gopher snakes and tarantulas. Though surely Dad worked all that first year in California, I still remember a feeling of festivity and adventure: trips to the giant redwood groves on the Russian River, and Sunday excursions out to see the ocean at Bodega Bay and to enjoy wienie roasts and hot marshmallows in the sand. A week or so after driving out with us, Bus and Marion traveled back to Minneapolis by train, where they sold their house and took an apartment for several months until they came out to California for good. Dale and Nona found a house only a few miles away at Camp Meeker. It was a new life for all of us.

We had big redwood trees on our own property and acres of apple orchards next door. We were awakened each morning by Frank and Mercy Medrano's roosters and a feeling of unbridled novelty. David is wrong when he describes the size of that place; "so wide, its plenitude of natural and man-made wonders affording such a kick to the imagination, that it almost had to be catalogued to be brought down to size." That, of course, must be an Easterner's perspective, because out in the Far West, 28 acres is not that big. Indeed, there were hundreds of properties in Sonoma County larger still: farms and ranches that ran 100, 1,000, 2,000 acres and more. And when we bought the Coffee Grounds, more than

"IF **YOU** WERE EIGHT YEARS OLD AND **YOU** WERE BEING READ TO ABOUT THE PLAGUES OF EGYPT, WHAT SORT OF QUESTIONS WOULD YOU ASK?"

From *Schulz's Youth*. [©2007 About Comics, ©2007 Warner Press]

20 of those 28 acres were densely wooded with ravines of ferns, blackberry bushes and poison oak.

And David telescopes the rate at which my mother landscaped and built upon our property, giving the impression that we lived in a whirlwind of construction activity from that first summer onward. In fact, the transformation of the Coffee Grounds was a fairly gradual process occurring incrementally over the 14 years we lived there. He makes a particularly careless error when describing how Mom, to my grandfather's advantage, "stocked the pond with forty bass; Carl could pursue his fondest pastime without having to face his alarms at leaving home." That pond was not dug out of the woods until several years after my grandfather had died of a heart attack in our basement apartment. And mistakes of that sort, much like David's Army-story errors, could have been avoided, in this case by shooting me off an e-mail to ask when the pond was built. Nevertheless, this litany of improvements was a manifestation of my mother's passion for building, but also arising out of circumstance. The miniature golf course David describes only existed because of the original house burning down one night from the spontaneous combustion of oil rags in the old garage, leading to the problem of what to do with that concrete slab and the area it occupied. It was a product of whimsy, more than anything, and it came late in our ownership. But we did have a great time living there in those years. Even my mother called me after reading David's book to say, "He makes it sound as if everything was in constant turmoil back then, but we had a wonderful life, didn't we?" And I agreed, because, again, those were our halcyon years. Rather than this portrait of perpetual conflict, I remember Coffee Lane as suiting each of us in our own way. I remember music on the living-room stereo in the early evening; both of my parents loved show music and I recall hearing the soundtrack to *My Fair Lady*, and *Camelot*, playing for months. Mom took French classes and studied the guitar, and Jill and Amy had piano lessons while Uncle Bus tried to teach me to play the cornet and one of Dad's tennis partners, Aaron Hamilton, attempted to teach Craig the clarinet. Those were years of togetherness. We would sit around the dining room table to play Old Maid and Password and Chinese checkers, or gather in front of the television set to watch *The Dick Van Dyke Show*, *Gunsmoke*, *Bonanza*, *Lost In Space* and *The Twilight Zone*. We had great gatherings of family and friends at Christmas and Thanksgiving, a houseful of food and conversation and games. We played touch football in the fall and winter, rain or shine, and baseball or softball games in the spring, and

pool parties in summer with Herb Alpert's Tijuana Brass playing in the background. We drove down to San Francisco to see stage musicals and big Cinerama movies and the Ice Follies at Winterland. We traveled down to Disneyland, first by train, then propeller airliner, in those early years. My mother renewed a Minnesota relationship with her old friend Jean Donovan who lived now in San Francisco, and we became close friends with her children, Casey, Bill, and the twins Jim and Jane, visiting them often in San Francisco and having them up to the Coffee Grounds — even flying with them one winter weekend for a rare snow holiday out in Sun Valley, Idaho. We ran with our friends through the wooded ravines and up to orchard heights above our property to take turns on a huge rope swing in a grand redwood grove, leaping from the bench into the dust and rotten apples below. We were also ordinary people who ate Spam, hash, meat loaf, pot roast and macaroni and cheese for supper. We were the last family I knew to get a color television.

In those years before *A Charlie Brown Christmas* and *Happiness is a Warm Puppy*, we had no sense at all of Dad as being any sort of celebrity, nor did our day-to-day lives reflect that. We attended church and Sunday school with our fellow Methodists where Dad taught a Bible class for many years. I can't say I had much zest for religion, but I do admit that my interest in theology certainly derives from Dad's own interpretive passion. When I was in grade school, Dad rose on school mornings to prepare oatmeal or cook French toast for our breakfast, then drove Meredith, Craig and I into Sebastopol to Pine Crest Elementary School. We rode back home in the afternoon with everyone else by school bus, Coffee Lane being more or less the last stop on the way, after which we walked up the long road to home. (This, incidentally, offered another peculiar error David made in talking about my Dad "stopping at the bottom of Coffee Lane to pick up the Medrano children." It's a careless mistake because Kenny, Mike and Sylvia Medrano lived next door to us. Why would they walk half a mile to be picked up? Moreover, the mistake is especially foolish, given that I walked the length of Coffee Lane with David one afternoon, taking care to point how it was back then and who lived where.)

Craig and I had haircuts on Saturdays at Ray's barbershop downtown and bought our mitts and baseballs and fishing lures at the Western Auto. Mom and Meredith bought feed at Purina downtown and Bassignani nursery did our landscaping. Our local Miller's dairy delivered fresh milk in glass bottles by truck to our doorstep, and we went to school with the Miller children and others from families who operated

Photo courtesy of Monte Schulz.

the local apple canneries. Not one of my classmates even mentioned an awareness of *Peanuts* until a classmate in fifth grade told me he liked Snoopy. That came as a shock because I didn't realize anyone read *Peanuts* besides us, and I only saw it in the books Dad would bring home for us to read upon their publication. As is typical of parents with school-age children, Mom and Dad made friends with our teachers and the other parents of our classmates. They joined a bowling league at L&L Lanes in Sebastopol, and Dad shopped at the men's store downtown owned by Stan Janes, whose son, Rory, was my best friend; Craig's best friend, Freddie Esselink, was the son of one of the town's electricians. Peggy and Jerry Jarisch ran the Humane Society of Sebastopol and Peggy was my second- and third-grade teacher. Mom still insists Peggy inflated my good grades back then, but I'm sure I did my own homework and learned to read in large part by the flashcards Dad made for me, lettering each by hand.

To imply, as David has, that Dad was solely involved with his work, leaving the household to my mother, is simply untrue, and demonstrably so. First off, it's important and necessary to remember that my father never worked at night, or on the weekends. So what does David imagine Dad is doing during all that time he is away from the drawing board? Perhaps he supposes that my parents ought to have entertained a New York-style social life when Dad was off work, but if so, he is forgetting how rural our home was. San Francisco was almost two hours away by car in those years, and many of Dad's friends and acquaintances in the cartoon and newspaper business were even farther off. Nobody just dropped in, and it would be unreasonable to imagine that Dad and Mom might leave us with a sitter to jump in the car and drive down to Carmel for the weekend. Nor is it fair for David to write that my mother required Dad to share in her enthusiasm for building projects. He did, in fact, enjoy everything she built out at Coffee Lane and expressed great pride in her artistic hand and accomplishment. On the other

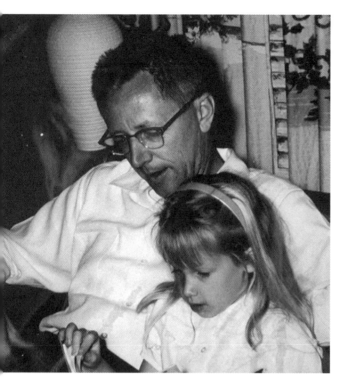

Charles Schulz reading to Amy: courtesy of Monte Schulz.

did she watch me play hockey or my brother race motocross. Bear in mind, of course, that neither David nor any of our family friends are authorities on how we lived back then. While it is certainly true that Mom was more opinionated and firmer in stating how she wanted things done, to suggest that Dad deferred to her judgment in how we were brought up is simply not true. Each of us, for example, had our own chores and responsibilities. Meredith fed the horses, as I fed the dogs and Craig fed the cats. Dad usually supervised these jobs, particularly my feeding the dogs to be sure I was not only doing it each evening, but actually doing it at all. And though Dad himself told an interviewer that he was no disciplinarian, I can tell you that one evening when my brother and I had a huge water fight in Dad's bathroom instead of taking a bath, he gave us a well-deserved spanking I still remember. The truth is, no part of our lives growing up was absent of his attention. He helped us with homework, read to us, drove us to school and to town on Saturday mornings and church on Sundays. He helped coach our Bronco League baseball team in the summer of 1962 and took me to see dozens of baseball games at Candlestick Park in the early '60s, during the heyday of Willie Mays and the San Francisco Giants. We would get up early in the morning on the weekend of a doubleheader and drive down to the ballpark, arriving in time to watch batting practice. We never caught a foul ball, but we did get to see Willie McCovey hit three home runs in the same game, and meet Casey Stengel at a champagne breakfast for special guests. I remember the men there teasing me to try a glass of champagne with my eggs and Dad whispering in my ear, protectively, that I "didn't have to try any if I didn't want to." Another gray, drizzling morning, Lee Mendelson filmed Dad out on the pitcher's mound at Candlestick for a segment of his documentary, *A Boy Named Charlie Brown*, while I sat in the Giants' dugout next to my heroes, Juan Marichal and Orlando Cepeda. Joe Garagiola came out to the Coffee Grounds one afternoon to do an interview, and Dad asked him to play catch with me, wanting Joe to see my best curveball. My father and I used to play nine inning games of whiffle ball on our front lawn before supper when the sun was still out, quitting only when we were called to the table. Teaching me to play the outfield, he'd take a tennis racket and ball and hit monstrous fly balls to me or wicked line drives by the dozen until I developed a keen eye for any ball in flight. And we did much more than play baseball or ping pong or throw a football around. He brought out a box of marbles he had saved since childhood and let me have them to play with. He regaled me for hours

hand, building was her passion, not his, any more than she shared a great interest in the comic-strip art. Each marriage involves the wedding of two distinct lives, and while some do reflect a single interest, those seem to me to be the exception. If my mother became frustrated with Dad's absorption in his profession, then it must also be said that without his success, her building would necessarily have been considerably reduced. And, in my view, chief among all the reasons we ultimately left the Coffee Grounds, was Mom's realization that she had outgrown the property; there was simply no place left there to build.

Yet most erroneous in all of David's narrative of our family life was the contention that my mother was the more involved of our two parents in how we were raised. He wrote, "Joyce, in charge of the children's meals, clothing, and activities, also set the house rules, adjudicated punishments, enforced groundings." That is simply not true. Mom, for instance, had nothing to do with the sports Craig and I became involved with, nor any of the games and adventures Craig and I found in and out of Coffee Lane. Maybe her attention was directed more often toward the girls, but she did not come to watch our Little League games, nor later on

about his life as a boy in St. Paul, his skating on backyard rinks and playing ball on a sandlot field, his victories and defeats. He and I hiked into the woods bearing a couple of retired Franco-Prussian War-era rifles and played war in the thick deep underbrush. He expected all of us to study and do well at school, even as he confessed that he had not been much of a student himself. But he was a good and fun father, someone to admire and enjoy. We knew he loved us and we loved him greatly in return. It would be impossible to separate my father from his cartooning and involvement in our day-to-day family life, because he shared each to its own best advantage and responsibility.

And David made a grave error by ignoring someone whose presence in our lives growing up was indisputably profound. While it's difficult to remember exactly when Jim and Eva Gray arrived at Coffee Lane, it's equally impossible to forget, because just as Eva crossed the threshold of our entryway, Meredith slammed the bathroom door on my foot, shearing off the nail on my big toe in a spray of blood. Jim and Eva were African-Americans from Alabama, who brought something distinctly gracious and lasting into our lives. All these years later, we still recall Eva as being something of a second mother to each of us, far more than the housekeeper she was hired to be. She cooked for us in the afternoon, cleaned house and disciplined us as necessary, which, in those days, was probably often, though years later, when I asked her about our behavior, she remarked that we were very good children. I just remember that all she needed to do to get our attention was say five words as she headed for the kitchen closet, "Let me get my belt!" Did she ever actually grab that leather strop? I don't recall, but I do know that our love for her memory is still present in all of us. Why David left her and Jim (who looked after the horses and the grounds until he started a business of his own) out of the biography is somewhat of mystery, given how much we told him about her importance in our growing up. I suspect he

did it to show the extent of my mother's role in our domestic lives in comparison to my dad's, suggesting that she was left to do everything while he devoted himself exclusively to his drawing. But, again, that was simply not true. And even my mother forgets how often Eva cooked for us and watched over the house during the day while Mom occupied herself supervising building projects. David dropped Eva completely out of the book where she needed to be, mentioning her name only once, and then, in error, when he wrote, "With the arena up and running, Joyce spent less time at home, leaving her fresh pies for the Warm Puppy first thing in the morning and arriving back at Coffee Lane only after supper. More often now, it was their housekeeper, Eva Gray, who fixed the kids an early supper." The problem here is that David is writing about 1969, when Eva had been gone from our household for more than three years.

And Eva was not the only person who worked for us back then. We had gardeners, too. Dennis Gruneau and his father, early on, then Cliff Silva, who was with us during most of our stay at Coffee Lane, as were several others, on and off. And even when Eva finally left in the mid-'60s to help Jim with his business, Mom hired two people, Larry and Sachiko, who stayed for a while before giving way to another housekeeper named Geneva, until we finally left the Coffee Grounds for good in 1972.

The point here is that both my mother and my father were equally involved with our upbringing, both sharing equal responsibility and interest in each facet of our lives from health to education, discipline, care and entertainment. To single one out from the other as taking a larger part is unfair and untruthful. And just as important were Bus and Marion, whose part in my life I will never forget, as well as Grandma Halverson, who came and stayed for years after Marion died, but who also played a significant role in helping us grow up. (If the other kids felt a greater affection for Grandma, say, than Aunt Marion, that is largely because they saw more of

The June 20, 1951 strip, collected in *The Complete Peanuts 1950-1952*. [©2004 United Feature Syndicate, Inc.]

her. According to Pat Swanson, I was Marion's "little Alka-Seltzer boy, her sweetheart." Maybe that was because I spent so much time visiting her until she died. I don't know, but I certainly told David how important to me she was, and how much I missed her once she was gone.)

When David writes that, from 1967 on, "parents and children in the Schulz household led increasingly separate lives," I'm not sure what he means by that. By then, three of us were in high school, so clearly our interests, particularly Meredith's, became more and more involved with friends. Yet, I could argue that with the building of the ice arena the following year, we had more in common and a greater shared interest than ever. After all, Craig and I played hockey, and Amy and Jill took up figure skating. Only Meredith found no passion in the ice arena. Then again, she never really shared much with the rest of us, anyhow. Although she and Amy and Jill had a great of love of horseback riding, neither young sister remembers Meredith either mentoring them or going on rides with them as they became older and more comfortable in riding. We've always seen the siblings as four plus one, or even two plus two, plus one. Jill says she grew up not knowing Meredith really at all. So perhaps it is no great surprise that the ice arena did nothing to bring Meredith back into the family. But until Craig finally chose motocross racing over weekend ice hockey, the rest of us found a passion on the ice that revitalized us as a family. We traveled to Squaw Valley together for skiing and ice-skating, and had season tickets to see the new Oakland Seals franchise in the National Hockey League. David writes that Mom and Dad "more often left the children with a sitter and took along another couple, such as their friends Don and Donna Frazer," but actually, Dad drove myself and Meryl Baxter and Meryl's son, Steve, and some of our assorted friends in the arena van

down to more than 30 games in the first couple seasons of NHL hockey in Oakland. We would eat hotdogs for dinner at the game and stop for cans of soda at a gas station in Richmond on the way home.

My mother's interest in going to those games mostly involved visiting with the Oakland arena staff regarding the nuts and bolts of ice-arena construction. Her needful attention was focused for two years on that project while the rest of us enjoyed watching the Oakland Seals. David wrote that she "expected construction to take four months and to cost, by contractor's estimate, $170,000," but that was absurd. You could hardly build a parking lot for that price, even back then. In fact, the contractor for the ice arena was the man my mother eventually married, Ed Doty, who says that the $170,000 bid David claims, was both untrue and ridiculous. His actual bid was $1.2 million, roughly the amount David says the rink's construction ballooned to, so Ed was fairly accurate in its final cost.

It was equally unfair for David to quote one of our close family friends, Bob Albo, as saying that, "it wasn't warm there … The household wasn't as warm and wonderful as it should have been." Not only has Albo himself denied that opinion, he further admits he wasn't even to our home more than a handful of times a year, despite David referring to him as "a constant visitor." In reality, we saw more of him down at the Seals' games where he was one of the physicians to the team. The same must be said of Chuck and Betty Bartley, who were friends, but not constant visitors, either, and clearly had no special insight into how our family operated or felt about each other. We had nothing like constant visitors of any sort. Only Bus and Marion, when they lived on the Coffee Grounds, and Grandma Halverson, could know how we lived as a family. Worse still, David writes about us

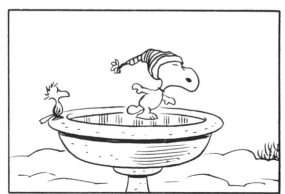

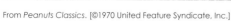

From *Peanuts Classics*. [©1970 United Feature Syndicate, Inc.]

being besieged by "old friends on vacation, friends of old friends, third cousins of old friends, fans, and well-wishers," coming into our driveway "in their campers and station wagons … waving their Kodaks and autograph books, expecting to be warmly received." Interesting, but a complete fabrication none of us remembers: not myself nor Jill nor Amy nor Craig, nor even my mother.

Naturally, I cannot expect to know what went on behind closed doors between my father and mother, and it would be presumptuous of me to say I did. But I can certainly have my own view of how we were treated as children, and to have David imply that our household wasn't "as warm and wonderful as it should have been" is unfortunate. But again, how could he know? Yet he does avail himself of comments each of us made regarding the affection we felt from Dad. He says my father did not "kiss his children goodnight. There were few, if any, hugs between father and child in the Schulz household of those years … he avoided physical closeness." David says, "Monte recalled his father embracing him but once in his life — when he was twenty-six and leaving home for graduate school." He writes that Amy had "to learn how to" hug from members of her church community. Neither of those quotes is true. What I told David was that the one time I particularly remember Dad hugging me was the afternoon I had loaded up my things to drive down to Santa Barbara for graduate school, and Dad stepped forward to give me a big hug as I climbed into the moving van. I always presumed he did so because I was leaving town, so I was surprised he hugged me like that, not because of the hug itself, but because I was going to be back in a month, anyhow. I never told David that was the only time Dad hugged me. Nor did Amy tell David she had to learn to hug from her church because of what she lacked at home. What she said was that when she was younger, she hated having people invade her personal space, but when she joined the church, so many members were coming up to hug her that she had to get used to giving hugs in return, a story that, she says, had nothing to do with Dad at all. Besides, what David really needed to be asking was how much affection did we feel from our parents, and Dad in particular. When I was a child, Dad would put me to bed singing an old Paul Robeson tune:

> *Little man, you're crying, I know why you're blue,*
> *Someone took your kiddie car away.*
> *You better go to sleep now,*
> *Little man, you've had a busy day.*

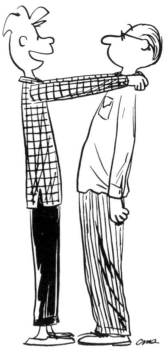

"YOU ARE MY DAD. I AM YOUR SON. ISN'T THAT A THRILLING THOUGHT? HOW ABOUT LETTING ME USE THE CAR TONIGHT?"

From *Schulz's Youth*. [©2007 About Comics, ©2007 Warner Press]

When I was a boy in grade school, Dad and Craig and I would wrestle in the living room and in the swimming pool. One rainy fall afternoon when I was a teenager, the three of us played a tackle football game of goal line stands on our old baseball field until all three of us were soaked through to our underwear and muddy head to toe. Even as David wrote that on our trip to Hawaii in August on 1964, Dad felt "everybody has a pal — everybody but me," he manages to avoid mentioning how Dad and I took a taxicab to Honolulu Stadium to see the Islanders play a ball game under the tropical moon, just the two of us together. On a fall evening long ago, Dad drove me down to Oakland to see Jack Benny perform live on stage just because he knew I wanted to. When I had surgery at 7 years of age, Dad was at my bedside each evening until visiting hours ended and it was he who came to bring me home at last. The same was true for when I had four teeth removed in preparation for braces: His was the last face I remembered seeing before anesthesia and the first I saw upon awaking.

Nikki Giovanni wrote, "Most of us love from our need to love, not because we find someone deserving." Did we feel loved, and was Dad deserving of our love? Unequivocally. We felt a warmth and bond between father and children that

never wavered or weakened over the ascending years into our adulthood. So our relationships with him were constant, each us of visiting whenever possible, dropping by the studio when we were in town, having lunch or going out to dinner together. Dad and I would meet at the ice arena late in the afternoon when he was through "drawing those stupid pictures" for the day, and go over to the bookstore and talk about politics or religion or what Craig or Amy or Jill were doing those days. Even into the last year of his life, when I would come into town to play in a late-night senior hockey league, Dad would sit up in the stands an hour or more past his bed time to watch his middle-aged son play. How can a son believe that is no sign of affection? Now it must be mentioned that David quotes my sister Meredith as saying that Dad "was so cold and so distant … because he was afraid to love." Whether that was her true and honest experience when Dad was alive, I'll leave up to her, but none of the rest us ever felt that way. Her life and her perspectives are certainly not ours.

If there was anything truly disappointing in David's story about the affair with Tracey Claudius, it was the emphasis he put on it in terms of Dad's relationship with women in his life. We had no objection to David writing about someone who was, for better or worse, important to my dad for a brief period. We had heard of the affair and fully expected David to write about it. None of us are lacking in weakness, after all, and what happened was 35 years ago. Knowing David would bring it to light in his story of Dad's life did not trouble us at all.

The genesis of the Tracey Claudius story is as follows: We were contacted by her cousin Shelley, who said that Tracey was interested in writing a book about her friendship with my father back in the early 1970s and hoped to use some drawings that Dad had done for her. Hearing about this led us to suggest to David that he might want to interview Tracey. After he spoke with her, David reported back to us that the relationship was not much more than a simple flirtation. Not until we saw the manuscript did we hear it described differently. After reading what David wrote, we asked him to explain the change, and he told us that subsequent conversations with Tracey had persuaded him to tell a different story. Apparently, Shelley also was surprised to hear Dad's relationship with Tracey described as sexual by David Michaelis because both Shelley and Tracey's daughter had always understood it from Tracey as having been flirtatiously romantic, but essentially platonic. True or false, according

to Shelley, David's version of Tracey's story is not confirmed by either herself or Tracey's daughter. I have no good reason to doubt Dad had that affair; I only question the nature and extent of it. In any case, whatever happened, I wasn't there, nor was David, and while Tracey's moment with my father appears to parallel what he was drawing in the strip during that period, let's not forget what David argued in that e-mail to me: "*Your father didn't draw from life; and I'm not looking for a one-to-one match-up here; and the reader probably can't finally understand art any better by knowing the conditions of the life of the artist.*"

What really bothered us more than David's description of the affair was how dogged he had become in unearthing this sort of thing. If there was anything that seemed to truly interest him in this biography, it was my father's relationship with women. David charts the progress of Dad's dating life from early adulthood up through Donna Mae Johnson and his marriage to my mother, and on to a litany of apparent flirtations with Janell Pulis, Peggy Fleming, Amy Lago, Lynn Johnston, even author Joan Didion, who, David writes, "filled a role that became standard in the fan of female figures he forever spread before him." However, our first president of Creative Associates, Warren Lockhart, who accompanied Dad on most, if not all, of his visits to Didion and her husband John Gregory Dunne, saw no hint whatsoever of any flirtation, rather describing their relationship as a "common respect for their shared enjoyment of art and the camara-

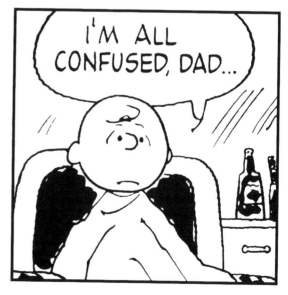

From *You're the Tops, Pops!* [©1998 United Feature Syndicate, Inc.]

From *You'll Flip, Charlie Brown.* [©1967 United Feature Syndicate, Inc.]

derie that comes from people who have a similar capacity to communicate with the written word, and they enjoyed each other for those very reasons." And Warren remembers how my father wanted to share with him what he derived from just those sorts of relationships. "He was in his element with them, because this was a profession that only a few can participate in." It was not about sexual flirtations. But David somehow decided that this was one of the driving forces in my father's life, while exposing deep character flaws. "He was an outrageous flirt," David quotes an ex-employee of United Media and Creative Associates, Barbara McLaughlin, in the first draft of the manuscript, "and I used to feel for Jeannie because there were uncomfortable situations where he acted like a stupid kid." As David has her tell it, Dad would joke, "Stand a little closer," and "Rub up . . . strange stupid teenager things, and most men, if someone was making a pass even in a joking way, you'd say, 'Get your hands off!' or 'Get lost,' or whatever. But Sparky being Sparky, people didn't talk to him that way." Of course, neither Jeannie nor Liz Conyngham — another licensing executive of United Media — believed Barbara's description of my father's behavior, and found her comments peculiar. Yet David writes that, "Now and then he seemed to be more restless than usual, pointedly saying in a conversation where Jeannie was present, 'After you're married, you're not supposed to even look at another woman. But you ought to be able to have a three-day pass now and then.' To his way of thinking, he wasn't cheating on Jeannie so much as time itself: if he could not repeat the past or marry the Little Red-Haired Girl, he certainly had the power, now, to make it all come out differently."

This is what David finally began looking for. Several months after interviewing cartoonist Cathy Guisewite, a close friend of Dad's for more than 20 years, David called her to see if he might interview her again. He told her that he had learned how Sparky had had an affair, and how other women had told him that Sparky had come on to them. He asked if Sparky had ever come on to her, as well. Yet, to Cathy, it felt somehow as if David were hoping there was "something other than friendship in our friendship." And there was not. Nor was there in Dad's relationship with Molly Boice, a theatrical performer in Sonoma County and close friend of my father's, whom David also asked if Dad had come onto her. Yet he pursued this research through several more of Dad's female friends and acquaintances. He quotes Amy Lago, his editor at the syndicate in 1990, as saying that, "Sparky was very good at flirting." And Lynn Johnston: "Sparky could make you feel like a princess." And Judy Schwomeyer Sladky, a wonderful ice-show performer: "Sparky fell in love with every girl. If they were blonde and pretty or cute, he would just fall in love with them and stay in love with them — to the point where I almost considered Jeannie a saint." Yet Judy need not have worried, because Jeannie knew that for my father, "it was all performance and play, and none of it detracted from his love or attention to me."

But David was persistent. Each biographer approaches the book's subject with an eye on the story of a life, and everyone's story will naturally provide more material than any volume can contain, so the issue is always what to include and what to leave out. Omissions, as I'll show later, truly do describe the larger part of Dad's life as it compares to David's biography, but one glaring omission is symptomatic of what apparently interests this biographer.

Barnaby Conrad, author of *Matador*, owner of the famous North Beach nightclub of the same title and all-around raconteur, first met my father at our home in 1967, interviewing him for *The New York Times Magazine.* Six years later, Dad traveled down to Santa Barbara to take part in Barnaby's writers conference with Ray Bradbury, Budd Schulberg,

James Michener, Alex Haley and a community of students. Nearly every June for the next 25 years, my father visited the conference where he was asked to speak on what it meant to be a writer. It humbled him to be invited to share his views on the literary life, given that he never truly considered himself one of that crowd. While he treated distinguished authors like Anne Lamott with great deference and humility, he seemed often only vaguely aware of the awe with which they regarded him. Almost as if he didn't accept the idea that fame in his own artistic endeavors gained him notoriety in a companion forum, he spoke fondly of the achievements of writers he admired and only grudgingly acknowledged how thrilled they were to have the opportunity of meeting him. The conference became part of his life, his yearly getaway, much as was the Bing Crosby Pro-Am: something to look forward to, a break from his own enforced routine, a chance to step out of his own life and indulge one of his passions. I began attending the conference in 1975 and have been there myself now nearly every year since. (Though David writes that Dad dropped in on the "workshops conducted by his son, Monte," actually, I did not begin teaching at the conference until after my father's death.) I was able to see how much Dad enjoyed that conference atmosphere, how many friends he made, how good it was for people to be with him and enjoy his company, too. Besides giving his talk Saturday evenings, he attended many of the speakers, (always Ray Bradbury's inspirational address on the opening Friday), entertained with lively conversation on the sun deck next to a train car that had been converted into a lunch wagon, or played tennis with the Conrads and other friends during the conference week. That week in June manifested my father's affection for the world of the written word and all those writers who reveled there with him. Somehow David either failed to grasp how important that conference was to Dad or had no interest in exploring that joy. In the published version of the biography, David acknowledges only

that my father "enjoyed himself immensely, talking about books with writers, meeting admirers who recognized him as something more than a cartoonist, soaking up the applause for his annual speech." He managed 13 lines to detail Dad's quarter of a century at the writers conference, and left it at that. Obviously, something about that part of my dad's life failed to move him. Yet in his first draft of the book, David did, in fact, find something of great interest regarding the conference:

I have been overwhelmed with useless activity," he confided to his writer's conference girlfriend, Suzanne Del Rossi. "The senior hockey games, the roller blade camp, etc. and then there are those cartoons that have to be drawn."

Home from his annual visit to the Santa Barbara Writers' Conference in 1996, he found letters from Suzanne and kept them on the desk beside his drawing board, reading them "over and over."

He had fantasized Suzanne as the prom queen he had never come close to knowing in high school. Now he projected her in the next stage of his life as a man: "You should have written to me when I was overseas in the war . . . Now, there is a novel."

He always put off speaking directly about his feelings for her, never moved their relations past where they stood — in exquisite unfulfillment. Instead he talked about a novel he wanted to write — an always unwritten novel whose plot, still in progress, revolved around an older man and a young woman, both married, who met on a train, became deeply attracted to each other, but, recalled Suzanne, "had not yet consummated their relationship, but the question was whether they would."

At the conference, Sparky picked up the narrative of this postmodernist fiction whenever they sat down with others to lunch, taking the story-within-a-story to another level of incompletion, and then saying wistfully, "I wonder how the

Oct. 19, 1981 strip — collected in *Snoopy's Guide to the Writing Life*, which Monte Schulz helped edit. [©2002 United Feature Syndicate, Inc.]

novel is going to come out." She realized afterward that "it was his code way of saying whatever he was trying to say to me." The novel became part of their intermittent but continuous conversation. He rarely spoke of a formal text, with a title and chapters. It remained always a fantasy, and that of course was its point — its unwritten-ness, its unwriteable-ness, its continuously just-out-of-reach potential.

"I cherish your message," Sparky replied to one of her letters "and search for an ending to the novel. Maybe even a middle." He thanked her for writing and told her he was flattered and appreciative. "The novel," he concluded, "will probably end with a sad letter."

We find no Barnaby and Mary Conrad here, no Ray Bradbury, no speakers, no writers, no workshops, nothing but another shameless flirtation. Why does this fascinate the biographer more than my father's yearly excursion into the world of writers? And where does this story come from? Who is Suzanne Del Rossi? He neglects to tell us that she is married, that she attended the conference with her good friend from Boston, Mary Beth Borré — that she and Mary Beth were Belles of Ball, so to speak, at the Miramar Hotel during the week of the conference and held a very popular cocktail party each Wednesday afternoon during the more official wine-and-cheese party put on by the Conrads. If Suzanne were, indeed, the "prom queen" Dad never came close to knowing in high school, what was he to Suzanne? What was her part in the narrative of that "postmodern fiction" they supposedly created during lunch and in that intermittent conversation David describes beyond the Miramar? Who was truly chasing whom? And why? For some reason, perhaps upon hearing of our displeasure with this scenario, David chose to delete it from his final draft, replacing it, again, with a perfunctory description of the conference week, but the die was cast. Nothing in this book gave a more graphic reminder of what focused David's attention.

So what part should the biographer play in the telling of a life? Whose story is it, anyway? The author's, or his subject's? In David's book, he injects a form of omniscience that describes and guides and finally attempts to inform the narrative he directs. When he writes about my sister Meredith's disputes with Mom, who felt she was "running wild, keeping bad company, taking drugs," David says, "Meredith had, in fact, tried marijuana once and did not like it." Had *"in fact"*? How can he know that? No journalist would be permitted to phrase the sentence in that way. More properly,

From *Snoopy's Guide to the Writing Life.* [©2002 United Feature Syndicate, Inc.]

he ought to have written that she "claims" or "maintains" or even "remembers" only trying marijuana once. But David cannot know anything about her perceived teen drug use as a "fact." He is not she, and he was not there. This sort of certitude dominates the biography. A life reveals what it reveals, but the biographer has a sacred duty to let that life be revealed as it was lived, not driven in one direction or the other by the biographer. Yet that is precisely what David Michaelis has done in this book. He chooses his emphasis, not by the weight or number of events, but rather by his own interests. And by doing so, he severely distorts that very life he purports to reveal. Narrating the end of my parents' marriage when we've left Coffee Lane and moved out onto the ranch on Chalk Hill Road, David describes how Mom had "lavishly redecorated the new ranch house. When Bill Melendez saw her work, the thickness of the carpeting, the richness of the materials, the shine of the new his-and-her master bathroom, he saw a woman — 'a real feminine woman, with a gorgeous figure and great big boobs' — trying to seduce her man back." Disregarding the fact that my mother

had instigated that move from our beloved home on Coffee Lane to a vast hilly ranch of grass canyons and live oaks, acres and acres of wild that clearly suited her more than Dad, what David writes here of Mom's effort to impress Dad was both chronologically and geographically false. This was not a "new ranch house," but rather a simple two-story turn-of-the-century frame house that barely accommodated us, and was not much significantly improved by a paint job and new carpets. (It was a nice old house, and I like old houses, but, in fact, Mom changed the character of it immediately into something neither new nor historical.) And that "his-and-her master bathroom" more properly describes either the house she built for herself and Ed Doty after they married, or the remodel done on my parents' bedroom at Coffee Lane a year before we left. But he uses this story of Bill's to illustrate a suggested effort on my mother's part toward a kind of reconciliation that was both hopeless and untrue. Indeed, our move to Chalk Hill Road ended the marriage, because it offered no hope whatsoever of saving it. Buying the ranch was Mom's exit since she surely knew Dad would never be comfortable there. Gone were his studio, his four-hole golf course, his tennis court, and our baseball field. And the three miles of gravel and dirt road access across several cattle guards would have ruined his willow green Jaguar XKE, so he sold it and drove off the ranch for good in a brown Pinto.

Still more significantly, the sins of omission truly drive the central error of this biography. By leaving out, disregarding, ignoring, or compressing huge aspects of my father's life, David is able to tell a story whose coherence masks its basic untruthfulness. For instance, my father's brief affair with Tracey Claudius was given 28 pages, but his courtship of the woman he eventually married, Jean Forsyth Clyde, earned only nine pages. Which of these two pursuits was more important to my dad's life? Unquestionably the latter. But just as certainly, the affair was more interesting to David. Similarly, Tracy Claudius got more space than did my father's 25 years at the Santa Barbara Writers Conference, to which the biographer parceled out 13 lines. Which was a bigger part of my father's life? Did the affair cause my father's divorce? No, it was a symptom of something that was, by then, clearly inevitable to all of us living in that household. But the Writers Conference occupied more of his time for a far greater length than did that affair.

The same is true of the senior hockey tournament Dad sponsored and played in at our ice arena. Back on the ice, playing regularly for the first time since his youth, Dad joined a team

"REMEMBER, NOW, FELLAS... NO LIFTING!"

Schulz sketch collected in *It's Only a Game*. [©2007 About Comics, ©2007 Charles M. Schulz Trust]

of over-40 players from Santa Rosa and the Bay Area to compete in the ice-hockey section of the 1973 Senior Olympics at Burbank, Calif. During the Fifth annual tournament in 1974, the director of the Senior Olympics hockey program asked my father if he might be willing to host future tournaments at our own Redwood Empire Ice Arena. That began a tradition that has lasted up to the present day, a tournament in which Dad competed more than 25 times. In 1982, he parted company with the Senior Olympics and changed the name of the event to "Snoopy's Senior World Hockey Tournament." His own team began life in the 50 and over division as the Santa Rosa Half Centuries and moved up by five-year increments, eventually becoming the Diamond Icers and taking 10 gold medals, the last of which Dad himself won with a pair of goals in his final game in 1998. That's the history of his involvement with the tournament, but doesn't tell the full story of hockey's impact on his life. On the afternoon of my father's memorial service, one section of the Luther Burbank Center was filled with men in colorful hockey jackets, his friends and teammates from all those years. So many names from games past, so many memories. Dad used to suit up nearly every Friday afternoon for a 1:15 to 2:15 skate, his chance to get away from the studio and forget the pressures of his daily routine. On the ice, he was just a strong and solid right-winger with decent speed, good hands and a terrific scoring touch around the net. He liked winning, bore losing with varying degrees of frustration, yet always enjoyed the careless fun and exertion of being on the

ice. Nowhere in his life was the passage of time more evident than in hockey. Growing old with friends and foes alike, his tournament team ascended through the age divisions. fighting it out for a period with the same three opponents: the Westcoasters of Southern California, the Mandai Memorials from Japan, and the Ottawa Oldtimers whose defeat one summer provided Dad one of his team's greatest victories. It was strangely poignant watching all these players — many of whom returned to Santa Rosa year after year to compete for medals — gradually age and slow down, stick skills eroding, skating growing awkward, shot velocities declining. Yet that competitive edge never seemed to erode. All that changed was a deepening appreciation of camaraderie, like old veterans reliving war stories, around a cup of hot cocoa or a beer in the parking lot. Over time, my father's hockey companions became his personal friends, formed allegiances to him that had nothing to do with his celebrity. Roland Thibault flew with Dad and myself and two friends of mine to the NHL All-Star game in 1970 (where we met up with my father's old Army buddy, Elmer Hagemeyer), and sometime thereafter, a new character appeared in the strip, a rough-edged friend of Peppermint Patty's named, naturally, "Thibault." In 1975, Dad and his goalie, Dick Wolff, flew down with my team from the Santa Rosa Junior College for a two-game tour of Southern California where they were our bench coaches. And, of course, Snoopy played hockey games of his own on Woodstock's frozen bird bath, his energy and enthusiasm for the ice never diminished by age as was my father and his Diamond Icers': Alex Young, Cy Cardiff, Foxy Foxcroft, Mark Sertich, Skippy Baxter, Raoul Diaz, John Riley, Sr., Ed Ross, Dick Wolff, Gerry Heffernan, Bill Dyroff, Hugh Lockhart, "Peanut" McAnally, Clay Nelson, Lorne Nadeau, and Tom Watmore. But time, sadly, does more than erode a player's skills. Dad died first, and was followed over the next few years by his original linemates Cy and Foxy, then Lorne Nadeau, Hugh Lockhart, and big Ed Ross from Florida, a jovial fellow who seemed to wear a perpetual smile at every tournament. Each of these men, and perhaps everyone who played in that tournament during the years Dad knew them, form another portrait of my father's life. Yet somehow, none of them were worth more than the three sentences David gave them in his biography. Even if David has no interest in ice hockey tournaments, which is clear enough, one could imagine searching out those people who managed to become significant to my father as the years went by. Few fit that description more than those men whom he met on the ice.

And what of the annual ice show? My father had a great love of show business, its music and emotional performances that gladdened hearts and brought smiles to young and old. He had a taste of it with the animated television specials and movies he did with Lee Mendelson and Bill Melendez, and perhaps more strongly still in those early days of *You're A Good Man, Charlie Brown*, with Clark Gesner's music bringing Dad's characters to life on stage before a live audience. But with the ice shows, he was able to experience show business in his own building and influence greatly what was presented. Beginning with the amateur shows put on by Meryl and Skippy Baxter that featured professional headliners, then evolving naturally over a period of years into the full professional extravagances at Christmas time, this became perhaps my father's favorite time of year. Ice stars such as Scott Hamilton, Peggy Fleming, Robin Cousins, Dorothy Hamill, Brian Boitano and Richard Dwyer came to Santa Rosa to perform, and Dad's attention was drawn daily across the street from his studio to watch rehearsals, advise on music and scenarios, and just "hang out," as he used to tell my sister Jill (who toured with Ice Follies and Holiday on Ice as a professional skater herself). Both she and Amy skated for years in the show and it was impossible not to see the joy on my father's face not only during their performances, but throughout each performance, each season. He loved costumes and sets, the smell of hot cider in the arena, the buzzing crowds and wide-eyed children for whom the holidays were made just that much more magical by the entertaining and original show Dad gave them. As his choreographer Karen Kresge said, "He always taught me that you must give the audience moments. You must give them laughter, you must give them a little poignancy, you must give them romance, maybe come close to a tear." He made it a point to attend virtually every performance and lead the standing ovation he believed each show deserved. It is impossible to understate how big a part of his life this show was, how much happiness it brought to so many people, how many friends Dad made from that ice show over the years, and yet the biography offered it only two short paragraphs.

Marrying Jeannie in September 1973 opened Dad up to an entire new world of enthusiasms, one of which was an old one he had left behind many years before. We had a tennis court out on Coffee Lane, but it saw more use for street hockey, paddleball, bicycles and skateboards than tennis. Other than Aaron Hamilton on evenings after those clarinet lessons with Craig, whom would Dad play with? We

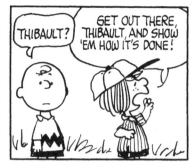

From *You've Come a Long Way, Charlie Brown*. [©1971 United Feature Syndicate, Inc.]

were too young ourselves to give him any kind of match, and there were so many other things to do. I had almost forgotten Dad knew how to play tennis until he began rallying with Jeannie on the outdoor court at the studio. Tennis seemed to revitalize him, make him younger, more fit, more alive than ever. In the noon hour nearly everyday, Jeannie and Dad would be out in the sun playing doubles with Creative Associates vice-president Ron Nelson and Warren Lockhart or Don Frazer (who eventually became a licensee of *Peanuts* cloisonné pins), Dad's attorney Ed Anderson, and eventually both myself and Craig, after we became competent enough to give them a decent game. Jeannie was incredibly agile and Dad played a wily tactical game of spins and power serves and lobs, and it must have taken Craig and I a couple of years to finally beat them. Dad and Jeannie took lessons from a contemporary of Jack Kramer's, a Korean War Air Force veteran named Jerry Dewitt whose constant idiosyncratic chatter and phenomenal racket control made him infuriatingly entertaining. Dad and Jeannie joined a tennis club, La Cantera, in Santa Rosa, expanding an already wide social life. They played tournaments there in doubles and mixed doubles, and by 1977, Dad was inviting friends from the club to play on rainy days at the new indoor court he and Jeannie built between the studio and ice rink. Even Dad and I played and won a father-son tournament at the club one summer weekend, but tennis led Dad into a far greater arena than either La Cantera, or his own courts.

When cartoonist Paige Braddock asked my father who his three heroes were, he told her, "Dwight D. Eisenhower, Winston Churchill and Billie Jean King." He admired Billie Jean not just as the great champion she was, but also for her indefatigable pioneering in the field of women's athletics. She pushed for equal pay at professional tennis tournaments that refused to acknowledge the draw of women players, and lobbied for funding of girls' sports programs in high schools

and universities. She endured the constant hectoring of an entrenched male establishment that viewed women as lesser competitors and refused to grant them a long-deserved seat at the table. Although Warren Lockhart remembers my father meeting Billie Jean down in Palm Springs in the early '60s, Dad really became acquainted with her when Eva Auchincloss asked him to serve on the board of directors of the Women's Sports Foundation in 1980. Eva describes that as "an astonishing acceptance of a well known person to put himself out on a limb, given the stakes and the time, for something most people did not understand, but for which he was willing to take a stand." But Dad admired women's sports, and particularly women's tennis. He thought their game was more entertaining than the men's and related better to the average tennis player. He admired the tenacity of Billie Jean and Rosie Casals, and the grace of Virginia Wade, Chris Evert and Yvonne Goolagong. When we flew over to Wimbledon in June of 1977, Billie Jean was the first person we saw at the hotel, ever generous and enthusiastic. Dad encouraged Rosie Casals to use the arena for a women's tennis tournament that featured Virginia Wade, Françoise Durr, Rosie and Billie Jean. The Women's Sports Foundation gave him the Billie Jean King Contribution Award for his enthusiastic interest in, and commitment to, women's sports. Dad did more than just pick up a tennis racket.

If cartooning was my father's greatest passion in life, it would be hard to argue that anything other than golf was his second. He had played when he was young at Highland Park in St. Paul, and grew to be a pretty good golfer by adulthood. It was perhaps the only sport he played at a level competent enough to at least be on a good course with professionals and not make a fool of himself. He was consistent off the tee, extremely accurate with his approach shots to the green and was a good and deliberate putter. By 1964, a short four-

hole golf course had been graded out of the woods on the back acres of the Coffee Grounds, giving Dad somewhere to practice any day of the week. One evening, after finishing work for the day, Dad stood on the fourth tee and used a three iron to get his first hole-in-one on his own course. He taught Craig to play, too, and entered them in father-son tournament one year and was proud of how well Craig drove off the tee and down the fairways. Shortly after we came to California, Bing Crosby invited my father to his yearly clambake, the National Pro-Am at Pebble Beach. Dad played there almost every year until he was no longer invited in 1997. Warren Lockhart remembered Dad spending an inordinate amount of time on the driving range and putting greens and hitting out of, and chipping over, the practice bunkers. Pebble Beach, Spyglass and Cypress are three of the most challenging golf courses in the world, so often due to the winter conditions on California's Central Coast. Yet my father seemed to be in his element there, a natural on the links, regardless of his final score. In 1963, Lee Mendelson filmed him hooking a ball through the cold wind into the ocean off the 18th tee at Pebble Beach for a segment of the documentary, *A Boy Named Charlie Brown*, but finally cut it out of the film when Dad let Lee know he wasn't amused. He was no golfing dilettante. He was a competitor and enjoyed many great years down at the Crosby (later, AT&T). Over the years, he played with Johnny Miller, George Archer, Mike Reid (more than once), Charlie Gibson and Dean James. In his foursome were Neil Armstrong, Roger Penske, Bob Albo, Dan Edwards, Howard Twitty, Billy Casper, Bert Yancy, Gene Littler, Rick Rhodes and many others. He even made his first and only cut with, I believe, a pro named Al Mengert.

Dad also played the Dinah Shore Invitational many times, and entered a huge number of charity events, including the Dan Vaughn Optomology Tournament. In the late '60s,

Dad was chairman of the Redwood Pro-Am and played with Willie Mays. He put on the Woodstock Open in Sonoma County over a period of 17 years for the benefit of Home Hospice Santa Rosa. For everyone who registered, Dad gave away wonderful prizes: golf bags, great jackets, golf balls, tees, interesting hats and lots of food. Much like the hockey tournament, the annual Woodstock was the highlight of many local golfers' year. He played a great number of golf tournaments and exhibition rounds in the western United States from Park City and St. George, Utah, to Palm Springs, San Jose (for his close friend Ward Wick and the Eyesight Foundation), Burlingame (for the American Cancer Society), San Francisco, Torrey Pines, and with friends on both public and private golf courses all over Northern California. Finally, too, on a trip to Scotland with Jeannie, Dad was able to play the most famous golf course on earth, the legendary St. Andrews. In his last few years, he had a Thursday foursome he enjoyed greatly at the Oakmont main course in Santa Rosa with Larry James, Bob Moratto and Father Gary Lombardi, always teeing off at 11:52.

But there were other grand enthusiasms of my father's that David ignored almost completely, none having anything at all to do with sports. Did we learn, for instance, what sort of music Dad listened to and enjoyed other than Beethoven? What about Brahms, Mozart, Bach, Vivaldi, Haydn, Dvorak, Schubert, Mahler, Tchaichovsky? Or hymns his grandmother adored and Dad learned at church? Because he loved music, as I wrote earlier, I cannot remember a time in our house where a record was not playing on the living-room stereo, whether soundtrack albums from a great variety Broadway shows or "Moon River" sung by Andy Williams. We listened to Tennessee Ernie Ford or Roger Miller on the radio as Dad drove us to school in the morning, or sat down at home to wait for the cannon shot in the "1812 Overture." Both he and my mother caused music to fill our lives. One art form

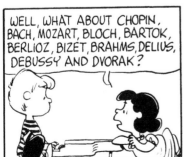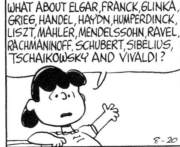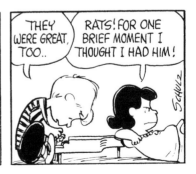

The Aug. 20, 1966 strip, collected in *The Complete Peanuts 1965-1966*. [©2007 United Feature Syndicate, Inc.]

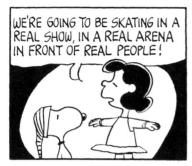
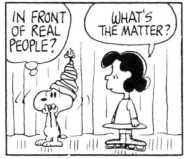
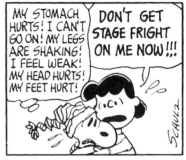

From "Ha Ha, Herman," Charlie Brown. [©1972 United Feature Syndicate, Inc.]

always influences another, and there must have been a reason Dad kept a record player across from his drawing table and a stack of LPs waiting to be heard. His tastes were extremely varied, and the following artists represent only a sampling of what my father had in his studio, but several names can be found here and there in the 50 years of the comic strip: *Eddy Arnold, Faron Young, Jo Stafford, Joni James, Herb Alpert, Ferlin Husky, Tom T. Hall, Hank Thompson, Harry James, Glen Campbell, Les Paul and Mary Ford, Rod McKuen, Johnny Cash, Richard Strauss, Hank Williams, Joan Baez, Frankie Lane, Julie London, Engelbert Humperdinck, Jack Jones, Bobby Goldsboro, the McGuire Sisters, Connie Francis, Sergio Franchi, Vladimir Horowitz, Spade Cooley, Jesse Crawford, Victor Borge, Barbra Streisand, Stan Getz, the Bill Gaither Trio, Cole Porter, Leroy Larson, Dory Previn, Greatest Hits of the Big Bands, and the Creedence Clearwater Revival (Willy and the Poor Boys).*

Look at that list. Who could have guessed Dad was a fan of old-time country and Western music? Why did David Michaelis leave that out of the book? Does he have no great interest in music himself? The story of our lives always has some sort of soundtrack, and understanding why each of these artists held some appeal to my father has to be important, it has to mean something.

I always thought that a good way to interview my father and get a sense of what interested and drove him both as artist and human being would have been to let him give a tour of the books on the shelves of his studio, asking him to speak freely about why he bought this volume or that, and what he found of value in each. Dad loved reading, and he adored the literary arts. His office walls were lined with 3,000 volumes on a myriad of topics, and the side table by his reading chair at home always had a further stack of books waiting to be read. He admired many a passage from those works he loved best — the famous scene of the tortoise crossing the

road in Steinbeck's *The Grapes of Wrath*. He introduced me to Thomas Wolfe by having me read that great lyric passage from *You Can't Go Home Again,* that began: *"Go, seeker, if you will, throughout the land and you will find us burning in the night."* He was intrigued by language, those lovely sentences and clever turns of phrases that have always made the written word so beguiling to readers of all ages. He once told me that the poet's gift and artistic responsibility is to express the sorrow and beauty of life for those who cannot: a jilted lover who finds solace in a book of poetry, or a traveler discovering the secret route to an undiscovered country. We read to hear these voices and learn from them.

Just as with music, his own reading was astoundingly eclectic. He loved poetry and prose, fiction and nonfiction. He spent a great many afternoons after work frequenting the bookstores of his hometown. He'd go and browse for an hour or so all the newest titles in fiction and nonfiction, constantly on the lookout for something to catch his attention. Rarely would he leave a bookstore without buying two or three books, often more. Impatient as he was intrigued, he'd read half a dozen books at a time, dipping into each one to see what held his attention and entertained or provided him both with ideas and further inspiration for his daily strip. No doubt he used Snoopy the author to express his own love and frustration with the creative process, to illuminate the writer's life by poking fun at the often incomprehensible divide between author and publisher while showing the amazing resilience of the everyday writer struggling for acceptance and acknowledgement.

Here are some of those books on the shelves of his office: *Beau Geste, The Human Comedy, In Flanders Fields, Point of No Return, The Bobby Jones Story, Thurber & Company, The Reader's Bible, Rabbit Run, Valentines, The French Foreign Legion, One Way to Spell Man, The Death of the President, Grant Moves South, The World of the Past, The War Lover, Agee On*

Film, Hans Brinker, The Interpreter's Bible, They Also Ran, An Unfinished Woman, The Dragons of Eden, The Great Gatsby, Apostles of Discord, The Bogey Man, Beloved Infidel, Ibsen, The Bridge Player's Bedside Companion, The Big Knock-Over, Ernie Pyle's War, Back Home, Max Perkins, The Gathering Storm, Caesar and Christ, Beethoven: Biography of Genius, Short Stories from The New Yorker, You Shall Be As Gods, The Complete Sherlock Holmes, The Caine Mutiny, Anna Karenina, To the Lighthouse, The Yearling, Wonderland, The Man Who Played God, August 1914.

When I was young, my father gave me some of his favorite adventure books to read: *Driscoll's Book of Pirates* and *Red Rackham's Revenge,* and *Treasure Island.* Once I'd reached the age where literary art is appreciated as much as bravado storytelling, he began recommending literary books for me to read. He wanted me to become as entranced by the literary art as he was. When I told him how much I admired the lyricism in Paul Simon and Neil Young, he gave me Carl Sandburg's *Complete Poems* and Edgar Lee Masters' *Spoon River Anthology.* He loved both of these volumes and Sandburg eventually exerted the most pervasive influence in my own writing style. This was where I was finally able to share his love of literature and ideas. We read many of the same books, while also talking about those we didn't enjoy in common. Of course, once my father had loaned his books to me, there was no hope of his ever seeing them again, but he didn't really seem to mind. He gave me his own copies of Joan Didion's *Slouching Towards Bethlehem* and Steinbeck's *East of Eden.* He was a big fan of Tolstoy and believed *War and Peace* to be the greatest novel ever written. He also loved Thomas Hardy's books and much of Dickens and Jane Austen, as well as the literature of the Bible. In fact, he spoke constantly of his admiration for *Ethan Frome* and *The Great Gatsby* and the Old Testament books of Job and Ecclesiastes. Later on, while reading novels of the Jazz Age as research for my second novel, I discovered John Dos Passos's *U.S.A.* and within a week my father was reading it, too. We talked about this great American novel for six months, and I believe *U.S.A.* was the first book I'd ever suggested that Dad read and he enjoyed. Certainly we didn't share all our favorite authors in common. He loved English writers and I preferred American. He enjoyed leisurely paced literary novels, while I'd read both literary and popular fiction. Yet we managed to find several living authors whose work we both admired and discussed: James Lee Burke's crime novels, Joseph Mitchell's *New Yorker* pieces, Carl Hiaasen's funny Florida novels, and the Border Trilogy of Cormac McCarthy.

Without question, our shared passion for the written word bound us together for the last years of his life, made us pals once again as we'd been in those long ago days of throwing the baseball after dinner in a summer twilight.

Now, I won't argue that Dad loved to travel. Not that he didn't enjoy going places, but too often he allowed himself to be troubled by the anticipation of his trips — not necessarily where he was going, but having to go there at all. Still, David Michaelis makes much more of this than it really was. Once Dad arrived anywhere, everyone seems to agree that he invariably had a great time. But none of his trips were undertaken on a lark. He was far too busy, day-to-day, week to week, to take off and go. David seems to want people to

Jean and Charles Schulz: photo courtesy of Monte Schulz.

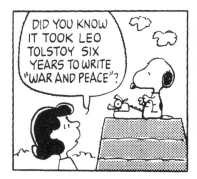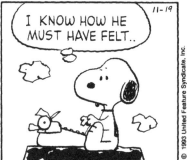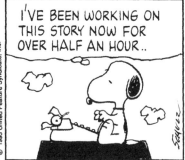

From *Snoopy's Guide to the Writing Life*. [©2002 United Feature Syndicate, Inc.]

think of Dad's artistic life as being comparable to an actor who does a picture, then takes several months off to rest and choose his next project — or a book author who publishes his novel or biography, then rests up for a period of time to mull over his new book and recharge his creative batteries. But my father had five dailies and a Sunday page to draw every week. He had a deadline that most artists do not, and he was only able to travel at all by drawing enough ahead that he could go off for a week or two. Even then, he always knew that he had to come back and work that much harder afterward.

When my father and mother were married with five of us children living at home, they did not have great opportunities to travel much. Aside from our holiday flight to Sun Valley, Dad's yearly appearances at the Bing Crosby Pro-Am, a few trips down to Disneyland and a couple of ski vacations up in Squaw Valley, most of our trips were down to San Francisco. I really don't recall Dad and Mom going anywhere alone, except for driving out to Anderson College in Indiana where Dad received an honorary doctorate in Humane Letters, and even that trip was cut short when Meredith and Craig took the horses out for a ride in the woods (after being warned not to do so by Mom), where Craig fell off and suffered a severe compound fracture of his left leg and wound up in a cast for months. Bill Melendez only remembers driving up Pacific Coast Highway with his wife, Helen, and Dad and Mom, both couples in their new Jaguar XKEs. Certainly, Mom would have preferred to travel more, but in those years, Dad didn't, and that was that.

While David makes much of Dad's notion of agoraphobia, in fact, after my father remarried, he traveled quite a lot during the last 30 years of his life. Maybe it was not to the extent of people who love to travel and make it a central part of their lives, but certainly Dad went many more places than

anyone with a severe aversion to travel would ever consider. Even when he would say, "I don't like to travel," and the apprehension of going away led him to complain, "Why do I have to do things I don't want to do," he was anxious more about the idea of having to travel, leaving his work, than actually being away from home.

In June of 1977, he and Jeannie were expected to fly to Wimbledon for the first time. My brother called me late in the afternoon on the day they were supposed to go and told me that Dad was backing out. So I drove up to his house and found Craig there with Amy and Jill, standing outdoors in the driveway with Dad who was feeling distraught. Jeannie had gone already to catch the plane, and we were trying to perk up Dad's spirits, and, in a moment of insanity, I told him that if he decided to change his mind and go to London the next day, I'd fly over with him. I'd just been on my own

From *You've Come a Long Way, Charlie Brown*. [©1971 United Feature Syndicate, Inc.]

first trip to Europe that April, and I wasn't anxious to go back so soon. Being the loving son and feeling for my father, I just thought if I could offer to help, that would make him feel better. Besides which, he'd flown with me out to Minnesota in the fall of '71 when I started college at Concordia in Moorhead, and flew back again in the late spring to deliver a speech there at semester's end and bring me home afterward. As you can guess, Amy telephoned at 6 a.m. the next day, telling me to pack my bags because I was about to fly with Dad to London. Unfortunately, he'd called my bluff. But I went, and so did he, and the only trepidation I noticed at all was when we were waiting at the gate and he excused himself to use the men's room, and I waited and waited for him to return, and when he finally did, he had a sly grin on his face. He said, "I'll bet you didn't think I'd come back, did you?" I laughed and told him, "Yes, actually I did, because what was I going to do if you didn't?" As it happened, we had a nice flight and when we arrived, a driver met us and took us to Wimbledon where Jeannie and the gang were waiting and Dad had a great trip, traveling on from Wimbledon to France with Bill Melendez and his wife Helen. Then he and Jeannie went back a year later to France with David and Karen Crommie to film the documentary, *To Remember*, for PBS. Jeannie found both of those trips instructive to Dad and to anyone seeking real insight into how he thought and lived. Recalling what it all meant to him, she writes:

Sparky and I made plans to go to the village in France where his squad had spent 6 weeks in their first bivouac after landing in Le Havre in January 1945. Following the detailed map given us by the squad historian, Sparky began to recognize features along the road and spotted the right turn down a small lane. He said, "We should cross the river soon" (more a stream, actually). Just then we crossed a wooden plank bridge and there on the right was the walled house where Sparky had been billeted twenty-seven years before. Now abandoned, the windows boarded up, the grass two feet tall, the house looked sad and derelict. Nevertheless, we were all so high with excitement. Sparky showed us where his squad had slept under the lean-to space meant for the livestock. Sparky was flooded with feelings I could only guess at, reaching back to remember how disoriented he had felt then, a pawn for the war which they all believed was going to have hold of them forever. I know he said later that during the army years he was never able to think beyond the day, maybe the minute, he was in. Later, we drove up the main road for

a mile to the crossroads where there was a café, a church, and a school. We stepped into the café, which is where Sparky had gone to write letters at night. It looked just as Sparky remembered it in 1945. He spoke to the proprietor in pidgin French and gestures, "I was here in la guerre." And "I played that," pointing to the fuss-ball game. The Frenchman indicated that he had been right there, too, in the war, and again, with gestures indicated that, "No, the game wasn't there, but there," pointing across the room. Sparky realized he was right. What are the chances of that? For those twenty-seven years, a small corner of France held in suspension as if waiting for Sparky to feel again the feeling of that young lonely soldier so long ago. It was an experience that was both profound and magical. On the way home, Sparky and Bill decided they had to create a TV show, which became What Have We Learned, Charlie Brown? *(CB and Linus look through grandpa's photo album, and Bill recreated in the animated show scenes of the Normandy landing). They knew that they had to bring truth and real emotion to an event that Sparky felt deeply connected to. It changed his feelings about himself as a character in his life story.*

From *Charlie Brown, Snoopy and Me*. [©1980 Charles M. Schulz and Whitehall, Hadlyme & Smith, Inc.]

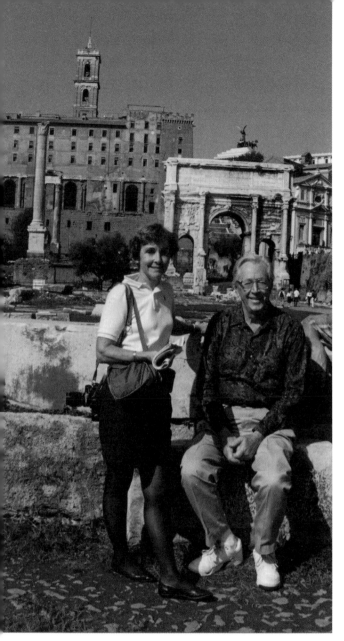

Charles and Jean Schulz posing at the Roman Coliseum: 1992. This photo is courtesy of the Charles M. Schulz Museum and Research Center, Santa Rosa, California.

After that, Dad began traveling more than he ever had in his life. A group of us went to Wimbledon in 1982 when Amy was living in England: Dad, Jeannie, Craig with his wife Judy, my girlfriend Barbara and I, all toured around for a week from London to Nottingham. Then Dad and Jeannie returned to Great Britain in 1985, where they visited Jeannie's aunt, who amused Dad greatly. They went to Scotland

in 1993 with George and Caroline Pipal, and to Paris in 1990 where Dad was honored at the Louvre, being named Commander in the Order of Arts and Letters. In 1992, he and Jeannie traveled to Italy for Dad's Order of Merit from the Italian Minister of Culture and met Giovanni Trimboli, who that year published *Charles M. Schulz: 40 Years Life and Art.*

Dad flew with Jeannie and Lee Mendelson to Montreal in 1978 for the opening of the masterpiece exhibit at the International Pavilion of Humor, Montreal, where he was named Cartoonist of the Year. He flew to New York City for the performance of Ellen Taaffe Zwilich's composition, *Peanuts Gallery,* at Carnegie Hall, and out to Tucson for the filming of *The Girl In the Red Truck.* He attended the National Cartoonists Society Reuben Awards weekend every year in a variety of locations from New York, La Jolla, Pasadena, Palm Beach and Boca Raton to Kansas City and San Antonio. He flew down to the Johnson Space Center at Houston in July 1995 with Jeannie, Craig, Bryan and Lindsey Schulz, Amy and her family for the exhibition "Around The Moon and Home Again: A Tribute to the Art of Charles M. Schulz." He took the inland-passage cruise to Alaska with Jeannie and Lee Mendelson, and a cruise down to Puerto Vallarta with Meredith, Ward Wick, Bill and Helen Melendez. He went back to Minneapolis with Warren Lockhart to visit Art Instruction, a trip in which they had dinner with Dad's "Little Red-Haired Girl," Donna Wold. And Warren reminded me of a holiday he took with my father and Jeannie and Warren's wife, Barbara, to Yosemite Valley in 1975. As he recalled, "The trip was Sparky's idea. It seemed he'd been thinking about it for some time. We talked about the park's beauty and its proximity to us. He was enthusiastic about the idea — we all were. I told Sparky I'd only been to the park twice, both times when I was pretty young. He made most of the first suggestions about what we should include. We stayed in the park at the Ahwahnee Hotel. I did the driving, and the trip in both directions was leisurely and relaxed. The first day included travel, settling in, buying and soaking ourselves in mosquito repellants, followed by more buying and drenching. Still, by late afternoon we were hiking, all mesmerized by the sheer beauty of the park. We had a beautiful dinner, and our conversations seemed to be diverse, fun and stimulated by anticipation. We spent two days in the Valley, hiking and exploring everywhere. We had fun."

Warren and Dad also flew up to Calgary for the World Figure Skating Championships and out to New York twice for meetings with United Features Syndicate to discuss the rights contract agreement. The two of them, of course, took

many trips down to Hollywood to see Bill Melendez, and they also flew down to San Diego one year for the Buick Open at Torrey Pines and ended up spending half the week at a hospital to support Dad's close friend, Dr. Bill Glasser, whose son who had just been stabbed at Balboa Park. David Michaelis recounts a whitewater-rafting trip on the Rogue River in 1975, where Dad, Jeannie, Lee Mendelson and 16 friends hummed, "Ommm," as they drifted along in a pouring rain. But my girlfriend, Nancy, and I went along with Dad and a crowd of his friends in another river-rafting trip on the Stanislaus only a couple of months later. He seemed very comfortable and exuberant there, researching for his third movie, *Race For Your Life, Charlie Brown*.

If any part of Dad's so-called travel anxiety derived from the whole airport experience, that was curtailed by his purchase of the Cessna Citation he bought in 1982 and Craig flew for him. He liked it so much that he replaced it in 1990 with a Citation V that carried more people. Freed from the tension and constrictions of commercial air travel, Dad could now go where he wanted, when he wanted, with the security of knowing his own son, a terrific pilot, was at the controls. Craig flew him to Pebble Beach, Palm Springs, Santa Barbara, Las Vegas, down to Los Angeles on many occasions for meetings with Bill Melendez, and up to my home in Nevada City for Thanksgiving a couple of times.

Craig also flew Dad, Jeannie and Craig's wife, Judy, out to Minnesota in August of 1992 where they met Jill, Amy and her husband John, for the opening of Camp Snoopy, then went out to Selby and Snelling to see the barbershop and Dad's upstairs apartment, and away to the old house at 473 Macalester Ave., and to all those small corners of my father's childhood. At John's urging, Dad bought potted pansies for his mother's gravesite. Two years later, they returned to the Mall of America for an exhibit of Dad's art, and drove back out to Snelling where Dad drew a Snoopy on a wall of the apartment where Dena Bertina Halverson Schulz had died.

Reading over that partial travel itinerary leads me to wonder what it means to presume my father did not like traveling. He went too many places, drove and flew too often to be considered agoraphobic in any meaningful sense of the word, particularly for someone whose work required him to be at his desk so often. Finally, Jeannie says, "The whole point is that Sparky, by nature, liked to be home, but he was also curious, and because he read a lot and wanted to see things, he wanted to enjoy what other people enjoyed. He traveled purposely, rather than for an escape."

What David Michaelis left out of his biography could, literally, make a second volume. I'm sure he knows that. And just as I am confident that everything he neglected to include would have given a better, fuller portrait of my father, I am certain David wrote what interested him most. Yet so much of it was just a waste of space. He has argued that the length of the book dictated his cuts, but what rationale can explain those 28 pages of Tracey Claudius and virtually nothing of what I just offered of Dad's passions. And, of course, there is so much more I could talk about. Where, for instance, are my father's politics? He was a great admirer of Eisenhower, but confessed to me once that had he the opportunity to do it over again, he would have voted for Kennedy in 1960 instead of Nixon. Was Dad a Republican or Democrat? Well, certainly he was a Republican during the Eisenhower years, but he endorsed many liberal virtues, being no fan of the war in Vietnam, nor persecutions of any sort, and considered Martin Luther King Jr. to be one of American history's greatest figures. Regardless of whom he voted for, he received at least four invitations to the White House over the years, none of which he was able to accept, but he did take a very kind telephone call from Ronald Reagan in 1981 when Dad was in the hospital after his quadruple bypass surgery. I was in the room with him that afternoon and saw him straighten to attention when thanking his Commander-in-Chief for

From *Peanuts Parade #29: The Way of the Fussbudget Is Not Easy.* [©1984 United Feature Syndicate, Inc.]

that thoughtful phone call. (He never did tell me whom he had voted for in the 1980 election, but I always thought it might have been John Anderson.)

My father believed in the transcendent benefits of law and common decency, quoting to me often from Hosea, "The Lord desires mercy, and not sacrifice," and was deeply suspicious of anyone wanting to make the world over in his or her own image. Nobody has all the answers, he argued, and he thought people with fervent beliefs of any sort ought to be asked, now and then, "Has it ever occurred to you that you might be wrong?" He was a study in contrasts that were perhaps not contradictory at all. A fervent believer in the divinity of Jesus Christ when he was young, near the end of his life my father described himself more often as a secular humanist. Yet he read his Bible commentaries with earnest devotion to bettering his understanding of Scripture and theology.

He admired Robert Bork and Carl Sagan, Eudora Welty and Willie Mays. He was distrustful of social welfare (having a deep faith in self-reliance), yet he and Jeannie donated millions of dollars to charitable organizations. He loved both fine art and popular movies, wishing he could paint like Andrew Wyeth, yet be tough like "Dirty Harry" Callahan. He had great affection for automobiles and dogs, fine sculpture and tuna fish sandwiches. He was popular because he did not see himself as greater than his fellow man. He was an ordinary human being with a singularly extraordinary gift. David Michaelis seems to appreciate the latter, but not the former. He refused to grant my father his simplest affections.

Late in life, Dad adopted a scraggly little mutt who needed a home. Somehow, he managed to insinuate himself into my father's life in a warm and surprising way. Andy was good for Dad, who looked forward to coming home at night to be with him, just as any of us with loving pets will do. But that apparently made little sense to David, who treated Dad's stewardship of Andy as a peculiar psychological quirk, just another of my father's neuroses. In his first draft of the book, David wrote how my father was so frightened of Andy running off and abandoning him that he began to dote on his little dog excessively. And, according to David, it was more than just doting; Dad actually "created a one-way bond by continuously making up and attributing thoughts and feelings to Andy as if he were a comic-strip dog. A real dog, of course, could not tell him directly what he was thinking, but from Andy's moods and gestures he attributed the magic of a full-scale reciprocal relationship. 'Now he's feeling sympathy for me. Now he loves me. Now he's hungry. Now he's questioning.'" This was apparently perfect for my father, in David's view, because my father did not have to answer to Andy about where he had been or whom he had seen that day. Because Andy didn't care; he was simply glad that Dad had come home so they could be together, a dog with his loving owner. Nor could my father complain he wasn't loved in that common relationship. Yet, sadly, as David saw things, "even with his dog, Sparky was unable to establish a bond in which he could trust that love could be received without conditions."

That story disappeared from the published biography.

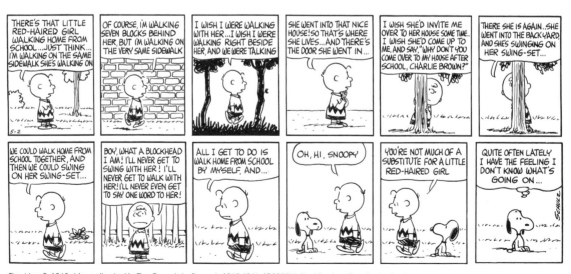

The May 2, 1965 strip, collected in *The Complete Peanuts 1965-1966*. [©2007 United Feature Syndicate, Inc.]

Why, I have no idea, but that David wrote it all greatly disappointed me. He seems not to appreciate the bond between pets and their owners, nor that basic desire to love and be loved we see fostered there. David prefers to play amateur psychologist, I suppose, rather than describing the comfort Dad found in that little dog, and how Andy caused this man, who could have nearly anything in the world, to choose to end his work day with a little dog at his side. Again, that story doesn't interest David, doesn't fit his conception of who my father was, or who David thought he was.

We never told David Michaelis what to write. It seemed unnecessary. I asked him not to repeat that worn out description of my father as perpetually dour and depressed, plagued by constant insecurities and identifiable fears. That wasn't the Charles Schulz I knew, neither was it whom his cousin Pat, my sisters and brother, mother, step-mother, close friends, business associates knew. Even strangers who came up to say hello found a man who was engaging and normal, far out of proportion to his fame and success. Certainly he could be cranky now and then, or abrupt; who isn't? But search among the faces of people in your lives to see if anyone is so much different. We share our humanity and cannot escape who we are. I think my father did well.

Now I want to tell you one last family story that David Michaelis left out of his book.

On Saturday, November 13th, 1999, I telephoned over to Santa Rosa to give Dad a prognosis on one of my cats that had been gravely ill in the past month. I never got the chance to tell him, because he let me know in a reasonably steady voice that he had stomach cancer. Dad had been severely fatigued all summer and into the fall, and finally went in for a check-up, and found out that the bloated stomach he'd been experiencing was a direct result of ascities, and cancer cells were discovered floating in that fluid. He seemed to indicate that this was not good news, but still treatable. On Monday, he planned to have the excess of fluid drained from his stomach. Greatly worried, I drove over to Sonoma from my home in the Sierra foothills on Monday evening. The next morning, my phone rang and I heard Amy's voice telling me that Dad had collapsed in his office and was undergoing emergency surgery. I dressed and raced across the county to Santa Rosa Memorial. Craig was there already and Jill was on her way from Santa Barbara, while Amy and her husband would be flying from Utah late that night. The surgery lasted several hours and once Dad had been moved to ICU, Jeannie, Craig and I went to meet with Dad's surgeon, a good friend,

From *Snoopy and the Red Baron*: he's riding his "Sopwith Camel."
[©1966 United Feature Syndicate, Inc.]

Bob Richardson. What he told us seemed impossible. My father had suffered a stroke from a blood clot, and treating the problem surgically had revealed advanced colon cancer. Having resected as much of the colon tumor as he could, Dr. Richardson told us quite frankly that, in his opinion, Dad had only about two years to live.

It was an unfathomable shock.

Was there anything that might alter the prognosis? Unfortunately, no. That was it. Two years. I went outdoors to my car and called the studio to get Pat Swanson's phone number. I hadn't seen her in more than two decades, if not longer, but she was Dad's closest living relative and I felt she had to see him. She cried when I told her where Dad was, and why, and she asked me when I wanted her to come up. "I'll get on a plane tonight if you say so." I said morning would be fine, then hung up to try and reach Bob Albo, feeling that his presence in the ICU might give Dad a great psychological boost. Dad enjoyed the company and conversation with lawyers and doctors, and he trusted Albo as much as anyone in his life.

It began raining after dark. Disbelief seemed to wash about. For the previous few years, Dad and I had spoken often about death with a melancholy acceptance. The trouble was, its inevitability was unspecific, like discussing who would be the next president of the United States. There would be one, and that was all that we could ever know with certainty.

Bob Albo drove up from Oakland late that night. Dad had been moved to ICU and Jeannie seemed hesitant about the effect Albo would have. I had no doubt at all. When Bob walked into the room and my father saw him, Dad's face lit up and he managed a smile. Sometimes we need comfort as much as a good prognosis, and Bob brought comfort to my father. Amid all our tears and worry that night, we were pleased.

Jill and her husband, Aaron (whose own father had died in March of 1997 of spindle cell rabdomyosarcoma), had been home in Santa Barbara that day and found out what happened with Dad from Amy. She immediately packed up her daughter and she and Aaron drove straight through to Northern California, stopping only to meet Amy and John at San Francisco International airport and take them up to Santa Rosa Memorial. The family was gathering now. Pat Swanson would arrive the following day, and Meredith would fly out after that. Many friends began appearing, as well, mostly from Santa Rosa those first few days, but from all over, after that.

Soon my father was given the only room available, upstairs on the fourth floor in cardiology. That was where we met his oncologist, Helen Collins, a wonderful young woman whose manner seemed just right to keep Dad's spirits level. She was honest and thoughtful. She told all of us that nothing would happen quickly, that this was a long process with options that Dad was free to choose. She did not tell him he could be cured. He had suffered a stroke quite likely caused by the drawing off of so much fluid on Monday. The result of that stroke was permanent damage to his left eye, leaving him with what he described as a "blooming of flowers," that made reading or drawing almost impossible. That damage led to his forced retirement, and that final deterioration of his will to survive, given that his prognosis for Stage Four colon cancer was already bleak and the stroke meant that he would never again be able to read, draw, drive, skate or hit a golf ball.

But we were determined not to let him go without a fight. Straightaway, Jill summoned a good friend of hers from UCLA, Dr. Patrick Soon Shong, who proved his worth within minutes of his arrival in Dad's room by teaching him to use a straw and swallow again, natural reflexes that the stroke nearly took away. While Amy traveled back and forth from Utah with various members of her family over the next three months, Jill and I basically moved in for the duration. We ate meals in the cafeteria and spent part of each day at Dad's room, letting him know he was loved by his children and that he would not face any of this alone. We refused to believe there was nothing to be done, no way to save him, regardless of his prognosis. I read to him one evening from one of his favorite novels, James Gould Cozzens' masterpiece, *By Love Possessed,* just a couple of pages before he grew drowsy and said that was enough. I think he just needed to know I was there and that reading was something we could share, even in a dimly lit hospital room. Some of his drawings were brought in to decorate a couple of his walls. When Pat Swanson walked into his room on Wednesday after his surgery, he brightened and said, "You came!" She gave him a hug and told him, "Of course, I came." Then they sat together and talked about family for a while and she tried to get a comb from nurse to comb my father's hair. Pat had expected to stay for just a couple days, but Dad insisted she remain for another after that, and when she did finally have to leave, he managed to tell her, "I will see you on the beach at Santa Barbara."

Then painter Tom Everhart came up from Venice in Southern California with a story that emboldened us to look for hope. More than a decade earlier, he had been diagnosed with Stage Four colon/liver cancer, and underwent two long surgeries and a year of radical chemotherapy in Baltimore at Johns Hopkins directed by David Ettinger, who was affiliated with Dr. Paul Sugarbaker of Washington Hospital. Sugarbaker's name was interesting to us because of the five or six doctors Jill and I had spoken to regarding any possible treatment for Dad, the only thing they agreed upon was that we not go to Dr. Sugarbaker. His procedure was somewhat new, considered radical by many oncologists, and he lost patients on the table. However, we also read that he had five-year survival rates running 50 percent for "selected" Stage Four patients with peritoneal metastases from colon cancer. The combination of intraperitoneal chemotherapy with hyperthermia following cytoreductive surgery in which all visible disease is removed can be enough to tip the balance towards "cure" for some. Tom Everhart, free from colon polyps for years now, was one of the fortunate. That would mean, of course, another surgery for Dad, this one elective. He was adamant, however, that there be no more surgery,

and so was Dr. Richardson, who remained unconvinced of the Sugarbaker procedure.

This was a terrible season for all of us. Craig's mother-in-law Billie Davis was already in and out of the hospital with advanced intestinal cancer, her prognosis very poor. Comic-strip historian Mark Cohen, a close friend of my father's, was in the last throes of lung cancer. On Wednesday evening, just 24 hours after Dad's emergency surgery, my wife Erin called me in tears to let me know her grandmother had just passed away. She had been found on the living floor of her home in the Oakmont community with family photos covering her coffee table, as if she wanted one last peek at her loved ones. Maybe this was why Jill and I, in particular, were in desperate pursuit of any reasonable avenue of treatment to save Dad, although we had no interest in alternative medicine; Helen Collins told us that she offered it to some of her patients now and again, but that, by and large, chemotherapy, radiation, and surgery provided the most consistent results when examined over thousands of patients.

Jeannie was not convinced that we ought to push Dad toward a more rigorous treatment, and we understood why. He began his first round of chemotherapy while still in the hospital, a drug called 5-FU. It's one of the oldest chemotherapy drugs and has been used for decades to shrink the tumor, slow it down and help to control symptoms. Side effects are considered relatively mild and Helen Collins thought Dad seemed to react well to it physically. Psychologically was another story entirely. He called it "brutal," and seemed beaten down by the diarrhea, fatigue and general all-around sickness he felt during the treatments. Jeannie was protecting him — perhaps accepting that he was going to die — and had no desire to watch the man she loved so dearly suffer needlessly. During that time, we had constant meetings both at the hospital and the studio to consider what we ought to do, if anything. While each of us had his or her own strongly felt belief about how to proceed, we refused to quarrel. Jill wanted to find some way to keep Dad alive, as did I. Jeannie cared most intensely about his quality of life. We all loved him and could agree that what he wanted counted most. Indeed, never had we gotten along better than when Dad was dying. We took care to consider each other's feelings on a variety of issues and made a conscious effort to be conciliatory, even when we disagreed, because what this circumstance was not about was us individually. Dad was the focus and, however we proceeded, we refused to be distracted by petty disputes. Never were we more together as a family. Day after day, we would come to the hospital and do what we could. For three consecutive afternoons, I walked Dad around the ward, hand-in-hand, as we had been on the sidewalks of Minnehaha Parkway all those years ago. We took one lap, then two laps, then three and four, as I urged him forward, needing to help him build up sufficient strength that he might soon be able to leave that ward under his own power. I found that experience of walking with him to be very poignant, very emotional, perhaps because it was, in reality, all I could do for him then.

The chief issue was how to prepare for what had to come. Helen Collins told us that, untreated, the tumor could eventually block Dad's colon resulting in the need for emergency surgery. By now, however, he had no thought of going under again. He was weakened considerably by chemotherapy, defeated by the simple fact of not being able to do what made him happy. How do you tell the artist he cannot draw? Or the writer that he cannot read? Jill was becoming increasingly impassioned. She had no desire to let Dad quit. I tended to agree with her, while Amy's religious beliefs and sympathy for Dad's suffering made her quite a bit less interested in sending Dad back into the operating room. He made it to

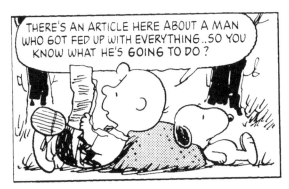
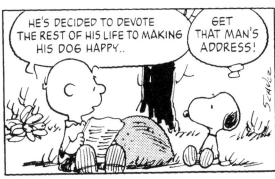

From *Being a Dog is a Full-Time Job: a Peanuts Collection*. [©1994 United Feature Syndicate, Inc.]

the ice show and received a great applause, which was terrific therapy. Then Al Roker came up to Dad and Jeannie's house in the foothills above Santa Rosa to do a follow-up interview for a segment the *Today* show had done that August. Dad was apprehensive about speaking on camera, given how much damage the stroke had done to his speech, but felt a strong obligation to do the interview. Though we supported his doing the piece, it quickly became clear we should have followed Dad's early instinct. He had great difficulty saying what he felt without becoming extremely emotional and when the camera was shut off and I tried to tell him how well he had done, all Dad said was that it had been "humiliating."

On Dec. 19, Mark Cohen lost his fight with lung cancer. Three days before Christmas, Craig's mother-in-law, Billie Davis, also passed away. Out of the hospital now, Dad attended her funeral with the rest of us. Craig, who seemed so dejected during Billie's illness and Dad's own struggle, wept inconsolably. That same day, Amy brought her entire family out from Utah to spend Christmas with Dad at Jill's house. When I look back over those saddest of times, that Christmas with all of us together again seems very precious. We took hundreds of photographs and ran our video cameras constantly. Meredith had come out from Colorado with her daughter Dena and this was the first time we had all been together at Christmas since 1985. That night, Pat and my father sat in the living room side by side talking and taking it all in. Watching the play of his children and grandchildren around him, Dad remarked at one point, "This is my family. They're all here." Was this the splintered, unaffectionate family David described in his biography? No single moment offers a clearer picture of who we were than that Christmas Eve at Jill's house in Santa Rosa. There was a cruel sadness that filtered every joy, yet did not shake our spirits. We knew why we were together that evening. I prefer to think of it as the best Christmas we ever had.

Afterward, Dad went back to his chemotherapy and a regimen of humiliating intrusions. I drove home to the Sierra foothills for a week or so, and seeing him when I returned provided a sobering illustration of how mean his cancer had been. He looked frightfully gaunt and enfeebled, still strong of thought, but debilitated in speech and mobility. Visiting the ice arena one afternoon, he found himself needing to lie down in the upstairs lounge. When one of the arena employees inadvertently walked in on him, he told her bleakly, "Don't ever get cancer."

Jill became relentless in pursuing our agenda for some course-changing treatment, whether surgery or something that might arise. Jeannie was increasingly protective of Dad, who seemed by then tired of it all. Old friends were calling on him daily. I spoke with Elmer Hagemeyer for the first time since seeing him at St. Louis in the winter of 1970. He was sobered by Dad's illness and I thanked him for his concern. We would never speak again, as he would die shortly after Dad. The regimen of 5-FU ran out and Helen Collins moved my father onto the next round of chemotherapy, a drug called, CPT-11 (Camptosar) in combination with 5-FU and leucovorin. Finally, Dad permitted us to schedule a meeting at UCSF with Helen and two prominent oncologists, to see what might be done besides letting the cancer run its relentless course. On January 5th, Amy flew in from Utah to meet us at UCSF with Dr. Alan Venook, a chemotherapy specialist, and Dr. Robert Warren, chief of Surgical Oncology and a specialist in gastrointestinal cancer. During introductions, Dad referred to us with a measure of pride as his "support system." Nothing new came out of that meeting except to convince both Jill and me that some form of surgery was still viable if Dad were to agree. One issue was that there was a good chance the tumor might, indeed, block his colon and the resulting emergency could not be as controlled as well as an elective procedure. Into the New Year, Jill and I were optimistic that something fresh might reveal itself, although by then Dad had been forced back into the hospital to treat another blood clot in his leg and to re-adjust the level of cumadin in his system. Simultaneously, his demeanor began tilting steadily toward the resignation of a fate he had not expected. He told me how this was all a big surprise, that he had imagined a heart attack would carry him off, not cancer. The phenomenal outpouring of true and abiding affection from fans and friends lifted his spirits more than anything else. He seemed so touched by these expressions of love. Cathy Guisewite spoke with him that final week, and said, "all he talked about was how much it meant to him that everyone in his family had stopped everything they possibly could to be with him when he got sick." I think he had always known how much he was loved; perhaps he just needed to see it. And so he did.

Jill and I tried one last avenue through the Dr. Sugarbaker idea, arranging a conference call with him and planning to share slides from the fluid in Dad's abdomen. Sugarbaker would have wanted to determine if what Dad had was a subtype of colon cancer called pseudo-myxoma (peritonei). If that were the case, then the question would have been if Dad would be able to tolerate a 10-hour surgery, either down at

UCLA or across the country at Washington Hospital. A connected ray of hope we received from Sugarbaker was the possibility that this was not a colon tumor, but one located in the secum, a cancer whose treatment and prognosis was different, perhaps more hopeful. Maybe he had more than two years to live. Maybe Dr. Richardson was wrong.

I was driving up to see Dad every day or so by then and I'd sit on the sofa beside his chair and we'd talk about things, as if I had brought him to an airport somewhere and we were just spending some extra time together before he caught his flight. We had spent so many hours over the years talking about death, how he felt, how I did, what losing each other would mean, that there really didn't seem to be anything left to say. He was resigned to a fate he knew was already chosen for him and it was useless to pretend otherwise. But he could still laugh and be funny. Even through the fog of his discomfort, he could still make us laugh.

By then, Dad had become increasingly anemic, and Helen Collins worried that perhaps the tumor was beginning to bleed. If that was the case, with his tolerance to the CPT-11 cocktail being so poor, Dad's life might have been prolonged more effectively by simply removing the tumor. This surgery would not be as extensive as Sugarbaker's, but would still involve great risk. Dad had to be psychologically prepared to endure an operation of this magnitude and fully willing to undergo recovery of a sort he had found so grueling in November. We went back and forth among ourselves, some of our meetings becoming testy as we maneuvered to have our own viewpoints adopted by the family. With the notion of another surgery on the horizon, something was coming quickly, but how it played out could never have been predicted by any of us.

On Saturday evening, Feb. 11, Jill had Dad over to her home for dinner. Amy had gone to back to Utah, but expected to visit again soon. I arrived early enough to watch part of a hockey game with Dad in Jill's living room. He hadn't been feeling well at all that day, enduring the effects of his chemotherapy with increasing disgust. Jill's mother-in-law, Lamar, cooked a chicken dish for Dad with mashed potatoes and Baked Alaska for dessert. We had to eat fairly quickly because Jill's houseguest, Shannon Lake, had a party planned for later in the evening. I filmed Dad with my camcorder, as he was finishing dinner. It was the last anyone ever caught him on tape. After finishing his dessert, Dad told Jill he just wasn't feeling right, so she decided to drive him home. I was busy with her husband on his computer when J.T. Tyson, a friend of theirs, came into the house to tell us that Dad was

still out in the car, feeling woozy, but didn't want to go to the hospital. J.T., a candidate in an EMT program, took Dad's pulse and determined that it seemed normal. Still worried, Jill telephoned Helen Collins who spoke briefly with Dad and thought he sounded OK. given the effects of chemotherapy and perhaps having an overly long day. So Jill drove Dad up to his house in the Santa Rosa foothills through a dense fog. She told me Dad was still able to make a joke when she almost hit a tree. Just as I got into my car to drive back to my own house out in the west county, Jill called my cell phone to say that Dad was up at his home now, but feeling still worse. So I went up there, too. Jeannie had gotten back to the house by then from seeing a play in the city that day. When I arrived, a doctor friend of theirs who lived nearby was having a closer look at Dad to evaluate his condition. While he was there, Dad vomited into a small bowl and we called Helen once again. She spoke with him for maybe 10 minutes, assuring him that nothing was out of the ordinary; his chemotherapy was expected to be rough. And he said he felt better after vomiting. So Jill and I both decided to go back to our respective houses and check up on Dad again the next day. Before we left, he told Jill that he "didn't think he was going to make it."

She said, "Well, you have to make it, Dad."

And I agreed. Then he told me to "keep going," which meant to keep on with my own work, finish the book I was writing just then. Don't quit.

We'd had a lot of rain that winter and it started pouring again about half an hour later while I was at home on the phone with a friend of mine and my father's, Peter Markle, a movie director who played occasionally on a hockey team with me. I gave him a short version of Dad's condition and hung up promising to keep him up to date. Then I went back to work, a section of my novel with a line that apparently resonated with Jill in that long dreary season. I suppose it said to her what we both felt during Dad's illness: *These trials we endure throughout our lives would be fairly intolerable without the mercy of another's hand to hold.*

The telephone rang about half past 9. Picking it up, I heard Jill's voice telling me, "Monte, I think Dad may have died."

The house was dark when I arrived in a cold downpour. Only a couple of lights were on and everyone was quiet. Our friends and lawyers, Barbara Gallagher and Ed Anderson, had already arrived behind Craig, Jill, Aaron and Jeannie's son, Brooke Clyde. A bleak look on Craig's face told me that what Jill had said was true. Jeannie wanted me to see my

father, maybe sit with him for a while. I did go down to Dad's bedroom and peek at him lying flat on his back, bedcovers pulled up almost to his chin. But years before, both my mother and father had told me they believed we should remember our loved ones for who they were when they were living. So I left.

Soon, Helen Collins arrived, clearly shocked by Dad's sudden death. Hadn't she just told Dad that evening he would be all right? Hadn't he been reassured? As the hour went by, each of us became aware of the peculiar coincidence of Dad passing away on the night before his final strip ran in the newspapers. Had that been his desire somehow? Who could say? But Helen theorized that, while none of us can will ourselves to die, she felt that perhaps under morbid circumstances we can withdraw that inexorable will to live. If my father had, in fact, been killed by a pulmonary embolism, which was her belief, then he need not have summoned that fatal blood clot, but merely let it take its course.

We planned the funeral together. Amy and John flew in Sunday afternoon, followed by Meredith later on. Jeannie graciously allowed us to direct the funeral and memorial service together, side by side, each offered some part by choice and desire. Of greatest importance was that each of us had our feelings deferred to, regarding how we dealt individually with Dad's death. We were all middle-aged by then, with little in common, truthfully, except for those 14 years long ago at Coffee Lane. I was living in the Sierra foothills, Amy was out in Utah, Meredith in Colorado, and Jill in Santa Barbara. Only Craig had remained in Sonoma County. But that shared experience given us by our parents had made us a family and kept us together, even after many years apart. David wrote in his biography that we were a family drifting apart, but he was certainly wrong, and how we dealt with Dad's death absolutely disproved that.

From Jeannie, we learned that Dad wanted to be placed to rest at Pleasant Hill cemetery on the outskirts of Sebastopol because that was where Jerry Jarisch, a dear old friend of our family, was buried. Also, Uncle Bus had his ashes scattered there, so it was somehow familiar to Dad. We quickly divided up responsibilities and planned for a Wednesday burial. While I worked on the funeral notice, Amy, John, Jeannie and Jill attended to the variety of funeral arrangements at Pleasant Hill. We chose his plot together as a family, finding a location on a gradual slope above the cemetery. His plaque would read:

CHARLES M SCHULZ
SGT US ARMY
WORLD WAR II
NOV 26 1922 FEB 12 2000

My father's lawyer, Ed Anderson, made a suggestion regarding the services that we agreed upon, but only after a difficult discussion. Accepting that the Pleasant Hill chapel was far too small and the gravesite too narrow to accommodate the sheer number of extended family members and broad circle of friends who would certainly wish to come and pay their respects, we decided to divide the services into two parts: first, a traditional funeral service and burial on Wednesday for family members only; then a larger, public memorial service at the Luther Burbank Center on the following Monday. The decision was difficult because it meant many of Dad's friends would be excluded from offering respects at his gravesite in favor of our in-laws who had only known him for a handful of years before his death. But we conceded regretfully that a line had to be drawn somewhere, and so it was.

At Jill's insistence, we declined the offer of a tent for the graveside service. She thought it more dignified, more traditional and respectful to use umbrellas if it rained, and believed that Dad would have agreed. And it did rain that Wednesday morning, a cold, steady drizzle as we left the chapel after a service that acknowledged each of our beliefs. We had learned tolerance from our father and used that week to demonstrate how firmly his instruction had taken root. Nine of us bore the casket to the gravesite: myself, Craig and his son Bryan, John and his sons, Chuck and Brian, Aaron Transki, Brooke Clyde, and his sister's husband, Pat Brockway. Conducting the eulogy was Father Lombardi, and I closed with a short passage from Thomas Wolfe. An honor guard fired a seven-gun salute, and gave Jeannie the flag. Then each of us left a white lily on the casket, and Dad was gone.

His funeral notice appeared on Saturday, as we affirmed publicly our love for him:

… His eldest daughter Meredith Hodges, and his granddaughter Dena, My love for you, Dad, will live on in my heart and guide my days for the rest of my life. My father, my hero, my friend. I love you — "Mimi."

His eldest son and namesake, Charles Monroe Schulz, Jr, and his wife Erin Marie. "Monte" will miss his father until the day he goes to his own rest. "Only the emptyhearted lament those days of carnival and renown once they're gone. A man's gift maketh room for him, and bringeth him

before great men. This, I believe, is the elation for which he was born." Your joyous and wonderful life, Dad, will forever inspire my imperfect hand.

Craig Schulz family, wife Judy, children Bryan and Lindsey. In loving memory of my father, the finest example of a human being I have ever met. It was a privilege being your son. We soared above the earth together for hours at a time and walked many a mile on endless fairways always closing with admiration and respect for each other. Your greatest gift to me was time, the time that allowed me to raise my children as I know you would have liked. You are my hero now and forever.

Our love for all eternity — John and Amy Johnson and their children Stephanie, Brian, Chuck, Melissa, Emily, Marci, Mikey, Heidi, and Daniel. Amy was known to her Dad as "Amos" and fondly referred to as "the girl with the golden eyes." She adored her many trips to California with her husband and children to visit "Grandpa." Amy and her family will forever cherish the gift of fun times spent at his house. Her husband John appreciated his many hours spent on the golf course with his father-in-law. Whenever asked, Amy's children would always say their favorite thing to do was to go to California to visit Grandpa. Their fondest memories include the special times spent around Grandpa's swimming pool and at his ice arena.

"Pa Pa" Forever in our hearts — Aaron Transki, Jill Schulz Transki, Kylie Transki, Lamar Transki, Bosco & Zumi. Dad, you instilled in me the value of caring, honesty, confidence, truth, and more than anything a sense of how to appreciate life. I know if you were standing here beside me now, you would squeeze my hand and say, "Show them how!" Thank you, Dad. I love you. Your Rare Gem.

…

Jill organized the memorial service, helped by Karen Kresge, and the ice arena's general manager, Jim Doe, both close to the family for many years. We wanted the service to represent what Dad loved and what we loved about him. On Monday, Feb. 22, we would say goodbye for the last time, and many of our closest friends would help us do so. By then, we had seen flowers laid on the sidewalk outside of the ice arena and Snoopy's Gallery, done those early-morning television shows, spoken with reporters and telephoned anyone we had missed before the funeral. I personally invited Dale and Nona Hale to come stay with me, Pat Swanson, and my wife during the weekend of the memorial service. Cathy Guisewite arrived, too, and we took a drive out to the cemetery together. She would be one of five speakers, other than family members, and I was grateful to her for accepting our invitation. She and Dad had become friends in the early '80s and she and I were close, as well. By then, both of us had finished preparing our remarks for the memorial. Jeannie, Jill, Amy and Meredith would also speak, while Craig preferred instead to design the handout for the program and deliver a video tribute to Dad's life and art that would run on a large screen in the auditorium before the service.

The next morning was remarkable. More than 3,000 people walked into the Luther Burbank Center to honor my father's memory. Our dear friend Tom Everhart provided the backdrop to the stage with a 20-foot painting of Spike's desert. So many people came whom we had lost contact with over the years, offering hugs and warm condolences. Barnaby and Mary Conrad had flown up from Santa Barbara, and Bill Melendez from Los Angeles. We put our old grade-school teacher and family friend, Peggy Jarisch, beside Pat in the front row. Not far behind her were Jim and Eva Gray, and behind them, occupying an entire section of the hall, were Dad's hockey pals wearing tournament jackets, proud of their fallen teammate.

Photo courtesy of Monte Schulz.

Photo courtesy of Monte Schulz.

The service began with a lovely dignified rendition of "You're A Good Man, Charlie Brown," sung a capella by Anthony Rapp, Kristin Chenoweth, Ilana Levine (all three had flown out from the East Coast just for this occasion), Mollie Boice and others from the theater world of the Bay Area and Sonoma County, most of whom had performed in the musical over the years. Ed Anderson welcomed everyone, and for the next hour or so, we heard tributes from five of my father's closest friends: Bob Albo, Chuck Bartley, Dean James, Billie Jean King and Cathy Guisewite. Amy's husband John gave an invocation before Jeannie and my three sisters spoke, and Amy's daughter Stephanie played a beautiful version of "Sweet Hour Of Prayer." We saw a video tribute by Ellen Taaffe Zwilich and heard three hymns performed by Carole Menke and Norma Brown. I offered a requiem of my own after Father Gary Lombardi's benediction. Then the choir returned to sing, "Just One Person," accompanied by David Benoit.

"When all those people believe in you, deep enough and strong enough, believe in you, hard enough and long enough, it stands to reason you, yourself, would start to see what everybody sees in you, then maybe even you can believe in you, too."

After that, the auditorium went dark, and we heard Dad's laughing voice, *"You know, that poor kid, he never even got to*

kick the football. What a dirty trick! He never had a chance to kick the football."

As the crowds filed out, Craig arranged for a flight of World War II-era airplanes to perform the missing-man formation overhead. Then we met with the press.

Of course, Dad never made it to Santa Barbara for that walk on the beach with his cousin Pat, but in April of that year we took the walk for him. Dale and Nona Hale, Jill and her family, and Pat and I, met on the boardwalk at the Miramar Hotel where the Writers Conference used to be held, and had a long stroll in the sand by the water's edge. We took some pictures, arm-in-arm, to share with those not present, then drove up to Jill's house and had a game of croquet on her lawn there. And while Dale and I fought wicket to wicket and he told me what a cutthroat Dad had been at that game, Jill watched her daughter Kylie play, and I was struck by the sweet strangeness of it all. Because when Dale and my father had last played croquet, Mom was about Jill's age, and Jill was Kylie's, and Pat was hovering in the background, both then and now. Somehow this confluence of friends and family had not been completely disrupted by Dad's passing, only changed into something different, yet recognizable, something to hold dear as long as we could.

Not a single part of our lives as described in this essay was denied to David Michaelis. And because of that, I firmly believe he had the obligation as a biographer to tell a story that was more than what his editor may have wanted him to write, or what he presumed would sell books, or even what represented how he personally may have felt about either us or my father. That he chose not do so is a startling disappointment. His book is not our story at all. I don't speculate on why he chose to write what he did. When we talked together about biography, he often used the expression, "a life reveals," but did his book truly reveal my father's life? How much of his life? How does the biographer choose to give weight to that which he leaves in, and that which he leaves out? How are those choices made? Somewhere during the writing of this biography, David must have decided that much of what I've described above had either no interest to the general reader, or no interest to himself. But in doing so, David Michaelis did a great disservice to that life he promised to reveal. ■

The Pagliacci Bit

by R.C. Harvey

Chip Kidd's dust-jacket design is perfect. Across a yellow ground, a fat black jagged line. Charlie Brown's perpetual shirt. Nothing says *Peanuts* so eloquently except, perhaps, a perfect oval. Then upon opening the book, we hit the end papers. Here, too, the designer, now, presumably, William Ruoto (Kidd having done only the dust jacket), expertly evokes the content. The end papers are solid black — unrelieved, funereal black.

And the story that biographer David Michaelis tells of the life of Charles M. Schulz is similarly funereal, beginning with one death, that of Sparky's mother, and ending with another, the cartoonist's. In between, more sadness — a portrait of Sparky (as Schulz preferred to be called) as a bitter, melancholy misanthrope, enacting in his art a revenge against all who, in his childhood, bullied or ignored him, but never achieving a victory perfect enough to lay his demons to rest.

The celebrated cartoonist who made millions laugh every day for almost 50 years was, Michaelis would have us believe, a joyless man who felt alone and unloved. Michaelis' aria to the creator of the world's most widely circulated comic strip is unrelievedly bleak. The clown may have laughed on the outside, but inside, like Leoncavallo's Pagliacci, he was forever weeping, writhing in a profoundly lonely unhappiness, from which the only escape was total immersion in his work.

Readers and reviewers were somewhat dismayed by these revelations. Judging from the appealing characters of his creation, they expected Schulz to be a more likeable person. Not everyone was disturbed, however. Garrison Keillor, who has made a career of extolling the chilly personalities of Schulz's native Minnesota, found nothing "unusual about Mr. Schulz's life at all, other than his extraordinary work ethic and his fabulous success." What others referred to as "a

" SAY, ' WOOF ! ' "

From Nov. 2, 1947, collected in *Li'l Folks*. [©2003 Charles M. Schulz Museum and Research Center, ©2003 United Feature Syndicate, Inc.]

tortured soul" seemed to Keillor "to be a perfectly nice guy who did his best and enjoyed his life. Which I guess shows you what a Minnesotan I am."

Schulz, as Michaelis demonstrates, is profoundly a Minnesotan, as woebegone as any of Keillor's hometown characters. Born Nov. 26, 1922, Schulz grew up in St. Paul, the

shy and only son of a barber. His career in cartooning can be outlined in a few sentences. He took a course in art from a correspondence school, the Federal School, based in Minneapolis. During World War II, he was drafted and served overseas in the infantry. After V-J Day, he returned to the Twin Cities and took a position with the Federal School, now called Art Instruction, correcting mailed-in student lessons. He freelanced in his spare time, lettering comic strips for a locally produced Catholic magazine and, eventually, producing a cartoon feature called *Li'l Folks* for the *St. Paul Pioneer Press*. The feature ran once a week, a collection of single-panel cartoons about the antics of little children who seemed a bit more sophisticated than most cartoon children.

Schulz also regularly submitted gag cartoons to magazines and ideas for cartoons to newspaper feature syndicates. Early in 1950, United Feature indicated interest in *Li'l Folks*, and when Schulz journeyed to New York for a conference, he learned that the syndicate editors had decided a strip format would be better than the panel format. They saw in the tiny figures of Schulz's cartoon a novel marketing ploy.

At the time, newspaper editors were restive about the amount of precious newsprint paper they devoted to comic strips every day and were looking for ways to reduce the size of comic strips. Because Schulz's characters were small, the syndicate editors decided to tailor the strip's dimensions to the kids' size — a maneuver that would, they believed, appeal to editors seeking to conserve space.

Whether the syndicate factotums were right about size and saleability is debatable. But there is little question that within a decade, *Peanuts* was a national phenomenon. Charlie Brown had become the archetypal mid-century American man in search of his identity, and his dog Snoopy had started to fantasize an assortment of human roles for himself. Schroeder had established Beethoven as the strip's icon. And Lucy Van Pelt had made a name for herself as a world-class fussbudget. By 1965, *Peanuts* was a commercial empire. The Age of Schulz had begun.

Michaelis puts flesh on these bare bones with thousands of carefully observed and ingeniously reported details, but the cartoonist's children and his widow Jeannie are not at all happy with Michaelis' version of Sparky's life. The book contains several inaccuracies, perhaps inadvertent, and some willful misinterpretations and outright misrepresentations, all of which family spokespersons have thoroughly and persuasively documented. And they say the book's emphasis upon Schulz's interior insecurity and unhappiness fails to

convey anything like a true portrait of the man. Moreover, the children insist, Schulz was not the emotionally distant father of Michaelis's narrative.

These matters, I'll leave to members of the family who are better equipped than I to speak directly to them. Here, let me focus upon the portrait as Michaelis gives it to us.

Before getting to that, I should point out that I am personally acquainted with Jeannie Schulz and I think we are friends. I don't believe that affected my assessment of the biography, however, since I'd already formed my opinion of the book before I learned that she didn't like it.

I must also confess that Michaelis and I have exchanged notes occasionally over the years that he spent working on the book, and our relationship is a friendly one. He phoned me very early in his work and asked to interview me; I said I had met Sparky just once and talked with him for only a couple hours, but I offered to send him all that I had written about *Peanuts*. Michaelis said he'd already read it all and pronounced me the world's most insightful interpreter of the strip (or words to that effect), a patent exaggeration that is undoubtedly among the most accurate of his statements about *Peanuts*.

In the copy of the book he sent me, Michaelis wrote a thankful inscription, saying my work helped him in his. Grateful as I am for his good opinion, I must report that I find little overt evidence of my interpretation of *Peanuts* in the book. But that doesn't mean I don't admire Michaelis's accomplishment, as far as it goes.

My biases, veering off in both directions at once, are therefore contradictory, rendering me possibly the only en-

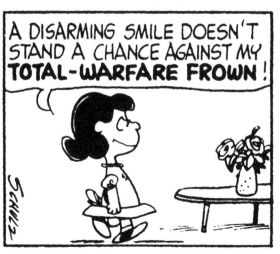

From *You'll Flip, Charlie Brown*. [©1967 United Feature Syndicate, Inc.]

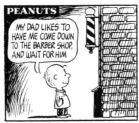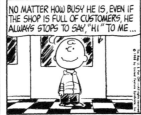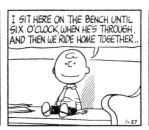

The Jan. 37, 1968 strip, collected in *Li'l Folks*. [©2003 Charles M. Schulz Museum and Research Center, ©2003 United Feature Syndicate, Inc.]

tirely neutral observer. Or perhaps the most conflicted. But I'm content to let my appraisal of Michaelis' book stand on the inherent merit of my argument, lofted henceforth without reference to any external influences except history, logic, common sense and Truth Itself.

And the Truth is that Michaelis has perpetrated a few purely factual errors in the realm of cartooning references. Walt Ditzen's cartoon feature, *Fan Fare*, was about all sports, not just football. Walt Kelly didn't get the Reuben in 1951: The National Cartoonists Society's "cartoonist of the year" award was still called the Billy DeBeck Award then; it didn't become the Reuben until 1953. Gus Arriola never worked in Disney animation; after a year in the Mintz shop, he joined MGM. And when Schulz was the subject of a *Time* magazine cover story in April 1965, it was not just the third time a cartoonist had been the cover story; it was at least the ninth time: 1927, Charles Dana Gibson; 1937, Walt Disney; 1945, H.T. Webster; 1945, Bill Mauldin (Willie pictured); 1947, Milton Caniff; 1950, Al Capp; 1951, James Thurber; 1954, Disney again.

But these drastic fubars are trifling errors in a work that ripples with thousands of facts both large and small. George Herriman did die in 1944, for instance, although why Michaelis wants to make this bald statement in a paragraph about Sparky's return to civilian life after his stint in the army, I'm not altogether sure.

Yes, Schulz was undoubtedly "glad to see" that the comics were "more plentiful than ever, despite wartime newsprint shortages and the death of George Herriman in 1944." Schulz may have been a particular fan of Herriman's later in life, but I doubt that he was a *Krazy Kat* reader while Herriman was still living. Not very many people were in those days: *Krazy's* list of client papers was pretty much confined to the Hearst chain, none of which were published in Minneapolis or St. Paul where Sparky might have seen them and the strip.

In his postwar paragraph about newspaper comics, Mi-

chaelis is giving Schulz's life the gloss of a neophyte's preoccupation with cartooning while also putting that life in the context of comics history. A good idea, but here, with Herriman, Michaelis is not as sure-footed as he might be. A trifling thing, as I said.

As I read the book, I applauded frequently. In many ways, it is an amazing feat of writing and organization. (And as I plunge, anon, into fault-finding, don't forget this apostrophe.) The biography confers upon its subject the serious respect Schulz deserves. The depth and breadth of Michaelis' research is impressive, and his masterful deployment of telling details is sometimes breathtaking. Moreover, he is a literate and often lyrical writer, and his admiration of Schulz's achievement is evident.

Reviews of the book typically remarked upon the apparently surprising news that Schulz's melancholia was the wellspring of his comedic inspiration, but that intelligence is hardly news: We find much the same asserted in the interviews with Schulz in *Charles M. Schulz Conversations* and in *Good Grief*, Rheta Grimsley Johnson's 1989 biography of the cartoonist, and in numerous newspaper and magazine articles.

Most reviewers also noted the book's revelation of another less well-known facet of Schulz's life: He had extramarital affairs. Disclosing this last requires a certain delicacy of Michaelis not only because Schulz has always seemed, judging from the strip and what public knowledge there was of him, a model of decency and decorum for whom such a dalliance would be anathema, but also because the female parties to these liaisons are still living and were among Michaelis' principal sources in lengthy interviews.

Michaelis proves equal to the task: He displays an uncommonly considerate sensitivity in revealing the two love affairs Sparky engaged in while still married to his first wife, Joyce. Michaelis carefully, thoughtfully, prepares the way for the first affair in 1970-72 with Tracey Claudius by showing that neither Joyce nor Sparky was working very hard at

their marriage: Both had drifted into absorbing compensatory activities — Joyce in designing and building residences and studios and at last the famed ice-skating rink, Sparky in devoting all his energies almost exclusively to his comic strip, virtually ignoring Joyce.

As the two pursued their separate projects, those aspects of each personality that grated upon the other emerged and became ever more pronounced. In Michaelis' telling, their ultimate separation and divorce seems not only inevitable, but fitting, nearly a beneficence to both. In that context, Sparky's search for love with another woman, which he did not so much seek as happen upon, seems much less a deviation from conventional morality or a violation of his presumed fundamentalist religious convictions (which, by then, may not have been as pronounced as they once were). This affair dissipated after a couple years as Tracey realized she could never make Sparky happy.

By 1972, when Schulz met Mrs. Jean Clyde, who became his second wife and his widow, Sparky and Joyce were living almost separate lives, although not legally separated. And Michaelis characterizes Jeannie's marriage at the time as relentlessly, albeit quietly, dissolving; it was "not yet over," but it was surely moving in that direction. "I wasn't thinking of not being married," she is quoted saying, "but Sparky swept me off my feet."

Relying, presumably, upon interviews with Jeannie, Michaelis is able to focus almost entirely upon the genuineness of the mutual attraction the two felt, gliding over what another author, seeking sensation, might have termed the illicitness of the affair. In Michaelis's treatment, Sparky and Jeannie were, as he quotes Jeannie, "meant to have come together." "To Sparky," Michaelis adds, "the deep good fortune of their encounter was magical." Not illicit; magical.

In Michaelis's narrative, none of the participants comes off badly as they might have in the hands of a less compassionate biographer.

Despite its several not inconsequential virtues, the book contains one dubious and startling proposition that gave me pause very early on.

During the first couple chapters of the book, Michaelis introduces us to Sparky's father and mother and their relatives, a reasonably close-knit but wholly undemonstrative lot, bleak emotionally. Sparky's parents undoubtedly loved him but apparently could not express their feelings. They lived by codes of conduct both Germanic and Norwegian, among which was the admonition against ostentation: "Don't get a big head." The lesson took: Even as an adult, Sparky would say, "I didn't want to be accused of thinking I was better than I really was."

Michaelis then engages in an enviable extravagance of poetic brio: He extends the big-head metaphor, leapfrogging from one seemingly unrelated facet of Sparky's life to the next, discovering at last the link to his art.

Minnesotan culture, he begins, eschewed self-aggrandizement. "You didn't think well of yourself, and if you did, you didn't show it," Michaelis quotes a friend of Sparky's. It was "a tall-poppy culture that struck the heads off its brightest flowers," Michaelis continues, invoking a fragment of Roman history in which a king teaches his son how to rule by "lopping the heads off the tallest poppies." Sparky's father was a barber, whose business was lopping the hair off heads. He was concerned with the outside of heads, not their insides, and cautioned his son against too much learning: "If you read too many books, your head will fall off." Then, finally —inevitably — "One day Charles Schulz would create a character with a big head."

This is the sort of dizzying flight of imaginative legerdemain that Michaelis will perform several times in the book, each a bravura demonstration of associative cunning in arraying details.

References to drawings of people with big heads and round heads show up with some regularity in the early parts of Michaelis' narrative, culminating in the chapter entitled "Heads and Bodies" with a description of Schulz drawing the first cartoon he sold to the *Saturday Evening Post* in 1948. It depicted a little boy reading a book as he sits on the end of "an impossibly long chaise lounge, his legs stretching still farther onto a supremely redundant ottoman. Thinking of the gag cartoons he had loved before the war — 'the little kids with the great big heads,' as he summarized them — Sparky hypertrophied the head, shortened the arms, and knew immediately that he was on the right track."

The comedy in the cartoon arises from the boy's size. He is so small that he is dwarfed by the expanse of the seating arrangements, which he makes even sillier by sitting on the end of a chaise lounge in order to prop his feet up on the stool. Michaelis, however, focuses on the size of the boy's head rather than on the kid's overall tininess, the basis of the cartoon's humor.

The repeated references to big and round heads in the earlier pages of the book coupled to the description of this supposedly watershed moment strenuously suggest that Sparky's singular gift as a cartoonist — and the reason for his comic

strip's success — lay in his inspiration to draw little kids with big round heads and small bodies. The implication is that Schulz invented this visual mannerism, but, of course, he didn't. And Michaelis knows it, allowing that Sparky was remembering cartoons he saw before the war.

Drawing little kids with big round heads was — and is — a convention of the cartoonist's craft. But Michaelis chooses to slip by this scrap of cartooning history, virtually ignoring the custom of the practice, as if to let his readers think Schulz was a cartooning genius because he pioneered what is probably in their minds the most distinguishing visual feature of his later triumph, the big round heads of the *Peanuts* cast.

Michaelis then goes a step further. In drawing a regular weekly comic feature about kids for the *Pioneer Press*, Schulz slowly evolved a kid's body type "that would help him create a radically original comic strip in 1950": His kids appeared initially at the "normal" cartooning scale of three heads tall, but their heads "swelled" until "the head [was] equal in height to the entire aggregate of torso and legs." They were now just "two heads high," Michaelis writes, implying this dimension was an unprecedented innovation.

He has apparently never seen Walter Hoban's *Jerry on the Job,* the title character of which was probably only a head-and-a-half tall. Michaelis refers to Hank Ketcham's *Dennis the Menace,* which would begin five months after *Peanuts* made its debut, but he believes Dennis was three heads tall; at first, however, Dennis was just two heads tall. Like Charlie Brown.

In short, the scale and big-headedness of the cast of *Peanuts* at the strip's debut is not the novelty Michaelis imagines. But he persists.

Having established to his satisfaction the signal achievement represented by the size and proportions of Schulz's juvenile creations, Michaelis then wonders what brought on the "metamorphosis," the shrinkage from three-heads tall to two-heads. He decides, based upon the testimony of some of Schulz's co-workers at the Art Instruction correspondence school (people who should have known better), that Sparky was inspired to make his characters smaller than the usual cartoon kid by another faculty member, Frieda Mae Rich, who was a dwarf.

"When Frieda put her elbows on Sparky's desktop" to visit with him, "she'd be resting on her elbows, the way the *Peanuts* characters rest their elbows on the stone wall while they talk," Michaelis quotes Hal Lamson as saying. And when she sat on her desk chair, "her feet would plank outward in front of her" — "just the way Schroeder would be when he

played the piano."

Michaelis concludes: "Among Sparky's colleagues, Hal Lamson and others recognized that 'the physical characteristics of the *Peanuts* gang were lifted right from Frieda's body. The way she stood, sat, and moved—and the relative size of the head and the body'—passed directly into the strip."

Not content with making this startling claim, Michaelis goes on: "Frieda had one magic quality that reached deep into *Peanuts:* she was an adult in a child-shaped body." Here, Michaelis nudges up against the fundamental uniqueness of *Peanuts,* but he has arrived at it by the most outlandish of routes.

Surely Lamson and the others to whom Michaelis refers, artists all, knew that the physiques of the *Peanuts* gang developed organically out of the cartooning conventions of rendering children. Surely, when they suggested Sparky was inspired by the body of a dwarf, they were reminiscing in a humorous way about an odd coincidence. They couldn't have been straight-faced serious. But Michaelis takes them at their word — or, at least, presents their words as if he believed them to represent a considered judgement.

His desire to find a cause for what he regards as a sudden "metamorphosis" led him seriously astray. But there was

"HEAR THAT? BET YOUR DAD CAN'T SNORE THAT LOUD!"

From the Oct. 8, 1951 gag panel collected in *Hank Ketcham's Complete Dennis the Menace: 1951-1952.* [©2005 Hank Ketcham Enterprises, Inc.]

no metamorphosis: There was only evolution, the sort of gradual stylistic change that every artist and every cartoonist evinces as he grows in experience. It is usually natural and nearly unconscious rather than deliberate, and we can see evidences of it throughout the Schulz canon. Charlie Brown and his playmates eventually developed necks, for instance, which were not present in the early strips.

As colossal a job of research and coalescing of details as Michaelis has done in the book, he does not, apparently, understand how a cartoonist works at his art. Not entirely. He understands a good deal about it. He understands the peculiar, almost hypnotic, attraction of art in its original state, for instance, as is revealed in this lyrical passage about the first time Sparky saw an exhibit of comic strips in their original state:

> *Sparky had never before seen original work by the professionals. He knew comics only as newspaper features, not as true extensions of the artist's hand. But here hung several hundred lengths of layered illustration board stroked in dense ink more purely black and warmly alive than the engraving process allowed for. Here, so much more vital than he had ever imagined, were actual penlines. Sparky could walk right up to Roy Crane's panels in a Sunday page for Wash Tubbs and see where the ink had dried to a gloss that still picked up light. Outside the panels, cryptic instructions had been penciled in the margin; sky blue arrows aimed to catch an editor's eye. Inside the panels, there were unexpected traces of effort: accidental blots, glue stains and tape bits, strips of paper pasted to correct mistakes in lettering, unerased letters, registration marks, residues of white gouache, pentimenti reversing all kinds of slips and false starts—a whole unseen world of reasoning and revision had passed over the drawing board before mechanical reproduction reduced and tightened the lines. Here, too, shone the effortless effects of freehand brushwork, delicate lettering, translucent watercolor washes—all the backstage craft of comic strip showmanship.*

Michaelis understands well enough to write passages like these, but not well enough to show us how the cartoonist does his work — how he gets ideas, toys with them, shapes them, and, finally, puts them down on paper.

With Sparky, as with many cartoonists, it started with funny pictures. During the only conversation I ever had with him, I asked him if it was true that he often generated ideas by just drawing his characters, sketching them on a piece of paper until the ideas jelled. Oh, yes, he replied: That's what it's all about— funny pictures.

"I tell people when they ask me that the most important thing about a comic strip is that it must be fun to look at," he said. "If you are drawing something day after day after day, no matter how funny the dialogue might be, it still must be fun to look at."

As a cartoonist draws his characters, he watches their antics on the paper before him, and as they move about, they talk, and he listens. After a while, they say or do something funny. In a character-driven strip like *Peanuts*, that's how the comedy is created.

In a long interview published in this magazine in 1997 (*TCJ #200*), Schulz said: "Yesterday, I think I spent almost the whole afternoon trying to get something funny out of Linus sitting in a cardboard box trying to just slide down the hill. I really liked drawing that, and I came up with one idea, but I still can't decide if it's funny enough or not. So I abandoned it."

The book brims with examples of pictures that are fun to look at. It is littered with *Peanuts* strips, sometimes page after page of them. But Michaelis doesn't talk about the humor in the strips. For him, the strips are evidence of how scraps of Sparky's life found their way into his strip and how the strip was the outlet for his frustrations and suppressed anger.

Here is Lucy speaking words that Sparky first heard coming out of his wife Joyce's mouth. (Significantly, Joyce is identified with the strip's man-devouring fussbudget, dominating and self-centered.) Here's Schroeder forever at his piano, as wholly immersed in his art as Schulz was in his and

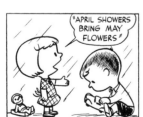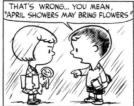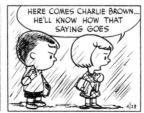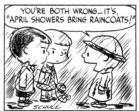

From the April 28, 1951 strip, collected in *The Complete Peanuts 1950-1952*. [©2004 United Feature Syndicate, Inc.]

The second *Peanuts* strip, collected in *The Complete Peanuts 1950-1952*. [©2004 United Feature Syndicate, Inc.]

as resentful of "Lucy's" intrusion to demand that he love her. And here's Snoopy, giddily silly as he writes a love letter to his "sweetie" during the time of Sparky's affair with Tracey.

Michaelis uses the strips as he might a diary. The strips are the diarist's visual record, not the cartoonist's inspired product. The cartoonist is there but appears, usually, as the diarist of Sparky's tortured soul rather than as a creative comedic imagination.

Michaelis apparently began with a single guiding light: Charlie Brown the loser embodies Charles Schulz. Not an unusual idea. Any reader of *Peanuts* arrives, fairly soon, at this supposition. One of the books about Schulz is entitled *Charlie Brown and Charlie Schulz.*
And once the strip became popular, Schulz himself encouraged the identification.

Reporters invariably asked him: Do you think you are Charlie Brown? Michaelis quotes Sparky reflecting on the question: "Well, that has so many ramifications and you can talk about that at so many levels, and they don't want to hear it. But if you say, 'Yeah, I'm a lot like Charlie Brown,' that's what they want to hear, that makes the headline; and [then] they don't care about anything else. They've got their answer and that's all they care about for their article. So why go into it?"

Schulz would say things that emphasized his kinship with his character. He went to a reunion, he once said during a TV interview, and when people read his name badge, they wouldn't believe he was the Charles Schulz who drew the world famous comic strip. Crushed again. Like Charlie Brown.

But, having never met Sparky, Michaelis wouldn't know that the cartoonist was smiling as he said such things, as if his being a nonentity like Charlie Brown was a kind of joke.

Still, Michaelis realizes that Schulz is merely posing as a loser like Charlie Brown. He knows the pose is part publicity stunt. He also knows that the ploy has an actual basis. He quotes Sparky: "I've always been lonely." Lonely, unwanted and unloved — all feelings nurtured by the chilly Minnesotan culture. He once said that *melancholy* is "the best word to describe" his state of mind and emotion.

Undoubtedly, Schulz sometimes felt alone and unloved, particularly as a child. Don't all kids feel, at some moment in their young lives, alone and unloved? Is there anyone who has not, at some early instant in his or her life, said to himself: "I'll run away from home — that'll show 'em." Here is the classic desperate stunt to get attention, the attention we felt was missing precisely because we felt unloved, neglected. We have all felt it.

And that brings us to an essential aspect of Schulz's *Peanuts* — the strip's universal appeal, our sense of recognition, our feeling that it speaks for us and therefore to us out of our common experience of childhood. Maybe Keillor is more right than he knows. What's so special about Schulz's life?

Nothing probably, except the extraordinary use he was able to make of it in provoking laughter.

Michaelis' achievement as a biographer is that he brings us to recognize this in more explicit terms and more extensively than Schulz's previous biographers. But the picture he paints is only a partial portrait. He emphasizes the dark side of Schulz to the virtual exclusion of the cartoonist's lighthearted aspect.

Upon this single idea — that Schulz was a tortured melancholic — Michaelis has structured the whole book. And he's given us an ingeniously contrived picture of a man haunted by the childish torments of his upbringing who found a way to live by transforming his miseries into art.

Says Michaelis: "Cartooning allowed him to harness his melancholy as the alternative to exploring what was making him so mad or, more pertinently, confronting what was

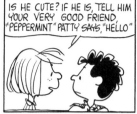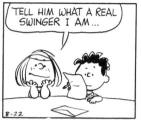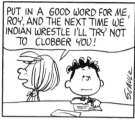

Peppermint Patty's first appeared on Aug. 22, 1966; collected in *The Complete Peanuts 1965-1966*. [©2007 United Feature Syndicate, Inc.]

hurting him." And in strip cartooning, "he could combine all the parts of his character into a powerful, coherent whole" — even if that whole brimmed with contradictions. A comic strip, Schulz pointed out, was an ideal medium for revealing that "we are all made up of contradictions," because in comics "you are not required to be consistent—you can say anything you think of, even if there are contradictions."

The situation Michaelis explores throughout the book is not an uncommon one with artists of all sorts: An artist's art is often the means by which the artist resolves inner conflicts and malcontentedness. But it is unusual to find this commonplace so fulsomely examined in a biography of an artist as inconsequential as cartoonists are always supposed to be.

In taking the comic strip as the record of Schulz's attempts to purge himself of his psychic agonies, Michaelis finds in it only the personal, the biographical anecdotal. The strips he reprints in the book document the one-to-one relationship between characters in the strip and people in Sparky's life. Fastening on *Peanuts* as evidence, Michaelis fails to see — or, at least, does not remark much upon — the strip's unique appeal.

Peanuts broke new ground in newspaper comic strips. The sense of humor on display in Schulz's strip was different, more subtle than could be found elsewhere on the comics pages when it first appeared in seven newspapers on Oct. 2, 1950.

The kids in the strip were cute. They were cute because of the way Schulz drew them. They were all tiny, and Schulz distorted proportions — giving them round heads as big as their bodies — which made them seem even more diminutive. And tiny was cute. There was nothing unusual about tiny, cute kids. But these tiny, cute kids were mean to each other.

The punch line in the first strip turned on one kid's hatred for the boy he called "good ol' Charlie Brown." In the second strip, a little girl punches a little boy for no reason at all. And in the fourth strip, the same little girl takes an umbrella away from a little boy, leaving him to slog through the downpour unprotected.

Reflecting on the strip's development, Schulz said: "When Lucy came into the strip, around the second year, she didn't do much at first. She came in as a cute little girl, and at first she was patterned after our own first daughter. She said a lot of cute, tiny kid things, but I grew out of that whole 'tiny' world quickly, and that's when the strip started to catch on. ... As Charlie Brown got more defensive, as Snoopy [became] a different kind of dog, as Lucy started to develop her own strong personality, I realized I was really on to something different."

Perhaps the most distinctive aspect of the cartooning medium is its combining of words and pictures to achieve a narrative purpose. The best examples of the cartoonist's artistry are those in which the words and the pictures blend to achieve a meaning neither is capable of alone without the other. And *Peanuts* reached this state of critical nirvana almost at once, and Schulz sustained it throughout the strip's run.

From the very start, the strip appeared quite simply to be about children who often spoke in a remarkably adult way. The pictures showed us children; the words suggested adult preoccupations. The humor arose from the dichotomy between the speakers and what they said, between the visual and the verbal presentations.

To this, Schulz brought a unique cast of characters, each with a distinct personality trait or quirk that offered additional possibilities for variation on the initial themes. Schroeder had a fixation on Beethoven. Lucy was a chronic complainer. "Pig Pen" was a kid who couldn't stay clean: No matter what he did, he wound up dirty from head to toe. And Charlie Brown was a loser. But he didn't start that way.

"I didn't know he was going to lose all the time," Schulz once said. "He certainly wasn't [at first] the victim [he became]. When he began, he had a personality a lot like Linus.

He was slightly flippant, a kind of bouncy little character. He was able to come back with a wise saying to the other characters."

But Charlie Brown was unpopular with his peers from the very first. He was often annoyingly clever. And he wanted to be "perfect," as he sometimes confessed. And from these ingredients, Schulz eventually fashioned the epitome of the loser, Charlie Brown the culture hero.

"I never realized," Schulz once told an interviewer, "how many Charlie Browns there were in the world. I thought I was the only one. Now I realize that Charlie Brown's goofs are familiar to everybody, adults and children alike."

Repetition and predictability remained at the core of the strip's comedic mechanism for its entire run. And Schulz was perfectly aware of the operational secret. "All the loves in the strip are unrequited," he said. "All the baseball games are lost; all the test scores are D-minuses; the Great Pumpkin never comes; and the football is always pulled away."

Failure, he frequently pointed out, was funnier than success.

Much of the humor in *Peanuts* arises from ordinary, trifling daily incidents. It is with this aspect of the strip that Schulz believed he did something new. "I introduced the

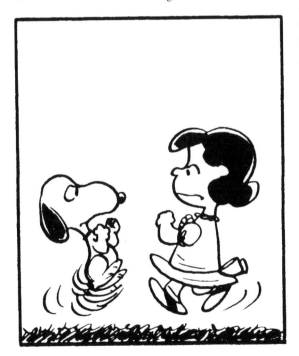

A panel from the April 10, 1966 strip, collected in *The Complete Peanuts 1965-1966.* [©2007 United Feature Syndicate, Inc.]

slight incident," he said. "I can remember creating it sitting at the desk ... what would happen in the three panels that I was drawing at that time was a very brief and slight incident. No one had ever done that before in comic strips. Older kid strips were of the 'What shall we do today?' school. I changed all of that. I remember telling a friend that I knew I was really on to something good."

Percy Crosby in his great kid strip *Skippy* had done something similar, Schulz acknowledges, but Crosby's kids haven't the idiosyncratic personalities that Schulz's kids have. The "slight incident" acquires comic impact only in conjunction with the pronounced personality of one of the strip's characters. Until Schulz showed how to combine these elements with a different emphasis, gag-strip humor had been chiefly situational: the comedy sprang more from the situation than the characters. The characters had personalities, and they behaved "in character" in whatever situation they were placed, but the emphasis was on the situation. Schulz shifted the focus.

He showed his characters reacting to the most mundane situations imaginable, and because their personalities were so convincingly developed, he could create comedy. When Charlie Brown coaches Linus in penmanship and Linus demonstrates an impressive calligraphic style at his first try, the incident (using a pen for the first time) is less important to the humor than Linus' personality (he's an unqualified genius, expert at anything he may put his hand to).

In similar fashion, Schulz could wring laughter out of Snoopy scowling at Lucy or licking her face, or Linus's shoelaces being too tight. And once Schulz had demonstrated how singular personalities can generate humor in a strip, other cartoonists began mining the same mother lode.

While the basic element of the strip's humor lies in the dichotomy between the speakers and what they speak, between the world of children and that of adults, the charm of *Peanuts* and its introspective greatness lies not in its pointing to the difference between adults and children, but in its emphasizing the similarity.

The achievement at the source of *Peanuts'* appeal is the trick Schulz played with the very nature of his medium. The pictures show us small children. But their speech reveals that they are infected with fairly adult insecurities and quirks and other often disheartening preoccupations. The dichotomy between picture and word permits us to laugh about heartbreak.

Because the *Peanuts* characters are kids, their personality flaws don't seem all that important to us. Kids' problems are

always relatively trivial compared to grown-ups' problems. As adults, we tend to dismiss kids' problems. Or we chuckle because those problems seem so monumental to the kids plagued by them. We — older and wiser — see that these problems are actually small problems. We understand that they will go away.

Even as we chuckle at the *Peanuts* gang, however, we realize that the same preoccupations that haunt them often haunt us as adults. Because these are kids, we can see the humor in their dilemmas. And because we can recognize their dilemmas as ours, we can see the humor in our predicaments, too. Before we know it, we are laughing at ourselves. With a giggle, we put our cares behind us (or beside us) and go on with our lives. That's how Schulz worked his trick. And he worked it so well that it made his comic strip the most famous comic strip in the world.

Lynn Johnston, creator of *For Better or For Worse,* a comic strip almost as beloved as *Peanuts,* and a friend and admirer of Schulz, added that Sparky's notable achievement was that he "had the courage to talk about loneliness and loss, about disappointment and anger. In so doing, he profoundly influenced a new generation of comic artists and readers as well. It was rebellion in reverse; impact with understatement and an honesty that healed even when it hurt."

Perhaps "unwittingly," she went on, Schulz "helped to unlock a nation's inhibitions. ... He made us look at and into ourselves. ... Until this funny, gentle, and simply drawn work came to be a part of our culture, we didn't talk too openly about deep personal feelings. You were a failure if you did."

Besides all that, his kids, with their big round heads and Lilliputian bodies, are just plain funny-looking. And that makes their having problems all the more hilarious: That these goofy-looking characters could have real-life problems is incongruous and therefore funny.

If it weren't for the funny pictures — and the comedy that is born in the dichotomy of pictures and words — *Peanuts* might be pretty discouraging. Charlie Brown never gets a valentine from the little red-haired girl; his baseball team never wins; his kite never flies. On the basis of this evidence, we have a strip about unrequited love and unrealized aspiration. But Charlie Brown always comes back. Every fall, he tries to kick that football once again —knowing, no doubt (how could he not?), that Lucy will snatch it away at the last minute and that he (and his ambition) will come crashing down one more time.

And Charlie Brown is not the only resilient loser in the strip. When Peppermint Patty joined the ensemble in the summer of 1966, she seemed the juvenile incarnation of a hip swinger. But her expertise — which soon turned out to be an abiding interest in sports — brought her no success in the other principal arena of youthful endeavor, the schoolroom. She is smart and bright but not academically talented at all. She fails at every opportunity.

And in her failure, Schulz presented a merciless indictment of the American public school system: None of Patty's teachers seem aware of her secret talent; none seem able to find a way to get this flower to blossom.

Oddly, Michaelis fails to note in Peppermint Patty what the rhetoric of his argument should have alerted him to: She is an almost perfect stand-in for the schoolboy he describes as Charles Schulz. Despite the undeniable esteem that his classmates expressed for the boy's artistic talents, Sparky persisted in believing that no one valued him. He was not only unappreciated, but the "special qualities that marked him," as Michaelis put it, were not even recognized. Peppermint Patty more than Charlie Brown was the alter ego of Charles Schulz.

We all know the ugly duckling is a swan that will somehow emerge from the classroom despite all the pedagogical efforts to proclaim it a duck. With the sporting heart of a true athlete, Patty keeps trying, getting up off the floor every time she's knocked down. And so, despite the reputation of the strip's star player as a loser, *Peanuts* is also about human resilience and hope, hope that rises again like a phoenix from the ashes of each and every disappointment.

Against this somewhat ordinary and certainly unglamourous assessment of the human condition, Schulz balanced the fantasy life of Snoopy, whose seeming brilliant success at every endeavor reassures us that life is not only about disappointment and endurance; it is also about dreams and the sustaining power of the imagination.

Charlie Brown and his friends may sound precocious, but the strip nonetheless preserves the innocence, the dreams and the aspirations as well as the trials and insecurities of childhood. *Peanuts* makes childhood universal without making it adult — as does *Miss Peach,* for example, Mell Lazarus' comic strip in which the precocious kids sometimes sound as cynical as we are led to believe all adults become. In *Peanuts,* the kids never become cynical.

Snoopy embodies the strip's constantly questing spirit better than any of the other characters. During the '60s, Snoopy rose to such prominence that he threatened to take over the strip.

The humor here springs from the dog's preoccupation with pursuits normally followed by humans; again, a dichotomy is at the core of the mechanism. And, again, it is the dichotomy of the non sequitur: from the evidence presented to our eyes (a dog), it does not follow that we will be witnessing activity usually associated with humans (flying an airplane, writing a novel).

Schulz saw Snoopy as the fantasy element of the strip. "He is the image of what people would like a dog to be," he told *Time*. Maybe not all people; maybe just children. In his role-playing, Snoopy clearly does what little kids normally do: He imagines adventures in which he is the hero. His charm, Schulz recognized, resides in the childlike combination of innocence and egotism that define his personality and propel him into new and unlikely circumstances again and again. He never tires, never gives up. And neither does Charlie Brown.

With Charlie Brown's resilience and Snoopy's imagination what we have, distinctly, is a celebration of the triumph of the human spirit. Most profoundly, *Peanuts* is not about human misery however melancholic its creator may appear under Michaelis's microscope.

Despite Snoopy's unintended bid for stardom in the strip, the strong personalities of the other characters kept reasserting themselves. And Schulz kept inventing more distinctive person-alities — Peppermint Patty, Marcie, Sally, Rerun. But he always came back to Charlie Brown.

"All the ideas on how poor old Charlie Brown can lose give me great satisfaction," Schulz once said. "But of course his reactions to all of this are equally important. He just keeps fighting back. He just keeps trying. And I guess that particular theme has caught the imagination of a lot of people nowadays. We all need the feeling that somebody really likes us. And I'm very proud that somehow all these ideas about Charlie Brown's struggle might help in some very small way."

Here, with his analyses of Snoopy and Charlie Brown, Schulz does not much sound like the melancholy bundle of insecurities that Michaelis gives us. He seems, rather, a creative personality with a thorough understanding of himself and his creation, in complete control of his medium. Michaelis seems to have missed this Charles Schulz. Or maybe he didn't so much miss him as overlook him, distracted by something else.

In *The New Yorker* of Aug. 6, 2007, Louis Menand examines the function of biography while reviewing the recent cogita-tions on the subject by two biographers, one of whom is Meryle Secrest, who, Menand reports, believes the purpose of biography is "not just to record but to reveal." Most people would agree with that, Menand says, because the premise of biography is "that the private can account for the public," a premise that justifies "digging up the traumatic, the indefensible, and the shameful and getting it all into print."

This premise, however, "poses a few problems. For one thing, it leads biographers to invert the normal rules of evidence on the Rosebud assumption that the real truth about a person involves the thing that is least known to others." Secrest, like many biographers, believes in "turning points — pivotal moments in a person's life when a single decision alters the future irrevocably."

Menand suggests that this conviction can lead a biographer up a garden path. "William James's diary entry 'My first act of free will shall be to believe in free will,' which makes a starring appearance in almost every life of him ... Charles Dickens's story, first told to his biographer John Forster, about his experience in the blacking factory [have acquired] an unstoppable explanatory force. But what if William James decided the next day that free will was overrated but didn't bother to write it down, or if Dickens later had a *really good* experience in a bluing factory, and never told anyone about it?"

If that can be imagined for James and for Dickens, then it is possible that their biographers have picked the wrong turning point. Considering, Menand continues, that most people's lives are "laughable messes," confused and seemingly pointless sequences of probably unrelated incidents, and that only "a sliver of what we do and think and feel gets recorded" then the "bits and pieces on which biographical narratives are often strung are not a little arbitrary." A biographer could pick a pivotal moment that wasn't, actually, pivotal at all.

"All any biographer can hope," Menand concludes, "and all any reasonably skeptical reader can expect, is that the necessarily somewhat fictional character in the book bears some resemblance to the person who actually lived and died, and whose achievements (and disgraces) we care to learn more about. A biography is a tool for imagining another person, to be used along with other tools. It is not a window or a mirror."

Having recently completed a biography of Milton Caniff that's 300 pages longer than Michaelis's book about Schulz, I appreciate the daunting magnitude of the job Michaelis has done — the challenge of selecting the appropriate material from the messy confusion of a life and then arranging

that selection into an informative and hopefully engaging narrative.

Because I was writing an "authorized biography" of a person still living, I chose to "report" the life rather than "reveal" something about it. Any attempt at revelation would be not only indecorous but presumptuous: Caniff would read what I wrote (he read two-thirds of it before he died), and to speculate after interviewing him about his motives, whether conscious or unconscious, seemed too much like questioning the testimony of my chief witness, as if I doubted his veracity.

My conviction was that an accurate report would be revealing enough. Michaelis chose to "reveal," to try to understand his subject from the inside out and to share that understanding with us.

He has certainly produced a biography that gives us some resemblance of Charles Schulz. I hope I've done at least as much for Caniff. But Michaelis found a pivotal moment; I never did. The pivotal moment in Michaelis's grasp of Schulz's life was the death of Sparky's mother. She died before he could prove to her his worth thereby earning her love. And so Schulz would feel unloved all his live and spend every effort to overcome his sense of unworthiness, producing, as a result, a comic strip about the human heart.

Michaelis, in focusing on the private Sparky that is revealed in his comic strip, has overlooked other professional or artistic aspects of his subject's life, and so his portrait, while bearing some resemblance to Schulz, is incomplete. Where in Michaelis's book is the funny man? Where is the laughter? Where is the whimsical Sparky? Schulz, after all, was a cartoonist, an artist who found a life's work in making people laugh. He cannot have confined this effort solely and entirely to the drawing board. He must've made people laugh — or smile, at least — in person as well as on paper. Mustn't he? His widow and his children assure us that Sparky was often funny. But we don't see that in this book.

Surely, Schulz was not sad and depressed all the time, every waking moment. His children remember a loving father who lavished time and attention on them. His friends remember his warmth and wit. And young cartoonists remember a kindly man who encouraged them. Where is the man we so valued and admired, however distant our remove? If we loved his comic strip because the characters were endearing, however idiosyncratic, and if the comic strip reflected its creator as Michaelis so insistently maintains, then the creator must've had endearing qualities, too. Where, in this book, are they?

The man who poured himself into the strip for nearly 50 years seems a much different person than the one Michaelis writes about.

The book's early chapters are the best. Michaelis supplies more information about Schulz's childhood and fresh insight into his school experiences and, particularly, into the milieu of the Art Instruction years. His treatment of Schulz's time in the Army is more extensive than we've seen before, and the chronicle of the sale of *Peanuts* to United Feature and Sparky's early adventures producing a syndicated comic strip is more detailed than in other accounts.

The chapters devoted to Schulz's life after his divorce seem, in comparison, superficial and almost perfunctory. Jeannie Schulz does not come alive here as much as Joyce Schulz does in the book's mid-section, and yet Sparky was married to Jeannie longer than Joyce.

Most cartoonist biographies begin to flag when their subjects achieve professional success. It's as if their biographers cannot find anything to write about once the cartoonist is chained to his drawing board by the relentless persistence of weekly deadlines. Michaelis avoids this pitfall, his narrative sustained by Snoopy's emergence as a major character and Sparky's venture into writing animation for television. But all this happened before the divorce.

The pages Michaelis devotes to the affair with Tracey Claudius seem, compared to the rest of the book, excessive. And the long preamble through the deteriorating marriage to Joyce which he so considerately builds as a prelude to the affair shifts the narrative weight of the book, skewing its rhetoric and shortchanging the last two decades of Schulz's life.

The rhetorical weight of the book was also affected by Mi-

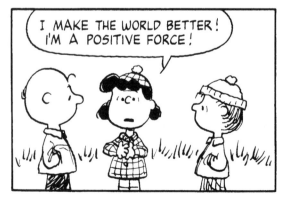

From *Peanuts Classics: Kiss Her, You Blockhead!* [©1982 United Feature Syndicate, Inc.]

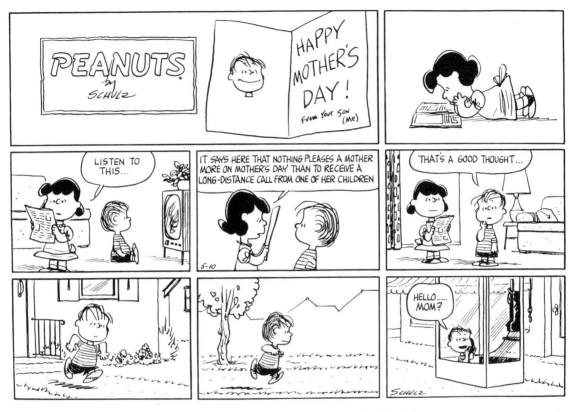

The May 10, 1964 strip, collected in *The Complete Peanuts 1963-1964*. [©2007 United Feature Syndicate, Inc.]

chaelis's final editing. He told Derrick Bang at peanutscollectorclub.com that he had to remove 900 pages of the book's first complete draft. Facing a similar task with my Caniff biography, I know what he means when he says he removed "entire plot lines ... every trace of certain people who crept through Sparky's life. One example was Sparky's relationship with his trusted business manager and adviser, Ron Nelson. I removed that whole story, along with other narrative lines. You make certain choices ..."

Doubtless Michaelis's first decision was to preserve as much as possible of what he saw as the biography's unifying thread, the thing that he thought tied the cartoonist to his creation — Schulz's melancholy, his sense of being alone and unloved. Sparky's marriage to Jeannie, his last 27 years, didn't serve that purpose. If Michaelis was going to slight anything in Schulz's story, it would have to be those years of relative happiness. Just as success isn't funny, happiness isn't dramatic.

That Michaelis missed seeing Schulz the schoolboy in Pep-

permint Patty is emblematic of the whole book. Michaelis' most extended treatment of Peppermint Patty is in a footnote. At the bottom of the page, he says both the first Patty in the strip and Peppermint Patty were named after Schulz's cousin Patricia Swanson, "whose temperament closely resembles that of the [latter]." In pursuing this tantalizing biographical aside, Michaelis overlooks something else — in this case, the other, more illuminating biographical connection. The larger picture is neglected in favor of something relatively insignificant.

By the time I reached the end of the book, I realized that Michaelis had left out another larger aspect of the picture: he had left out Sparky the cartoonist.

Not entirely. You see the cartoonist here and there in fleeting moments of Michaelis's book. But the rhetorical weight of the narrative tips the scales of our lingering impressions of Schulz's life away from the cartoonist and toward the tormented soul within — just as the rhetorical weight of this essay tilts it away from Michaelis's successes. Closing his book, we remember the melancholic man and not the iconic

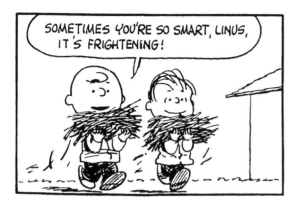

The Nov. 25, 1962 strip, collected in *The Complete Peanuts 1961-1962.*
[©2006 United Feature Syndicate, Inc.]

cartoonist. And that's too bad.

More than anything else in his life, Charles Schulz embodied the essence of cartooning. He was the very emblem of *cartoonist.*

Talking once to his colleagues at a convention of the National Cartoonists Society in 1994, Schulz revealed a truth about why he — and countless other artists and cartoonists — draws pictures, a truth so stark as to be fundamental: "I am still searching for that wonderful pen line," he said. "When you are drawing Linus standing there, and you start with the pen up near the back of his neck and you bring it down and bring it out, and the pen point fans a little bit, and you come down here and draw the lines this way for the marks on his sweater, and all of that. This is what it's all about — to get the feelings of depth and roundness, and the pen line is the best pen line you can make. If there's somebody who is trying to be a cartoonist, or thinks he is a cartoonist, and has not discovered the joy of making these perfect pen lines, I think he is robbing himself — or herself — of what it is all about."

Michaelis quotes a portion of the foregoing, but he seems to have misunderstood its import. He offers it as evidence that, among all the characters in the strip, Sparky liked Linus most of all. But Schulz wasn't talking about his affection for Linus: he was speaking for all his colleagues, past and present and future, the legions of scribblers who find pleasure and fulfillment in their lives by making pictures. His remarks are profoundly insightful. No one has said it better: Stunningly succinct, his words encapsulate the central fact in a cartoonist's life, the essential vital motivation that drives a cartoonist, an artist — any artist, cartoonist or musician or writer, whether looking for the perfect line or the perfect note or the perfect sentence. But Michaelis takes it as a paean to Linus.

Michaelis refers to the perfect pen line at the end of the book at the end of Schulz's life, but by then, it's too late. He has let the moment of revelation slip by, unremarked upon and therefore rendered irrelevant. In searching for the man, he missed the cartoonist, the essential Charles Schulz.

Schulz often said that anyone who wanted to know him should read the strip. "If you read the strip for just a few months, you will know me," he said, "because everything that I am goes into the strip. That is me."

As he said when he retired, doing the comic strip fulfilled his childhood dream. Being a cartoonist was all he ever wanted to be. And it was, in effect, all he was. When he ceased being a cartoonist, he ceased being. There can be no more stunning an instance of the intimate relation between Schulz and his creation than that accompanying the last *Peanuts* strip that he produced. When he died the night before its publication, the nearly simultaneous departure proclaimed with the awful power of some sort of celestial poetry that, as he often said, he was himself the comic strip he created. When it stopped, he did.

"Cartoonist" defined Charles Schulz more than anything else. Sadly, we don't find the cartoonist much in this book. The cartoonist is there, true enough, but the rhetorical weight of the narrative bends it in another direction, towards the man struggling with his unhappiness. And therefore, the biography, for all the stupendous achievement of its research, for all the cunning ingenuity in the arrangement of its details, for all its beautiful moments, falls woefully short, a flawed and unfinished portrait.

Michaelis, sadly, is fully aware of his book's shortfall. "It's not the definitive biography of Charles Schulz that will stand for 30 years," he told Bang. "Other significant, valid books about his life and art will come along. There's more to be discovered and learned about him, and I look forward to reading the next one."

Perhaps the next one will give us Sparky as he'd like to be seen. In an interview with Sharon Waxman at the *Washington Post,* he said: "I'd like to be remembered with what E.B. White once said about James Thurber: 'He wrote the way a child skips rope, and the way a mouse waltzes.'"

Perhaps the next one will give us the cartoonist that Charles Schulz was. ∎

The Impossibility of Being Definitive
by Jeet Heer

I reviewed *Schulz and Peanuts* for the *Globe and Mail* with great enthusiasm when it came out. I wouldn't take back a word I wrote. But I did register a sense in my review that the book had its faults and wouldn't be the last word on Schulz. Since writing that review a few weeks ago, I've found myself constantly thinking about Michaelis's book, conducting a one-man debate about it in my head, puzzling over what was convincing in the book and what was patently half-baked. It's a mark of the book's strength that it won't leave you alone after you've read it; this is a book that needs to be revisited and reread carefully. In that spirit, here are some second and third thoughts about Michaelis.

A strong story. Charles Schulz as Charles Foster Kane and Jay Gatsby. What drives the book forward and keeps it interesting over the course of more than 500 pages is a strong basic plot: A young boy from the provinces overcomes obstacles to achieve great success but never finds happiness and dies feeling unloved. This elementary plotline can describe Schulz's favorite movie (*Citizen Kane*) and one of his favorite books (*The Great Gatsby*). Michaelis uses the archetypical framework of these classic tales as the backbone of his biography. By his account, Schulz was both a rags-to-riches success (transforming himself through dint of sheer effort from being the son of a middling barber into one of the most popular entertainers in the world) and also a tragic figure (his global fame never brought him emotional security or a feeling of being loved).

The Grievance Collector. The success and the tragedy go hand in hand: The emotional wounds Schulz suffered were the very source of his art. He didn't leave his traumas alone or move on from them; he cultivated misery as a source of inspiration. Schulz nursed every grievance as if it were a foundling pet that needed to be kept alive, he collected every slight as if it were a rare stamp worth preserving in mint

From *Win a Few, Lose a Few, Charlie Brown*. [©1974 United Feature Syndicate, Inc.]

condition. This made him a great and beloved artist but also a melancholy, prickly man. Narcissistically focused on his own problems, Michaelis argues, Schulz could never have an open and full relationship with anyone, not his parents, his

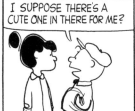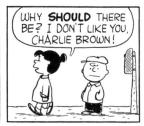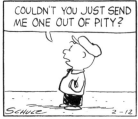

The Feb. 12, 1959 strip, collected in *The Complete Peanuts 1959-1960*. [©2006 United Feature Syndicate, Inc.]

lovers, his wives or his kids. Instead, his whole emotional life flourished in his comic strip. This is a compelling story that links life and art in a nice tight knot. Is it true?

Drawing in Prose. Before judging the accuracy of Michaelis's story, his real virtues are worth calling attention to. Michaelis is a lively writer; more than that, he's a very visual writer. He uses photographs and cartoons not just as "illustration" (that is to say as secondary material to enliven the text), but as primary evidence in their own right. His own prose is a form of cartooning, limning characters and places in well-executed brush strokes. Nothing is fuzzy in this book. Everything has the firm and definite grace of a good comic-strip pen line. In his *New Yorker* review, John Updike rightly praised a paragraph where Michaelis describes the 12-year-old Schulz visiting an art exhibit and seeing, for the first time, original comic-strip pages. "Here hung several hundred lengths of layered illustration board stroked in dense ink more purely black and warmly alive than the engraving process allowed for. … Outside the panels, cryptic instructions had been penciled in the margin; sky-blue arrows aimed to catch an editor's eye. Inside the panels, there were unexpected traces of effort: accidental blots, glue stains and tape bits, strips of paper pasted to correct mistakes in lettering, unerased letters, registration marks, residues of white gouache, pentimenti reversing all kinds of slips and false starts-a whole unseen world of reasoning and revision had passed." This remarkable passage is surely a form of drawing in words. This pictorially rich prose wins our trust: Michaelis's discussions of Schulz the artist carry an earned conviction.

Thinking in visual metaphors. Michaelis's strength as a writer really shines through in the passages where he is thinking visually, trying to see the world as a cartoonist does. Here is a description of the barbershop Schulz's father ran: "The shop was a place of craft and routine, of tersely told incidents — far more of a community center in those days of few telephones and the walking city. Here, too, were in-

teresting things to look at: three sequentially paneled mirrors in which appeared tilted heads, foreshortened throats, and draped torsos of men and boys." Who would have thought to connect the mirrors on a barbershop with comic-strip panels! This is passage is partially speculative of course, but it's an example of good speculation, the type that imaginatively connects Schulz's life with his art.

Voices of the dead. Michaelis deserves our gratitude simply for all the interviews he did. He never met Schulz himself but he seems to have talked to everyone who could still remember the young Schulz. We hear from cousins, playmates, Army buddies and work friends. Many of these people died while Michaelis was working on his book, so without him all these voices would be lost. Any future book on Schulz will have to attend to the primary evidence Michaelis gathered.

Problems with book. A quick summary: It's too judgmental; the author often makes wildly unwarranted speculations; the picture of Schulz and his parents is too darkly drawn; melancholy is emphasized at the expense of other moods; there is a lazy reliance on ethnic stereotypes; we're given only a sketchy sense of how earlier cartoonists influenced Schulz; equally skimpy is the account of Schulz's intellectual interests (the books he read, the movies he watched, the music he listened to, the art he surrounded himself with); and the portrait of Schulz as a father seems seriously mischaracterized. This is a fairly extensive list and each of these points deserves elaboration.

Too judgmental. A cloud of disapproval hangs over this biography. Michaelis constantly highlights Schulz's weaknesses and failures (as well as those of his parents, which supposedly made him the way he was). Michaelis doesn't accept Schulz as he was, but seems to be constantly holding him to account, measuring him against some unstated standard of good behavior. This judgmental tone is well-caught by the salon.com summary of the book as portraying Schulz as "a depressive, self-deceiving character many found hard to love." Now, I have to say that that my sense of Schulz, based

not just on the biography but also on numerous interviews he gave and on comments made about his by his family and friends, is that he wasn't "hard to love." In his interviews, Schulz comes across as thoughtful, intellectually curious, honest and winningly vulnerable. In accounts by his children and friends constant reference is made to Schulz's generosity and sensitivity. This is very different than the man described by the salon.com encapsulation. (Of course, some of this has to do with personal morality: If you think adultery is a grave sin, you'll judge Schulz much more harshly than if you think its an understandable human failing.)

Unwarranted speculations. All biography above the level of genealogy involves some type of speculation. And as we've seen, some of Michaelis's speculations are thought-provoking and enriching. Still, as the book progresses, some of the speculations he makes seem wildly without evidence. Here's a small example: "[Schulz's friend Charlie] Brown detected the cold, untrusting side of Schulz, which flared whenever Sparky's inner workings were exposed to view. When, after receiving yet another rejection from one of the professional markets, he announced to the entire Educational Department that he, Charlie Brown, was giving up his 'cartoonist career,' Brown recalled that Sparky's reply was, 'Good. That will make one less cartoonist I will have to compete with.'" First of all, as a friend of mine observed, the jape Schulz made is not really that cutting by the standards of most cartoonists. Secondly, notice the word "whenever" in the first sentence: it implies that Schulz was always cold inside, despite his surface exterior of Midwestern affability. Was Schulz always "cold, untrusting" despite the mask he wore? There is really no reason to think so; it seems like an outrageous claim to make not only about Schulz but about any human being short of a psychopath.

Cold, distant parents. The impression left by this book is that Schulz's parents, Dena and Carl, were cold, distant, withholding, and didn't offer emotional support to their son's ambition of becoming a cartoonist. This bad parenting is purportedly the root of much of Schulz's later psychological problems: his melancholy and his inability to build a loving home with his first wife. But how true is this account? Schulz himself in interviews always spoke of his parents with affection and gratitude. And Michaelis recounts two stories that seriously belie the overall portrait of Schulz's parents as aloof and unsupportive. In 1934, Dena saw a notice for an exhibit of comic strip art at the St. Paul Public Library. Knowing her son's interest in comics, she insisted that the family go see the show (despite the fact that she and her husband were not exhibit-going people). Later, when Schulz was finishing high school, Dena came across an ad for a mail-order school offering cartoon lessons. Despite the fact that the tuition of the school was very high ($170 or about $2,000 in current terms), Dena and Carl were willing to scrimp and save in order to pay for their son's cartooning lessons. Michaelis mentions these facts but he doesn't weigh them. Yet they indicate that Dena and Carl were supportive of their son's interests and ambitions in a way that contradicts the biography's argument.

Reliance on ethnic stereotypes. Schulz was half-German (from Carl) and half-Norwegian (from Dena). Michaelis gives us a shorthand account of what these two groups were like: the Norwegians lazy but earthy, the Germans cold but hardworking. "Norwegians accepted no more of America than they had to. Physical evidence of German culture could be found on the lintels and pediments of libraries and athletic unions, music clubs and shops, and businesses in the center city before 1918. The Norwegians … produced a single secular institution from which to launch themselves into American life: the family farm." These ethnic generalizations can hardly stand up to a moment's scrutiny. The Norwegian immigrants to Minnesota in fact built many institutions, especially labor unions and civics groups. They were at the heart of the progressive movement. This reliance on stereo-

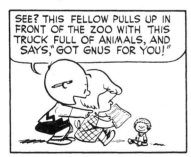 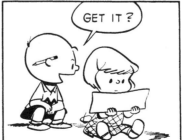 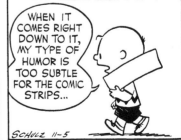

The Nov. 5, 1952 strip, collected in *The Complete Peanuts 1950-1952*. [©2004 United Feature Syndicate, Inc.]

types speaks to a lack of grounding in the local history.

Cursory comic-strip history. In my *Globe and Mail* review I listed some factual errors: "He incorrectly describes a few comic strips (for example, compare page 22 with the *Peanuts* strip of April 28, 1954); has Schulz being influenced by *Krazy Kat* when young (although Schulz didn't actually read that great strip until he was an adult); misattributes a quote to anti-comics psychiatrist Fredric Wertham; and gets the spelling of Winsor McCay's name wrong." Many of these errors center on comic-strip history, a field that Michaelis seems to possess only a cursory knowledge of. In general, we're given a quick listing of the strips Schulz read when young but there is no sense of what he might have learned from them. I would suggest that Schulz's sleek and stylized pen-line owes something to such earlier cartoonists as Crockett Johnson, Virgil Partch and Gluyas Williams. And perhaps Schulz's sense of rhythm in dialogue and his play with repetition derived from George Herriman's *Krazy Kat*. But Michaelis is too tightly focused on Schulz's life to take these aesthetic influences into account. In particular, Schulz's relationship to Herriman is botched in Michaelis's rendering. The actual story is quite dramatic. Schulz grew up on all sorts of ordinary comic strips, then went off to war and matured. When he got home, he read the *Krazy Kat* book that was published in 1946 and it altered his sense of what comics were like, because it was so much better than what he was used to. In effect, *Krazy Kat* was a revelation to Schulz. But this doesn't come across in Michaelis's book, which makes it sound as if Schulz had been reading *Krazy Kat* all along.

An artist's taste. The biography doesn't give us a sense of Schulz's intellectual life, which is a shame since the cartoonist had a lively mind and wide-ranging curiosity. We're given a few glancing hints of his reading habits (Tolstoy, F. Scott Fitzgerald, the *New Yorker* short stories and John Updike). Much more could be said. Schulz had, for example, an unexpected taste for Southern gothic fiction (Flannery O'Connor, Carson McCullers) and tended to like contemporary women writers more than men (he was a fan of Ann Tyler and Margaret Drabble). This could easily have been linked with Schulz's preference for strong women: His two wives, his girlfriend and his many female friends all tended to be formidable, tough, independent and intelligent. This attraction towards strong women could in turn illuminate the strip: Has there been any other cartoonist who created such an array of strong and distinct female characters: Lucy Van Pelt, Peppermint Patty, Marcie and Sally Brown. Some more paragraphs about Schulz's taste in movies, music and painting would have been immensely humanizing, and given a dimension to the man that's missing.

An aloof father? Perhaps the most controversial aspect of Michaelis's book is the portrayal of Schulz as an aloof and emotionally undemonstrative father. When Schulz married Joyce Halverson in 1951, he adopted her daughter Meredith (child of Joyce's earlier marriage). The couple had four more kids: Monte, Craig, Jill and Amy. In general, the kids are not a large presence in the biography. All five of them together receive less attention than Tracey Claudius, who was Schulz's girlfriend for a few years. Three of the kids (Monte, Jill and Amy) have expressed strong objections to how their childhood was portrayed in the book. As Amy Schulz Johnson said, "I thought I had a happy childhood until I read David's book." How can an outsider adjudicate these claims? It's difficult but it has to be said that the Schulz that we find in interviews seems like a very different father than the one shown in the biography. In interviews, Schulz talked frankly about the pain of his 1973 divorce, and especially how much he missed his kids when they were temporarily separated from him while the legal proceedings went through. After the dust raised by the divorce settled down, four of the kids (Monte, Craig, Jill and Amy) came to live with Schulz rather than their mom. And in a long 1997 interview with Gary Groth in *The Comics Journal*, Schulz often mentions his kids, spontaneously bringing them up and talking about their lives even when he wasn't asked about them. From all this, it doesn't seem likely that Schulz was a hands-off father.

The impossibility of being definitive. Given all these complaints, you would think that I hate the biography. But I don't. It's wonderfully well written and made Schulz come alive more than any other portrait of the man. The problem here might be with the expectation that this biography, or any biography, can be "definitive." Richard Ellmann's life of James Joyce, a richly documented and splendidly written biography, was often described as definitive. But the literary critic Hugh Kenner, Ellmann's rival as a keen-sighted commentator on Joyce, was having none of that. Reviewing the revised edition of Ellmann in the *Times Literary Supplement* in 1982, Kenner raised many objections and then argued that "there can be no 'definitive' biography. Biography is a narrative form: that means a mode of fiction. Many narratives can be woven from the same threads." Michaelis's life of Schulz isn't definitive but, like Ellmann's life of Joyce, it's a great work that anyone who cares about the artist will have to enjoy and struggle with. ∎

Schulz and Peanuts: A Biography

by Kent Worcester

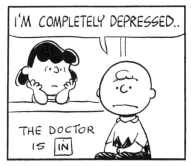
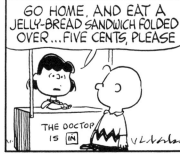
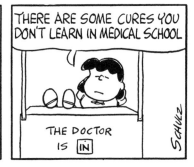

From *You Need Help, Charlie Brown*. [©1965 United Feature Syndicate, Inc.]

David Michaelis' *Schulz and Peanuts* is the first biography of a cartoonist that you could reasonably expect to find in an airport bookstore. Cross-promoted with PBS's *American Masters* series, which recently aired a 90-minute documentary titled *Good Ol' Charles Schulz, Schulz and Peanuts* carries weighty endorsements from Chris Ware, Jules Feiffer, Chip Kidd and Walter Cronkite. *Time* called it "an extraordinary achievement; sympathetic and unsparing and rigorously knowledgeable," while Charles McGrath in the *New York Times Book Review* said the author "maintains affection for his subject without losing sight of how exasperating and narcissistic he could be." Meanwhile, *GQ* pronounced it the season's "breakout biography." As of this writing, it is ranked #771 in books on Amazon, selling at a 34-percent discount on a $34.95 list price.

The book has unleashed a wave of nostalgia for a creator and strip that were already beloved icons. Nearly everyone has a story about how Schulz's drawings and characters touched their lives. For an oversized commercial phenomenon that conquered the worlds of newspapers, books, records, musical theater, television and character licensing, the language and imagery of *Peanuts* retains an uncanny ability to connect on

a deeply personal level. As Michaelis points out, just as "the public had taken Robert Frost as its one great poet, Albert Einstein as its one superscientist, the late John Diller as its number one public enemy, and Arnold Palmer its one golfer, Schulz was now its one grand cartoonist-philosopher." This emotional imprint is especially meaningful inside the world of comics and cartoons. *Peanuts* references have become a trope of *Comics Journal* interviews. And Schulz is one thing that Art Spiegelman, Steve Ditko, Trina Robbins, Ronald Perelman, Johnny Ryan and Dave Sim can all agree on.

David Michaelis has, of course, written a warts-and-all biography, one that focuses on Schulz's family background, melancholia and romantic dalliances. The narrative tells the story of a passive, neurotic antihero who sketched gracefully but nursed longstanding grievances. Schulz is basically portrayed as an emotionally arrested Midwesterner who found it difficult to converse with strangers or hug his own children. Michaelis returns time and again to the question of Schulz's moodiness, and finally diagnoses him as "unhappy" rather than "depressed": "unhappiness paid him a dividend that depression scarcely ever does," he writes. The book is also crammed with incidental detail, from the contents of mid-

The 1959 Lucy nodder doll, from one of the homes of Craig or Monte Schulz, photographed by Geoff Spear for the *Peanuts: The Art of Charles Schulz* book. [©2003 Random House Inc.]

have labeled it repetitious. More damningly, Schulz's second wife Jeannie, who was married to Charles Schulz for over a quarter-century, and his son, Monte, have raised plausible objections to the book's portrayal of Schulz the father and husband and his underlying emotional disposition. In addition, critics have pointed to factual errors in the text. In the *Globe and Mail*, Jeet Heer reported that Michaelis "incorrectly describes a few comic strips; has Schulz being influenced by *Krazy Kat* when young (although Schulz didn't actually read that great strip until he was an adult); misattributes a quote to anti-comics psychiatrist Fredric Wertham; and gets the spelling of Winsor McCay's name wrong." Michaelis has conducted extensive research on Schulz's parents, family tree, Army years and first marriage, but the slip-ups that Heer and others have cataloged suggest that the author is not particularly invested in the larger history of the comic strip.

Biographers sometimes invoke the phrase "life and work" to capture the multifaceted relationship between human development and creative expression. The life presumably helps explain the work, and vice versa, but the connection can be subtle and the fit between the two is never complete. Schulz's experiences beyond the drawing table obviously informed his major creation, *Peanuts*, and as Michaelis demonstrates more than once, the strips themselves disclose a great deal about their creator's day-to-day vicissitudes. (The intriguing juxtaposition of individual strips and the biographical narrative is one of the book's real strengths.) In the case of Charles M. Schulz, there is another crucial dimension, that of *Peanuts* not as a literary and artistic undertaking, but rather as an entrepreneurial behemoth. The runaway success of Schulz's rather spare daily strip not only made him super-rich; it rewrote the rules of cartoon-based licensing.

Michaelis often comes across as more engaged by the person than by the strip or its cultural and commercial significance. It is not for nothing that the cover assigns a far larger font size to "Schulz" than to "*Peanuts*," despite the fact that both words appear in the main title. It might also be useful to point out that his account concentrates on the first four or five decades of Schulz's long life, which pretty much guarantees that his increasingly unhappy first marriage to Joyce Halverson would receive far more attention than his bucolic second marriage. Indeed, Michaelis nearly devotes as much space to Schulz's short-lived infatuation with Janell Pulis, an actress who played Lucy on the San Francisco stage, as to his marriage to Jean Forsyth. His narrative discounts the possibility that Schulz's anxieties diminished in his later years, and that his capacity for emotional growth and love corre-

century sermons to the monthly rent on Carl Schulz's barbershop. The reader acquires a tangible sense of the schoolyards, neighborhoods and lower-middle-class families of Minnesota in the 1930s and 1940s. Michaelis is an energetic journalist and a formidable researcher. Despite an abundance of prosaic factoids, his chronicle of "one of the most misunderstood figures in American culture" (back cover) is highly readable — even if the claim itself is dubious.

While *Schulz and Peanuts* has been applauded in the media, it has not been universally embraced. Some reviewers

The Dec. 31, 1964 strip, collected in *The Complete Peanuts 1963-1964*. [©2007 United Feature Syndicate, Inc.]

spondingly expanded. The book's very structure reinforces the author's preeminent theme, which is that the creator of *Peanuts* was by nature a wet blanket.

Michaelis refers more than once to the fact that Schulz was uncomfortable with the idea of seeing a psychiatrist. He marks this down to the cartoonist's fear that therapy would rob him of his creative juices. It may have also reflected deep-seated attitudes rooted in Schulz's upbringing and generational location. (Jeannie recently said on the website *Sans Everything* that her husband did in fact visit a therapist on a couple of occasions, to address his reluctance to travel.) But there is no reason to suppose that he lacked self-awareness. When Schulz told interviewers, "I only draw pictures," and "I like being a cartoonist," he was telling the truth. Michaelis says that this "was still the only role in which he could truly accept himself," as if cartooning is somehow intrinsically limiting. But Schulz had plenty of reasons to maintain a wary distance between his personal space and the roles that the outside world foisted on him (teacher, philosopher, preacher, celebrity and so on). And he was more than justified in taking pride in his devotion to his life's passion.

That said, Michaelis' forays into comic-strip analysis are insightful. "Schulz uncovered topics that in anyone else's voice would have come out as impieties," he notes. By "sub-

stituting melancholy for anger," *Peanuts* "could give voice to a kind of sorrow at once inescapable and yet endurable." Michaelis' treatment of the main characters is particularly engaging. Consider his suggestion that Schroeder's toy piano serves as a metaphor for cartooning: "Just as *Peanuts* stretched its shrunken black-and-white panels to introduce themes never before presented in the funny papers, Schroeder 'somehow manages' to elicit everything from sonatas to jazz suites from his dingy painted-on keyboard." While Schroeder served as the straight man to Lucy's id, Michaelis makes it clear that his contribution went beyond his standoffish relationship with Linus' crabby older sister.

In fact, Michaelis finds that "the entire population of *Peanuts* exhibited his own traits and characteristics." Schulz gave Charlie Brown his "wishy-washiness and determination," Lucy her "sarcasm," and Linus "his dignity and 'weird little thoughts.'" His "perfectionism and devotion to his art" went to Schroeder, while his "sense of being talented and underappreciated" was given to Snoopy. The effectiveness of these characters depended at least in part on Schulz's intuitive grasp of their inner logic. At the same time, the special bond between Schulz and his A-list characters seems potentially problematic from the standpoint of introducing new characters. After all, how many different ways could he slice his

The March 16, 1963 strip, collected in *The Complete Peanuts 1963-1964*. [©2007 United Feature Syndicate, Inc.]

inner contradictions? This may be one reason why some of the participants — e.g., Sherman, Pig-Pen and Franklin — come off as rather insubstantial in comparison to the strip's leading cast members.

Michaelis does a nice job of tracing the emergence of Lucy and Snoopy as larger-than-life figures whose unpredictable trajectories refashioned the strip as a whole. "Before Lucy," he notes, "*Peanuts* had been relatively quiet. Except for an occasional KLUNK when someone took a pratfall … the words inside the speech balloons remained in the small, tight, all-capital lettering, drawn by Schulz's C-5 chisel-point Speedball pen, which he had been forced to adopt in *Peanuts*' early, space-saving days." With "the arrival of Lucy," everything changed. "Her aggressiveness threw the others off balance. Not only could they now shout at each other at the top of their lungs, but with Lucy setting the tempo, one character's sudden rage might reach a level of force that could literally bowl another over, spinning the victim backward out of the frame." In a story without villains, Lucy provided a useful foil. She was the strip's frenemy.

The transformation of Snoopy, from mild-mannered pet into major-league fantasist, had a similarly catalytic impact on the strip, and an even larger impact on its readers. "Of all Schulz's characters," Michaelis reports, Snoopy "was the slowest to develop." Although he did not start out this way, Snoopy became "distinctly a postwar, even a 1960s, phenomenon: he was purely adolescent — grandiose, revolu-

tionary, with a mind of his own and feelings to match." As "Snoopy's rebellions developed, his personality as a player in the *Peanuts* repertory company evolved." In a world "without adults, he now behaved for all intents and purposes as the one and only child." This may explain why "Snoopy is the one character in the strip allowed to kiss, and he kisses the way a child does: sincerely, and to disarm."

Michaelis' discussion of the commercial side of *Peanuts* is similarly discerning, although his approach is often descriptive rather than analytic. He provides syndication figures and Nielsen ratings, and usefully highlights the role of marketing whiz Constance Boucher in repositioning the *Peanuts* brand. Boucher, for example, "produced the *Peanuts Date Book*" in the early 1960s; this was "itself an original idea — calendar-sized books did not exist, let alone one that featured bold graphics, bright solid colors, and the beloved characters and bite-sized nuggets of 'impassioned philosophy' from a truthful comic strip." By encouraging Schulz to engineer a new kind of gift book for his ever-expanding audience, she also helped concoct the bookstore novelty item. The result, *Happiness Is a Warm Puppy*, spent 43 weeks on the best-seller lists in 1962-1963. It was followed by *Security Is a Thumb and a Blanket*, which boasted an initial print run of 300,000 copies. While publishers did not know what to make of these titles, with their unconventional shapes, color schemes and subject matter, they were stunningly popular with the general public. It turns out that Schulz and Boucher are at least partly to blame for all of those gimmicky pseudo-books that booksellers like to position next to their cash registers.

Despite its shortcomings, *Schulz and Peanuts* is a thoughtful and well-written study of a major cartoonist. While mainstream reviewers may have exaggerated its virtues, there is the danger that the comics press will inflate its limitations. Admittedly, the book slights Schulz's later years, dramatizes his emotional ups-and-downs and commits errors to print. Any and all factual misstatements should be corrected in the paperback edition. But there is no point in denying that some of the backlash against the book has its origins in the psychodrama of fan culture. Michaelis is an outsider to comics, and in the minds of some, that makes his work suspect. Too bad. The book deserves a B+ rather than an F. ∎

Kent Worcester is the author of *C.L.R. James: A Political Biography* (1996), and the coeditor, most recently, of *Arguing Comics: Literary Masters on a Popular Medium* (2004).

[©1962 United Feature Syndicate, Inc.]

Schulz Roundtable Round Two

by R.C. Harvey

Monte Schulz's novella by its very length proves his point: No son would write so much in the service of his father's memory if the father were as distant as Michaelis' book claims. Monte's essay, however, does more than persuade by sheer weight. In quoting Michaelis' letters, Monte shows us how glib the biographer is, how deft at saying what his listeners want to hear. I don't mean to say that Michaelis deliberately misled his interviewees: At the time, he doubtless had no precise idea of the range and extent of the book he would get published, and he remained, throughout, a sympathetic witness to Sparky's life and quandaries, a sympathy no doubt extended to those Sparky left behind.

Still, he had an inkling: He knew enough about what he suspected would be the main theme of the book that he could be accused of employing an unctuous empathy to cultivate candor among those he interviewed. The interviewer's hoary ploy is to agree with whatever the interviewee says whether he believes it or not, a duplicity that, as most inquisitors know, often yields truth.

Beyond the letters and what they reveal, Monte's nearly point-by-point refutation of much of Michaelis' diagnosis is convincing in every instance. Among the most telling to me is the explanation of the seemingly hypnotic appeal of Orson Welles' *Citizen Kane*, which Michaelis alleges the cartoonist watched more than 40 times, implying that its attraction to Sparky was that the movie "resonated" with the themes of Sparky's own life.

In fact, Monte says, his father told him that "he thought *Citizen Kane* was the greatest movie ever made because of the cinematography, its innovations and artistic achievement. He never made one mention of its astonishing insights, or any connection to his own life." In short, Sparky's engagement with Welles' masterpiece was exactly what you'd expect in a cartoonist: He was fascinated by the moviemaker's ma-

From *You're the Tops, Pops!* [©1998 United Feature Syndicate, Inc.]

nipulation of visuals.

Michaelis missed this insight in the same way, and for the same reasons, that he missed other key aspects of the cartoonist's life: Because he is not attuned to what cartooning is and what a cartoonist does, he cannot apprehend the significance of some of what he encounters. Besides, he was looking for something else, as we have noted.

Monte's description of his father playing sports with his sons and playing "war" with him, shouldering "a couple retired Franco-Prussian War-era rifles" and lurking through the woods, is wonderfully evocative of a childhood happily lived. After reading this passage, I can understand Monte's

disappointment and rage at Michaelis' interpretation of his father's life.

Some of the errors Monte discusses are likely no more than simple instances of carelessness, which, were it not for the distortion that results, we could easily overlook, but we cannot ignore the effect on the version of Sparky that emerges from Michaelis' having left out vast reaches of his subject's life — the hockey games Sparky played with his "tournament team" ("growing old with friends and foes alike"); the cartoonist's involvement with the annual ice show that grew and grew, finally becoming a "spectacular" in which his daughters Amy and Jill performed for years; the father's pride in their performance, his tennis-playing, his passion for golf, for music, for books, for writing (especially as revealed by his annual attendance at the Santa Barbara Writer's Conference).

By the end of his essay, Monte has amassed enough evidence to support his contention that "the sins of omission truly drive the central error of this biography." Moreover, his insight into the biographer's apparent method is more than adequate to explain the reason Michaelis' book seems so true: "By leaving out, disregarding, ignoring or compressing huge aspects of my father's life, David is able to tell a story *whose coherence masks its basic untruthfulness*" (my italics) — coherence achieved by canny selectivity in reporting the facts and by the sheer rhetoric of highly skillful writing.

Kent Worcester and Jeet Heer (coeditors of a landmark collection of long-lost erudite essays on comics by notable critics of yore with the catchy title, *Arguing the Comics*) provide a chorus of similar criticism in a minor key, but both excuse Michaelis' sins by applauding his writing ability.

If, as Worcester claims, Michaelis is "more engaged by the person" of Charles Schulz "than by the strip" into which the cartoonist poured his thought and emotion, then it seems to me that Michaelis failed at his self-imposed task, which was to "reveal" the man who was the cartoonist. Moreover, the "insights" with which Worcester credits the book — chiefly, that the "entire population" of the strip exhibited the cartoonist's characteristics — are scarcely astonishing: As I said earlier, Sparky repeatedly asserted as much himself. Worcester is more accurate than he may realize, though, when he calls the book "a study of a major cartoonist." A study rather than a biography. A "study" may be excused its "slight" of Schulz's later years, its dramatization of his emotional ups and downs, even its errors. A biography, however, cannot be so casually pardoned its omissions even if it is, as Worcester says, "well-written."

Heer also thinks the book "wonderfully well-written" — its prose "a form of cartooning, limning characters and places in well-executed brush strokes." Heer finds it marvelous that Michaelis connects "the mirrors in a barbershop with comic strip panels." I, on the other hand, think this admirable conceit, inventive though it is, reveals through its very metaphorical ingenuity Michaelis' naïveté about cartooning: Neophyte cartoonists such as Sparky was at the time this passage refers to tend to think about figure drawings, not sequential panels. And when they start thinking in narrative terms, they are likely to think of the panels in the comic strips they see in newspapers rather than mirrors on barbershop walls.

Despite its failure to be "definitive," the book is "a great work," Heer says, although he acknowledges that it might be "a compelling story which links life and art in a nice tight knot" but isn't, quite, true. Heer's own opinion of Schulz is, he says, "quite different" from the man Michaelis describes. Still, he doesn't "hate the biography" but sees greatness in it.

(Heer, by his own account, is struggling both with the book and with his own earlier enthusiastic review of it — in which he says "part of Michaelis' achievement is that he clearly understands how cartoonists think," an assertion I severely question. Heer manages, with candid rhetoric, to extricate himself from this a predicament by remembering that he also accused Michaelis of leaving out evidence that contradicted his thesis, an observation I happily agree with.)

In sum, both Worcester and Heer take considerable pains to find merit in a work that they also contend is ridden with faults, faults that ought to lead them to less favorable opinions than they espouse. Admittedly, I do somewhat the same. Perhaps all of us are bending over backward to avoid ganging up in the "psychodrama of fan culture" that Worcester acutely sees as prone to inflate the limitations of the book in a stampede of backlash over an "outsider's" presumption in writing about an iconic cartoonist.

Then, too, we are all, by one measure or another, writers like Michaelis, and we admire good writing when we see it. But good writing, however engrossing the linguistic legerdemain, is not enough for a biographer. Verbal facility is not a good substitute for the honest open-mindedness that enables the biographer to find his subject's authentic personality. Good writing cannot excuse biased reporting. It can mask the problem, but it cannot change distortion into truth.

The temptation, after reading Monte's essay, is to see Sparky as something akin to the saint that his comic strip implies must be lurking behind it all. But Schulz was not a

From *It's Only a Game*, with Jim Sasseville. [©2007 About Comics, ©2007 Charles M. Schulz Trust]

saint. A good man, but a man for a' that, as Robert Burns might say. Schulz, by his own testimony, had "Lucy moments," times when he was short with fans or friends, even nasty or mean — momentarily.

A stunning example of what Michaelis might call Schulz's cold-hearted self-absorption occurred when Sparky ended his newspaper panel cartoon about sports, *It's Only A Game*. The feature ran from Nov. 3, 1957 until Jan. 11, 1959, although it wasn't a daily cartoon. United Feature, Schulz's *Peanuts* syndicate, offered it in either of two options: As a single-panel cartoon three days a week (Mondays, Wednesdays and Fridays) or as a Sunday feature that combined in one display all three of the single panels. In all, only 63 weeks worth of the cartoon were ever published.

The cartoon's theme would seem to be a natural outgrowth of Schulz's abiding interest in sports — skating, hockey, baseball, football. Nat Gertler, who published a collection of the cartoon, said of it: "Schulz focused mainly on participation sports and games, so there are strips about bowling, bridge and fishing, as well as the big team sports. In fact, it's rather amazing how broad a range of topics is covered. Over

the course of 255 cartoons, the series covers everything from Monopoly to rodeo."

Schulz drew only two months of the feature: With the Jan. 26, 1958 release, *It's Only A Game* was being drawn by a longtime Schulz associate, Jim Sasseville, who had been producing original *Peanuts* stories for the comic-book incarnation in *Nancy*, *Tip Top* and *Fritzi Ritz* since the summer of 1957 when Dell took over the titles and gave up reprinting newspaper strips.

Schulz and Sasseville had become friends in Minneapolis in the late 1940s when they both worked as instructors in the Art Instruction School. On the basis of his employment with Schulz, ghosting *Peanuts* characters for comic books and doing the sports panel, Sasseville moved himself and his family to California in the spring of 1958, following his boss. There, Sasseville continued writing as well as drawing the comic-book *Peanuts* stories and drawing the sports panel, occasionally contributing an idea of his own. Then, without any advance notice to Sasseville, Schulz shut down the panel.

It had failed to catch on, and he and United Feature had decided to call it quits. At the end of a long day during which Schulz and Sasseville had been working side-by-side to finish off several stories for Dell's *Peanuts* comic book, *Four Color* #969, he told Sasseville that his other ghosting assignment had ceased.

Schulz tried to sugar-coat the news, Derrick Bang reported (*Comics Buyer's Guide*, #1472, Feb. 8, 2002), saying, "You're off the hook" — as if losing a substantial portion of his income was a good thing (just as Sasseville was contemplating payments on a new house in his new locale).

According to Bang, the abruptness of the announcement effectively alienated Sasseville: He and Schulz severed all ties and never reconciled. And Sasseville, despite hatching several ideas for syndicated comics, never again earned a living as a cartoonist. (He did, however, contribute to the Gertler volume, providing the book's running commentary and an assortment of special visuals, including roughs that were never used.)

This anecdote, damning on its surface as a portrait of an insensitive Schulz, might actually prove the reverse: the episode does not so much demonstrate that Schulz was unfeeling and self-centered as that he was so sensitive of others' feelings that he couldn't bring himself to tell his longtime associate the bad news, knowing how devastating it would be.

If Schulz were a saint, he could have managed the situation much better, no doubt. One of my reasons for includ-

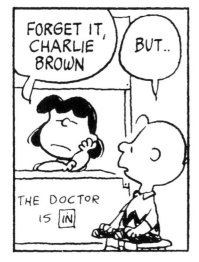

From "Ha Ha, Herman," Charlie Brown. [©1972 United Feature Syndicate, Inc.]

ing the tale here is to demonstrate that Schulz was not a saint. But that's no sin; none of us are. Certainly, not David Michaelis.

My other reason for rehearsing this episode is to show how a single piece of evidence can be interpreted in at least two wildly different almost contradictory ways. Michaelis might have seen in Schulz's abruptness a sign of his nearly heartless insensitivity. I see it as evidence of a sensitivity overwhelmed by shyness.

Unhappily, Michaelis' verdict on Sparky's personality will doubtless persist. His book, after all, is an impressive performance by a biographer who has earned his credentials with a critically acclaimed biography about the illustrator N.C. Wyeth.

The Week magazine lists Michaelis' biography of Charles Schulz as one of its five nonfiction "Books of the Year," quoting a review in the *Pittsburgh Gazette* by Roger K. Miller, who thought the book "superb" but "almost dangerously insightful." Also quoted: Carlo Wolff in the *Boston Globe:* "If the story the book tells saddens some readers, that's only fitting: *Peanuts* itself was 'deeply American in its wistfulness.'" And Scott McLemee in *Newsday:* "A caveat: Michaelis plays backyard psychiatrist a few too many times."

After I wrote my review, I spent a few hours combing through the pile of other reviews that *Schulz and Peanuts* had prompted in the nation's press. I had glanced at many of them before attempting my own assessment, enough to know which way the prevailing winds tended. After writing my review, I returned to the pile and plowed through it more

attentively.

I was struck by the quantity of banal observations and by the foolish ignorance of many statements, usually made by people wholly unfamiliar with either the cartoonist or his strip who therefore accepted without question the sad and lonely Schulz that Michaelis gives us. Most such reviewers, I suspect, never got closer to Charlie Brown or Charlie Schulz than the TV specials. And those often lack the nuances that found their way into the strip.

The most perceptive of the reviewers was a Scot, Damien Love, writing in the *Scotland Sunday Herald.* Love notes that Schulz "gave the phrase 'security blanket' to the world, but only because insecurity — along with rejection, disappointment, melancholia, loneliness, self-consciousness, paranoia and unrequited longing — was his real theme."

He continues: "What might raise eyebrows among Peanuts fans, though, is how many commentators and reviewers have reacted to [Michaelis' portrait] as though this was some great revelation, the cracking of a secret code. Did they ever read *Peanuts* in the first place, or are they basing their knowledge on the drawings of Snoopy and Woodstock dancing happily on their pencil cases?"

Love's conclusion: "While it's the melancholy that lingers, *Peanuts* could not have survived fifty years, nor become so beloved, if Schulz did not also have a deep sense of fun and humanity. Schulz is unsentimental and sarcastic in *Peanuts,* but he is never cold and mean. He depicts losing as the universal condition. If he says that we are all ultimately alone, he also says that at least we're all in it together. Schulz's

characters ... facets of himself, were baffled by life's constant disappointments, cruelties and absurdities, but never fully defeated. The sad cosmic joke might be that Charlie Brown never gets to kick the football, but the really funny thing is, he never stops trying."

But Love's is a lonely voice, crying in the wilderness. The damage has been done. In most of the other reviewers' comments we see more than just a glimmer of what the world at large is likely to believe, now, about the cartoonist. Michaelis' biography will serve hereafter to perpetuate its author's jaundiced opinion: A sad and lonely Schulz is only part of what Michaelis sees, but the fragment, by virtue of its sensation, is getting all the notice, and it is shaping popular opinion in a way profoundly at variance with the man Schulz was.

Entertainment Weekly, mentioning the broadcast of *A Charlie Brown Valentine*, said: "Chuck and the Little Red-Haired Girl were way cuter before we killed the magic and read the Schulz bio."

Perhaps in such statements the Schulz Empire might find grounds for a lawsuit. I hope not, but it could be alleged that the revenue-producing potential of the *Peanuts* franchise has been diminished, particularly if advertisers for the *Peanuts* TV specials back away because "the magic" has gone off the rose.

Among the reviews that I'd stacked up were a few interviews with Michaelis, who makes his admiration for Schulz quite clear. The freight of the book, alas, bends our perception in another direction, as I've said. In one of the interviews (at mrmedia.com) with journalist Bob Andelman (who wrote a biography of Will Eisner), it's obvious how Michaelis sabotaged his own book. At first, Michaelis says, he thought he wasn't properly prepared to write a biography about Schulz. "I had no business writing about Schulz, probably because I wasn't known as or had not had adult professional training as a comics guy. I was not a writer about comics."

But friends, knowing of Schulz's affection for Andrew Wyeth, N.C.'s son, persuaded Michaelis to explore the possibility of writing the cartoonist's biography. Michaelis' reasoning is revealing: "I felt strongly after looking into [N.C. Wyeth's] images of *Treasure Island* and Robinson Crusoe, familiar images if you read those books and Scribner Illustrated Classics, and finding Wyeth's life in them, that this might be an approach to *Peanuts,* and I felt strongly that there that there was more, there had to be more to *Peanuts* if it was as complex in nuance as it seemed to be, and it had to relate in some way to his life."

In short, Michaels began his task with a preconception — that the life of the cartoonist outside the strip would be reflected inside the strip. Just as Wyeth's life was, apparently, reflected in his illustrations of books like *Treasure Island, Robin Hood, Robinson Crusoe* and others. David Usborne of the *London Independent* (news.independent.co.uk) observed that Michaelis "pretty much advertised his take on the cartoonist in an appreciation of him in *Time* magazine shortly after his death. In it, he laid out the premise that would later be expanded to make the book — that the genius of Schulz was driven ... by his own inner discontent and anger at life."

The premise was valid, as we've seen, in a general way — as it often is with artists. Michaelis' early commitment to the idea, however, paved the way for the mistake he made when, in pruning his typescript to a publishable size, he decided to yank out much of Schulz's life in order to preserve the thematic strand that supported his central notion, a notion that, despite Schulz's own well-known words about the strip and its intimate relation to his life, Michaelis found so novel that promulgating it justified excising the rest of the cartoonist's life from the book.

He defends the result by saying that the biography is of the whole man and the artist that was Schulz, not just the father or husband that his children or wives remember — and can't find much evidence of in the book. The debate that flooded the Web in the wake of the book's publication in October 2007 "misses the point of biography," Michaelis says, " — which is to understand Charles Schulz as Schulz understood himself, not as his children understood him or the world understood him, but as he saw his life. That's certainly the point of view from which I was trying to approach his life, both finding it through *Peanuts*, which is a more abstracted way of understanding how Charles Schulz knew the world, and how he in his own words understood." [From an interview on Mr.Media.com.]

If that's what Michaelis thought he was doing, he missed the mark he set for himself. Sadly, in cutting out swaths of Schulz's life, Michaelis was left with something decidedly less than "the whole man." In his partial portrait, distorted enough to seem untrue, we see the fallacy of Michaelis' method: It's highly risky and perhaps dishonest to make a man's life fit a theoretical template devised before researching that life. ∎

Further Reflections on Michaelis
by Jeet Heer

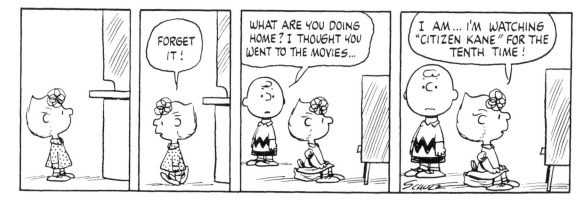

From *Thompson is in Trouble, Charlie Brown*. [©1973 United Feature Syndicate, Inc.]

Monte Schulz, Kent Worcester, and Bob Harvey all offer thoughtful, incisive comments on the Michaelis book. Before addressing what they have to say, I want to focus in more detail on one particular thread of the biography, the storyline about Tracey Claudius. Like other reviewers, I was quite impressed by Michaelis's handling of this story. But then Jeannie Schulz, in the comments section of a blog I write for, raised some strong objections. This caused me to have second thoughts, which I'll detail in the first section below before responding to the other writers on this roundtable.

Part one:
Charles Schulz as Charles Foster Kane

Charles Schulz's favorite movie (at least on occasions when he wasn't smitten by *Beau Geste*) was *Citizen Kane*, a film that is in part about the impossibility of writing biography. In the film, newsreel reporters struggle mightily to uncover the meaning of the mysterious last word of the media magnate Charles Foster Kane: "Rosebud." They interview many

who knew Kane but fail to solve the riddle. The movie itself, a work of art, discloses the meaning of Rosebud in the last few frames. (Schulz did several strips where the ending of the movie is ruined by thoughtless people prematurely revealing the solution). In effect, the movie argues that art can get at truths denied to fact-scrounging biographers.

The problem with biography is made particularly clear in a scene where one reporter interviews Mr. Bernstein, Kane's lifelong business partner. Bernstein offers the reporter a lesson on the tricky nature of memory: "A fellow will remember a lot of things you wouldn't think he'd remember. You take me. One day, back in 1896, I was crossing over to Jersey on the ferry, and as we pulled out, there was another ferry pulling in, and on it there was a girl waiting to get off. A white dress she had on. She was carrying a white parasol. I only saw her for one second. She didn't see me at all, but I'll bet a month hasn't gone by since that I haven't thought of that girl."

We can call this the Bernstein conundrum: Our experiences are not weighed equally. A teenage fling that ends in

heartbreak might mean more than many years of marriage; a year of soldiering could leave a stronger impression than decades of peace; the death of a loved one can cast shadows on all subsequent events. And in fact some of these key events could be utterly private and inaccessible to outsiders, undocumented but potently alive in memory, as with the girl "carrying a white parasol."

All biographers deal with the Bernstein conundrum. One solution is to give equal weight to all facts, as we see in the long plodding multivolume tomes like Norman Sherry's life of Graham Greene or Martin Gilbert's life of Winston Churchill, where we get a nearly day by day chronicle of the protagonist's activities. The other option, the one taken by most biographers, is to be more selective, to highlight certain facts and events as pivotal and character-forming. In essence, a biographer has to be like a novelist, shaping the narrative for maximum effect. The danger is that the biographer's choice of which facts to highlight might make his biography novelistic in a bad way: more a work of fiction than fact.

Michaelis's *Schulz and Peanuts* tries to solve the Bernstein conundrum through sheer writerly bravado, not to say overbearing presumption. Like Herman J. Mankiewicz and Orson Welles working on the script for *Citizen Kane*, Michaelis wrote his biography knowing the secret of both Rosebud and the untold story of the girl "carrying a white parasol." Schulz's Rosebud was the death of his mother, a lasting trauma. The girl with the white parasol is Tracey Claudius, a young woman who had an affair with Schulz in 1970.

No one, as far as I know, is disputing the importance of the death of Schulz's mother, which took place while he was a young man about to head off to war. It's an event that Schulz often referred to and left permanent scars. But the role of Tracey Claudius in Schulz's life, and especially the prominence this affair is given in the new biography, can be questioned.

It's a dramatic story. Like many reviewers I was seduced by it and gave it pride of place in my recounting of the book's narrative. Here's a quick summary (keeping in mind that the value judgments made here are from Michaelis's disputed biography): Schulz married Joyce Halverson, a single mother, in 1951. Their marriage, which produced four more kids, became increasingly contentious over time, with Schulz's aloofness, introspection and diffidence constantly clashing with his wife's bossy adventurousness. By the late 1960s, the marriage becomes especially fraught as the couple quarreled over money spent on building an arena and on the best ways to raise their kids (Joyce was supposedly a hands-on mom while

Schulz was allegedly more withholding and withdrawn). As their marriage soured, Schulz was increasingly attracted to other women, and in the 1970s he had a fling with a young photographer who comes to interview him, Tracey Claudius. Although the relationship with Tracey quickly tapers off it does lead to a crisis in the marriage. In 1973, Schulz falls in love with Jean Forsyth Clyde, who was then also unhappily married. They divorce their respective partners and marry. The marriage of Charles and Jeannie Schulz lasts until his death in 2000.

To make the case for Michaelis: the importance of Tracey is that she came at a key moment in Schulz's emotional life. Prior to meeting her, he was thwarted in his search for love and awkward with women because of his unhappy marriage. Tracey thawed Schulz out; warmed by the affair with her, he was more willing to take emotional risks. Tracey was the bridge between the end of Schulz's first marriage and the beginning of his second.

The case against Michaelis: Considering how briefly it lasted, the affair is blown way out of proportion in the biography. As Jeannie Schulz noted (in a comment I posted on *Sans Everything*, a blog I run with some friends) Schulz didn't seem to spend all that much time around Tracey: "If you look carefully at the timeline you'll find: 1 weekend in Monterey, another possible night at Tracey's when the roommate was gone, a dinner at the Tonga Room, a night at Jacques Brel, a lunch on the waterfront and a couple more

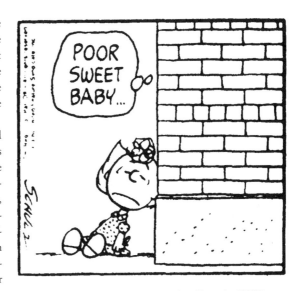

From a strip reprinted in *Schulz and Peanuts: A Biography*. [©2007 United Feature Syndicate, Inc.]

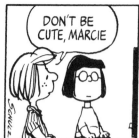

From *Peanuts Classics: You're Weird, Sir!* [©1981 United Feature Syndicate, Inc.]

meetings in book stores. The rest was telephone calls, notes, drawings, etc. Why does Michaelis give it so much space?" It could be argued that Schulz's marriage to Joyce was already on the skids and that the fling with Tracey was simply one more milestone on the road to divorce. His affair with her was surely more a symptom of a broken marriage than a cause. And after Schulz's marriage to Jeannie, it doesn't seem he ever gave much thought to Tracey, who in any case had moved on.

If we grant the importance of Tracey in Schulz's life, it's still striking how much she overshadows almost everyone else in the biography. Aside from Schulz's mother and his first wife, Tracey is the largest character that Schulz deals with (according to Michaelis). We're given a nearly blow-by-blow account of the affair (the first meeting, the tentative signals sent out, the dates, and even when the couple first had sex). By contrast, Schulz's marriage to Jeannie, which lasted 27 years, glides by quickly. It is Tracey's somewhat unfavorable account of Schulz as a lover (he was allegedly selfish and given to romantic flights of fantasy while not listening to his partner) that leaves a strong impression. By comparison, Jeannie's and Charles's love for each other is only tepidly hinted at. Tracey also looms much larger in the narrative than any of Schulz's five kids, not to say Jeannie's kids from her first marriage (who are quite wraith-like in the book).

The questions we keeping running against are ones of balance, proportion and selection. Yes, Schulz had the affair with Tracey. Yes, he was often melancholy. The question is what weight to give these events and how to keep them in balance against other facets of Schulz's life (like his love for his kids and Jeannie and her kids; even his happy early days in marriage to Joyce). Some fans of *Peanuts* are keen to emphasize the dark side of the strip, in order to counteract the syrupy "Happiness is a Warm Puppy" reputation it has. The dark side of the strip is there, but there is also joy in *Pea-*

nuts: The Snoopy dance surely owes something to Schulz's gratitude for being alive, when he could easily have died as a soldier. After the war, Schulz knew every day was a gift and the intensity with which he lived his life was a testament to how much the gift meant to him. As a biographer, Michaelis seems to want to give us a "dark" portrait of Schulz, in the same way that DC Comics occasionally offers up a "dark" version of Batman or the Green Lantern (to shake things up and make the stories more interesting). But the darkness of the portrait hides some key elements of Schulz's life. The shadows don't just give character and create mood; they also obscure and distort.

Part Two:
The need for more books

Monte, Kent, Bob and I come at the book from different angles: Monte as a son contrasting his memories with the very different man portrayed in the biography, Kent as a cultural critic valuing the book for what it says about *Peanuts* as a work of art, and Bob as a fellow-biographer shrewd about how to tell a life story at epic lengths, me as historian of the early 20th century. Still, I think the four of us have, despite our varying perspectives, a fair bit of consensus: We all agree that the book has factual and interpretive problems but all of us also have some respect for Michaelis's writerly skills. (I think this is true even of Monte, whose essay is written more in sadness at the lost opportunity for a better book than anger). So I'm not sure if there is much here to disagree with, but I'll make a few notes.

Monte's in-depth account of his relationship with Michaelis and his objections to the biography have the same effect that Jeannie Schulz's comments did: They make me feel foolish for initially taking much of what Michaelis wrote at face value. As Monte shows in great detail, Michaelis's strong interpretive agenda governs every word of the biography,

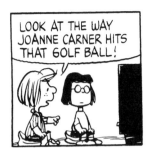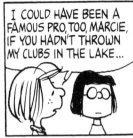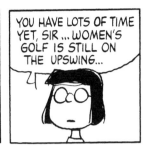

From *Peanuts Classics: You're Weird, Sir!* [©1981 United Feature Syndicate, Inc.]

which means that the facts as presented can't be relied on but always have to be traced back to their original source. Every sentence in the book needs testing. Which is not to say the whole book is worthless, merely that the book should be seen as an extended interpretive essay rather than a biography.

I want to highlight one particular sentence by Monte that gets to the heart of the matter: "Still more significantly, the sins of omission truly drive the central error of this biography." As I understand Monte's objection, the problem with Michaelis is not mainly the errors (although they are legion), but what was left out. This I think is the rub: The decision to emphasize the terminally melancholy Schulz meant that an enormous amount of contrary evidence was simply left out. Aside from what Monte mentioned, I'll add one more example of omission: Numerous young cartoonists have praised Schulz as a mentor, offering stories of how he took time from his schedule to offer them advice (Terry Laban and Tom Tomorrow are two examples, but there are many others). You really don't get a sense of this kindly, avuncular side of Schulz in the Michaelis book. I think any subsequent biography of Schulz has to address these "sins of omission."

Kent does a good job of emphasizing the strengths of the book, particularly as a work of cultural analysis. I was particularly glad to see Kent highlighting Michaelis's prowess as an analyst of *Peanuts*. The only thing I would add is that I think Michaelis is better on the early *Peanuts* (from 1950 to 1975) than on the second half of the strip's run. This is in keeping with Michaelis's tendency to scant the marriage to Jeannie Schulz. *Peanuts* became a very different strip in the last 25 years: more introspective and less cruel. Lucy gave way to Sally, Peppermint Patty and Marcie. Many have argued that the strip became worse. But rereading late *Peanuts* lately, I was struck by how subtle and deep it often was: Peppermint Patty and Marcie in particular are great characters, alternately self-assured and self-defeating. The see-saw

teasing dynamic of their friendship introduced a new element into *Peanuts*. This whole second half of Schulz's career remains virgin territory, something that future critics and biographers should tackle.

This brings me to an excellent point Bob Harvey made: "The book's early chapters are the best." Yes, the first half of the book, for all the problems that Monte points out, is really quite valuable simply for the way it evokes the world Schulz grew up in. The account of the death of Schulz's mother, for example, is incredibly moving. The book's second half is much more cursory and unsure, as if Michaelis had lost his handle on the material. Again, this points to where future writing on Schulz has to go: The life of the cartoonist from the mid-1950s till his death deserves a thorough reexamination.

The point I'm trying to make is simple: as weighty as it is as a physical object, *Schulz and Peanuts* isn't a definitive book by any means. There will be other books on the cartoonist, books that will build on Michaelis, while also taking issue with him. One suggestion: I know that Monte is resistant to the idea that he write a memoir of his father. This is perfectly understandable since Monte has his own work as novelist to do. But it might make sense for someone to put together an oral history of Schulz's life, filled with quotes from the voices that were omitted by Michaelis. That would be one step toward redressing the problems with the book.

Schulz left a large legacy, too big to be canvassed in just one book. The main lesson to draw from the controversy over Michaelis is that there is much more to say about the creator of *Peanuts*. ■

Schulz Roundtable – Round Two

by Kent Worcester

Charles Schulz and his children, courtesy of Monte Schulz.

Bob Harvey, Jeet Heer and I seem to have arrived at broadly similar conclusions regarding David Michaelis's *Schulz and Peanuts*. In different ways, each of us identifies important strengths and weaknesses in Michaelis's widely reviewed biography. Bob's contribution covers more territory and is informed by his personal connections to both the biographer and his subject. He has written about Schulz elsewhere, and pays greater attention to the intellectual conundrums that are intrinsic to biography as a literary genre.

Jeet provides a careful balance sheet of the book's pluses and minuses, while my short review pokes a few holes in the narrative but nevertheless assigns it a favorable grade. If I read Bob and Jeet correctly, they each placed *Schulz and Peanuts* in the same evaluative ballpark as I did. None of us thought the book was a home run, but neither did we ignore its virtues.

In particular, there was agreement about the quality of David Michaelis' prose and what Bob calls "the depth and breadth" of his research. Michaelis is a seasoned journalist who knows not only how to construct a sentence but how to weave a larger argument. As Bob says, Michaelis' "masterful deployment of telling details is sometimes breathtaking." The integration of individual strips into the larger narrative is similarly impressive. Having decided more than a decade ago to write on Charles Schulz, he proceeded to interview several dozen family members, friends, neighbors and acquaintances. He visited old haunts, checked old documents, tracked down interviews by others and delved into the secondary literature. The book does indeed ripple "with thousands of facts both large and small." Whatever the limitations of *Schulz and Peanuts*, it would be difficult to convince me that its author did not put in the necessary legwork or lacked the requisite chops.

The fact that the book is well written, extensively researched and generously illustrated may be part of the prob-

lem. It is difficult to imagine that an incompetent biography would generate anything like the attention that Michaelis' study has received. It also possible that had he focused more on the comic strip itself and less on Schulz's midlife dalliances and crumbling first marriage, *Schulz and Peanuts* would have attracted less interest on the part of the media. But I do not think that Michaelis was motivated by potential reviews and sales to play up the depressed-cartoonist and middle-aged-adulterer angles. He seems genuinely gripped by the drama of Schulz's existential moodiness, and disturbed by the prospect of an unhappily married man holding hands with a 20something actress in post-'60s San Francisco. The book may be judgmental, but it is not wholly cynical.

What Jeet calls *Schulz and Peanuts*' "strong basic plot" is, of course, both an asset and a liability. The local-boy-makes-good-but-stays-sad storyline propels the reader through the thicket of detail, but imposes an unrealistic aura of confluence on life's vagaries. The narrative ends up slighting the longer of Schulz's two marriages and the final decades of his life. It discounts ample evidence that the famed cartoonist found some real measure of happiness as he got older. The author provides numerous examples of Schulz's mature irony, but writes as if Schulz never gained any distance from the accumulated slights and setbacks of his early years. Michaelis is so preoccupied with the "dark side of Schulz" that he fails to grant his subject anything resembling a sense of self-worth or creative fulfillment.

There is something of a paradox in Michaelis' relationship to cartooning. He is incurious and somewhat careless about comic-strip history, and certainly not as comics-centric as he could have been. At the same time, he reveals an aptitude for narrative-art analysis and has useful things to say about the evolution of *Peanuts* and its characters, and about the strip's larger impact on television, musical theater and publishing. Admittedly, this material is almost buried under the weight of grievances, failed romances and family lore. Not everything he says about individual strips or artistic choices holds up. But sections of the book offer credible comics analysis, starting with the author's astute observation in the preface that "Schulz needed to know that he was reaching the reader with his own voice – almost as if his medium were radio – for he wanted his audience to identify not with him but with his temperament."

Schulz and Peanuts is probably a little unkind in its treatment of Schulz's parents, Carl and Dena. Given the passage of time and the effective lack of documentary evidence it is difficult to know how much credence to give to Michaelis'

precise tone and emphasis in this context. Clearly, by contemporary standards Schulz's parents were cold and distant. But Michaelis' account may be unnecessarily negative. One question is whether he needs the rigid ethnic framework that Jeet rightly objects to. Behavior that Michaelis labels "German" or "Norwegian" could just as easily reflect class, regional and/or generational influences. This may represent another instance where the author's approach was overly judgmental.

Some of the evidence that Michaelis brings to the table is a little underwhelming. I was struck, for example, by the opening passage of Chapter 14, "Saga," which discusses the family background of Joyce, Charles Schulz's first wife. Life, it seems, was not particularly jolly for Joyce's parents, Henry and Dorothy Halverson. "Family happiness," Michaelis reports, "was made impossible by a mutual sense of deprivation, with Henry blaming Dorothy for withholding the love he craved, and Dorothy attributing their chronic financial instability to Henry's grandiose dreams of success." Furthermore, "each thought he or she was better than the other; Henry's self-righteous sense of injury mingled disastrously with Dorothy's fearful snobbery." The source for this bleak summary was the couple's divorce papers, or rather an excerpt in a family genealogy. Divorce-related documents offer a treasure trove for historians and biographers but they should not be taken at face value. I am especially doubtful whether poor Henry and Dorothy would recognize themselves in Michaelis' downbeat portrait.

Monte Schulz obviously does not recognize himself in Michaelis's book, and I can't say I blame him. As a first-time reader I was less interested in the treatment of Charles Schulz's family life than of *Peanuts* as an undertaking and as an industry. Now that I have read through the book a second time the discussion of Schulz's role as a father seems seriously off-kilter. It must be disorienting to become friendly with your dad's biographer and then to receive a manuscript in the mail that so thoroughly cleaves to a great-artist/tragic-man script. Monte's contribution to the symposium usefully documents the family's ongoing dialogue with Michaelis and makes a strong case for an alternative portrayal of the mature Charles Schulz from the one offered in *Schulz and Peanuts*. And yet, at the risk of sounding single-minded, it would be disappointing if the next major Schulz biography did a better job of talking about Schulz's relationships with his children, but failed to say anything new about his art. ■

The Matt Madden Interview
Conducted by Gary Sullivan

In 2003 my wife, Jessica Abel, Nada Gordon, and I asked Matt Madden, along with Warren Craghead and two poets, Tina Darragh and Jena Osman, to show and talk about their work at the Bowery Poetry Club in Manhattan. The event, "Process and Formal Invention," took place on Nov. 22 of that year, and is still talked about by the poets who attended. It was the first time I met Madden in person.

Madden showed slides of his then in-progress "Exercises in Style" (published as *99 Ways to Tell a Story: Exercises in Style* in 2005 by Chamberlain Bros., Penguin), a book-length reinvention in comics of Raymond Queneau's *Exercices de Style* or *Exercises in Style*. Queneau co-founded Ouvroir de littérature potentielle, better known in the States as OuLiPo, or the Workshop for Potential Literature, a group of writers, mostly French, who focus on constraint-based work — writing that is partially shaped by the adoption of one or more limiting rule(s).

In 2004, I took Madden's adult-education Experimental Comics class at the School of Visual Arts. I also joined the OuBaPo-America listserv, which Madden moderates with Tom Hart and Jason Little, and which is devoted to discussion of constraint-based comics. (In 2002 Madden was voted the U.S. Correspondent for OuBaPo, or Ouvroir de la Bande Dessinée Potentielle, one of a half-dozen wings of the original OuLiPo.)

What has impressed me most about Madden, beyond his considerable skills as a visual artist and storyteller, is his constant experimentation. His approach to comics differs from that of most practitioners, which is to find a particular style that works well and refine it, often revisiting the same subject matter from book to book. I pretty much know what I'm going to get in the next comic by Adrian Tomine, the Hernandez brothers, or even Chris Ware — though I love what each of them does. But Madden, even before *99 Ways to Tell a Story*, has approached each project as an opportunity to explore different styles, methods and even subjects. In this, he embodies the great New York poet Frank O'Hara's most famous line: "Grace to be born and live as variously as possible." (O'Hara came up numerous times in the interview.)

Experimentation and lack of consistency are not qualities that typically earn artists of any kind a huge following. But *99 Ways to Tell a Story* is not only selling well in the States, it has been published in translation in France, Japan, Belgium, Italy and Spain. An English-language edition was published

in 2006 in the United Kingdom.

Madden discusses his earlier minis, comics and graphic novels in some depth, so I won't go into detail about them here, other than to encourage anyone who hasn't yet, to pick up *Black Candy* (Black Eye Books, 1998), *Odds Off* (Highwater Books, 2001), and the two issues of *A Fine Mess* (Alternative Comics, 2002 and 2004), as well as to dig around for his work in back issues of *Rosetta*, *Hotwire* and *Top Shelf*. And keep an eye out this year for two projects he has been working on with his wife, Jessica Abel: *The Best American Comics 2008*, for which the two are series editors, and *Drawing Words and Writing Pictures*, a textbook for comics artists, the first volume of which should be out from First Second by the time this issue is being read.

I interviewed Madden at the couple's home in Sunset Park, Brooklyn, in October 2007. They were expecting their first child, Aldara Juliet Abel Madden, who was born the next month. Madden showed me the work that was being done upstairs to turn a small workspace into a baby room, and then gave me a tour of their upstairs office, their comics library downstairs and their backyard garden before we settled in the living room.

Madden is an expressive, if thoughtful, talker — had it been a bit later in the day, I would have suggested we move the interview to a neighborhood bar. As much as I tried to get him to talk more about his own work, I had the feeling I was hanging out with poet friends after a reading at the Bowery Poetry Club, with the conversation veering off to the aforementioned O'Hara, as well as numerous other poets, fiction writers, filmmakers and dozens of comics artists from every part of the world.

— Gary Sullivan

Transcribed by Brittany Matter, Kevin Kepple and Sam Schultz

GARY SULLIVAN:
I want to start out with a quote from Kathy Acker that you had in the Terrifying Steamboat Stories #3 *from 1994, which is actually pretty early to have gotten into Kathy Acker …*

MATT MADDEN:
It's actually fairly coincidental that that's there. I happened to be reading what is to date the only Kathy Acker book I've read, and that quote just caught my eye.

"I thought that people today when they move, move only by

car, train, boat or plane and so move only on roads. They perceive only the roads, the map, the prison. I think it's becoming harder to get off the roads." What book is it? Great Expectations?

Something about a runaway girl, the narrator is a teenage girl …

Oh, that's Blood and Guts and High School.

Blood and Guts and High School, that's what it is. But I knew more about her as a cultural figure than being familiar with her as an author. I knew that she appropriated other people's writing in her work, so I felt like taking a random quote from her book and sticking it into my story, even not being all that familiar with the book, and sticking it into my book seemed appropriate.

It makes sense obviously with the story you're telling, with the guy who's on the road, and this is a story called Off the Road, *which is told entirely from the guy's point of view.*

Yeah. There's actually an alternation in the point of view between first- and third-person depending on which page you're on. On the right-hand pages, you are looking through the car window through the driver's eye. And on the left-hand pages, you see external views of the car and the landscape.

So the left-hand side is all third-person and the right-hand side is first-person?

Yeah. At the time that I wrote this, more than Kathy Acker, I was reading a lot of J.G. Ballard and coming out of the college phase of reading William Burroughs and the Beats and stuff like that. But I was especially influenced by *Crash* and a lot of Ballard's more experimental stuff …

Just a fascination with the car …

Highway dystopia was on my mind.

A good portion of what you have done since then deals with the prison of constraints, let's call it. And you say you just pulled this quote randomly, but I wonder how much you've obsessed over this idea.

From "Off the Road" in *Terrifying Steamboat Stories* #3. [©1994 Matt Madden]

It's funny because the Acker quote is talking from a very different place and it's almost like the opposite of what I practice and talk about now — the sort of creative freedom you get from constraints. The Acker quote, and the reason I used it for that particular story — which is a pretty pessimistic story about people getting stuck in their lives manifested as an endless highway the character is unable to exit — is about constraint in the negative sense of restriction. It's about people who have no freedom and aren't able take the time to look outside the road that they are on. It's more of an oppressive flip side of constraint in the creative OuLiPian sense.

At the time I was working on this story, I was aware of [European experimental literary group] OuLiPo and constraint somewhat, but I hadn't really started to investigate it. It's before I started doing *Exercises in Style*, (but I had read Queneau and maybe *Zazie dans le métro*, as well) before I read any Georges Perec or other OuLiPo writers. Looking at it now it is clear to me that what made that story work for me and helped me to construct it, past the initial idea of a story about a guy who basically goes crazy and goes AWOL, were the formal constraints that I came up with — to tell the story alternating the points of view, the stylized, subjective view through the windshield, with the windshield functioning as the panel border which appealed to my impulse to make art self-referential: the windshield-as-panel reminding you that you are reading a comic and perhaps making you think about the frames through which you experience life, even the fold-out on the last page which reveals the ending — all those constraints and formal considerations helped me bring that story to life.

I never noticed that it's so regulated and you really do have an open space that's white on the left-hand side, and the windshield becoming the panel on the right-hand side.

And then the rearview mirror, which is a sub-panel within the panel and which becomes increasingly important as the story goes along.

This is in '94 and you were in Austin, Texas when you did this?

I finished it in Austin, but I think I started it when I was still living in Ann Arbor, Mich, It was the fall of '93 that I moved to Austin from Ann Arbor.

So you went to the University of Michigan?

Yeah, I did my undergrad. at Michigan in comparative literature and that's where I discovered a lot of the literature that's been a real source of inspiration for me, Julio Cortázar and Borges being two of the big ones from that era, the sort of Latin American fabulists that have been a big influence and continue to be. I'd actually transfered to U of M to major in linguistics and found it a very restrictive department. They were doing very empirical stuff that I enjoyed and liked doing, but I was interested in a larger idea of language and communication. That's what led me into comparative literature, where they were talking about some of the same ideas about language and linguistics and structuralism …

So then you went to Austin?

I graduated from the University of Michigan in 1990 and stayed there for another three years, working in a bookstore. Those three years were my self-imposed grad school for comics. Pretty much those three years were all taken up drawing and self-publishing comics, getting to know the rest of the world of comics and meeting other cartoonists and going to my first comics conventions.

I started getting seriously into comics around '89, and around that time, I got to know Terry Laban and Matt Feazell, who were living in Ann Arbor and Ypsilanti, respectively. I started hanging out with them right toward the end of my college career. For better or worse I got into comics just too late for me to really take advantage of it in school.

From the same story. [©1994 Matt Madden]

I didn't take any studio art classes or anything like that, and when I graduated, I found myself without those resources.

How did you fall into comics then? You weren't doing that as a kid?

No, I wasn't. I always drew a lot and doodled and stuff. I read comics occasionally. I wasn't a fanboy at all as a kid. I didn't read any superhero comics. The only superhero comics I ever read were when I was living in Paris when I was a little kid. I had these Marvel comics translated into French; it was like Daredevil and Spider-Man and stuff. For whatever reason, I had like two or three issues or paperback collections and I would read them over and over again. But when I moved back to the U.S. in 1976 and I was 8 years old, it didn't occur to me to continue that.

Why were you guys in Paris?

My dad is a retired lawyer. He worked for an international corporate law firm that has an office in Paris and basically finagled a transfer because he and my mom thought it would be fun to live over there for a while.

I thought you were born in New York.

I was born in Manhattan. I lived on the Upper East Side. My mom grew up there. My dad's from Boston, but my dad went to Harvard Law and started working in a firm in New York. My mom was a summer intern there. They fell in love and got married in 1966. I was 3 when we got transferred to this Paris office, and we lived there for five years, and then came back in 1976. Since then, my parents have lived in Greenwich, Connecticut, the swanky suburbs north of here.

So going back to Michigan, obviously you were publishing stuff there because this is Terrifying Steamboat Stories #3?

Yeah.

This is offset. And this is very nice paper on the cover and it's printed in two colors.

Yeah, in retrospect I should have stuck to photocopying longer. I was excited about the idea of the little art books. The very first *Terrifying Steamboat Stories* was just black and white, but I had it offset, because I wanted to get a good cover and had it stapled by the printer. And the second issue is when I started doing a second color on the cover. The second, third and fourth issues all have cardstock and one color on the cover, and tinted paper and stuff. Looking back, I wish I'd been less precious about it and had just concentrated on the comics themselves. Number 3 was worth it because I wanted to do this foldout thing and either I was going to do

100 of those by myself and kill myself or just shell out and it would pay off in the long run. I mean the foldout that's the climax of the "Off the Road" story. To do that and make it work and line up too, I figured it was definitely worth it to me to get it trimmed. (It never did pay off in the long run, though: I still have a pile of them lying around!)

Completely abstracted road here. So you moved to Texas to go to grad school?

I actually moved with my then-girlfriend who got into graduate school in paper conservation in Austin. I was just ready for a change and we'd been going out for a couple years and it was going well, so we decided to just move together for the change in location. Which didn't really work out for the relationship, but it was ultimately a great move for both of us in our own ways, I think. We were together another year or two, almost two years from when we moved there and then we broke up and I stayed on for another two more years until I met Jessica in 1997.

You told me once that you were hanging out with somebody doing comics then.

I've been lucky to find cartoonists to hang out with everywhere I've lived. In Ann Arbor, I ended up at this weekly comics group that was really great. The first real cartoonist I met was Terry Laban, who was then doing political cartoons for the Ann Arbor newspaper. I initially went to see him to

From the exercise in style "Madden/Queneau" which appeared in *A Fine Mess* #2. [©2004 Matt Madden]

get him to do a button design for WCBN-FM, the University of Michigan radio station which it turned out he listened to all the time. So he did his little button for our annual fundraiser. When I told him I was interested in doing comics and stuff, he loaded me up with a bunch of minicomics and *Factsheet Five* which was like the Internet in one little monthly catalog. So, he turned me onto that and a bunch of other stuff. Pretty soon he introduced me to Matt Feazell who was then living pretty close by in Ypsilanti, Mich. They used to hang out once a week at one of their houses or at a café and they invited me to join them. We would draw in our sketchbooks and doodle and talk about comics.

So these guys dragged you into the comics world?

Yeah, very much so. Terry and Matt did a joint minicomic called *5 O'Clock Shadow* for the Chicago Comicon in 1989 or so and Matt and I went on to use that title for an anthology that was reasonably well-known in the minicomics scene of that time. (I understand it still comes out now and again.) That Ann Arbor/Detroit scene expanded over the years with various younger people coming along too, so by the end of my time in Ann Arbor, Terry had moved to Chicago and the nucleus of the group was myself and Matt Feazell and Sean Bieri, who's really great, a very underexposed cartoonist. He does a thing called *Jape*; it's a hilarious minicomic — he's one of the funniest cartoonists out there. They're still hanging

out weekly and doing comics in Detroit.

When I moved to Austin, it took me a while to get the lay of the land but I knew that Roy Tompkins was there. He was doing *Trailer Trash* at the time. We corresponded a little bit when I was in Ann Arbor. In fact, he used to do a little broadsheet called *Fruit of the Tomb* and he was one of the first people to ever review a minicomic of mine. Right when I moved there, Roy was going through a divorce so I didn't see him at all. We talked on the phone maybe once when I moved into town and things were too crazy for him. I didn't even meet him for another two years. But meanwhile, I found out that there was this other group of cartoonists basically my age: Tom King, Jeanette Moreno, John Keen, Walt Holcombe …

Walt Holcombe I know, but not the others.

They all did comics in the *Daily Texan*, the University of Texas student paper, along with Chris Ware when he was still there. They all had different strips they would do. When I met them, Tom and Walt were doing a series of pamphlets and anthologies, the two of them together, *Love and Rockets* style. They did one called *Pal-Yat-Chee* and they did one called *Golem*. They did a couple issues of each I guess. Shannon Wheeler was in town at that time and all of them were doing an anthology called *Jab* for a while before I got there. After a while, I fell into a rhythm again of doing the weekly

From the titular tale in the *Enchanted Rock and Other Early Comics*.
[©2003 Matt Madden]

comics night out with that gang, usually at a bar. We would make these crude little minicomics that were inspired by the stuff that the Chicago crowd was doing at that time: Chris Ware and Dan Clowes and Gary Leib and maybe some others would do these really revolting little jam comics and the Austin gang was following suit when I met them. The format was kind of novel: a single piece of paper folded up into eight little panels. You do a cover in the middle, draw on each page and then you print them up and you make a slit in the middle and you fold it out from the middle and make a 4 ¼" x 2 ¾" booklet — sort of a cross between an accordion-fold book and a cooty-catcher.

Everybody was contributing to this?

Yeah, it was just a jam comic. It wasn't even comics really, they were just funny drawings. The gimmick was that each one would have a title and usually really offensive ones like, "Smelly Homeless Guy" or whatever. *[Sullivan laughs.]* Or "Fat Santa" and everyone would do just some riff on that idea. It's not my strong suit. I've never been a gag-cartoonist guy, so it was fun to do, but I mainly went to hang out. Tom and Walt — Tom especially — always had a zinger for every comic, they were just able to crank out these hilarious and beautifully-drawn drawings one after the other, it was impressive to watch.

So you guys weren't bringing in comics you were working on?

Not so much. I always wanted to do more of that, but it

wasn't "let's critique each others work" it was much more like, "let's hang out and make funny, offensive drawings." We would certainly talk about comics and stuff we were working on. But no, we weren't really showing around new work all that much, which I kind of missed.

Mack White was not a part of this?

No. We all knew him and he worked on campus, so we would see him occasionally. But he wasn't a part of hanging out. He had a teenage kid …

He's older.

… and was going through his own divorce *[laughs]* at that time too, so it was a complicated time. Eventually, Roy recovered from his situation and he started hanging out regularly. I became quite good friends with him and Penny Van Horn when I met her. Probably at some comics party. We had quite a lively social life going on, especially after I broke up with my girlfriend. Roy and Penny and I would go to parties together a lot and misbehave. It was a bit like a second and more fun college partying experience … Some of that stuff wound up in *Odds Off* and "Night of the Grossinator" in *A Fine Mess* #1. "Edie" is a thinly disguised version of Penny, and I hope my affection for her comes across in those stories. (Extra trivia: There's a dance party sequence in "Night of the Grossinator" and the first panel on that page (21 in *AFM* #1) is based on a photo of Roy and Penny dancing at a party at John Keen's house, and that's Walt in the background.) Anyway, Penny didn't come out for the weekly thing very often: another divorcée with a kid! There were all us young guys and there was this slightly older generation that were all divorced with children — although Roy doesn't have kids.

So this is your future? [Laughs.]

I don't think so! Pretty soon it developed into this pretty rich community of cartoonists that I knew. There was a guy named Josué Menjivar who did *Broken Fender* for Top Shelf. He appeared out of the blue one day. He and his then-girlfriend were traveling around the country in a car looking for a place they wanted to live and they settled on Austin. So we started hanging out and he and I would go to cafés and draw in our sketchbooks. That was a much more intense talking-about-art kind of friendship. There was a brief sort

of golden period when Tom Hart moved to town because his girlfriend was an anthropologist spending a semester or year at UT and he came along. Around that same time, I got to know Warren Craghead.

He was also there?

Yeah, yeah. So it was like this period where there were lots of people there doing really different stuff — from Tom and Walt doing this crazy, funny stuff to Warren who was just starting to do his *Speedy* comics, that were the beginnings of

a more poetic style.

Speedy *comics?*

Yeah, most of his earlier comics would have this almost Chris-Ware-like little potato-head guy. I think he probably still does it, but as he expanded his palette, he stopped relying on that. I'm talking about the first few books that he did. And around that time is when I did the 24-hour comic *First Warning*. That was in '95 or '96, I think. and Tom Hart — who had already done two or three of them — and Warren Craghead and Josué Menjivar all got together at my apartment — it must have been '95 because I was still in my first big apartment (which is the model for Shirin and Morgan's apartment in *Odds Off*). That was really fun. It's that kind of friendship with cartoonists that I really thrive on: hanging out and having fun but also talking about our goals and what we're trying to do, looking at each others' work and talking about it.

So how long did those guys stick around? Was Tom there one year?

Tom ended up being there for just about a year. Warren left right after he graduated so we hung out like three or four times — he graduated, then he was gone.

But you've seen him…

This page: From Madden's sketchbook, courtesy of Madden. [©2008 Matt Madden]

Oh yeah, we've stayed in touch. He actually just wrote the other day to see if I knew anyone who might be going to a comics convention he was invited to doing something in Portugal. Yeah, I have stayed in touched with almost everyone from that time. Pretty much everyone has dispersed. Roy and Penny are still in Austin. The reason you haven't heard of Tom and Jeanette is that they've moved into animation. They have worked on *Futurama* and a bunch of different stuff. They were doing that when we were in Austin. There was this little animation studio that they were working for. Walt also went to L.A. and is doing animation-related stuff, although he briefly had the *Poot* series at Fantagraphics.

Maybe it's too soon to jump into Odds Off, *but this seems like a totally different crowd than the crowd that's in that book. Is* Odds Off *based on people that you knew like the Iranians…?*

Not really. The Iranian character, Shirin, is visually based on a woman I kind of knew from the University scene, but just visually. I didn't really know her. The characters are basically entirely made up in *Odds Off*. The thing is, I was hanging out with cartoonists but I also ended up getting a master's degree in foreign language education, so I was definitely steeped in campus life. On top of that, I was regularly hanging out in cafés and going to see a lot of rock shows in the evenings, so I had a pretty broad spectrum of acquaintances.

Where did you get the info about the Iranian New Year?

That comes from another friend of mine (who has a brief cameo towards the end of the book). The characters are made up and a lot of the situations and places are real Austin events and settings. That scene at the end of *Odds Off* that you are referring to takes place during NowRooz, which is the Persian New Year. And I did go to a celebration one year, probably '96 or '97, with my friend Lili, who is Iranian and whose family has been living in Austin since the revolution. She told me all about it and dragged me to this thing one evening and it was a lot of fun and fascinating to observe. I wanted to use that experience in the book, because there are a bunch of little vignettes, like the one about the character Chad who has hidden a box of white wine in the kitchen away from the more fundamentalist of the group. A lot of that dialogue is transcribed pretty directly from memory. I wrote it down in a sketchbook the night after we went to that event. The Persian Student Alliance are doing this Now Rooz celebration, but then they are trying to explain what all the different things are and what they all mean and none of them can quite remember: "Well I think that's long life and the goldfish …" In a way, a germ of the story, a real theme of the whole book, at least for Shirin's character, is her ambivalence of being neither American nor fully Iranian. I went to the event not knowing anything about NowRooz. I just took down what people said and later on talked to my friend and did a lot of research online and figured out more exactly what it is.

Where did you come up with the idea — this guy basically has a social disease …

Shirin from *Odd's Off*. [©2002 Matt Madden]

Word lice. *[Sullivan laughs.]* I don't remember exactly how I came up with it. It's just from an old sketchbook. I write that kind of stuff all the time, little notions. Sometimes it's a misunderstanding of something that produces a funny idea. I think that just occurred to me, the idea, the difficulty of writing manifested as an actual physical disease, sort of itchy writing, actual lice that are infesting your writing. *Odds Off* was written that way a lot. I had a lot of just notions lying around that I wanted to fit into some larger book. I didn't think, "I'm going to do a story about a break-up" or "I'm going to do a story about this one character." There were just a bunch of conceits and individual scenes. There were basically three ideas in my head. One was the NowRooz meeting and I liked the idea of this ambivalent, very modern, American character who's also a foreigner and is stuck in between and a bit of ambivalent about that. The French lesson thing was another idea I was obsessed with. That's actually based on the Yale University *French In Action* TV program. I got a lot of comments from people who've read this book and who've seen that series of instructional videos which used to run on a cable access channel in Austin.

But there is a fascination with the Other that must have been either alienating to comics readers at the time or refreshing. To me, it was refreshing. It kind of mirrored my experience in San Francisco in the '80s because there were a lot of Iranians in San Francisco during the Iraq-Iran war.

That became clear to me as I was thinking about the Iranian thing on the one hand and the French language and learning another language. That became some key connecting those things. And then connecting those by making the two characters with these different concerns a couple almost suggested that it would be a relationship that wouldn't work. You have these two ambivalent — well, one ambivalent character and another character who is stuck in a fantasy land, like a Francophile fantasy, an escape from reality in some ways. The hardest part was fitting in the "word lice" concept, of a writer who is blocked so severely that it is manifesting itself physically *[Sullivan laughs]*, but it seemed to me that there was some connection there too, that that was some alienation — this is all about communication as well: language, cultural communication and then writing. That started to suggest a love triangle situation where the writer, Lance, and I can't remember how this configuration quite came about, but I just came up with the idea that Lance would be gay and develop a crush on Morgan who is the

The NowRooz celebration in *Odds Off*. [©2002 Matt Madden]

boyfriend in the relationship.

When I was reading this the other night, I noticed that everything was constructed at the level of the page. Most of the transitions happen from page to page, and while some are several pages long, you don't break any scenes in the middle of a page. That seems like it was thought out in advance.

Yeah, it was deliberate. It was very much written in terms of pages and scenes, there's not too much where I thought about the two-page spread, because when I was writing, I was shuffling scenes around a lot and I knew I basically wasn't going to nail it until the very last minute — I couldn't say for sure what pages were going to be facing as opposed to back to back.

Since it's episodic, I guess it doesn't really matter, right?

Exactly. It's episodic and I wrote it by carrying a three-ring binder around that had my thumbnails in there broken down by scenes and eventually I figured out how many chapters there were going to be, and as I would go, I would be like: Well, here's a scene with Lance, and here's a scene with Shirin, and in the middle, I needed some scene with Morgan to bring us back to him. But I don't know what yet, so I would stick a piece of paper in there saying, "Do a scene with Morgan." Sometimes that would end up being a one-page vignette and other times it would expand into a larger, five-or-six page scene. That's how it grew that way.

In terms of thinking about page composition and how the book was going to look, I had to keep it flexible that way so things could be either single pages or discrete scenes. The way I think about comics, it always seems to me that the

Panels from the Francophile fantasy sequence in *Odds Off*. [©2002 Matt Madden]

page is such a convenient and natural place to start something new. I pretty much always start a scene at the top of the page. To the point where it actually shocked me when I was talking to Jason Little about it once — it might have been when I showed him an early draft of this and he was like, "I notice you always start your scenes at the top of the page. That's weird, because I always do scene changes in the middle of the page." He had a totally opposite theory about it, because it's the top of a page and you don't want to break that rhythm of the reading, I guess, so you should introduce a new scene in the middle of the page. Which I have thought about and I think that's valid, although I still prefer to use the page for scene breaks.

But I've read this book three or four times and I didn't notice it until the last time. Which was literally about a week ago. I wondered if you were thinking about constraints at this point, but it sounds more like this was a practical decision.

Yeah, I wouldn't call it constraints except in a more general sense of a working method. It's a rule that I followed, in the sense that I tried to be pretty straightforward in the rhythm of the storytelling here and I followed a nine-paneled grid pretty clearly and I was concentrating on creating a compelling and seamless narrative. I think of *Odds Off* as like a masters thesis or something, I really wanted to concentrate on the structure and rhythm of storytelling in comics, and develop my drawing skills — as a self-taught artist (like most cartoonists) I've always felt like I'm playing catch up. So to do that, I felt like I should do something that was more conventional than I

necessarily wanted to do in the long run. I struggled with it and I still look back and sometimes think I should have done something more radically experimental with it.

With this?

Yeah, but I also thought this is sort of like my "straight story" …

It's funny you call it a straight story, because it's totally not the story you would get from anybody else. You're doing things here, for instance where Shirin comes home and she tears her skin off and by the time she gets down to the bed she's just nothing but bones. I don't know if you've read Richard Brautigan, but he'll take a metaphor and run with it, take it to its logical conclusion, which you do there. And the "word lice" thing is also…

A variation on that. I don't mean to downplay the sort of playful and experimental aspects in there because they are certainly there. At the narrative and character level, it's an episodic structure, but I tried to give it a satisfying, traditional arc where you have these characters in the beginning, each of them has a problem and by the end of the book it's in some way resolved. I still wanted to keep it subtle and avoid melodrama so for instance the ending is … slightly open.

You also left the page open. In a way it is ambiguous and I think it's meant to be ambiguous. We assume these people are breaking up, but at what point? They're not going to break up tonight, obviously.

A definitive turn has been taken and how it's going to play out isn't all that important.

How did you get this guy's hair to look like that? What did you do?

The character Chad has this shaved very close-cropped hair, a little shorter than a crew cut, like stubbly hair and again visually more than personally based on a guy that I knew briefly, another Iranian student at UT and he had this great look, this sort of expressive, bony face and this close-shaved head with a very dramatic widow's peak. I wanted to show that visually. Crosshatching it would look too much like thin hair. I didn't want to actually stipple it.

Around that time I was looking at these Alberto Breccia comics. He's an Argentinean cartoonist who's still way, way under-appreciated in the U.S. Fantagraphics did *Perramus* back in the late '80s and that's one of his few appearances in English. Not even one of his better series, I don't think. He was really one of the first cartoonists to really start to play around with mixed media back in the '60s. My friend Fabio Zimbres sent me a cheap Argentinian reprint of a really interesting1960's series called *Mort Cinder*. Breccia did some stuff in there that I love. Sometimes I find it a little over-worked to be honest, but he did a lot of stuff with sponges and rags to get all these cool textures on the paper. So what I did there was to take a rough cotton rag and dip it in ink and that is that pattern you're getting. You can see more clearly in the opening pages: There's a scene where they go to a party

in a warehouse, the New Year's scene — the only other place I used it was for the concrete walls there. I varied the density of it by dabbing at the rag. And then I used a Liquid Frisket, sort of latex-y masking fluid to mask off the head, so I could keep it inside the lines.

Yeah, it's a great technique, and it's so subtle…

It's subtle and works well for the book. I don't really like doing that stuff too much. I like trying to keep it pretty simple.

You seem to have a natural gift for characters. There really is no story, but it's a totally compelling book, largely, I think, because of how compelling these characters are.

Yeah, based on people's reactions to my work I've come to the conclusion that I have a way with characters that have this palpable warmth to them. Which is a good thing. It's my secret weapon as an experimental cartoonist in a way, because I've done stuff that's more arch in its structure, in its formalism. Something like the "U.S. Post Modern Office Homes Inc." story, for example, that was in *Rosetta* [Vol. 2], if the characters were very like stiff, Robbe-Grillet type of characters with no interiority that were just sort of pawns in my narrative that I was developing, it might thoroughly alienate more readers than I wanted to. *[Sullivan laughs.]* I want to do experimental stuff and challenging stuff, but I don't feel like that requires alienating readers. So this thing

Lance struggles with a textually transmitted disease in *Odds Off*. [©2002 Matt Madden]

I have that seems to come pretty easily to me, imbuing my characters with a bit of something recognizably human, something you can relate to or react to, I think serves me well as an artist.

A lot of artists — probably the majority of storytellers — they want to explore characters. That's a classic reason to tell stories. But it's not my motivation. My motivation is — there's not just one, but to generalize — I come to art of any sort because I like the medium, the form and the way that it works. The characters and who they are and what they do is in a lot of ways secondary to the story I'm telling and the way I'm choosing to tell it using the tools of comics. But that doesn't mean that the characters aren't important; that just means that they're …

It's not like you have to really separate it out.

I'm not sure if you can, because if I put it very bluntly, I'll say I'm a formalist — I'm interested in the form of stories. But you can't divide that entirely from the content of the story and the characters you're creating and the narrative arcs that they're going to live out, whether you try to give them one or not.

Forms are part of life. That's the thing. So, in another piece that I just reread this morning, "U.S. Post Modern Office Homes Inc.," I realized that the first time I read it, I didn't realize that there were so many weird sub-constraints within the piece. The title obviously comes from the U.S. Post Office and Modern Office Homes Inc. being next to each other and then reading them straight across because that's how the signs are on the buildings …

As we see on the last page.

As revealed at the very end. But obviously it's a postmodern romp, as we use to call experimental novels in the '60s. But in the beginning, this one's an obvious constraint using the letters "U" and "S." Each of the pages begins with a portion of the signage and you add on a little bit more as you go along.

One word at a time and then two words at a time.

On the first page, every word begins with either "U" or "S,"

Opposite: One of the more surreal sequences in *Odds Off*.
[©2002 Matt Madden]

From *Odds Off*. [©2002 Matt Madden]

except for a few words like "and" or "the" or whatever.

Some of the objects, too; like, there's an umbrella stand.

Umbrella stand, and what else have we got here? How deep did you go in with that stuff? The snail is obviously — slugs and snails are "S"s.

You just saw the "U S" on the newspaper down there.

Right, the stars-and-stripes tie. So you're adding as many things as you can.

Right, U.S. as in U.S.A., but also as a generalized acronym. That's where the American flag came in, which became a theme throughout the whole book.

What is the motivation to do something like this? In other words, do you start with the idea that you've got these signs — you saw this sign maybe somewhere in reality and then decided to build a story around that?

I don't think I saw it. I think I saw a similar situation where there were two signs next to each other that suggested you read them in a similar frame. I think I came up with this one on my own. You know: Can I think of two signs that might make an interesting combination? And that was the kernel of it. Again it was just one of these little sketchbook things that I jotted down at some point. Oddly enough, this comes back to J.G. Ballard in a way, too, because, in *The Atrocity Exhibition*, there are a couple of stories where he'll have a framing sentence, like "the blood splattered on Jackie O's pink dress in Dealey Plaza," but then he'll break each of those phrases down and use them as a heading for a paragraph of the story. You'll see that line and then you'll have a couple of paragraphs of texts in the middle. Say, "on Jackie Kennedy's pink dress" in black bold and then a chunk of normal text, which may or may not refer to the "header." So he's creating a kind of two-tiered work …

It's an overlay.

So, the idea here was that I'd do a similar thing where I'd take each of these words and make it a title of a one-page comic. It's almost like you're going to be reading a collection of one-page stories. And that was my starting point. Then I decided that each of those pages, whatever stories in there would have to come out as much as possible just from that key word at the top of the page, "U.S. Post" or whatever. So a couple things suggested themselves pretty early: obviously the post office and real-estate office …

Now those become the settings by default?

Didn't necessarily have to be the settings, but it seemed like that would be good and I could just have a character who works at one of those places. I came up with this character, Stacy — I don't remember how — she just developed from sketching and thinking about the character that we're experiencing the story through. In a way, all of this is in her mind. That's a postmodern idea in the philosophical sense that she's creating her identity every day; every day is a new identity for her. Early on I thought it might even be that you could read these pages either as a sequence of days or as the same day refracted through different ideas she has about

This spread: Panels that were scattered on the front and back covers of *A Fine Mess* #2: when they are put in this sequence, they appear to be in conversation with one another. [©2004 Matt Madden]

it. As it developed, it became more clear that it actually is a story that happens over the course of a few days.

How did you come up with the real-estate owner, Rich Homes?

At a certain point, in thinking about real estate and what kind of characters to stick in the story, I remembered there's a famous '70s porn star — I think it's Harry Reems, you know, a John Holmes-era porn star — that I've read more than once has retired and become a born-again Christian and moved to Florida or something and become successful in real estate. I loved that idea: The porn industry is so completely separate from the rest of the economy, it's weird to think of it being just one of somebody's many jobs. "Oh, I worked in porn for a few years …" *[Sullivan laughs.]* That's again one of those sketchbook notes that I've had lying around for years, and that bubbled up at one point and seemed like a nice detail to send this thing in another direction.

It was a pretty quick jump from there to having Stacy, this androgynous-slash-asexual-seeming young woman figuring out that her boss is a retired porn star and becoming increasingly obsessed with the idea of …

We get more and more crotch shots of Rich Holmes here. The Post page is pretty clear: You've got Post-it notes, you got the Daily Post *here, you've got Stacy talking about …*

Her boss's ass. They're talking about his posterior. It's also a post-work drink.

So basically, as much as you can cram in there that's referring back, as though radiating meaning …

Yeah, although the approach varies. They're not all just based on riffing on a word root like "post." On the next page, for instance, "Modern" is actually a very shorthand attempt to cover the history of modernist art and literature in one page. So it goes from Seurat, kind of an impressionist, pointillist thing, through Munch to cubism, dada, surrealism, Rothko and Jackson Pollock. And the text goes from Proust up through …

Oh, I didn't realize the text was also…

Yeah, that first line, "For a long time I've been getting up early" and so on. That's a riff on the opening line from

From "Night of the Grossinator" in *A Fine Mess #1*. [©2002 Matt Madden]

Remembrance of Things Past. That sort of pastiche, I mean, it goes on — and I feel like I'm even forgetting who I was trying to channel in these next panels — "Increasingly the urge comes to analyze ..."

" ... *divide up, rearrange and otherwise reimagine the elements of a day* ..." *Which I just thought was a comment on this image.*

It is a comment on the process of cubism, but it's also about the story itself and about Stacy's imagination, the way each page in this comic reimagines her situation. Which then ties into the Beckett-influenced notion, "I can't go on. I must go on." — pointing out both the basic futility of all ventures yet also the need to act

So why stop?

Yeah, why stop: Obviously, keep going. *[Sullivan laughs.]* In the end, because of the Pollock thing I tried to channel into Frank O'Hara and that exuberance of his. O'Hara and Kerouac, this sort of Beat, what does she say at the very end?

"I love them, I love them both." She's talking about things like, "a whirling slot machine and I don't care if it comes up cherries or bananas, I love them, I love them both." Which sounds like a Frank O'Hara line actually.
And actually, when I was reading Odds Off *my first impression of the gay Iranian guy was that he looked like Frank O'Hara to me. And I was wondering if that was intentional,*
because O'Hara comes up in another piece that's set in Austin, I believe.

It's "Night of the Grossinator." There's a reference to the Lana Turner ...

To O'Hara's "Lana Turner has collapsed!" poem?

Right. Frank O'Hara is probably the first poet that I got really connected with, and this is only six or seven years ago when I did that. (By the way, he's not the visual model for Chad in *Odds Off*.) Somewhere I came across a copy of *Lunch Poems* and I was just like, it's a small book of poetry; I'll try it. And it really sucked me in. I read that over and over again. Frank O'Hara is an inspiration not just in that I like the poems, but that exuberance and that kind of spirit of his work is something that I aspire to. Spinning fantasies out of daily life, that's a theme in *Odds Off*, as well, like you were saying about the Brautigan thing about extending metaphors, taking the very, mundane stuff of real life and O'Hara's walking around New York, just letting his reverie take off. It's this joy for ordinary, everyday life that really appeals to me.

It's also self-mythologizing.

Right, that too.

There're many, many imitators in New York now doing that. Moving on to the "Post Modern" page, obviously this building is a total postmodern mess, and it's hilariously so.

Well it's kind of a McMansion from hell, and I used the Frank King technique of the panel grid dividing a single scene into multiple panels and I made each panel a different and very incompatible architectural style: a turret, modernist, Southwestern adobe, Tudor and so on.

But what is going on in the "Office Homes" page? This is where I got lost with how the titles are supposed to match up with the action and details on the page.

"Office Homes" is the most loosely applied one where it's — at that point really the story had to take precedence. But the way I thought of it is: Here the office and home distinction becomes blurred, because she's bringing her personal life into the office and basically makes a pass at her boss. So the constraint there wasn't rigorous, but it worked thematically. And then "Homes Inc." is the story of Rich Homes, and the name refers to Rich Homes as a kind of one-man industry — "Rich Homes Inc." — and his story of going from being a deadbeat kid to porn star to fallen man to born-again Christian and real-estate business leader.

So when was this comic done?

Four years ago, I think I finished it probably in 2003.

The Odds Off *book, even though it is about Austin, was drawn in Mexico City. So let's talk about how you got to Mexico City, because I'm assuming you went there from Austin.*

After five months in Chicago, and that's because of Jessica. You know the whole time I had this group of cartoonist friends, both in Ann Arbor and Austin, I also, from the very beginning, dove right into the self-publishing and correspondence minicomics and fanzine scene. I had a lot of correspondence over the years and traded comic books with people through the mail. Then around '95-'96 e-mails started to become more common. By that time, I ended up getting a masters degree at U.T. in Foreign Language Education.

Like an ESL teacher.

Yeah, as an ESL teacher. I was working as an ESL teacher full-time for my last couple years there.

That's where some of this stuff comes from then? Like the interest in Others in Odds Off.

Yeah, it plays into it. Again, language and communication is a theme throughout my life and interests. I studied a lot of foreign languages, I did linguistics for a while, and teaching English as a second language, any variation on that is interesting to me. So anyway I had e-mail access for the first time and I was playing around with it and got in touch with Jessica Abel, who at that time was in Chicago and we had traded stuff in the mail, in fact, I threw a little plug for *Artbabe*, the self-published version, in *Terrifying Steamboat Stories #3*. In 1993 on my way to move to Austin, I stopped off in Chicago for a night or two and it happened to be the weekend of the Chicago Comics Convention. I went and one of the things on my checklist of things to do was to meet Jessica. I found Terry Laban who was living in Chicago at the time and I was like, "Hey, I want to meet Jessica Abel" and he's like "Oh you just missed her." So I didn't meet her that time, which we both agree is a good thing — we weren't ready for each other yet!

Another couple years passed, and she had a comic in *Pulse* magazine, where I had also done a couple things for that back-page music comic, Flipside, which was a great little venue for cartoonists for the years that it was going on. Somehow I got her e-mail, probably from one of her more recent minicomics at the time. I think she had started pub-

From the same story. [©2002 Matt Madden]

lishing at Fantagraphics by that point. She at least had done her Xeric Grant book.

So I sent her e-mail, as I did with a lot of other cartoonists: "Hey, I saw your thing in *Pulse*; it was pretty cool." From that, we just started chatting over e-mail about comics and then pretty soon about both being single, we both had gotten out of relationships in the last couple years and stuff, so we sort of commiserated about bachelor life. It developed into a playful and increasingly flirtatious correspondence to the point where — it started in late '95-'96 — it got to the point where by the spring of '97, it was clear that we had to meet in person and either nip in the bud or see if it was something real. So in March of '97 I flew up to Chicago and Jessica met me at the airport and we went straight to the airport bar and drank a bunch of bourbon and then *[Sullivan laughs]* spent the weekend together and had a great time.

And in retrospect, I've realized how lucky we were, since correspondence-based relationships, as you know, generally don't work out, it's too easy to build up myths about yourself or just plain lie. We had nothing to hide and we were always very straightforward with each other. So there were no unpleasant surprises. But still you never know, personal chemistry ... As it turned out, we had it, and within two months we were going to Mexico together, on vacation but also very much with the idea that we should scope it out as a place to live. We both had been talking about moving, but also leaving the country and trying to live abroad for a while. Part of my plan of teaching ESL was to be able to go abroad and travel around.

We went to Mexico City and Guadalajara and we both really liked Mexico City, although it was kind of scary and overwhelming. And basically we decided on the spot: "All right, a year from now we're going to move here."

In the fall of '97 I went up to Chicago and taught ESL for a few months there while we got our affairs in order and then we moved to Mexico in the spring of '98 and lived there two years. We showed up without any real game plan, we had our passports and money saved up and just figured we would look for work when we got down there. And I ended up teaching, more or less lucrative but boring one-on-one classes with Mexican lawyers — tutoring English, more tutoring than teaching. An occasional teaching job came along, but it was so cheap there at the time that it was enough to support us.

Meanwhile, Jessica ended up doing a lot of comics and illustration stuff. She did the *Radio: An Illustrated Guide* comic with Ira Glass, which also worked out because it meant

they flew her back to Chicago once or twice to do research stuff. I actually had a working visa while I was there but she was there on a tourist visa, which meant she had to leave the country every six months. As it turned out, at least every six months of the two years we were there, she had to go back to the States anyway, usually being flown by one or another job. You're only supposed to do that twice or something, but they don't check that in Mexico; you really have to overstay your welcome to get the Mexican government mad at you about that kind of stuff.

We felt busy at the time, but as I look back now, it was such a laid-back period of our lives; we'd go out every night if we wanted to. We lived in a nice area where there wasn't a lot right near us, but we could walk for 15 minutes and there would be lots of restaurants and bars, and we had pretty good friends — a few ex-pats, but mostly Mexicans and other Latin Americans that were living in Mexico City —

From "La Mulata De Córdoba: a Colonial Legend" in *A Fine Mess* #2.
[©2004 Matt Madden]

writers and DJs and a pretty interesting group of people.

You mentioned that you had sort of moved away from the ex-pat community there, because they weren't really integrating so well with the local culture. You were actually publishing some stuff through Mexican presses, right?

Right. The other thing is that the ex-pats we met were mainly journalists and a few other English teachers maybe, but the Mexicans we were meeting were involved in publishing and they were writers and publishers and artists and stuff. That pretty soon led to getting invited to do some comics stuff and drawings for some different magazines.

My first thing that was supposed to be published in Mexico was called *Así Pasan los Días (So Pass the Days)*, which is a line from the song "Quizás, Quizás, Quizás." That was actually originally intended for some magazine that was going to be a neighborhood arts magazine that was never actually published, but it was going to be in color, so I did the whole thing in color, I did watercolors over the original line-work, only to then find out that it was never going to get published at all in the full-page format, or in color. I turned it into a minicomic and later it turned up in one of the Top Shelf anthologies.

So there were various opportunities coming up. We also had some friends that worked at more of a kind of fashion magazine called *Complot* that was kind of like fashion spreads and culture stuff — but mostly written by members of Mexico's literary underground scene — and was actually sold at major magazine stores around the city. I had some comics and illustrations in both of those.

Another thing is: In Austin and Ann Arbor, I didn't really know other kinds of artists; I knew other cartoonists. I didn't really meet that many people who were doing other stuff, and if I did they weren't really interested in comics and sort of looked down on it. But in Mexico I found a very different attitude about comics, which in retrospect I wonder if maybe I'm not romanticizing it a little bit. But it seemed to me like when I met people at parties and gallery openings that I went to, there wasn't that kind of raised eyebrow or recoil when I would say, "I do comics." It was more like: "Oh, that's really cool," and, you know, they would ask me questions about it and be really interested.

Is there much of an alternative comics community there?

Well, not really, especially when you consider how big

Mexico City is. There really is very little comics community in Mexico in general. It's got a great tradition up until about the '50s, of comic books and newspaper strips and stuff that is this great treasure trove waiting to be rediscovered, but since the '50s it's really been something of a desert. There're a couple of popular strips that are pretty decent but very little alternative or underground scene to speak of. There's some political cartoonists who do comics on the side like El Fisgón and Manuel Ahumada. In fact I wrote a review of a book by Ahumada called *La Vida en el Limbo* (*Life In Limbo*) for *The Comics Journal* many years ago and I can't remember if it was ever published or not. I never even met most of these guys. They were a bit older and probably they were seeing the French *Heavy Metal,* being influenced by some of the European stuff and stuff from Argentina, which also had a big comics scene for a while. So, it's a small scene in Mexico City. There's a magazine called *El Gallito* that might even be still coming out. It was this newspaper compendium of a mixture of young Mexican artists doing, more or less, alternative fantasy comics. And then there're in reprints of European and Spanish artists, all in black and white on really cruddy newsprint, and each issue had a really ugly cover, like the worst *Heavy Metal* cover you can imagine *[Sullivan laughs]* month after month. It came out irregularly, but apparently some artist had just dropped off like 20 paintings one time. Like, "Here, these can be cover art." And the publisher was like, "Yeah, sure," and he still hadn't run out of them by the time we left Mexico. Like *Heavy Metal* (at least when it was better), the covers didn't really reflect the variety and interesting stuff that was actually inside.

There was one studio of artists that were associated with *El Gallito* where they would meet and draw and stuff but we never got to know them all that well. That has since disbanded, so, it really is a pretty small scene there. Although there's some new publishers in Mexico, so we'll see what happens in years to come. Hopefully, there will be some stuff to report about there.

But somebody published this Sayonara *book.*

Yeah, *Sayonara* was part of the ambitious publishing project I was involved in while I was there. That was with these guys from the studio I mentioned, the Taller del Perro, and a roommate of a friend of mine who worked in publishing, who was an editor and publisher. We had a couple meetings and decided to do a series of minicomics called La Corneta, but get them published, you know, offset-printed, and have

From *Sayonara*: Madden's version of Parque México. [©2008 Matt Madden]

a series look to them, with cool, silkscreened covers on silver cardstock. We started out with Mexican authors and myself but with the idea of eventually making it an ongoing series and inviting other cartoonists from around the Americas, if not around the world, to contribute. The comics would either be wordless, such as in the case of my story, or we would have translation inserts so that we could sell the stuff in the U.S. and get it distributed.

Anyway, it was a big disaster logistically. Everyone drew their comics and we got them printed up, but that was about it. And at that point there were all these plans to get the books out. It's very hard to get stuff distributed in Mexico, so it's not like we just forgot to send it to Diamond or whatever. There were definitely obstacles, but we knew that going into it, and the whole point was we had connections in the publishing world in our group, and various people were going to talk to their contacts and try and get something going with these books. And meanwhile, I was bringing them back to the States. I brought it to SPX in 1999. I gave some to Robert Boyd, who at the time was doing distribution, although that didn't pan out either.

I'm trying to remember where I got it. I think I actually got this at Jim Hanley's. You probably sold it to Jim Hanley's after you moved back…

I might have sold a few. By the time I got back from Mexico I only had maybe 50 of mine left and a handful of the other titles. At this point, I only have three or four of them, so they're almost gone. It was a disappointment, because I thought it was going be something that would be, not so much some nice books, which they are, but really start a movement in Mexico of self-published comics, because minicomics aren't really that common there, but it just went nowhere. It never got into stores. I'm sure there are still boxes of them sitting in various people's houses in Mexico. It's too bad.

Sayonara is really a beautiful story actually.

Thanks. Yeah, the story itself was fun to do. It's not constrained in the way that I tend to work on stuff now, but I

set some rules to follow and one was that it was going to be wordless. Another was that it was going to be a sort of two-tier page, because it's basically minicomics size … they're pretty small pages.

And the most important rule that I gave myself was that I drew everything on location. You know, I wanted to do a very local story about my neighborhood, Colonia Roma in Mexico City. So, a couple days a week when I could find time, I would go out for a few hours with a sketchbook, and I penciled in the panel borders and had a general idea of how the story went and where it needed to take place. The story is about a Japanese student on his last day in Mexico City. He's supposed to fly back to Japan the next day and it's about him visiting some old haunts and having a going-away party. But it becomes increasingly clear that he's ambivalent about going home. He's apparently got a girlfriend waiting for him and …

Yeah, we see her earlier on in the little photo-booth photo.

Right.

Is this the merry-go-round on Jessica's cover?

Yeah, it is in fact.

The same place.

He walks through that. That's the park that we walked through very often called Parque México in the middle of Mexico City and it's one of the most beautiful, little idyllic city parks in the world.

Yeah, it's kind of amazing.

There's old merry-go-rounds and stuff. So, yeah, if you were to match this up with *La Perdida*, especially in the opening pages of *La Perdida* when Carla is first arriving in Mexico City, you'll see a lot of similar panels—she swiped from me shamelessly! This, for instance, is our old apartment. This doorway goes up to our apartment and Jessica drew almost the same shot, maybe from a different angle.

[Laughs.] *This is page nine of this book.*

Yeah. So, what I did was I went around and I drew quickly in pencil and in ink on location in these two places, includ-

ing this great old bar in La Roma, and I would just leave a space in where I knew the figures, the characters, were supposed to be.

I would fit them in later. It was an interesting experiment in "on-location cartooning." Another issue I was trying to deal with — one was to try not to draw from photos or rely on making stuff up. Another issue — and I think every cartoonist will identify with this — was the problem of maintaining the spontaneity of one's sketchbook drawings in one's comic work. I think that's an almost universal problem. Every cartoonist, if you look at their sketchbook, there's invariably this looser, more spontaneous, gestural style that you see, because they're drawing from life, they're drawing off the top of their head without pencils and, more importantly, without the pressure of "this is for a final book that's going to be published."

It has a Wim Wenders feel.

Yeah actually, that's funny. Definitely I was thinking of cinema. Wim Wenders is a good call, but I wasn't consciously thinking of him. I was watching a lot of Wong Kar Wai movies at the time — you see it especially in this night

Parque México as represented by Abel. [©2006 Jessica Abel]

market scene. *Happy Together, Chungking Express*, all those movies with these good-looking Asian characters wandering around markets moodily at night, there was sort of mood-piece thing that I was going for here, but also with a very specific, earthy sense of place. Like Wong Kar Wai: It never gets too precious in its glamour, because there's always these grungy backgrounds, like the bus depot that the guy visits here and this old cantina where he ends up getting drunk and giving away his ticket to a random guy … That's a real, very specific, Mexico City feel, which was one of my goals for the story: to just give a sense of place.

And you're using a pen on this …

Yeah, it was the Rotring art pen that I inked all that with, and then a brush just for the solid black stuff.

So then this came out in '99 and you left in 2000?

Yeah, we left right at the beginning of 2000. So that came out with a few other short things I did while I was there. Meanwhile, I was working on *Odds Off* and I had started *Exercises in Style*, at that point, too, in 1998.

So you started Exercises *in Mexico? Because that scene, which is the primary scene and the only scene…*

The template, yeah.

… is of a spiral staircase in the Mexico City apartment.

Exactly. That's the apartment we lived in for two years.

Did it start out as, "I'm going to do a full length booklet of these?"

Oh, yeah. I first had the idea when I was still living in Ann Arbor when I was working at the bookstore and came across a copy of *Exercises In Style*. I think someone pointed it out to me, and I fell in love with it and got the French and English edition and started thinking pretty much right then that it would be great to do some kind of comic based on this.

But I knew I was still too green as a cartoonist to take it on, both in my understanding of the language and especially in my basic drawing skills. So by '98, I had done *Black Candy*, I'd done a lot of short work, and I still didn't quite feel ready. I never really do, but I felt like if I was gonna do this, I should start it now. And doing it meant doing 99 pages, because that's what Queneau did in his original prose version and it seemed only fair to match him exercise for exercise, at least numerically. So, I projected it as kind of a long haul and something that I'd do simultaneous to other projects That's why I started it and *Odds Off* at the same time.

Oh, you did? That's kind of insane.

Yeah, but I find it's nice to have different projects to bounce back and forth from.

These are all huge projects. Wow.

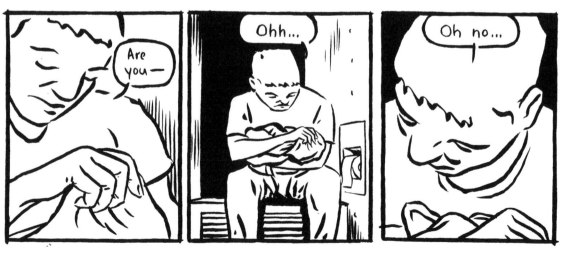

This spread: A sequence from *Black Candy*. [©1998 Matt Madden]

Yeah, but again, like I said, we had so much time there that I'm kind of ashamed that I didn't get more done while I was there with that amount of free time. Although I look back and I realize I did half of *Odds Off*, about 20 pages of *Exercises in Style* and *Sayonara* and a bunch of other short pieces, so it was reasonably productive in the two years I was there. But my original projection for the *Exercise in Style* was that I would do it on my own time and kind of for my own enjoyment, although pretty soon I thought of — or maybe Jeff Mason suggested it — but we put it on the *Indy* magazine website for a while. Back then Alternative Comics had this magazine which I was in a few times. That's when it first appeared online. And I got a lot of good feedback from that stuff, which encouraged me to keep going. But I still figured, "I'll just do it on my own and when I'm done. I'll apply for a Xeric Grant and try to get it self-published, because it's too offbeat a project to really appeal to a general audience."

Which is ironic, considering… [laughs].

Well, yes and no. It turned out to be a much bigger project, in a lot of ways, than I thought it would be, and it's been really gratifying because I also don't feel like I've changed it at any point from what I — it's still always been a project that I've wanted to do for my own enjoyment and for the challenge. But, yeah, it turned out to get a lot of good feedback from people and to the point where I ended up getting an agent, Bob Mecoy, and shopping it around to publishers and got it published by Penguin in October '05.

How much had you done before you got the book contract?

Maybe I miscalculated slightly because I was thinking that I had it about half done in a general way, and the reason I got an agent was I was thinking, "Well, if I get a decent advance I could afford to, if not stop working, then at least only teach at SVA, which I'd been doing for a few years already, and take the rest of my time to just get the book done in like three or four months or something. So, I got the book deal in about Sept./ Oct. of '04 and I was thinking, "Oh, great. I'll just do my remaining 30 pages or so that I had to do," and actually got my pages out and counted up, and realized that in fact I only had about 33 finished out of 99. So by the time I got to actually working on it, it was already November or something and my delivery date originally was March, so I was supposed to do 60-some pages, each one being, you know, a brilliant new variation of the idea so that I had to come up with the concept and plan it out and imitate drawing styles, all that stuff, by March.

So, it was a bit crazy. I got it done by May, I think early May, is actually when I turned it in. But it was a good six months of pretty solid grind.

One of the things that I think of when I look at it is just how comparatively loose your version is with the idea of what style means. Maybe because of the medium.

Yeah, I think it's the medium. In Queneau's, when he says "style," he's often talking about styles of rhetoric and it's actually all these terms that, even if you look at most

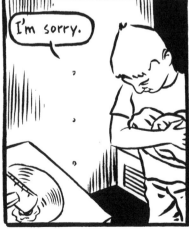
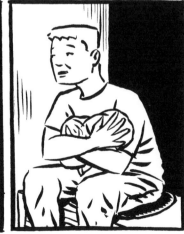

A fragment of the "A Newly Discovered Fragment of the Bayeux Tapestry" exercise in Madden's 99 *Ways to Tell a Story: Exercises in Style*.
[©2005 Matt Madden]

literary-criticism guides or style guides, you can't find any of these words any more: "parachesis" and "homeoptotes," but a lot of it he was just going through the manual of what the different kinds of rhetorical modes are and rephrasing his story that way.

You could do that in comics, but I don't really see the point necessarily. The point for me was to use the idea of the experiment, of the repetition of the same story, to tease out all of the different things that comics can do and particularly well and interestingly and productively, and that quickly led me to a couple of different approaches. The most basic one is different points of view and that is more directly analogous with the Queneau version and any theater or film adaptations — apparently there's been a theater version done.

Really?

Yeah. Back in the '60s.

But to me it becomes a meditation on style, like "What does style even mean?" Are we talking about more than personal style? How conscious were you in thinking about that?

Yeah, I was pretty conscious about it, because I realize that when I'm saying "style" and I'm showing like a first-person view versus a monologue version of the story, styles are really like modes of storytelling, the way you present the story to a viewer or reader. And then when I'm doing a manga or science-fiction or superhero version…

That's a style of genre.

It's a style of the genre and it's more like the sets of convention that are associated with certain genre storytelling, which is one of the other basic approaches I used. And then there are ones that deal more with visual style: There's a minimalist one and a maximalist one and one that's done all in silhouettes, that may be more purely about visual or graphic strategies, but again it comes to that question: "What are we talking about when we say style?" And I decided it was more interesting to keep that sort of fairly open, instead, covering all of those things, especially because, for me, the style that comics are drawn in is one tool in the kit.

At what point did you say to yourself, "I have to draw the same fucking thing over and over again?" [Laughs.] Did it ever become a drag?

No, it never was. On a couple of individual ones, the ones that are based on the template comic — on the first one, where I had to redraw it with everything just changed slightly, maybe, that definitely got a little bit tedious in terms of tracing over the same panels and then figuring how to change it, but make it match the original: The mechanics of that got tiresome on a few of them. But I never got tired of the project. I never thought, "All right, I still have five more left, what am I going to do?" It was always a rewarding challenge for me.

I notice here you've got at least two translations, so this obviously has quite a bit of international appeal, this piece.

Yeah. Which in part was just the experience of going to

a major publisher: being published by Penguin. There were two major downsides to going with Penguin, with this imprint in particular, because it crashed and burned before the book had even come out — Chamberlain Brothers.

Really? Is this an idea they had, to do comics or something?

No, it wasn't even a comics imprint, which is, again, quite a problem, but my agent and I were given a different idea of what this thing was going to be and by the time we realized how lame it was, it was too late and then it crashed and burned anyway.

But, anyway, the two general drawbacks: One was that I lost control over the production and everything downgraded on me without my consent or ability to protest. I thought I was going to have nicer paper, I thought I was going to have more color pages and I was supposed to have French flaps, and all of those things got cut out. So it just ended up being a kind of a shoddier-looking book than I'd hoped for.

Do you have color versions of some of these that are in here?

Yeah, if you look in the foreign editions you'll see that there's like five more in color. The Kirby one, the Krazy Kat and even like the little Jack Chick tract, which is the little red spot color on the cover there. So it was cool to be able to do that.

The other problem was that, although the book came out and it got into all of the bookstores in the country, it made very little impression on the comics scene. It didn't go to comic-book stores. And also, the way Penguin decided to market it as a creative-writing book. I was OK with that, provided that it's also available elsewhere. But if you go to a bookstore — it's still available in bookstores, but you're not gonna find it in the comics section, in the graphic-novel section. It's in the writing reference section. Along with *How to Write Better Short Stories* and things like that. Because that was sort of their idea, that the comics audience would take care of itself and this was going to open up a new market for it.

I have gotten interest from people who are creative-writing teachers and all kinds of readers like that, which has been gratifying, but the comics audience definitely didn't take care of itself. It didn't make enough of a buzz to reach a wide audience that way.

Really? You don't think that it's been …

No. I think people who follow my work know about it, but it never really got on the radar of the larger comics scene. I think a lot of regular comics fans and readers just never came across it.

But then it seems to have taken off in other places.

Yeah. The advantages of being at Penguin is that it's all over the place. Also the Japanese edition came out almost accidentally because my agent secured the foreign rights for me, which my editor didn't realize, and so when my book came out they automatically sent it out to all their international co-agents, because usually the major publishers keep all the foreign rights. So they sent copies out all over the world to all of their companion publishers and agents overseas and I got a Japanese and a Korean edition out of that fortunate oversight.

So were there any weird things you had to deal with, like culturally, translating something that's not going to make sense to them?

No, I don't think so. The Japanese translator actually sent me a few e-mails with a few questions about some onomatopoeia, stuff like that, but no, he was really excited about it. He seemed to get it all and …

They've got Jack Chick there.

Yeah, I'm, sure they do have Jack Chick tracts in Japan. And I'm even more certain they do in South Korea.

A panel from the "Superhero" exercise. [©2005 Matt Madden]

THE EXERCISE!

M.J.M

From the "Paranoid Religious Tract" exercise. [©2005 Matt Madden]

Yeah.

But I think it's actually done pretty well. Japan might be the first foreign market that I get a royalty check from. I think they're reprinting it over there, and again it's kind of a weird situation there because that publisher is not a comics publisher. They're called Kokusho Kankokai and they publish literary stuff in translation. They do, like, Thomas Pynchon, and Borges and they do some graphic stuff. I think they've done Edward Gorey or Charles Addams, that kind of "literary" cartooning, I guess.

So maybe now you'll be able to go to Japan.

I would love to. Yeah, I'm hoping that — wishfully thinking — that the Japanese edition is going to lead to getting invited to some kind of book fair in Japan or something. Seems slightly more possible that it would happen in South Korea, just because the South Korea *manhwa* scene has taken off so much in the last five,10 years and I know they have major corporate sponsoring for their conventions there. Yeah, they've had some *manhwa* competitions that are sponsored by Samsung or some of the major cell-phone companies. So, who knows? It could happen.

So the plan was: You guys were going to leave Mexico City for Japan.

Yeah, our *original* plan, was to leave the U.S. and go travel for a minimum of five years and just sort of country hop for a few years. I would teach English, maybe we both would.

From the "Manga" exercise. [©2005 Matt Madden]

We'd do our comics. And on the Internet was starting to get more easy to upload and do stuff through e-mail, so we thought, "Yeah, no problem. We'll do freelance illustration and stuff like that."

The first thing that changed that plan is that we were having such a good time in Mexico City, we ended up staying for two years. The second half of that last year we started talking about what to do next, and I started looking into Japan. Of course, anyone can go to Japan and get a job teaching English, but you're going to get paid $20 a day or whatever and live in an apartment with a bunch of other undergrads who are doing it on the cheap. And it's relatively difficult even still, to get a low-paying part-time job, but to get an actual job at a decent, real school or a university is extremely difficult even with a masters degree. It's one of the reasons I got the degree. I was like, "Well, at least I have a fighting chance at getting a good job in a more competitive market like that." So I researched for, nine months, looking at stuff on Internet and writing, and I'd had some Japanese students in Austin and wrote to them for advice and got a few applications, but never even got around to seriously applying for any jobs. There just wasn't anything I found that was worth pursuing.

So is that basically what persuaded you not to go?

Yeah, and at this point we'd just turned 30 and I should have done all this right out of school, right out of college.

From "Night of the Grossinator" in *A Fine Mess* #1. [©2002 Matt Madden]

Neither of us was really willing to do the sleeping on the floor or couch and sharing a tiny apartment with three other strangers for any extended period of time. We wanted to do it with a bit more style and that wasn't working out in advance. On top of that, we had the idea of kick-starting our illustration careers. When we went back to the U.S. during the two years we were in Mexico, we went to New York, to San Francisco, to Chicago, and everywhere we went we would try and set up meetings with art directors and show our portfolios around, but for whatever reason, it wasn't really taking off. We'd get the occasional job, but even art directors that we'd worked with before who liked us, there was something about the fact that we were in Mexico, I think, it was like a psychological block. It was just as easy as hiring someone down the hall, but we realized that being far away we were still outside the action — in people's minds anyway — and if we wanted to make more of a go, that we'd have come back to the U.S. to get established.

And so pretty quickly we narrowed it down to New York since that's where so much publishing is based. We could have moved to Chicago, but Jessica had had enough of the cold winters and also she didn't want to go back to where she came from. So we ended up moving up to New York in 2000. We also decided to get married then, so it was a big whirlwind. A six-month period of coming back from Mexico, staying at various parents' houses and pretty quickly arranging a wedding, which happened in July.

Here? In New York?

No, we got married in the northern suburbs of Chicago. Jessica grew up in Evanston and so we got married in her mom's backyard and had a small ceremony and then a party a couple towns out where we found a hall to rent. Then from there, we moved to New York and found an apartment like a few weeks later and moved in and started showing our portfolios around and doing illustration work, which went OK, but was really grueling. I haven't done much illustration in the last couple years, and I'm happy to not be doing it. I can see getting back into it at some point, but it's been nice to have a break from it, because it pays really well when you get the work but there's a lot of pounding the pavement and just trying to get people to pay attention to you and give you work and stuff. It gets pretty discouraging even when it's going well.

Is this book here, The Perfect Drink for Every Occasion, *from that period?*

Yeah. This is one of the more fun projects I did. It's a cocktail guide, which coincidentally coincided with my growing interest in making and mixing cocktails and studying them and stuff so it was a pretty good match. It was a rush job like these things tend to be, but it was the kind of job that if I was getting that kind of stuff regularly I might still be doing illustration. But it's 40 illustrations in two colors that I cranked out over the course of a summer.

Were you working at SVA then?

Good question. That's around the same time, I think.

2003 it says.

2003, yeah. See we started in 2001 at SVA. Basically our first semester, our second class was right after Sept. 11, so it was like right around there. We're in our seventh year teaching there and it's been great. It gives both of us a base income and insurance and that kind of protection. I really love teaching. Most semesters I do two undergrad and two adult education classes, continuing ed classes.

I remember you said one time in the Experimental Comics class that I took that you lamented the fact that it's hard to talk theory with comics people. And that you can do that more in the classroom. People are more willing to talk comic-theory type stuff.

That is true. I mean, not theory in the academic sense, necessarily, but just talking about the nuts and bolts of art and craft. It's easy to fall into a jokey banter and have fun together and I really do enjoy that. I'm not that much of a romantic, but I do have a few romantic notions about being an artist, and one of them is that community of passionate, you know …

People sitting around talking …

Yeah, talking about art and, not just comics, but art and life in general. So yeah, that's a really rewarding aspect of classes like that — that's what everyone's there for. And you know, with younger students, they're exploring these ideas for the first time and really finding their voice, and with the older continuing-ed students, you get people with all kinds of different backgrounds. It's a constantly rewarding and challenging, enriching experience.

So then obviously your and Jessica's textbook, Drawing Words and Writing Pictures, *came out of this.*

Yeah, it did. It came out of the fact we were teaching and enjoying it so much. The way it specifically came about at this time was that my agent was pitching the *Exercises in Style* book around. He showed it to a lot of editors who really liked the book, but who were like, "This is a bit too offbeat for us to really get behind and publish, but if you can get this guy to do a how-to-make-graphic-novels book, we're on it."

Because we're in this time right now where comics, or graphic novels as they're being marketed these days, are considered really hot and considered something desirable …

There are comics artists doing Penguin covers now.

Right. You've got the Penguin covers and all kinds of stuff like that and movie tie-ins. and the *Persepolis* movie is coming out, and let's not forget the comics themselves too: *Persepolis* and *Fun Home* and *Jimmy Corrigan*, all these things. So anyway, it's just a good time for it. And then there's James Sturm opening his school up in Vermont, which is apparently doing well.

Jess and I are both self-taught as cartoonists and artists and we know from our experience that trying to learn about stuff and figure out how things are done that it's been very piecemeal. Most of what we have learned has been through trial and error or through bits of information we've gleaned from older cartoonists and our peers. And there are lots of books out there — there's the Eisner books and, of course, *Understanding Comics* — that have lots of nuggets in them, but, you know, *Understanding Comics* isn't really a "How To" book.

No. But Making Comics …

Making Comics is more so. But even that is more kind of insights and nuggets of information laid out in an essay kind of format. None of these books is structured from the bottom up, starting with the basic skills and building up in a deliberate way, and that was quickly what we latched onto when we started talking about it. We always had the idea of maybe someday we'd like to do a textbook, but once my agent had this experience with editors, he told us what they were looking for and my reaction was like, "Great. I'm been thinking about doing that someday anyway. So when I'm ready 20 years from now, I'll give you a call and we'll make a pitch." *[Sullivan laughs.]* But he convinced us that we really needed to do it now 'cause if we didn't, someone else was going to do it and, very possibly, not someone who was as qualified as we are. There are probably less than 50, probably quite a bit less than 50, cartoonists out there who have teaching experience and have been doing it long enough to have that background.

That's a big deal. And that book is so well set up, I mean, it's set up in an incredibly logical way. I read the first, I would say, seven chapters, and it seems very well put together.

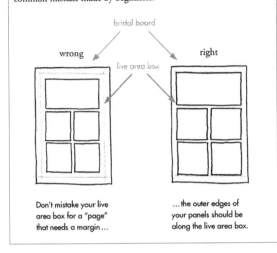
From Abel and Madden's textbook *Drawing Words and Writing Pictures*. [©2008 Matt Madden and Jessica Abel]

It's a challenge to take on, the thing about comics is that teaching storytelling and drawing while also teaching all these arcane outmoded technical skills that go in, just like laying out a page and knowing what the different kinds of pens are …

Well, the approach to that was kind of hilarious, too. You admit there that this is sort of archaic as well.

Yeah. We sort of played that up a bit. The other thing is that it's very possible that 10 years from now, even hardcore traditionalist cartoonists …

Will be on tablets.

… drawing on tablets. Right. And that's fine, I think, that the medium evolves and develops, but our experience in teaching too has suggested that people want to know how people have been doing it for the last hundred years even if they're not going to be doing it for another hundred. There's always going to be people who want to use pens and nibs and know what kind of brush you use and how to get this and

that kind of effect manually.

And just historically, it's always good to know where the medium's coming from. We come across this in classes a lot that it's such a wide spread of students, some kids they want to do painted stuff, some kids don't want to tell stories, and you have to reach out to that whole crowd, but if you just dilute it, you're not really talking about anything in particular any more. I have no problem, when students are starting out, saying, "All right, well you should learn the traditional, standard way to do it." Especially because it applies to everything from superhero comics to manga to underground, and pretty much everyone has worked this way up until pretty recently. Computers really shuffled things up a bit, but Robert Crumb, Jack Kirby, and Osamu Tezuka were all using Bristol board and India ink and nibs and pens and brushes. If later they decide to work in Adobe Illustrator or use only ballpoint pens and notebook paper, that's fine.

You mentioned a group of people that you were sending stuff out to. Were they taking a course?

Yeah, they were taking the course — at least the first few chapters — and giving it a test run, sort of like beta testers.

So, did you have to shuffle around things, like chapters and so on, after people had responded?

We had mixed results with that the whole project. We are planning for the book to be a classroom textbook and also something that you can use on your own. But ideally we're hoping and expecting that groups of people are going to get together — like I always did in Ann Arbor and Austin, like you do with your friends here in Park Slope — every two weeks, every month and have a critique and talk about each chapter and its assignments. So the beta tester groups were a way to test that out and see how realistic of an expectation it was and I think the truth is, even at its best, probably four out of five of those kind of groups will make it past a few meetings *[laughs]*. But we knew that from the outset. It's hard to really keep up that commitment level with a group of people, but the thing is, that fifth group that keeps on going, they're going to have a great experience and produce amazing stuff. So anyway, we only had about three groups that got started up. We were hoping to get more, but just logistically, it was hard to do with the time that we had.

Is the website up and running yet?

Yeah, the website's going to be done by the time the book comes out.

Because it seems like there's an awful lot of material that's supposed to go up there at some point.

No, the website we're going to start working on toward the end of the year because the books coming out in June now, so we have time. We'll have everything there that's pointed to in the book and we will go on adding new content over time. Blogs, message boards, all that kind of stuff. We expect it to be a big component of the book and the learning experience.

Do you have a commitment from the publisher to keep up the website?

Yeah, definitely. We're going to be working with a designer they've hired.

Who's the publisher?

It's First Second.

So these are comic-book publishers who are doing a textbook.

Yeah. And they're really behind it. They're really excited about it and they've been really supportive about it. So, we've been meeting with the marketing and sales people and academic division of Henry Holt — they're all part of Mac-

millan We're pretty confident with how it's all going so far.

So now that that's off, I see you have started — I saw upstairs — what you call a Crab Canon. *Is that what you call it?*

Crab Canon. I'm not sure who coined that name, if it was Bach himself, but the crab canon refers to a kind of canon, a musical form that Bach came up with.

Is it palindromic?

Yeah, it's not just that it's a palindrome, but it's like an A,B,C,D melody line and the same melody line, running backwards, is played at the same time on top. So you have A,B,C,D below and D,C,B,A on top. So it's like a palindrome, but you've stacked the two halves on top of each other. And it's actually been done in a small way, in a comic by Tom Motley in one of his Hector strips. I don't think he was necessarily referencing the Bach thing, but he did this strip where there's some aliens that enter the last panel of the comic and they're basically walking backwards, through the six-panel or eight-panel strip.

Oh, I think I've seen this.

Yeah. They're walking through and they're trying to meet Earthlings and make friends. *[Sullivan laughs]* The Hector character comes in moving normally, left to right, they interpret him as attacking and they shoot him, when actually what they perceive to be an attack in their backwards time frame

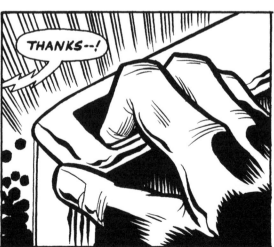

From the exercise "Homage to Jack Kirby." [©2005 Matt Madden]

is Hector keeling over and falling forward after being shot by their laser — it's a tragic misunderstanding that's almost inevitable because of the crab canon-like structure. That was really the inspiration. I love the idea that there are characters that you can read it both ways and it gives you two stories.

So I started thinking about expanding that concept and making it a bit more elaborate and came up with this 32-page story that I've, unfortunately, been working on for about two-and-a-half years now, just because of the textbook mainly. But the last two summers, I've spent chunks of time on it and gotten it to where it's mostly penciled. It's got a lot of difficult logistics, sort of narrative logistics, just to make it read. My ultimate goal is that it'll read like a normal comic and most people when they pick it up and start reading it will have no idea that there's this constraint behind it, at least until I they get to the end of the book and they realize they've got to read it back to front to sort of finish the whole book — that's a bit of a spoiler but by the time I finish this thing no one's going to remember this interview anyway! So it's coming along really well, but just incredibly slowly and that will presumably be *A Fine Mess* #3, whenever that's done, but I won't even make a prediction as to when that's going to come out.

We're having a baby in mid-December [2007], so with any luck I'll get the thing done before the baby comes so I'll at least have one thing off my drawing table and in the production pipeline while I sit and change diapers for the next six months.

At some point along there, you guys started the OuBaPo-America Listserv and the OuBaPo-America website. Is the website up again?

Website, I think, is up. Tom had some website domain problems, but I think he's reloaded it on a new site …

Who was it? You, Jason Little and Tom Hart?

Right. And pretty early on, Tom Motley became a member in absentia and now he has just moved to town recently. And then there was a bit of miscommunication with the French OuBaPo guys at first, where it wasn't clear if we were going to be like an official OuBaPo offshoot or not. It's not necessarily what we intended, although I had written them — Jean-Christophe Menu and Thierry Groensteen — for their blessing before we uploaded the site. As it turned out, the French OuBaPo guys had nominated me in absentia as a foreign correspondent to the French OuBaPo, although it took them two years to get around to telling me. I never got my "certificate" in the mail. So yeah, our group became more of a social thing. For one thing, Tom Hart is more of an enthusiast of constrained comics than necessarily a creator of them. You know, he's done 24-hour comics and stuff, but his other work doesn't actually get into that too often. He's one of these friends, like I was thinking about, that just loves to talk about art.

But then you put him on the spot.

Oh yeah. I had a lot of fun recently giving him constraints for his *Hutch Owen* strip. He invited me to do sort of a riff on *The Five Obstructions,* the Lars Von Trier film. And he took to it great. I mean I wish he did more stuff like that, because he really rose to the challenge of my increasingly perverse and numerous challenges.

So have you met many of the OuBaPo people in France?

I was just in France in January '07 for Angoulême for the French L'Association edition of *Exercises In Style*, which is the first book they've published that has the OuBaPo logo on the front cover. That's outside of the Oupus books that they put out, collecting their various experiments. I met and spent some time with Jean-Christophe Menu, who's also the head editor of L'Association and kind of the main guy behind OuBaPo. Thierry Groensteen I've met a couple times. He's not really active in the group any more, but he's definitely sort of a spiritual godfather to the whole thing. And Francois Ayroles, who's one of the younger guys in the group and also, I think, overall the most talented in terms of doing stuff that's very rigorously experimental, but also really charming and fun and weird and fun to read. Killoffer, I've met a few of times. There're four or five other members that I haven't met yet. Actually I missed a few of them at a party by a half-hour or so.

They're sort of caught up in their project and what they're doing. Whenever I do talk to them, they're like, "Oh, yeah. We're going to do something in the future." Eventually, I think we're going to either collaborate on something or maybe they'll do another book of my shorter, constrained stories, I'm not sure; it's a very open-ended thing.

This may be the first large project that comes out of this. I mean, you probably know, certainly, better than I do, what has come out of OuBaPo in terms of books. Other than the OuBaPo

books themselves.

Yeah, I mean there have been a couple of book-length projects already. There's Jochen Gerner's *TNT en Amérique*, where he selectively blacks out a Tintin book; the *Trois Chemins* books that Lewis Trondheim has done with Sergio Garcia, a Spaniard who's the other non-French OuBaPo member. That's sort of a children's book where you read a story on multiple paths and make them cross.

I noticed at MoCCA you were talking about, maybe you even had fliers or something for the Best American Comics? *Were you series editors before?*

The "Vertical" exercise. [©2005 Matt Madden]

Jessica and I are starting with the issue that's being collected for right now, so it'll be the 2008 edition. Anne [Elizabeth Moore] was the series editor of the first two. Harvey Pekar was the guest editor of the first one and the Chris Ware one is hitting the stands this week, I think, so we came on board in the summer and are signed on to do the next two.

You're going to do it for two years?

Yeah. And I think it will be a good gig for us for at least one reason: There are two of us and we can get through more books that way and trade off administrative jobs. The other thing is, in terms of reading the comics, we read so much stuff anyway, it's definitely a big augmentation in what we read but it's something we like to do anyway. Being a teacher, too, I always like to be on top of all the different kinds of stuff that's coming out. My one reluctance to take the job was that I didn't want to take on a tastemaker role. I don't think I ever want to do that, but definitely not now, I'm too young and not established enough to be someone who's making decisions at that level, like what's considered the "best American comics," for example.

But the way the Best American books work is that the guest editor, who changes every year, makes final decisions and is encouraged to really be idiosyncratic about it. It's not meant to be necessarily consistent from one year to the next. If it was like, "No, you got to keep it similar to last year and not contradict what the last editor did," that would be a drag. But as it turns out, the idea's more to just let the guest editors follow their muses and we're there to facilitate all of that. Specifically, our job is to read through all the books that come out and select up to 120 books or stories that we think are worthy of the guest editor's attention. We pass those along and then they can bring in any sort of thing they want, as well, and from that pool they make their final choices.

So the first year it's Lynda Barry. Who's doing it next year?

Right, Lynda Barry is going be the editor, the one we're working with right now. That's going great and I think she's going to have a very eclectic choice of finalists.

I can't even imagine what she's going to be interested in.

Yeah, yeah. She's been having us send her everything. She even wants to read all the superhero comics and everything,

The "Ligne Claire" exercise. [©2005 Matt Madden]

so I think it's going to be a pretty interesting book.

Probably very different from this last one.

Yeah, definitely different from the current one, the Chris Ware book. And beyond that we don't know, but also we don't choose the guest editors. We have a lot of say in it, but it's us in combination with Anjali Singh who's the senior editor. And also there are general higher-ups at Houghton Mifflin or whatever, so there'll be just a little bit of negotiation there. But I'd like to keep it, you know, luminaries, but hopefully from different parts of the comics world.

Your own work seems to be flying in the face of what a lot of people expect from comics in terms of story in particular, but especially this book which actually seems like your most successful book, 99 Ways to Tell a Story. *God knows how many times I've read some variation of "Comics must tell a story," on blogs, the* Comics Journal *message board and elsewhere. Is the landscape changing?*

I do think the landscape's changing, and I also think that kind of eternal argument you see, especially on blogs and message boards, is a sort of eternal tempest in a teacup and you as a poet know that probably more than anyone as these arguments people get into over their little world of the medium that seem like these life-or-death struggles, and then 10 years later, you look back and you're like, "Who cares if *Weirdo* or *Raw* is the better anthology?" They're seemingly epic struggles that you have to put in perspective.

Well, you'd think that, but actually it goes on. It goes on forever. There's a lot of that in the poetry world, and there are people who are still upset with arguments that happened 30 years ago, like between the people at the Poetry Project and the series that my wife and I do for the Segue Foundation. So, it may not be resolved or forgotten in 10 years when we look back …

Yeah, maybe 50 years then *[laughter]*. My point is that these kinds of arguments don't really tend to stand up over time. To a certain extent it's productive to argue about your medium and what direction your medium is going in or how to define your medium, but only as a sort of signpost, something to measure against, you know, sort of like test the weather now and again, you know? So, as an artist or as a reader it can be useful every couple of years maybe to dive into maybe like a message board or read the blogs and sort of see what the current …

What the obsessions are.

What the current obsessions are and then you're kind of like, "All right, well …" you know, I think all artists when it comes down to it, and readers too — and this is why I don't think this kind of divisive sort of arguing you see on the Internet really even means that much — because at the end of the day most artists and readers go back to doing the stuff they like to do and what that is often crosses over a lot more of the barriers than these arguments would suggest … they create a very limiting, binary view of things. And you're right that a certain element of debate just won't die down,

WHAT THE HELL
WAS I LOOKING
FOR, ANYWAY?!

From the "Photocomic" exercise. [©2005 Matt Madden]

like there's still people arguing that people should either be doing superhero comics or indy-autobio comics as if those are two totally different things that have no relationship to each other (and as if they were the only options available). I can understand that argument to some extent, but I don't find it very relevant to my own work.

But it's relevant to your output because a lot of it, you couldn't have gotten some of this stuff published maybe 20 years ago. Say you were a much older guy, you were doing this stuff much earlier, maybe there would be no venue for it.

Yeah, I do think that if I'd done the *Exercises in Style* book 20 years ago, say like in the mid-'80s or something, it would have been hard to find a publisher for it, definitely.

It seems like there is a little bit of a shift maybe.

There's definitely a change and it's mostly for the better. It's mostly an expanding and not a restricting kind of vision of the medium and it doesn't really affect particularly whether you want to read superheroes or not. Whether superheroes or autobio/indy, comics live or die based on whether they're good or not and whether they find their audience. And sometimes it seems like people are angry at artists like the Fort Thunder gang or something because in some way they're not supposed to be doing that, but be doing superhero comics instead, as if there was any way that artists that are that far out could ... *[Sullivan laughs.]*

I don't know. It doesn't make sense. It's like there's an apple-and-orange element to the argument: getting angry that people are doing something that doesn't fit in the categories that you cling to. The whole indy autobio thing — yes, autobiography is very important for indy comics in the U.S., and in Europe too, in the last 20 years, but it's just one aspect of it and, as much as it's produced some stuff that's tedious, there's been a lot of amazing work. I mean, *Fun Home*, Chester Brown's *I Never Liked You,* Harvey Pekar's early work. There's fantastic work that's been done in autobiography. So there's the fact that it's outlived its initial novelty. Well, superheroes did that 50 years ago and they're still going. And meanwhile, there's all kinds of other great, you know, weird, more offbeat stuff or all-ages stuff or whatever that can fall between the cracks.

I see arguments like that and I can even sort of get heated up about them briefly when I feel like I side more with one side than with another. I'm certainly no great lover of superhero comics and that whole culture, but neither am I very hostile to it either. And mainly I look at comics and I just see we're at a much more wide open, heterogeneous stage in the growth in the medium in a very healthy way than we've ever seen before. And yes, that means that there's a lot of mediocre stuff or half-baked ideas that aren't really ready for prime time being seen out there. That's happening in publishing too, where everyone's trying to jump on the graphic-novel bandwagon and that's definitely going to lead to some stuff getting out there that's not really up to par. But it also means really great works that, 20 years ago, wouldn't even have found a publisher are getting, like my book, into the world. ■

Repeat Offender

by Kristian Williams

The Dec. 23, 2004 strip collected in *All the Rage: The Boondocks Past and Present.* [©2007 Aaron McGruder]

All the Rage
Aaron McGruder
Three Rivers Press
265 pp., $16.95
B&W + Color, Softcover
ISBN: 9780307352668

Imagine this scene: Two black children go to see Santa Claus at the neighborhood department store. Santa looks at them and says: "I hope you chimpanzees don't have a chimney."

Now add this detail: The department store Santa is also black.

It's hard to explain how this one fact changes so much. The line is offensive and absurd in any case, but from the mouth of a black man it is also pretty funny. In part, of course, that's because it confounds our expectations. But also I think it's because, whether he realizes it or not, the black Santa condemns *himself* with the abuse he hurls at the boys.

His prejudice is self-defeating, if not actually contradictory. Both these elements of the humor are reinforced by the fact that the line goes to a washed-up, crazy-seeming old man dressed like Santa Claus and not, for instance, a black cop.

Part of the secret of *The Boondocks'* success is this trick of saying the unsayable by putting it in the mouths of fundamentally harmless characters. The two most menacing images of black-ness, from the perspective of white society, are undoubtedly the gangster and the revolutionary. These are represented, in *The Boondocks*, as pre-adolescent boys — Riley and Huey, respectively. This incongruity makes it more shocking, in a sense, when Huey says things like "I resolve to mercilessly abuse my illusions and smack stupidity in the mouth. I resolve to never acquire a taste for the bitter lies I am fed. I am making a resolution for revolution!" It's startling to hear, not only such anger, but such *seriousness*, from a child in the funny pages — but *because* it's a child, it's also less threatening. Aaron McGruder, the writer of the strip, explains the strategy like this: "The grand experiment of *The Boondocks* was to take on radical politics and make it cute."

HELLO and a hearty salute to Bob Johnson and BET, who recently proclaimed that BET does more to serve the Black community each and every day than the creator of this feature — one "playa hating" Aaron McGruder — has done his entire life.

In order to follow the fine example set by Mr. Johnson, we present to you, the reader, in the spirit of Black uplift —

a black woman's gyrating rear end.

From now on, when you think "black women's gyrating rear ends," don't just think BET, think "The Boondocks."

And thank you, Bob Johnson, for shining your light for the rest of us to follow!

© 2000 Aaron McGruder/Dist. by Universal Press Syndicate

www.boondocks.net www.uexpress.com

1/31

According to McGruder, this Jan. 31, 2000 strip, collected in *All the Rage: The Boondocks Past and Present*, was the first strip several major newspapers pulled. [©2007 Aaron McGruder]

I suppose it bears mentioning, at this point, that McGruder is himself a black man. Whether this makes his work less offensive — or, perhaps, more so — is the matter of some debate. It's clear that no family newspaper would stand a white cartoonist calling black children "chimpanzees" or (later) "Negro hooligans." It turns out, though, that neither the narrative distancing involved in making radical ideas look "cute" and racist ideas crazy nor McGruder's own racial identity was enough to insulate him from criticism and censorship. The Santa strips, which introduced the character "Uncle Ruckus," were pulled from 11 newspapers, and when Ruckus (this time as a school bus driver) again called Huey and Riley "negro hooligans," one uptight publication notified the syndicate that their Diversity Committee would be meeting to discuss the issue. (Is *that* what diversity committees are for, keeping black cartoonists in line?)

But the Ruckus ruckus came toward the end of the strip's life, and by that point such turbulence was entirely expected. McGruder writes in his introduction to *All the Rage* that during *The Boondocks*' first year, editors squashed it so often that "If a strip was only banned in a paper or two, the syndicate wouldn't even bother telling me." Controversy had just become part of doing business — apparently a good part, since for every squeamish paper that pulled a strip, moved it to the editorial page, or canceled it altogether, a dozen more subscribed, and by the end of its run *The Boondocks* was in over 300 papers. Controversy was never exactly McGruder's business plan, but he hasn't been afraid of it, and it has served him well.

All the Rage, the latest volume of *Boondocks* material, is arranged in three parts. The first reprints the strips from December 2004 to December 2005, the series' last year in

the papers. These comics address contemporary issues in the culture (gangsta rap, celebrity gossip, *Brokeback Mountain*) and major political events like Hurricane Katrina and the CIA leak case, as well as standard comics topics like holidays and family life — all, of course, with a particularly African-American flavor. The strips also go after black icons like Bill Cosby, Condoleezza Rice, 50 Cent, and Michael Jackson, mocking them with a level of vitriol unusual for contemporary newspaper cartoons.

These strips are consistently smart, funny and well drawn. Unfortunately, the color Sunday strips are printed much smaller than necessary, seemingly to leave room for superfluous design features like margin bars and over-generous white space. Perversely, the images in the shorter, black-and-white, daily strips actually appear *bigger* than their Sunday counterparts, making the computerized grayscale needlessly distracting. (Perhaps it would look better on actual newsprint.) Nevertheless, in terms of humor and commentary, *The Boondocks* ranks with the 1970s *Doonesbury* and the 1980s *Bloom County* — two strips that McGruder vocally admires and, at times, openly imitates.

The second part of the book collects 17 interviews with or articles about McGruder himself (including the *Comics Journal* interview from September 2003). In them, the cartoonist talks about censorship, the *Boondocks* TV show, politics, the influence of hip-hop, the art of cartooning, and the stress of putting out a daily strip. Unfortunately, he tends to address the same issues again and again. It's not really his fault that professional journalists tend to ask the same six or 10 unimaginative questions, but clearly the number of interviews here is excessive and too much time is spent talking about the television program. (Maybe McGruder is sick

of the strip, and I don't begrudge him moving on to other media — but it's pretty tiresome to pick up a collection of comics, only to have the author go on and on about how great the TV version is.) Probably, the editors could have picked out the half-dozen strongest articles without much loss of actual content.

The third section is called "The Controversy," and it spotlights the strips that got killed. This is, on the whole, the most interesting part of the book. Not only does it contain much of McGruder's sharpest work, it also gives his brief summaries of the newspaper's objections, and in some cases shows how the strips were altered so as to slip them past the editors.

Most of the banned strips are surprisingly harmless: In one sequence, Riley attacks some other kids with a plastic light saber; the editors somehow equated this with a school shooting. In another, a panel showed "a black woman's gyrating rear end" as "a salute to Bob Johnson and BET." (McGruder writes that he "only wish[es] I had drawn the ass bigger.") But some of the suppressed cartoons were also McGruder's most politically acerbic, and it's interesting to use them to gauge where the boundary of acceptable speech lies. Several of the censored strips concern public reactions to the Sept. 11 attacks; in one, Huey calls the FBI to report Ronald Reagan's support of Osama bin Laden. Another infamous plotline had the boys try to find Condoleezza Rice a boyfriend, because "maybe if there was a man in the world

who Condoleezza truly loved, she wouldn't be so hell-bent to destroy it." (Later, Huey comments, "And what I really like about this idea is that it isn't the least bit sexist or chauvinistic.") In a third, Huey pointedly refuses to compare Bush to Hitler: "I mean, Hitler was democratically elected, wasn't he?" And then there are the strips where Uncle Ruckus plays Santa.

It's particularly entertaining when McGruder himself pokes fun at the newspapers' imposed limits, as when he replaced the usual characters and storyline with a super-patriotic feature called "The Adventures of Flagee and Ribbon." A fictitious editor's note explains, "Due to the inappropriate political content of this feature in recent weeks, it is being replaced by 'The Adventures of Flagee and Ribbon,' which we hope will help children understand the complexities of current events." The strip then features a talking American Flag and a talking Yellow Ribbon, who say things like: "Hey Flagee. There's a lot of evil out there." "That's right, Ribbon. Good thing America kicks a lot of *@#!"

In a later controversial strip, the neighbor girl, Jasmine, says to Huey, "Bob Johnson is a very important African-American entrepreneur." Huey replies, "Whatever, I still don't like that n***a." The syndicate sent out two versions of the strip; in the second the already-censored "n***a" has been changed to "****". The next week, McGruder decided to point out the obvious absurdity of this. He ran another editor's note, this time saying, "Last Saturday's installment

The Jan. 21, 2003 strip, collected in *All the Rage: The Boondocks Past and Present.* [©2007 Aaron McGruder]

From a series of unpublished strips in all *All the Rage: The Boondocks Past and Present.* [©2007 Aaron McGruder]

of this featured [*sic*], which included a character referring to BET founder Robert Johnson [as] a 'ni**a,' was found to be distasteful, ignorant, and downright offensive. We offer our most sincere apologies. We assure you the word 'ni**a' will never again appear in this feature. Instead, we will use the more acceptable social euphemism: 'N-WORD'."

This disingenuous mea culpa is followed by a week's worth of ineffectually censored offensive dialogue, starting with:

> **Caeser:** "And then the n-word on tv said we shouldn't use the word n-word!"
> **Riley:** "Uppity n-word!"
> **Huey (reading a newspaper):** "Will you n-words be quiet. I'm trying to read."

and ending with:

> **Caesar:** "You ever notice how n-words use the word n-word all the [time]."
> **Riley:** "Well, you know n-words."
> **Caesar:** "And then you got other n-words that don't like it when n-words use the word n-word."
> **Riley:** "Bougie n-words, like Huey."
> **Huey:** "Hey, I'll call a n-word, a n-word, n-word!"

Four of the five "n-word" strips got killed, and the fifth only ran weeks later. McGruder notes, "I remember not being too upset about this, probably because I knew I had no business doing them in the first place" — meaning, I take it, that he rather expected them to get the axe.

McGruder has built his following, not by keeping to the "safe" path of avoiding controversy, but by consistently breaking the rules. He specifically *seeks out* the things that no one else is saying. Often as not, these are observations that people just don't want to hear. After Sept. 11, for example, he deliberately decided not to pull his punches. Likewise, in dealing with race, no one — white or black, the racist right or the politically correct left — is spared his brutal, damning honesty.

Clearly this put editors in a tight position. People typically don't read the funnies to get mad; they want a laugh. But if a paper pulled one of McGruder's strips, they got angry letters from fans accusing them of censorship. And if they gave McGruder free rein, they knew they'd get angry letters about that, too.

The Chicago Tribune received complaints to the effect that McGruder got away with saying the things he said simply because he's black. Dan Wycliff, the paper's ombudsman, replied: "It would probably be more accurate to say that he is able to see the things he sees because he is black. Loath though many Americans are to accept it nowadays, having a different historical perspective … gives one a different perspective on life and issues. And that perspective, while not the sole determinant of a person's point of view, will assert itself in ways and places both expected and unexpected — even, sometimes, on the funny pages." ∎

Kristian Williams is the author of *American Methods: Torture and the Logic of Domination* and *Our Enemies in Blue: Police and Power in America* (both from South End Press), as well as *Confrontations: Selected Journalism* (available from Tarantula Publications).

Keeping Up Appearances

by Kent Worcester

Buffy the Vampire Slayer: The Long Way Home
Joss Whedon/Georges Jeanty
Dark Horse
124 pp., $15.95
Color, Softcover
ISBN: 9781593078225

Heroes Vol. 1
Various
DC/NBC
235 pp., $29.99
Color, Hardcover
ISBN: 9781401217051

Brand management is a growth field in the new virtual economy. Any well-known pop-culture franchise, from Jason and Freddy to Nancy Drew and Speed Racer, requires careful monitoring and adjusting, as well as occasional overhauls and reboots. Creatively managed brands can generate cash into the indefinite future, while franchises that fail to adapt will fade away. Part of the challenge of brand maintenance has to do with globalization: What are fans in Indonesia thinking? Why isn't our product moving in Finland? Another has to do with juggling multiple platforms: Will the paperback help videogame sales? How will the movie perform on iTunes? Then there is managing talent: reconciling egos, spinning scandals, using old brands to create new stars, and so on.

That comics, movies and television can be synergistic is old news. What is interesting about *Buffy Season Eight* is how Joss Whedon and Dark Horse have welded television-based continuity to the current graphic-novel boom to make it seem as if these comics are culturally innovative rather than

part of a long-established pulp tradition that assumes that if, say, Bob Hope or the Little Rascals are popular on the big screen their inky caricatures will sell comics. Sarah Michelle Geller may have moved on — to other brands, naturally — but her tough-girl grimace can still shift Buffy product. *Heroes* may be on hiatus and the writers on strike, but plenty of gift-wrapped *Heroes* Vol. 1 hardbacks will have been opened this past Christmas. For their stakeholders, multiplatform global brands are the gift that keeps on giving.

That the titles under review are connected to larger economic ambitions does not tell us much about their individual merits, however. Some of those Bob Hope comics were pretty funny. The fact that these books are glossier and pricier than their cultural antecedents, aimed at bookstores rather than newsstand racks, is neither here nor there. Assuming for the moment we can analytically disentangle these books from the pecuniary calculations they embody, how do they read, or work, as stand-alone comics?

The *Heroes* volume is, to put it bluntly, more annoying than the Buffy collection. Admittedly, it offers a fancier package, with a cover by Alex Ross, an introduction by Masi Oka ("Hiro") and self-congratulatory interviews with Jeph Loeb and two of the show's writers. The idea, I think, was to package the collection as if it were a DVD loaded with extras. Rather than presenting long-form stories, the volume "collects the first 34 installments of the online graphic novel" (back cover). Each installment is a few pages in length, providing dollops of background info on the show's main characters. For hardcore fans, there are tantalizing hints about new characters and plotlines, as well as incidental details that flesh out the *Heroes* universe. The stories about Hana Gitelman, who can mentally access computer and satellite transmissions, are intriguing. At the same time, anyone who is not immersed in the television show will not get a lot out

From *Buffy the Vampire Slayer* #2, which was written by Joss Whedon, penciled by Georges Jeanty and inked by Andy Owens. [©2007 Twentieth Century Fox Film Corporation]

of this book.

Masi Oka is the breakout star of the NBC show, popular with ordinary viewers and science-fiction fans alike. But his introduction is egregious. "We've all been affected by graphic novels in one form or another," he insists, which seems unlikely. "Hold on to your imagination and your dreams. … Take a vacation and let your mind wander in the magical world of graphic novels. No one can stop us from learning. No one can stop us from dreaming. No one can stop us from believing." Graphic novels, he explains, "can unite us and inspire us." Is he kidding? Buy the hardback, save the world?

The stories themselves, text and art, are uneven. Some of the artistic personnel are well established (e.g., Michael Turner and Phil Jimenez) while some of the others are fairly obscure. (Are there *Journal* readers who follow the work of Staz Johnson, or Adam Archer?) There's not a lot of common ground between the various visual styles — Turner's lines are taut but show-offy, while Jason Badower's pages, which close the book, have that greasy, Photoshop feel that was fashionable for a few weeks in the mid-1990s. Inevitably, the faces of even the best-known characters undergo unnerving transformations at the hands of so many different pencilers, inkers and colorists. Michael Turner, for example, makes Mohinder Suresh look about 15. Micah Gunnell turns Peter Petrelli into Wolverine on heroin. And Tim Sale's depiction of Midland, Texas, waitress Charlie Andrews is simply appalling. Fewer artists but better would have been my recommendation.

By comparison, the Buffy volume offers a tightly constructed exercise in genre. By the end of the television series, a couple of major characters had been killed off and Sunnydale itself was wiped off the map. The "season eight" comics pick up the story's threads, with Buffy and Xander working overtime to prep the new slayer army for anti-demonic warfare. Meanwhile, bad witch Amy and her creepy boyfriend, Warren, are in league with the U.S. military, which has concluded that the slayers have "a hard-line ideology that does not jibe with American interests." There's a subsequent confrontation with a bullying general who explains, "we will wipe you out … you're at war with the human race." It's to Buffy's credit that her response is simply, "oh…kay."

A number of issues remain unresolved by the end of this volume. Who or what is Twilight? Where has Willow been? Will Dawn revert to her original size? Will Xander get laid? (Some of these questions are more interesting than others.) Joss Whedon has a knack for flirty dialogue, multifaceted plots and keeping a few surprises up his sleeve. Georges Jeanty's art is not quite on the same level, but at least it is reasonably consistent. It seems likely that further Whedonesque weirdness will unfold in this eighth season — in sharp contrast to the rather more predictable *Heroes*, which as we all know fell into a deep rut in its second season on television. *Buffy Season Eight* does not belong on anyone's best-of-the-year list, but it's darn entertaining. ∎

Kent Worcester is the program chair for the upcoming MoCCA Art Festival, to be held at the Puck Building in lower Manhattan on June 7-8, 2008.

Betsy and Nobody in Particular
by Noah Berlatsky

Betsy and Me

Jack Cole

Fantagraphics

90 pp., $14.95

B&W, Softcover

ISBN: 9781560978787

Jack Cole's June 10, 1958 *Betsy and Me* strip.
[©2007 Fantagraphics Books]

Jack Cole created less than three months of his syndicated newspaper strip *Betsy and Me* before committing suicide in 1958. Inevitably, when you dole out such a factoid to a critic, the pull of *post hoc ergo proptor hoc* is almost irresistible. And, indeed, few have tried to resist it. Art Spiegelman fulsomely declared that *Betsy and Me* "reads like a suicide note delivered in daily installments!" In his introduction to this Fantagraphics collection, R. C. Harvey concurs, suggesting (on the basis of what seems to be virtually no direct evidence) that Cole and his wife desperately wanted children, and that their infertility blighted their marriage. Harvey goes on to argue that "the basic comedy of the strip lay in the contrast between Chet's romantic vision of life and its actuality. In working up the basic comedy of the strip, Cole was forced, day after day, to confront the laughable difference between appearance and reality. ... The burden of it was finally too much for Cole to bear."

From such descriptions, *Betsy and Me* sounds like it should be an agonizingly personal work, a cheerful surface resting atop depths of pain and neuroses — Jack Cole's *Peanuts*. If that's what you're looking for, though, you're going to be disappointed. In fact, *Betsy and Me* is an entirely generic sitcom vision of postwar American family life, complete with a bumbling but well-intentioned husband as hero, a wife without any discernable personality as sidekick and a very mildly sarcastic bachelor friend as foil. The baby obsession of the early part of the run has no surplus of anxiety that I can detect — it's cutesy family drama indistinguishable from any number of feel-good family comedies of that time — or, for that matter, of this one. Even the super-intelligent child Farley is a pretty stale gimmick that is used to make garden-variety egghead jokes rather than advance the plot in unexpected ways (as, say, Oliver Wendell Jones did in *Bloom County* a few decades later.) Even the irony that Harvey identifies as central to the strip is pretty weak tea. For instance, we learn that young lovers think that pet endearments ("Poopsy-doo! Cuddle-Boo!") are cute, while everybody else who hears them does not. What a bitter, satirical genius that Cole was.

The truth is that, of all the great comics creators, Cole seems like the one whose work was the *least* personal. If there's a core to Cole's work, it's his refusal, or perhaps simply his disinterest, in showing anything of himself. I don't think it's an accident that *Plastic Man* is about a hero who constantly changes shape. Indeed, one of the oddest things about the Plastic Man comics is the extent to which they eschew a singular imaginative vision; the sight gags and goofy plots are amazing, but there's no coherent world to compare to those of, say, Jack Kirby or Winsor McCay. Whether working on

The July 29, 1958 strip collected in *Betsy and Me*. [©2007 Fantagraphics Books]

genre comics, *Playboy* gag cartoons, or a family syndicated strip, Cole produced a superior product with wit, charm and formal mastery, but without anything that could be called personal investment. Perhaps that's part of the reason why he moved so easily from comic books to one-panel cartoons to strips.

I love Cole's work, but I have little interest in family sitcom, and *Betsy and Me* is hardly up to the standards of Cole's greatest work. But the skill is still present, and there is certainly a lot to like in this book. The variation in layout Cole manages within the (literally) narrow confines of a strip, for example, are simply amazing. In the episode where Farley is born, the first panel is devoted to a nurse whispering into Chet's right ear. Chet's face is actually split in half by the panel border, and then the second double-sized extended panel is filled with the giant words "IT'S A BOY" shooting out of Chet's left ear. My description is clumsy, I fear, but the visual effect is instantly readable and dramatic — it looks like Chet's head is functioning as a megaphone, and the split-panel effect makes it seem like the nurse's whisper has traveled an enormous distance through the empty space between his ears before booming out of the other side.

In other strips the panel sizes expand and contract according to the demands of pacing; sometimes there's four, sometimes five, sometimes three. There are also often images shoved into the white space between the borders. One of the best strips has only two panels: a little unbordered introduction and then a long rectangle in which Farley is three-quarters of the way through writing "Antidisestablishmentarianism" on a fence. The fence is by a lake, and before he finishes Farley is going to run out of space and fall in the water — we see Chet racing to catch him in a panic. Again, the description doesn't do the gag justice: The idea is fairly funny, but what really takes your breath away is the elegance of the execution and the way in which such a logistically complicated idea is communicated so clearly and instantaneously. Bushmiller has nothing on Cole.

You'd think the strip's clarity and elegance would be compromised by its other main feature — its wordiness. Speech bubbles are so crammed together they sometimes seem ready to choke the characters. To complicate matters further, Chet narrates virtually every strip, so above each speech bubble there's a little note: "Finally, Farley said" or "Betsy said" or "I said." Yet Cole is such a deft artist that the clutter isn't clumsy; instead the clustered verbal rhythms, and the teetering towers of words combine to create lively, rapid-fire humor. This is all the more impressive because much of the dialogue is not actually all that funny. Jokes tend to be along the lines of: Hey, the car's not broken; it's just out of gas! Or: Oh no, the pastor decided to visit and our house isn't clean! It's as if Howard Hawks did a fast-paced screwball comedy in which, instead of sexual innuendo, witty reversals, and brilliant putdowns, every punch line was taken from *The Brady Bunch* or *Leave It To Beaver*.

Which is to say that *Betsy and Me*, like most of Cole's work, is a triumph of form over content. This is more of a problem in a comic strip than in some other areas. Certainly, Cole's luscious *Playboy* panels don't suffer particularly when the gags are tired — I mean, who's looking at the gags? With a strip, though, the jokes are indeed the point, and if they aren't that good, you have a problem. If Cole weren't the well-known figure he is, it seems unlikely that this particular series would have ever been reprinted. Still, if you're a fan of Cole in particular or of top-notch cartooning in general, it's certainly a curiosity worth checking out. Just don't expect to get a glimpse of the man's soul. ∎

Low-Calorie Cheesecake

by Kristian Williams

Clean Cartoonists' Dirty Drawings
Various; Craig Yoe, ed.
Last Gasp
159 pp., $19.95
B&W + Color, Softcover
ISBN 9780867196535

Carl Barks' entry in the collection *Clean Cartoons Dirty Drawings*, edited by Craig Yoe. [©2007 Carl Barks]

Clean Cartoonists' Dirty Drawings features art from more than 70 cartoonists, none of whom are famous for their filthy minds. The contributors include some of the most impressive figures in cartoon history — people like Rube Goldberg, Jack Kirby, Will Eisner, Johnny Hart, Dr. Seuss, Stan and Jan Berenstain, Walt Kelly, Al Capp, Jack Cole and Steve Ditko.

The thing that's striking about this collection, though, is how altogether *innocent* so many of the drawings actually are. Most of them are only "dirty" in the sense that they are the sort of pictures that one is discouraged from making in elementary school. Many of them are cheesecake, of that simple, now-wholesome-seeming 1940s pin-up variety, with girls in bathing suits, lingerie, or in the sunny, healthy, playful nude. A minority of the images are what we might call sexually explicit, but even most of these are more parody than pornography. And even the actual porn is largely either unerotically cartoonish or (like Gustave Doré's) so lavish and beautiful as to be of more aesthetic than prurient interest.

Of course, there are exceptions. Joe Shuster's drawings — accompanied by captions like, "She struggled but was helpless against both of them," and "Strange desires filled her brain as she knelt before him" — are frankly disturbing.

But dirty or not, there is still something nice — practically heartwarming — about seeing what your favorite wholesome artists produce when they let their moral guard down. The most entertaining are those cartoons that show that the artists have a sense of humor about their own work, as when Prince Valiant reprimands Hal Foster, "Too long you have made me the hero. Now, write some peasant sin into my saga."

There's also something weirdly liberating about some of the images. My favorite of the bunch, Wally Wood's *Disneyland Memorial Orgy*, shows — among other things — Goofy fucking Minnie as she leans against a cash register,

Miss Buxley

Disturbingly, Killer Diller heads for Miss Buxley's unclad nether regions with a smile and a pair of shears in this Mort Walker doodle. [©2007 Mort Walker]

Tinkerbell performing a strip tease, and the seven dwarves assaulting Snow White, all while dollar signs beam sunnily from the magic kingdom's trademark castle. It's all done in that characteristic Disney style, so it takes a minute to really understand what you're seeing. It's vulgar and it's hilarious, and it's also extremely satisfying to see the subversion of the cheap sentimentality and shallow moralism that has made Disney our most beloved commodifier of childhood. Is Wood meanly corrupting these sacred icons? Or is he merely stripping away the hypocrisy and laying bare the repressed subtext of our corporate fairy tales?

Unfortunately, the sophistication of Wood's humor is the exception. Most of the purportedly funny cartoons just recycle clichés about sailors on leave, drunk blondes, strip poker, kissing booths, nudist colonies and sexist jokes about women in the workplace.

Alongside these, there's plenty of adolescent (or pre-adolescent?) wish fulfillment: In addition to the above-mentioned Disney characters, Miss Buxley, Zatanna, Brenda Starr, the Scarlet Witch, the Phantom Lady, Dale (from *Flash Gordon*) and Wonder Woman all make libidinous appearances. On the other hand, some taboos remain: The most we get of Superman is a view of his zipper and a satisfied smile. The absence of beefcake is sadly typical. Not only are the fantasies represented here almost entirely *male* fantasies, they're also depressingly straight. I mean, has no one at DC ever tried to sneak in some hot Superman-on-Batman action? Did no one at *Archie* ever think, "Enough with Betty and Veronica in swimsuits. Let's show what the boys get up to in the locker room"?

Each set of drawings is accompanied by a brief biography of the artist, which is interesting on its own, but also the sort of thing that (for most of those featured) is readily available elsewhere. It would have been more interesting to read the stories behind the images. Why were they created? Where did they appear? Which ones were altered, or censored altogether? Is this the only such work by this artist, or just a representative selection? A few of these questions get addressed, here and there, in the bios, but only the issue of censorship gets an extended treatment. Craig Yoe's introduction offers a very quick history of cartoon censorship, with some interesting before-and-after case studies. Serious consideration of the surrounding issues of creation and suppression could open the door to a whole other history of cartooning, with details about the numerous men's magazines, newsletters and individual collectors responsible for publishing or preserving this artwork. But Yoe keeps the emphasis on the *fun*, and fun is good. Fun is important. I guess I was just looking for something more — a good personality as well as a pretty face. ∎

In Praise Of Powell

by Michael T. Gilbert

Few comic-book stars have burned as brightly, or as briefly, as Bob Powell. During comics' Golden Age his work ranked with Will Eisner, Jack Cole and Jack Kirby. And though he died at the tragically young age of 50, the prolific Powell left behind an enduring comic-book legacy.

Stanley Robert Pawlowski was born in Buffalo, N.Y. on Oct. 6, 1916, the only child of Stanley and Jacqueline. Stanley managed wrestlers while Jacqueline, reportedly a rather dour woman, raised their son. Bob, a natural athlete, excelled at baseball, hockey and football.

After graduating from Pratt Institute in 1938, he began his career at the studio run by Jerry Iger and Will Eisner. Powell's early work included forgettable features like Fox's *Dr. Fung,* ZX-5 for Fiction House, and *Landor, Maker of Monsters* for Harvey Comics. But by 1940, he was drawing *Spin Shaw, Lee Preston, Betty Banks* and *Abdul the Arab* for publisher Everett "Busy" Arnold's Quality Comics.

Powell's art style blossomed as he worked alongside comic-book greats like Eisner, Cole, Klaus Nordling and Lou Fine. Soon he was drawing and writing a number of popular features for Quality, including *Sheena of the Jungle* and *The Blackhawks,* which he helped to create.

In 1940, Eisner began to produce a weekly newspaper comics insert featuring the Spirit. He tapped Powell to draw *Mr. Mystic,* a four-page backup series in the mold of Mandrake the Magician. Powell quickly took over the writing chores as well, producing more than 150 stories from June 2, 1940, until Oct. 3, 1943, shortly before the series ended.

In 1941, he married childhood sweetheart Florence Dzimian, an attractive young lady he'd first dated at age 16. Shortly after, Stanley Robert Pawlowski legally changed his name to Bob Powell. Two sons followed, Robert in 1942, then brother John three years later.

Powell enlisted in the Army Air Corps in 1942, but con-

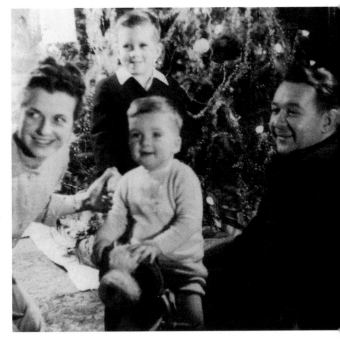

Bob and his family (Florence, Robert and John) look picture-perfect in this 1946 Christmas photo.

tinued to draw comics on the side. After returning to civilian life in late 1945, Powell formed his own studio with four other artists: Marty Epp (inker, letterer), George Siefringer (backgrounds), E. A. Weller (pencils, inks) and Howard Nostrand (pencils, inks). Soon the talented crew was producing a flood of beautifully drawn features for Harvey, Hillman, Street and Smith and other publishers. Powell wrote many of the stories himself, along with his usual penciling and inking duties.

He drew or created numerous features for Harvey Com-

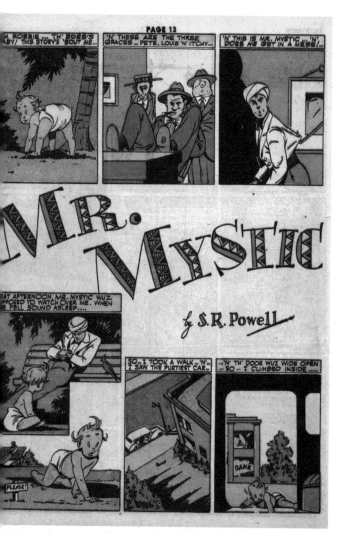

Bob's newborn son, Robert, stars in Powell's final Mr. Mystic story, from the Oct 3, 1943 Spirit section.

ics, including *Chickie Ricks* (*The Flyin' Fool*), *The Black Cat,* and his signature character, *The Man in Black Called Fate.* The latter was inspired by the radio dramas like *The Shadow,* and starred Death himself! These stories were primarily human-interest tales, narrated by Fate, who often stepped in to guide the characters toward their inevitable destinies. Powell drew the first story in 1945 and periodically returned to the character over the years, including one final visit in 1966, months before his death.

Another Powell creation was *Atoma,* a jet-powered anthropologist from the future, drawn in an innovative minimalist style. He also came up with *The Spirit of '76,* a Revolutionary War version of Eisner's *Spirit,* and drew such Harvey luminaries as *Shock Gibson, Tommy Tween, The Blonde Bomber* and *The Black Cat.*

The busy Powell Studio produced comic-book versions of Doc Savage, Nick Carter and The Shadow for Street and Smith, plus a handful of Shadow illustrations for their pulp magazines. Many consider Powell's Shadow to be the definitive comic-book version. He also drew occasional features for Hillman and other companies.

These stories display Powell's strengths — tight storytelling, lush inking, detailed backgrounds, inventive layouts and superb figure-work.

A Hard Driving Man

Bob Powell worked hard and played hard. A racing enthusiast, he enjoyed refurbishing classic sports cars, and assembled quite a collection over the decades. He was elected president of the Long Island Old Car Club, and also helped to design the Bridgehampton Race Course.

With the money rolling in, Powell enjoyed the high life. An elegant dresser, he often dined at Sardi's during his monthly trips to Manhattan. He also loved to pamper Gorgeous George, his beloved English bulldog. Powell often fed him expensive ground horsemeat, and Gorgeous repaid the favor by appearing in cameos in many of his master's strips.

By 1950, Street and Smith had pulled the plug on their comics, but Powell found new clients to pick up the slack. Magazine Enterprises kept Powell busy on *Thunda, Cave Girl, Jet Powers, I'm A Cop, Strongman* and *Bobby Benson's B-Bar-B Riders.* Sometimes it seemed like Powell was drawing their entire line.

Harvey Comics continued to be a reliable source of income. When superheroes died out in the late '40s, they jumped onto the horror bandwagon, fangs bared. Powell fit right in, providing gloriously gruesome art for *Witches Tales, Chamber of Chills* and *Black Cat Mystery.* He also kept churning out humor strips like *Tommy Tween* in *Joe Palooka* comics, along with true-life sports tales for books like *Babe Ruth Sports.*

And then there was Fawcett. Some of Powell's best work appeared under their publishing imprint. Stories for *Worlds Beyond, Hot Rod Comics, Vic Torry And His Flying Saucer, Battle Stories, Romantic Secrets* and *Strange Suspense Stories* demonstrated his range and versatility. Powell and his studio also worked overtime turning out stories for Atlas (Marvel), St. John, Charlton, Ziff-Davis and a number of smaller com-

panies. He was busier than ever.

But things were about to take a dramatic downturn.

The Final Chapter

In the late '50s, the comic-book industry went through a near-fatal slump. A congressional investigation into the effects of comics on children produced a whirlwind of bad publicity. The advent of television didn't help much, either, and comic sales plummeted. Weaker comic companies fell by the wayside, as many talented cartoonists left the field. Powell soldiered on, but maintaining his expensive lifestyle became increasingly difficult.

He still had clients, primarily Prize and Harvey, but there was simply not enough work to keep his studio busy. After letting his assistants go, Powell streamlined his art style, hoping to attract better-paying commercial-art jobs.

Topps proved to be a lucrative client, and he helped to design their now-classic *Batman* and *Mars Attacks!* card sets. More of his work appeared in the 1958 *Harwyn Picture Encyclopedia For Children* series (later reissued as the *Art Linkletter's Children's Encyclopedia*).

Powell also drew features for *Sick,* a humor magazine put out by his friend Joe Simon. He served a stint on the *Bat Masterson* syndicated comic strip, and later, Bessie Little's *Teena-a-Go-Go.*

However, comic books remained his first love. During these lean times, Joe Simon hired him to illustrate Prize's *Black Magic* and *Young Love,* as well as Harvey's *Alarming Tales* and *Alarming Adventures.* Simon also gave him work on *The Fly* and *The Shield* for Archie, as well as Hastings Associates' *Eerie Tales* magazine.

But the hard times had taken their toll. After nearly 20 years of marriage, Powell and his wife, Florence, divorced in 1960. Though it was a difficult time for him personally, his professional life slowly started to improve.

After years of poor sales, Marvel had rebounded by 1965 and was looking for new artists. Editor Stan Lee assigned Powell to pencil stories featuring the Hulk, Daredevil, Human Torch and Giant-Man (upsized from *Ant-Man* in Powell's debut story). Powell's work on these titles was solid, if unexceptional. He had always worked best when he was in charge, but now he was just a hired hand, often working over Jack Kirby layouts and Stan Lee plots. Incompatible inkers made things even worse.

But Marvel wasn't the only game in town. From 1966-67, Powell wrote and drew seven issues of *Henry Brewster,* Country Wide Publishing's *Archie* knockoff.

Ever-dependable Harvey Comics also came through. When they asked Joe Simon to edit their new adventure line, he gave his old friend a call. Soon Powell was working on stories featuring his beloved Man In Black and The Glowing Gladiator, a new superhero he created for their *Double-Dare Adventures* title. The Gladiator's 15-page origin tale was classic Powell, filled with exciting layouts and drawings that popped right off the page.

If Powell's work situation was improving, so was his home life. He had met Bettina Hollis, a young divorcée, and married her in 1961. Powell adopted Kyle, her little boy, shortly after. Five years later, Kyle learned that he was going to have a baby brother. It was a happy time for the Powell family.

Then, in 1966, Powell was diagnosed with incurable pancreatic cancer.

It was a crushing blow, but Powell was too busy to waste time on self-pity. His wife Bettina recalled a conversation Powell had with Joe Simon shortly before the end. Joe was understandably shaken, but Powell tried to reassure him.

The Man In Black, from *Green Hornet* #33, March 1947.

"It's OK, Joe," Powell told his old friend. "Life's a great big beautiful balloon and I hate like hell to see it burst."

Bob Powell died Oct. 1, 1967, just five days before his 51st birthday. Seth, his fourth son, was born six weeks later.

A tireless worker, Powell left a legacy of exceptional work in every genre. His athletic background gave life to stories in *Babe Ruth Sports, Real Sports* and *True Sport Picture Stories.* His brash humor shines through in the slapstick comedy of *Tommy Tween, Joe College* and *Henry Brewster*, as well as *Panic* and *Sick* magazines, both *Mad* wannabes.

But he had a soft side, too. Powell's *First Love, Romantic Secrets* and *Hi-School Romance* stories were guaranteed to make any lovesick teen's heart go pit-a-pat.

Powell's military background gave a gritty realism to his work on *War Ace, Foxhole* and *Battlefront*. But he was equally adept at fantasy. His depictions of the super-heroic Doc Savage, The Shadow, Mr. Mystic, Shock Gibson and The Avenger showed power and nobility. Powell's futuristic machinery and aliens stood out in sci-fi titles like *Vic Torry and His Flying Saucer* and *Jet Powers*, while his sexy drawings of jungle queens Sheena and Cave Girl proved he could do "good girl" art with the best of them.

And then there was …

The Horror! The Horror!

As you'll see in the reprints that follow, Powell's work on terror titles from Fawcett, Harvey and Ziff-Davis displayed a remarkable feel for the genre. Few cartoonists could draw scarier monsters, or sexier damsels in distress.

A stunning page from Harvey's *Witch's Tales* #10, May 1952.

Powell's depictions of decaying swamps or fog-shrouded tenements would be right at home in a Will Eisner *Spirit* story, which isn't surprising, as he and Eisner had learned from each other when both were starting out. Like his old studio-mate, Powell knew exactly how to pace a story for maximum effect, using dramatic lighting and deep shadows to create a creepy atmosphere.

Powell also took advantage of color, often using spectacular color-holds to depict ghosts and other ethereal creatures. In one audacious story reprinted here, he even used the technique to let the reader see the story through the monster's eyes.

This is peak Powell, ably assisted by Marty Epp, George Siefringer and Howard Nostrand (a superb inker who later illustrated some memorable solo stories for Harvey). The authors of the stories reprinted here are unknown. However, Powell often wrote his own scripts, or rewrote those given to him by others.

Bob created the Glowing Gladiator for Harvey's *Double-Dare Adventures* #1 in 1966, less than a year before his death.

The Stories

"Wall of Flesh!"

(This Magazine Is Haunted #12, August 1953, Fawcett).

Once Captain Marvel was the brightest star in Fawcett's comic-book line. But by the early '50s, superheroes had been "knocked out" by the rise in horror comics. Fawcett proved to be surprisingly adept at the genre, publishing some truly outstanding stories drawn by George Evans and Bob Powell. Though fans generally cite EC's horror comics as the finest in the field, some of Powell's Fawcett stories even exceeded them. "Wall of Flesh!" is a perfect case in point. Note how excruciatingly slooooooowly the ghastly "wall of flesh" absorbs its victim on pages four and five. An exceptional story, exceptionally told.

"Walking Dead!"

(Chamber Of Chills #23, October 1951, Harvey)

Richie Rich, *Casper* and *Hot Stuff* generally come to mind when today's fans think of Harvey Comics. But in the early '50s, the publisher was famous for more gruesome fare, achieving a well-deserved reputation for cheesy and exploitative horror comics. But there were gems among the coal, including Powell's "Walking Dead." In this story, the reader witnesses the spine-chilling events through the cold, dead eyes of the main character! *Brrr!* Will Eisner used a similar idea in one of his 1940s Spirit stories, but Powell pushes the idea to a whole new level. He achieved this effect by drawing the blood-shot orbs on a separate sheet of art, which were then printed as a "color-hold."

"Colorama!"

(Black Cat Mystery #45, August 1953, Harvey)

"Colorama," like "Walking Dead," tells the story from the protagonist's point of view. The story itself is pretty minor, and like many Harvey scripts, the silly ending doesn't really hold up. But Powell's brilliant storytelling and clever use of color makes "Colorama" a visual *tour de force*.

Below: This 1945 piece, drawn for a proposed syndicated comic strip, features many of Powell's most memorable characters. Left to right: Maylene (from Chickie Ricks), an unknown masked swashbuckler, The Scarlet Arrow, Banks Barrow (from Loops 'n' Banks), the Professor (from *Treasure Chest Comics*), The Spirit of '76 and girlfriend Susan, the Man In Black, Sheena, a baby (possibly Robert or John Powell), Abdul the Arab, The Black Cat, Chowderhead and his pal, Mr. Mystic. Art courtesy of Robert Powell.

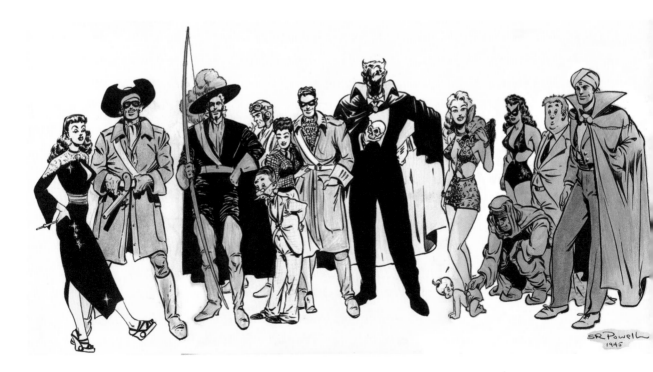

Censored "Colorama!" page! Bob Powell originally drew "Colorama!" for *Black Cat Mystery* #45 (August 1953). When it was reprinted in the renamed *Black Cat Mystic* #61 (January 1958), the newly instituted Comics Code demanded that the story be toned down. Note how the last three panels have been redrawn, compared to the version printed in our comics section.

"Vampires from Venus!"

(*Eerie Adventures* #1, Winter 1951, Ziff-Davis)

Powell only did a handful of stories for Ziff-Davis, but "Vampires From Venus" ranks as one of his best. How can you go wrong with Venusian vampires who look like man-eating asparagus? This story may remind you of John Wyndam's novel *Day of the Triffids*, about similar carnivorous foliage. Oddly enough, Wyndham's book came out in December 1951, shortly after the Powell version. Even odder: Powell's story ends with the plants being destroyed by sunlight, similar to the ending of the 1962 film version of *Day of the Triffids*, in which they are destroyed by salt water. (In the book, the Triffids survive.)

"Twice Alive!"

(*World's Beyond* #1, November 1951, Fawcett)

"Twice Alive!" brings to mind the kitschy 1966 movie *Fantastic Voyage*, in which Raquel Welch and crew shrink to near-microscopic size in order to travel through the body's bloodstream to cure a dying man. Powell's version, published 15 years earlier, is considerably darker. Not only does the story's hero find himself inside his own body tying to outrace Death, but he somehow finds himself in a spirited conversation with his own DNA. Improbable as the plot sounds, Powell brings it to crazy life with his masterful storytelling and uncanny drawing ability. Part of the fun of Powell's stories is seeing him constantly experiment with structure and technique. Even tiny throwaway panels, like the fourth picture on page two, provide unexpected visual treats. The highly dramatic coloring also adds to the claustrophobic feeling. ■

Much of the information for this introduction was culled from my three-part article, "The Powell Family Album!" in *Alter Ego* magazine #66, 67 and 69. My thanks to *Alter Ego* editor Roy Thomas, John Morrow, Ed Lane, Bettina Lussier, Florence Feustel, Seth Powell and Kyle Powell, as well as Gary Groth, Michael Dean, Ken Quattro, Ger Apeldoorn, Nick Caputo and proofreader Janet Gilbert. We are especially grateful to Bob's sons, John and Robert Powell, for providing photos and art used in this introduction.

Powell by Powell from *Sick* #42, February 1966.

A BEAUTIFUL GIRL stumbles through the darkness! Her unwary hand touches a slim, warm, pulsating mass! Fear chokes her screams--ices her blood! She has come upon...

The WALL of FLESH!

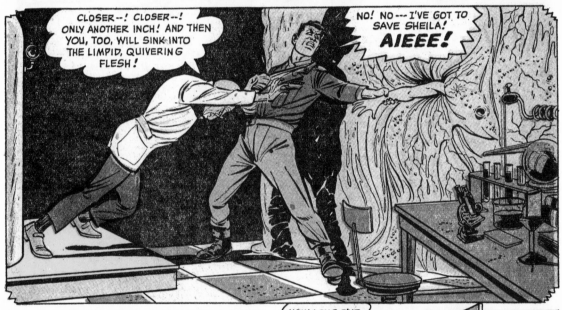

CLOSER--! CLOSER--! ONLY ANOTHER INCH! AND THEN YOU, TOO, WILL SINK INTO THE LIMPID, QUIVERING FLESH!

NO! NO--- I'VE GOT TO SAVE SHEILA! AIEEE!

THE CLICK OF HER NURSE'S SHOES ECHOED DOWN THE LONG EMPTY CORRIDORS OF THE HOSPITAL AND THE NIGHT-LIGHTS PULLED HER SHADOW INTO VARYING SHAPES...

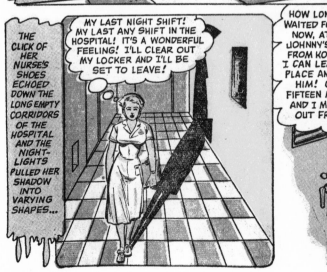

MY LAST NIGHT SHIFT! MY LAST ANY SHIFT IN THE HOSPITAL! IT'S A WONDERFUL FEELING! I'LL CLEAR OUT MY LOCKER AND I'LL BE SET TO LEAVE!

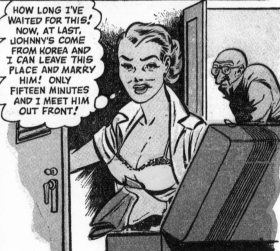

HOW LONG I'VE WAITED FOR THIS! NOW, AT LAST, JOHNNY'S COME FROM KOREA AND I CAN LEAVE THIS PLACE AND MARRY HIM! ONLY FIFTEEN MINUTES AND I MEET HIM OUT FRONT!

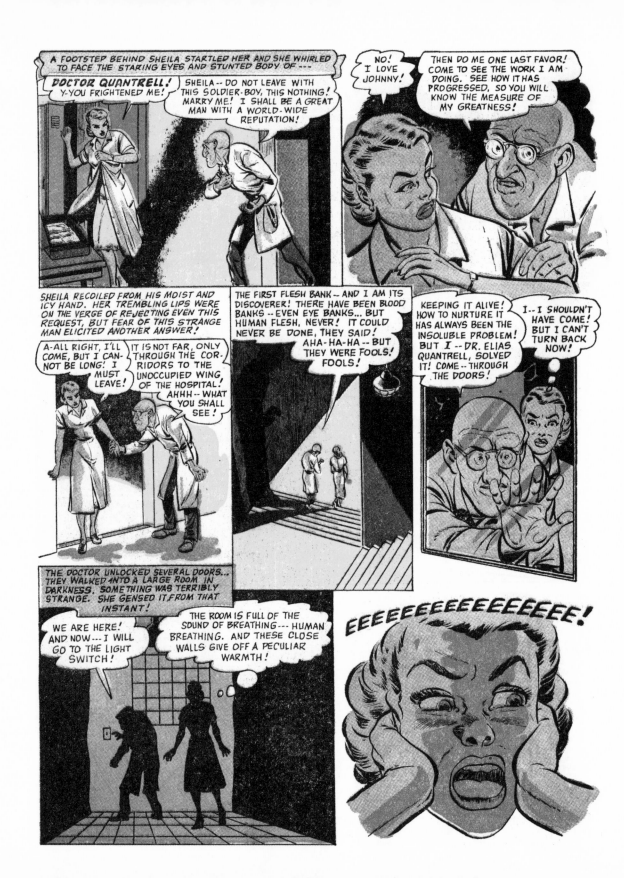

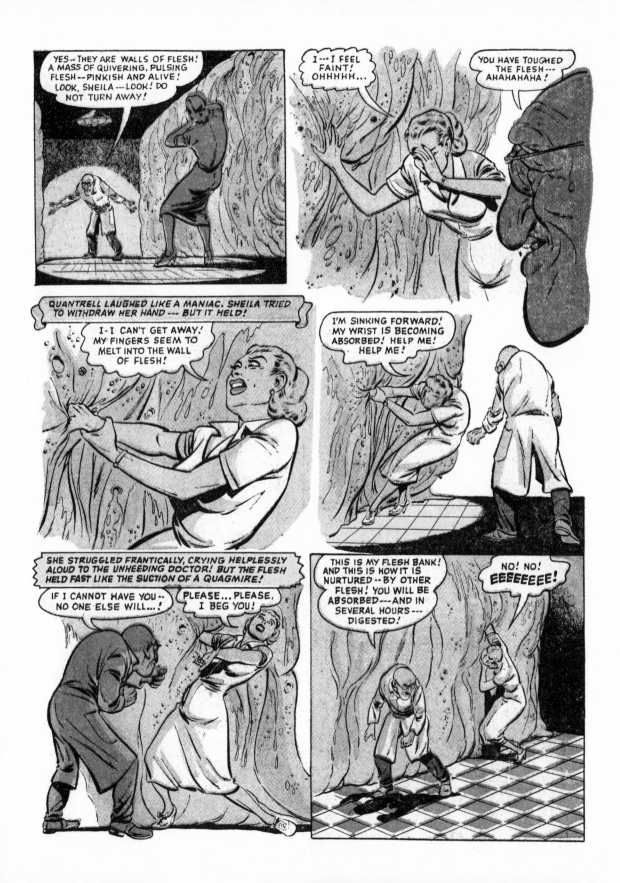

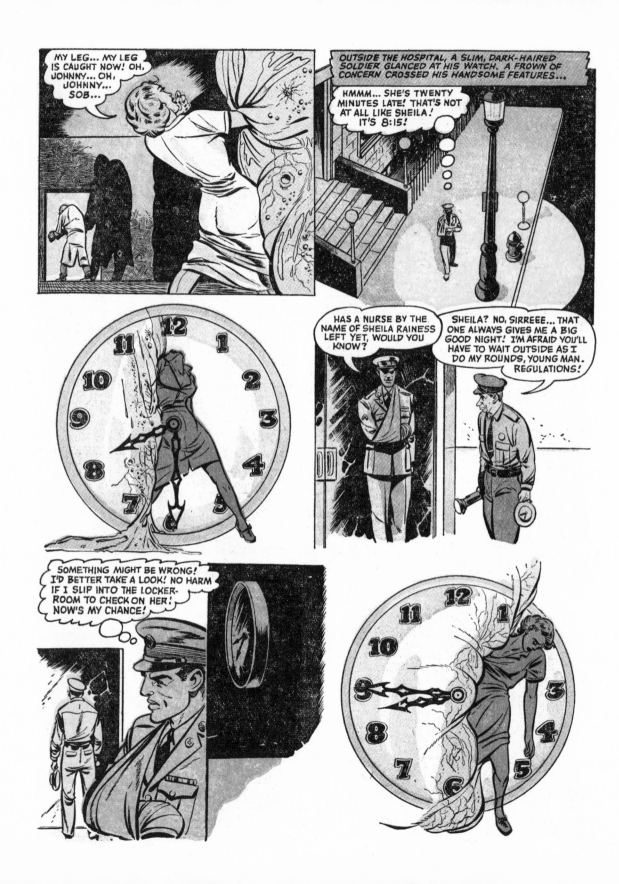

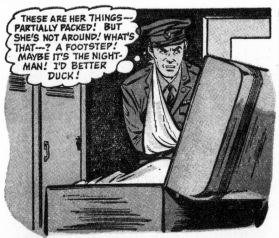

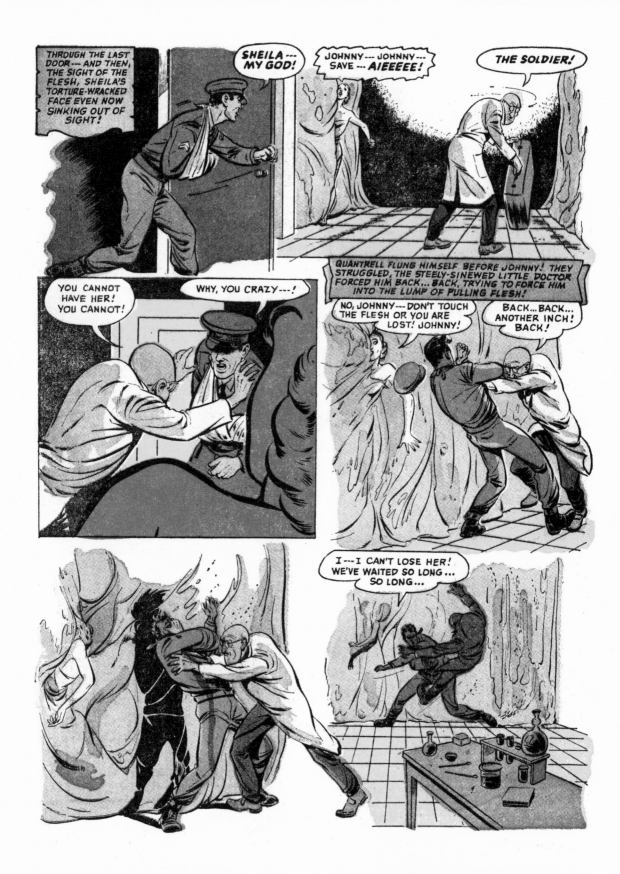

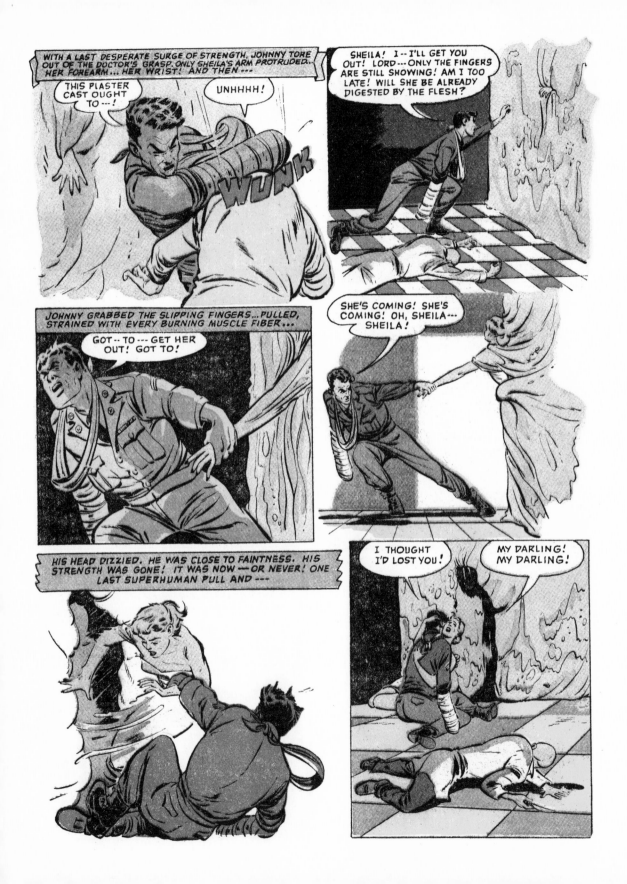

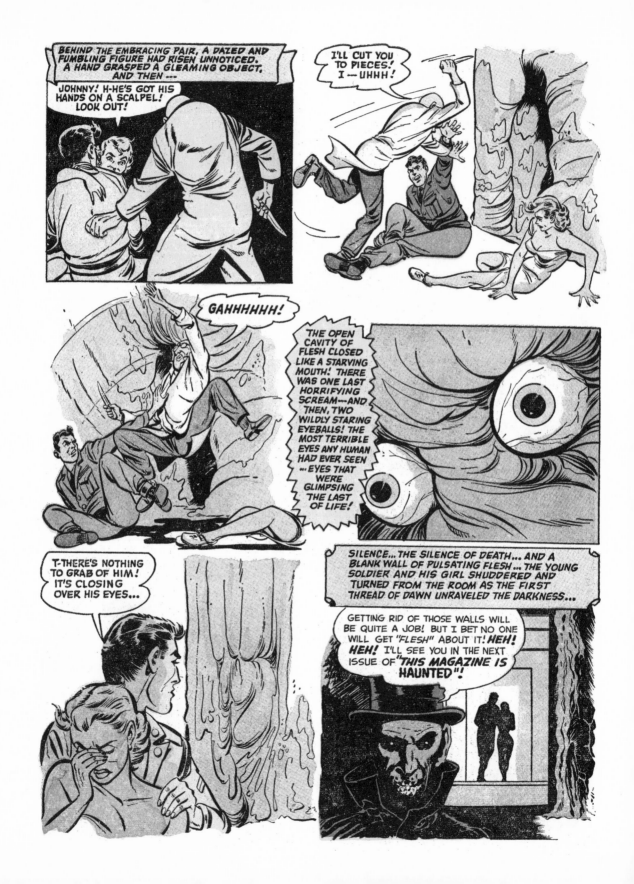

FATE SMILED CRUELLY AND OFFERED KURT JENSEN SIGHT FOR BLINDNESS. BUT JENSEN'S EYES BELONGED TO A DEAD MAN AND THROUGH THEM HE KNEW THE TERRIBLE CURSE OF THE...

WALKING DEAD

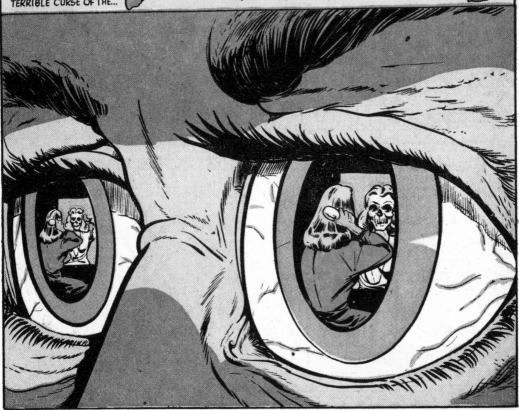

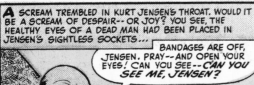

A SCREAM TREMBLED IN KURT JENSEN'S THROAT. WOULD IT BE A SCREAM OF DESPAIR-- OR JOY? YOU SEE, THE HEALTHY EYES OF A DEAD MAN HAD BEEN PLACED IN JENSEN'S SIGHTLESS SOCKETS...

BANDAGES ARE OFF, JENSEN. PRAY--AND OPEN YOUR EYES! CAN YOU SEE-- *CAN YOU SEE ME, JENSEN?*

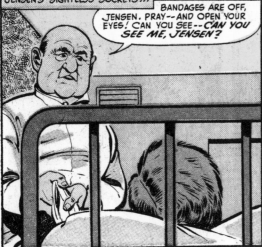

YES--*YES!* I CAN SEE! *AT LAST I CAN SEE!*

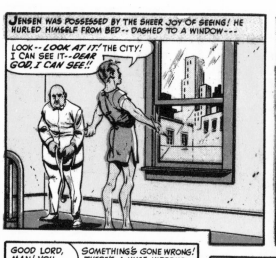

JENSEN WAS POSSESSED BY THE SHEER JOY OF SEEING! HE HURLED HIMSELF FROM BED -- DASHED TO A WINDOW ---

LOOK -- *LOOK AT IT!* THE CITY! I CAN SEE IT -- *DEAR GOD, I CAN SEE!!*

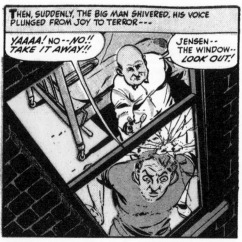

THEN, SUDDENLY, THE BIG MAN SHIVERED, HIS VOICE PLUNGED FROM JOY TO TERROR ---

YAAAA! NO -- NO!! TAKE IT AWAY!!

JENSEN -- THE WINDOW -- *LOOK OUT!*

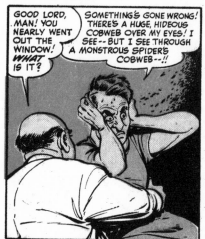

GOOD LORD, MAN! YOU NEARLY WENT OUT THE WINDOW! *WHAT* IS IT?

SOMETHING'S GONE WRONG! THERE'S A HUGE, HIDEOUS COBWEB OVER MY EYES! I SEE -- BUT I SEE THROUGH A MONSTROUS SPIDER'S COBWEB --!!

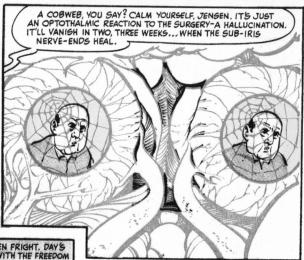

A COBWEB, YOU SAY? CALM YOURSELF, JENSEN. IT'S JUST AN OPTOTHALMIC REACTION TO THE SURGERY -- A HALLUCINATION. IT'LL VANISH IN TWO, THREE WEEKS... WHEN THE SUB-IRIS NERVE-ENDS HEAL.

THE DOCTOR'S WORDS SOOTHED JENSEN'S SUDDEN FRIGHT. DAYS PASSED. AND A MAN, ONCE BLIND, NOW WALKED WITH THE FREEDOM OF SIGHT --- SIGHT THROUGH A DEAD MAN'S EYES...

GLAD T'SEE YOU AGAIN, MR. JENSEN! I'M SURE GLAD THE SAWBONES FIXED YOU UP WITH NEW PEEPERS!

THANKS, GEORGE. GIVE ME A QUICK ONE.

THE COBWEB! ALWAYS THERE! IF ONLY -- *ONLY* -- IT WOULD GO AWAY --!

THAT CASTLE! DON'T TRICK ME, GEORGE! TAKE THAT PICTURE OF A CASTLE AWAY!

CASTLE? *WHAT* CASTLE, MR. JENSEN --?

A VISION HAD SNAPPED INTO FOCUS BEFORE JENSEN'S EYES. THE VISION WAS A CRUMBLING, FRIGHTENING STRUCTURE, INCONGRUOUSLY PLACED AGAINST THE MODERNITY OF THE SEVENTH AVENUE BAR!

IT'S TOO MUCH--;GASP;--THEN--THE CASTLE! I CAN'T STAND IT--;GASP;--I CAN'T STAND IT!

POOR GUY - HE'S GOIN' OFF HIS NUT. BRRR-- WHAT A FUNNY LOOK IN THOSE NEW EYES OF HIS...LIKE THE EYES OF A-- A DEAD MAN!

FRANTIC, JENSEN SOUGHT OUT THE DOCTOR WHO HAD GIVEN HIM A DEAD MAN'S EYES THAT HE MIGHT SEE AGAIN--

A CASTLE--YES, A CASTLE! IS *THAT* A HALLUCINATION, TOO? OR-- OR DOES IT HAVE SOMETHING TO DO WITH THE MAN WHO-- WHO *FIRST HAD THESE EYES*--?

WHAT? COME, COME, MR. JENSEN! HA-HA-HA-HA---

BY LAW, JENSEN, I CAN'T TELL YOU WHOSE EYES YOU HAVE. HOWEVER, THE THOUGHT THAT A PERSON IS HAUNTING YOU THROUGH YOUR NEW EYES IS SHEER FANTASY. THESE VISIONS ARE MERELY REACTIONS OF YOUR OPTIC NERVES. WHY DON'T YOU TAKE A VACATION-- TAKE A GOOD REST--

LATER, THE DOCTOR STOOD ALONE WITH HIS THOUGHTS-- TREMBLING!

IT'S FANTASTIC! JENSEN'S EYES CAME FROM A SPANISH NOBLEMAN KILLED IN A PLANE CRASH AT THE CITY AIRPORT... AND THAT CASTLE JENSEN DESCRIBED--- I'D SWEAR IT WAS A *SPANISH* CASTLE! BUT IT CAN'T BE--- IT--CAN'T--BE--!

MEANWHILE, JENSEN, TENSE AS TAUT RUBBER, WALKED GRIMLY, EVEN WILDLY, TO THE NEAREST TRAVEL BUREAU...

ALL RIGHT-- I'LL LEAVE! NOW-- *TODAY!* ANYTHING--ANYTHING TO SEE *CLEARLY* AGAIN...

YESSIR, HELP YOU?

NOT YET, I DON'T KNOW WHERE I WANT TO GO. ALL THESE FOLDERS--THESE DIFFERENT PLACES--- I'LL JUST PICK ONE OUT, ANYWHERE---

THEN, ABRUPTLY, THE CASTLE LEAPT INTO JENSEN'S VIEW... AND FOR LONG MOMENTS JENSEN'S VERY SOUL WAS FROZEN... NUMBED...

THEN, QUICKLY, IT VANISHED... AND JENSEN HEARD THE CLERK SPEAK TO HIM...

WHAT--? TICKETS? WHAT TICKETS?

WHY, SIR, YOU JUST ORDERED TICKETS ON A PLANE TO SPAIN, DON'T YOU WANT THEM?

I MUST'VE ORDERED THEM WHEN THAT-- THAT HIDEOUS CASTLE BLINDED ME.

AH--YES. SPAIN'S ALL RIGHT--AS GOOD A PLACE AS ANY FOR A VACATION. YES, YES, I'LL TAKE THEM...

OH, BROTHER! *THAT* GUY SHOULD HAVE A ONE-WAY TICKET TO THE LOONEY-BIN-- NOT SPAIN! BRRR--WHAT EYES! LIKE FROZEN BLOOD!

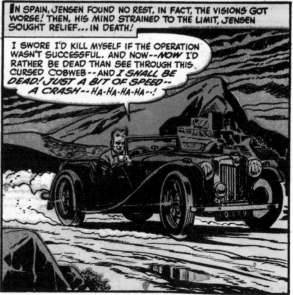

IN SPAIN, JENSEN FOUND NO REST. IN FACT, THE VISIONS GOT WORSE! THEN, HIS MIND STRAINED TO THE LIMIT, JENSEN SOUGHT RELIEF... IN DEATH!

I SWORE I'D KILL MYSELF IF THE OPERATION WASN'T SUCCESSFUL. AND NOW--*NOW* I'D RATHER BE DEAD THAN SEE THROUGH THIS CURSED COBWEB--AND *I SHALL BE DEAD! JUST A BIT OF SPEED-- A CRASH--HA-HA-HA-HA--!*

BUT FATE HELD HORROR, NOT DEATH, IN STORE FOR JENSEN. JUST AS HE BEGAN TO SPEED, THE SKY SPLIT OPEN AND--

THE LIGHTNING STUNNED BOTH JENSEN AND THE CAR. THE MOTOR CHOKED OFF. JENSEN'S FURY FLARED UP TO MATCH THAT OF THE RAGING STORM ABOVE ...

CURSE IT, *CURSE IT!* I CAN'T EVEN KILL MYSELF! I'M TO *SUFFER*, NOT *DIE*, IS THAT IT? HA-HA-HA-HA--- SUFFER--HA-HA-HA--- S-U-F-F-E-R---

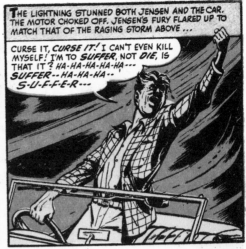

BUT JENSEN STRANGLED HIS MANIACAL SCREAMS WHEN HE SAW SOMETHING MOVING AT THE ROAD'S EDGE...

A WOMAN--IN THIS GODFORSAKEN WILDERNESS! WAIT--WAIT! DON'T LEAVE!

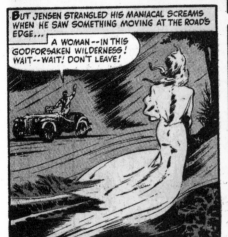

WAIT! I'M LOST-- ¿GASP¿-- IN THIS STORM! ¿GASP¿ IN THIS DARKNESS-- ¿GASP¿-- IT LOOKS LIKE SHE'S FLOATING-- ¿GASP¿-- NOT WALKING--MAYBE SHE COULD HELP ME!

JENSEN RACED THROUGH THE WOODED DARKNESS AND STINGING RAIN, UNTIL---

YAAAAA! THE CASTLE! THE CASTLE I'VE BEEN SEEING-- *THERE IT IS-- AND IT'S REAL!*

JENSEN FELL HEAVILY TO THE GROUND AND LAY AS IF DEAD. SOON THERE CAME A SIGH AND A FAINT RUSTLE. THE GRAVE'S DAMP ODOR SWELLED FORTH AS BESIDE A GNARLED, STORM-SEARED TREE THERE APPEARED THREE FIGURES...

HE IS HERE, SISTER. THE MORTAL WITH OUR BROTHER'S EYES--

COME...COME, LET US TAKE HIM TO ETERNITY'S TOMB.

A DIM, VAGUE CONSCIOUSNESS FILTERED THROUGH JENSEN. HE FELT HIMSELF MOVING...FLOWING...FLOATING...AND, THEN, HE FELT THE NEED FOR SLEEP...ENDLESS SLEEP.

LIGHTS, SHADOWS, AND SOUNDS GLIMMERED AND DIED IN JENSEN'S MIND...AND THEN HE FELT A COLD HAND PRESS HIS ARM...

NOW...TO MAKE HE-WITH-OUR-BROTHER'S EYES ONE OF US...BY GIVING HIM THE TOUCH OF...THE UN-DEAD...

MAKE HASTE... THE BREATH OF DAWN HOVERS... WE MUST RETURN... TO THE DEAD...

HOURS LATER, JUST AS THE HAZE OF TWILIGHT SLITHERED OVER THE MOUNTAINS, JENSEN AWOKE...

THAT'S FUNNY--THERE'S NO COBWEB OVER MY EYES NOW! OHH...WHERE AM I? WAS I DREAMING, OR WERE THOSE TWO GIRLS--THAT GIANT DOG-- REAL? OHH....MY HEAD...

WHY--THIS IS A--A TOMB! AND--THAT-- COBWEB! IT'S THE COBWEB I'VE BEEN SEEING! IT'S REAL---IT'S REAL!

THE GIRLS-- I DID SEE THEM! DEAD IN THIS DUST AND DECAY-- LOOKING AS FRESH AS LIFE! I-- I MUST BE MAD-- STARK RAVING MAD---

SUDDENLY, JENSEN WAS NO LONGER A MAN...BUT AN ANIMAL, CRAZED WITH FEAR, SPURRED BY TERROR...

YAAAA-- LET ME OUT-- LET ME OUT OF HERE!!!

HA-HA-HA-HA -- I'M ONE OF THEM NOW! A GHOUL -- A GHOST! I DIDN'T BREAK THE COBWEB WHEN I RAN THROUGH IT! HA-HA-HA-HA! A GHOUL -- I'M A GHOUL --- HA-HA-HA-HA --

SOBBING, SCREAMING, JENSEN RAN OUT OF THE CASTLE, DOWN A ROAD... AND THE DARKNESS PRESSED IN ON HIM LIKE THE JAWS OF A VISE...

EEEEEEEEE --

GRANDFATHER -- LOOK! AN UN-DEAD ONE FROM THE CASTLE!

JENSEN FELL... GIBBERING CRAZILY...

YAAAAA --

HA-HA-HA -- ;GASP; -- I'M DEAD -- BUT YOU -- WHY DON'T YOU RUN, TOO, OLD MAN -- ;GASP; --

I AM TOO OLD, SEÑOR. DEATH CANNOT FRIGHTEN ONE WHO WAITS FOR HIM!

OLD MAN... I WON'T HURT YOU -- JUST TELL ME WHAT -- OR WHO -- YOU THINK I AM! THAT GIRL -- SHE CALLED ME "UN-DEAD" -- WHAT DID SHE MEAN? WHAT DID SHE MEAN --?

YOU DO NOT KNOW? BUT -- I DO AS YOU ASK, SO THAT I MAY DIE IN PEACE, AND NOT PROVOKE YOUR UN-DEAD CURSE...

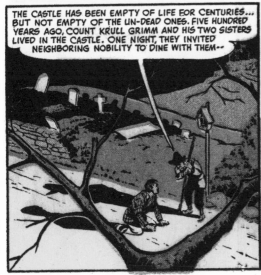

THE CASTLE HAS BEEN EMPTY OF LIFE FOR CENTURIES... BUT NOT EMPTY OF THE UN-DEAD ONES. FIVE HUNDRED YEARS AGO, COUNT KRULL GRIMM AND HIS TWO SISTERS LIVED IN THE CASTLE. ONE NIGHT, THEY INVITED NEIGHBORING NOBILITY TO DINE WITH THEM --

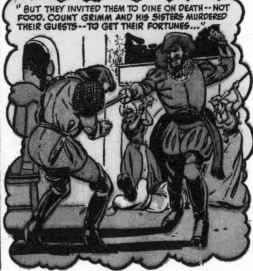

"BUT THEY INVITED THEM TO DINE ON DEATH -- NOT FOOD. COUNT GRIMM AND HIS SISTERS MURDERED THEIR GUESTS -- TO GET THEIR FORTUNES..."

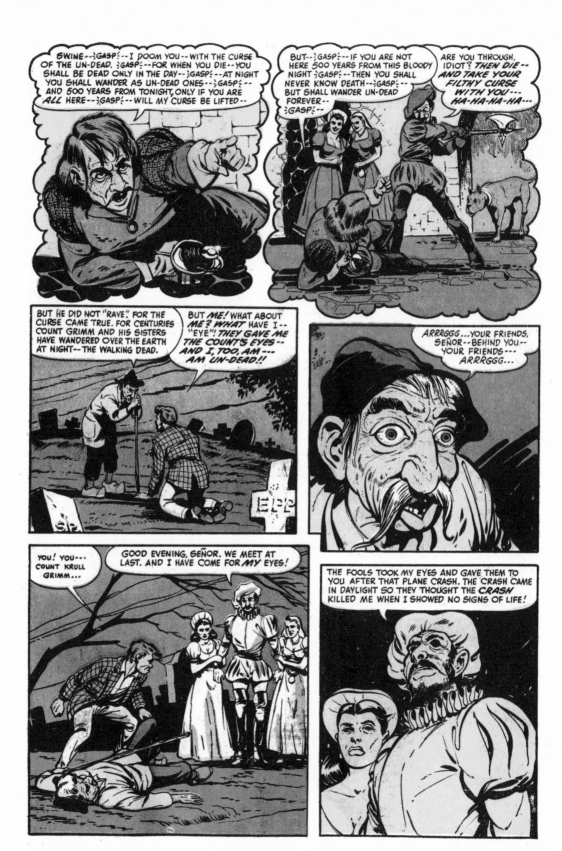

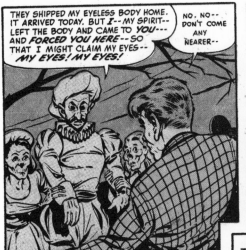

THEY SHIPPED MY EYELESS BODY HOME. IT ARRIVED TODAY. BUT I--MY SPIRIT-- LEFT THE BODY AND CAME TO *YOU*--- AND *FORCED YOU HERE*--SO THAT I MIGHT CLAIM MY EYES-- *MY EYES! MY EYES!*

NO. NO-- DON'T COME ANY NEARER--

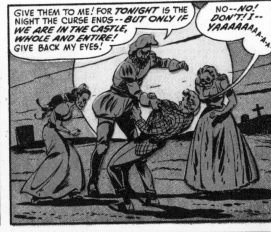

GIVE THEM TO ME! FOR *TONIGHT* IS THE NIGHT THE CURSE ENDS-- *BUT ONLY IF WE ARE IN THE CASTLE, WHOLE AND ENTIRE!* GIVE BACK MY EYES!

NO--*NO!* DON'T! I-- YAAAAAAA-A-A.

THE *DANKNESS* OF THE GRAVE, OF DEATH ITSELF, SWEPT OVER JENSEN AND, IN A FINAL SWOON OF TERROR, HE BLACKED OUT. HOURS LATER, WHEN HE AGAIN AWOKE--

CAN'T SEE--CAN'T SEE-- MY EYES--GONE. A SKULL! I FEEL-- A SKULL---

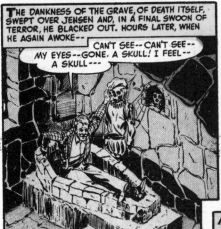

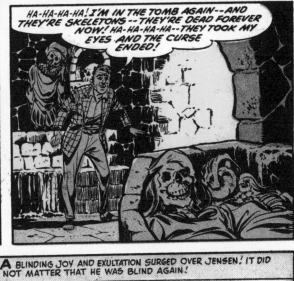

HA-HA-HA-HA! *I'M IN THE TOMB AGAIN--AND THEY'RE SKELETONS--*THEY'RE DEAD FOREVER NOW! HA-HA-HA-HA--THEY TOOK MY EYES AND THE CURSE ENDED!

BUT *ME!* ME! I'M BLIND AGAIN--AND I'M UN-DEAD! I'M--WHAT-- *I'M TEARING IT, I'M TEARING THE WEB!!* I'M HUMAN AGAIN! *THEY LEFT ME HUMAN!!*

A *BLINDING JOY* AND EXULTATION SURGED OVER JENSEN! IT DID NOT MATTER THAT HE WAS BLIND AGAIN!

I TORE THAT COBWEB--*TORE IT! HA-HA-HA--!* I'M REAL--- I'M WHOLE! HA-HA-HA-HA---I'M BLIND---BUT I'M FREE--- FREE--FREE--FREE---

FREE!

FREEEE

FREE!

FREE!

FREE

THE END

YOU ARE DRIVING ON THE STREET WITH THE MILLION NEON LIGHTS! YOUR EYES TAKE IN ALL THOSE LIGHTS THAT FLICKER... DANCE...STAB IN ALL DIRECTIONS! YES, YOUR EYES TAKE IN THIS WONDROUS...

COLORAMA

SUDDENLY...YOU SEE A NEW LIGHT...A DEEP, BLARING *RED*... THAT JABS LIKE AN ASTERISK!

YOU DRAW CLOSER...AND THE POINTS OF THE GROWING BALL BEGIN TO MELT...THEN DRIP...

IT *SPLITS*....INTO TINY PARTICLES, BUT...THE *RED NUCLEUS* IS STILL THERE! WHAT IS IT? WHERE DOES IT COME FROM?

YOU APPLY THE BRAKES! BUT...THE RED BALL HAS DISAPPEARED...AND ALL YOU SEE IS A *TRAFFIC LIGHT*...A *RED* TRAFFIC LIGHT! YOU WONDER...?

WAS IT THE TRAFFIC LIGHT...ALL ALONG? YOU CAN'T THINK STRAIGHT! YOU STOP TO BLINK YOUR EYES...AND WHEN YOU OPEN THEM...YOU CATCH A GLIMPSE OF SOMETHING...

YOU TURN YOUR HEAD...AND SEE ...A SNAKE-LIKE GLOB OF *BLUE*!!!

AND...IT'S APPROACHING YOU. IT'S GROWING LARGER NOW... AND WIDENING...

AND THEN...IT'S RIGHT ON TOP OF YOU...SMOTHERING YOU LIKE A WAD OF BLUE DOUGH...

BUT...A VOICE MAKES IT VANISH...JUST AS THE HURT IN YOUR EYES RECEDE! AND...YOU SEE A *POLICEMAN*...IN A *BLUE* UNIFORM!

HEY, BUDDY! DON'T YOU KNOW YOU PASSED A *RED LIGHT?* LET'S SEE YOUR LICENSE!

YOU SHOW THE COP YOUR LICENSE, AND...YOU REMEMBER THAT IT READS...*20/20 VISION!* THEN...YOU KNOW IT! IT'S YOUR EYES...SOMETHING HAS GONE *WRONG* WITH *YOUR EYES!*

I'M GIVING YOU A TICKET, BUDDY! YOU *DESERVE* IT! MISSING THAT *LIGHT!* YOU *OUGHT TO HAVE YOUR EYES EXAMINED!*

2

YOU THRUST THE TICKET INTO YOUR POCKET... AND *LEAVE THE CAR!* YOU CAN'T TRUST YOURSELF! YOUR EYES MAY GO AGAIN... ANY MINUTE ... ANY SECOND! YOU'VE GOT TO GET THEM EXAMINED BY AN OPTOMETRIST... ANY ONE... BUT *FAST!*

YES! WHAT CAN I DO FOR YOU?

A SILLY QUESTION... BUT YOU ANSWER IT! HE SEEMS INTERESTED... VERY INTERESTED... AS HE EXAMINES YOUR EYES... A PINPOINT OF LIGHT PIERCING YOUR PUPILS.

YES... YES... I THOUGHT SO! EYES... *HYPER-SENSITIVE TO COLOR!* THAT'S ABOUT IT!

YOU HEAR A LOT OF MUMBO-JUMBO... YOUR EYES CAN'T TAKE *COLOR.* THAT'S WHAT THE EYE-DOCTOR SAYS! AND... HE SAYS SOMETHING ELSE...

FOR YEARS I HAVE BEEN TRYING TO PERFECT A PAIR OF GLASSES TO CORRECT YOUR DISEASE. THIS IS WHAT I HAVE DONE SO FAR! TRY THEM ON, PLEASE! TAKE A LOOK AROUND!

IS THIS GUY A *QUACK?* BUT... YOU GO ALONG WITH HIM! YOU PUT ON THE GLASSES... AND YOU SEE GREAT! THE *COLOR* SEEMS TO REMAIN STILL... STATIC... NO WEIRD SHAPES!

YOU WANT TO PAY FOR THE GLASSES... BUT THE OPTOMETRIST TAKES THEM BACK!

NO, I'M SORRY! THE GLASSES ARE NOT FOR SALE! YOU SEE... THERE'S STILL A FLAW IN THEM... A *FLAW* WHICH I HAVE TO *RESOLVE!* BUT... YOU CAN COME BACK *TOMORROW*... AND WE'LL CARRY ON OUR EXAMINATION!

YOU WALK OUT INTO THE STREET... AND FIND HOW LATE IT'S BECOME! YOU NEED SLEEP... GOT TO REST YOUR EYES! A STREET LAMP SENDS DOWN ITS RAYS... A PALE YELLOW LIGHT...

3

SUDDENLY...THE LIGHT BLOWS UP...

THEN...SPIRALS CRAZILY...

YOU CAN'T TAKE IT! YOU BLOCK OUT EVERYTHING WITH YOUR HAND!

SO...THE NEXT DAY...YOU GO BACK TO THE OPTO-METRIST. YOU NEED HIS GLASSES...THOSE SOOTHING GLASSES...

I'M SORRY, SIR...I TOLD YOU...

BUT YOU DON'T TAKE *NO* FOR AN ANSWER...

NO...I...I CAN'T...THERE'S A *FLAW* IN THEM...

YOU NEED THE GLASSES...*DESPERATELY!*

YOU'LL... ARG-H

YOU HAVE KILLED FOR THE GLASSES. YOU FIND THEM...AND...

...*PUT THEM ON!* THEY FIT SNUGLY...COMFORTABLY...AND YOU LEAVE THE OPTOMETRIST'S STORE! THE PEOPLE ON THE STREET PASS YOU BY...AND YOU LOVE THE COLORS...ONCE AGAIN *NATURAL*...

ALL'S RIGHT WITH THE *COLOR WORLD*...YOU TURN A CORNER...AND SEE SOME CHILDREN PLAYING!

SUDDENLY, THE COLORS BEGIN TO FADE...INTO WEAK PASTELS...

SOMETHING'S GONE WRONG! YOU RIP AWAY THE GLASSES FROM YOUR EYES. BUT...THE SCENE HAS BECOME A PURPLISH MIASMA.

THEN...THE PURPLE DISAPPEARS...AND AN OVERSHADOWING BLACK PREDOMINATES! THEN...YOU REALIZE WHAT'S WRONG WITH THE GLASSES! YOU REALIZE...

YOU ARE BLIND...THE GLASSES COULD NOT HOLD BACK THAT ONE COLOR...*BLACK*...THAT ONE COLOR WHICH HAS *ALL THE OTHERS* IN IT!

THE END 5

THE STREAMING VEGETATION OF THE FLORIDA EVERGLADES HOLDS MANY HORRORS — QUICKSAND, ALLIGATORS, WATER MOCCASINS. BUT EVEN THESE WERE TAME BESIDE THE AWFUL NIGHTMARE THAT ROSE FROM THE SLIME WHEN THE DESOLATE SWAMP BECAME HOST TO --

The VAMPIRES from VENUS!

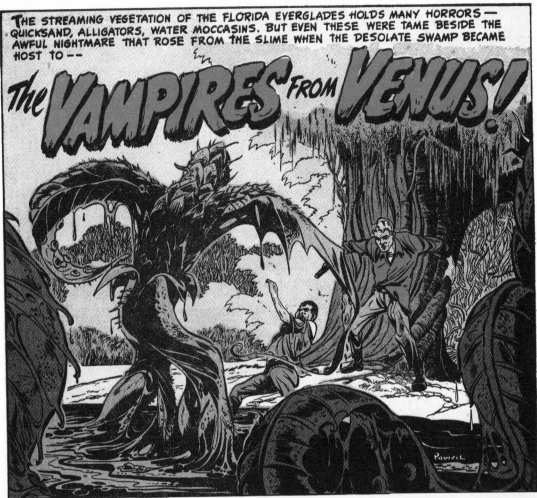

ON THE EDGE OF THE EVERGLADES LIVE JAKE AND MIKE ZUKOSKY, TWO ADVENTURESOME VETERANS WHO MAKE THEIR LIVING SELLING SNAKES AND SMALL ANIMALS TO BIOLOGISTS. ONE NIGHT...

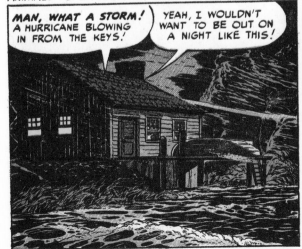

MAN, WHAT A STORM! A HURRICANE BLOWING IN FROM THE KEYS!

YEAH, I WOULDN'T WANT TO BE OUT ON A NIGHT LIKE THIS!

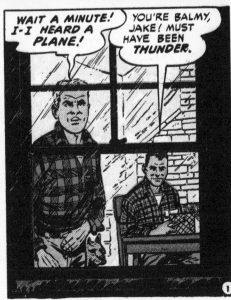

WAIT A MINUTE! I-I HEARD A PLANE!

YOU'RE BALMY, JAKE! MUST HAVE BEEN THUNDER.

1

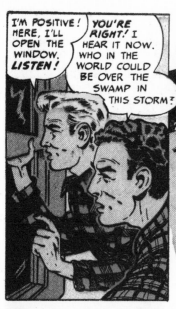

I'M POSITIVE! HERE, I'LL OPEN THE WINDOW. *LISTEN!*

YOU'RE *RIGHT!* I HEAR IT NOW. WHO IN THE WORLD COULD BE OVER THE SWAMP IN THIS STORM?

LISTEN! A *CRASH!* MIKE, THAT PLANE *CRASHED INTO THE SWAMP* AND NOT FAR FROM HERE!

HURRY! MAYBE IT WAS AN *AIRLINER!*

DIDN'T SOUND LIKE A TRANSPORT. MAYBE A PRIVATE PLANE!

I DON'T THINK IT WAS TOO FAR. LET'S GO!

RIGHT WITH YOU. MAN, *THIS WIND IS MURDER!*

THERE IT IS! HURRY, MIKE! IT'S SINKING!

CRAACCK!

2

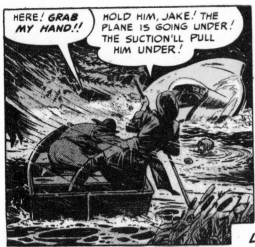

HERE! GRAB MY HAND!!

HOLD HIM, JAKE! THE PLANE IS GOING UNDER! THE SUCTION'LL PULL HIM UNDER!

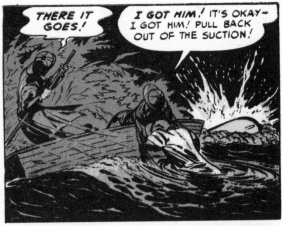

THERE IT GOES!

I GOT HIM! IT'S OKAY—I GOT HIM! PULL BACK OUT OF THE SUCTION!

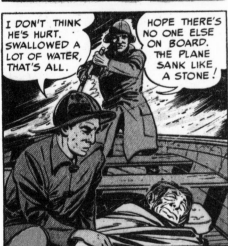

I DON'T THINK HE'S HURT. SWALLOWED A LOT OF WATER, THAT'S ALL.

HOPE THERE'S NO ONE ELSE ON BOARD. THE PLANE SANK LIKE A STONE!

LATER, AT THE CABIN...

HERE, DRINK SOME OF THIS!

UGGHHHH... MMMMM... GNN-NNAHHH-RR-RR...

LISTEN TO THAT! WHAT'S HE TRYING TO SAY?

GNA'RRRGH... UNRGHHHHH... RRRGGGNNN...

MUST BE SOME FOREIGN LANGUAGE. GOSH! MIKE, LOOK AT HIS EYES!

GNNNHHHH ... GOSH .. MIKE .. LOOK AT HIS EYES...

DID YOU HEAR THAT? HE SAID THE SAME WORDS I SAID! THAT'S ODD!

THE .. SAME WORDS I SAID... THAT'S ODD...GOSH! LOOK AT HIS EYES... MUST BE SOME... THAT'S ODD...

3

BY REPEATING WHAT HE HEARD, THE STRANGE VISITOR SEEMED TO LEARN ENGLISH AMAZINGLY FAST! BY THE NEXT DAY HE HAD BUILT UP A WORKABLE VOCABULARY!

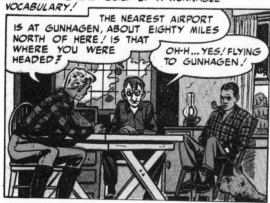

THE NEAREST AIRPORT IS AT GUNHAGEN, ABOUT EIGHTY MILES NORTH OF HERE! IS THAT WHERE YOU WERE HEADED?

OH-H...YES! FLYING TO GUNHAGEN!

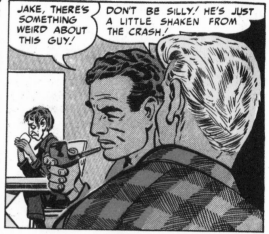

JAKE, THERE'S SOMETHING WEIRD ABOUT THIS GUY!

DON'T BE SILLY! HE'S JUST A LITTLE SHAKEN FROM THE CRASH!

YEAH? LOOK AT PIRATE! HE'S UNEASY! I TELL YOU, JAKE, DOGS CAN SENSE!

OH, PIRATE ISN'T USED TO STRANGERS, THAT'S ALL! AND WE'D BETTER TIE HIM UP IN THE BOATHOUSE! WE CAN'T HAVE HIM GROWLING AT OUR GUEST!

AND "GUEST" WAS WHAT THE SURVIVOR WOULD BE... FOR AWHILE ANYWAY! THE STORM HAD BLOWN THE TELEPHONE LINES DOWN... AND THE NEAREST TOWN WAS FORTY MILES AWAY!

...SO I'M AFRAID YOU'LL HAVE TO STAY WITH US UNTIL FRANK CASEY COMES OUT FROM TOWN AGAIN WITH SUPPLIES!

OH, THAT'S... ALL RIGHT! I HAVE SOME WORK TO DO ANY-WAY... AND THIS PLACE IS AS GOOD AS ANY!

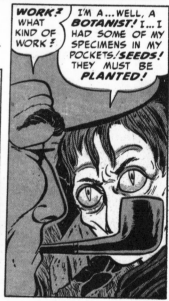

WORK? WHAT KIND OF WORK?

I'M A...WELL, A BOTANIST! I...I HAD SOME OF MY SPECIMENS IN MY POCKETS! SEEDS! THEY MUST BE PLANTED!

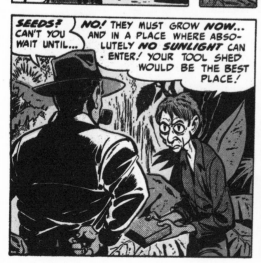

SEEDS? CAN'T YOU WAIT UNTIL...

NO! THEY MUST GROW NOW... AND IN A PLACE WHERE ABSO-LUTELY NO SUNLIGHT CAN ENTER! YOUR TOOL SHED WOULD BE THE BEST PLACE!

SEVERAL DAYS LATER...

WHERE'S OUR FRIEND? HAVEN'T SEEN HIM ALL DAY!

HE'S BEEN OUT IN THE TOOL SHED! FIDDLING WITH HIS PLANTS I GUESS! MAYBE I OUGHT TO TAKE HIM SOME CHOW!

4

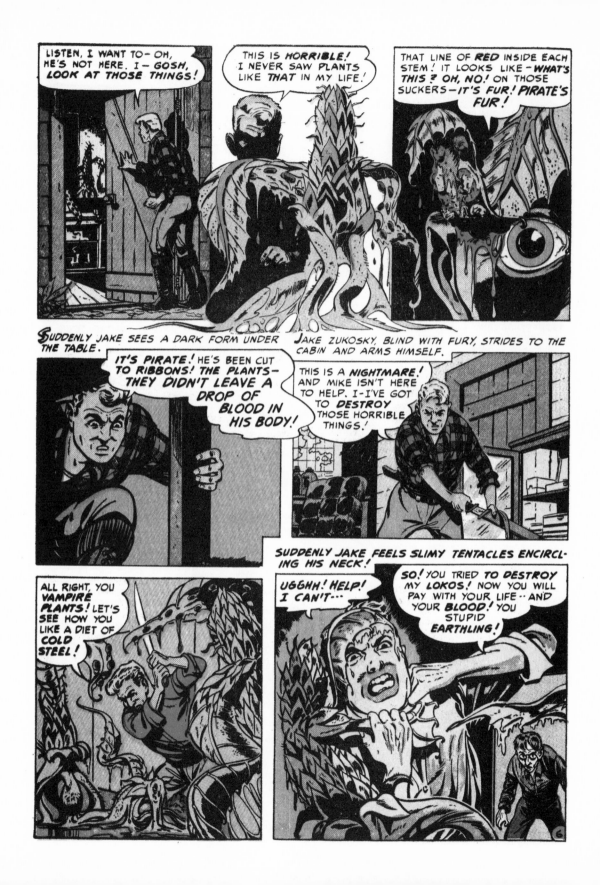

EARTHLING! THEN YOU ARE... NO! IT CAN'T BE!

YES! WE ARE *NOT OF THIS WORLD!* I AM KORO..FROM VENUS! I SEE IT SURPRISES YOU THAT THERE IS A RACE ON *VENUS* SUPERIOR TO YOU EARTHLINGS!

I TRIED TO GET OUR COUNCIL TO INVADE EARTH.. SOFT, LUSH EARTH...BUT THEY REFUSED! SO I CAME MYSELF! NOW, WITH THE HELP OF THESE *LOKOS VAMPIRE PLANTS*, THIS PLANET WILL BE MINE TO RULE *! MINE !*

THESE LOKOS LIVE IN THE DARK CAVERNS OF VENUS... AWAY FROM THE SUNLIGHT! ONCE THEY MATURE THEY CAN MOVE ABOUT ON THEIR OWN ROOTS...SEEKING *BLOOD* THAT WILL KEEP THEM ALIVE!

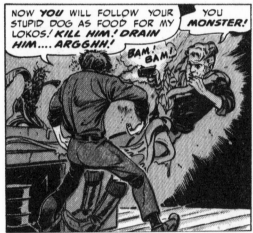

NOW *YOU* WILL FOLLOW YOUR STUPID DOG AS FOOD FOR MY LOKOS! *KILL HIM! DRAIN HIM..... ARGGHH!*

YOU *MONSTER!*

BAM! BAM!

As KORO FALLS, THE VAMPIRE PLANTS, AGITATED BY THE PRESENCE OF BLOOD, RELEASE JAKE AND WHIP THEIR SUCKERS TOWARD THE MAN FROM VENUS!

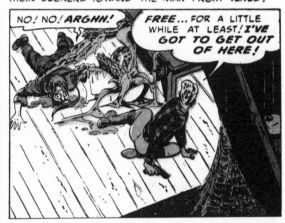

NO! NO! *ARGHH!*

FREE... FOR A LITTLE WHILE AT LEAST! *I'VE GOT TO GET OUT OF HERE!*

IT'S TRUE! THEY CAN MOVE! THEY'RE COMING! THEY'RE COMING AFTER ME!

JAKE, WHAT'S THE MATTER? *OH! GOOD GRIEF!*

MIKE, *HURRY!* PUSH THE BOAT OUT AGAIN! THESE THINGS ARE *MURDEROUS! IT'S OUR ONLY CHANCE!*

7

THEY CAN SWIM! FASTER! MAYBE WE CAN LOSE THEM IN THE SWAMP!

HOURS LATER, DEEP INSIDE THE MURKY SWAMP...

JAKE, I CAN'T... I'M EXHAUSTED! I CAN'T GO ANY FURTHER!

ALL RIGHT... WE'LL REST... I DON'T SEE THEM! MAYBE THEY GAVE UP!

NO! THEY'RE HERE! MIKE, POLE FOR YOUR LIFE!

ALL NIGHT LONG THE TWO MEN POLE FURIOUSLY ALONG THE CANAL! SUDDENLY, THEY RUN INTO A SAND BAR! BEFORE THEM IS AN IN ENETRABLE WALL OF VEGETATION!

WE'RE TRAPPED! AND MY PISTOL IS EMPTY!

I... I'VE STILL GOT MINE! HERE THEY COME!

JAKE! THAT WAS MY LAST BULLET! WE'VE GOT TO RUN!

WE CAN'T! WE'RE TRAPPED! THERE'S NOTHING WE CAN DO!

SUDDENLY THE DAWN BREAKS, AND THE SUN BEAMS DOWN! THE VAMPIRES WRITHE UNDER THE GLARE!

MIKE... LOOK! THE SUNSHINE! THEY CAN'T BEAR THE SUNSHINE! LOOK WHAT IT'S DOING TO THEM!

THEY'RE SHRIVELING UP! THEY'RE DYING!

THEY'RE ALL... DEAD! AS SOON AS THE SUN HIT THEM... THEY DIED! JAKE... WHAT HAPPENED?

KORO SAID THEY LIVED IN THE DARK CAVERNS OF VENUS! AND HE GREW THEM IN THE DARK TOOL SHED! THAT'S IT! LIKE ALL VAMPIRES, THEY COULDN'T BEAR SUNLIGHT! THAT BIG, BEAUTIFUL OLD SUN DID IT, MIKE! THE NIGHTMARE IS OVER!

THE END

One day of stark tragedy, without a premonition or forewarning---Mitchell Ames stepped off this earthly existence into a weird, supernatural state of being no mortal had ever experienced and survived!

TWICE ALIVE!

DON'T LET IT TOUCH ME! SAVE ME---I BEG YOU! SAVE ME!

THE WAIL OF THE SIREN WAS LIKE A CRY OF HUMAN ANGUISH AS AN AMBULANCE SKIDDED TREACHEROUSLY ACROSS RAIN-SWEPT STREETS ON A DARK AUTUMNAL NIGHT!

SCREEE SCREEEE

THAT LAB EXPLOSION CAUSED A SEVERE SHOCK TO HIS HEART! THE BEAT IS BARELY AUDIBLE NOW! I DON'T KNOW IF HE'LL MAKE IT!

TOO BAD! WELL--THEY SAY HE WAS EXPERIMENTING WITH THEORIES ON LIFE AFTER DEATH! SAY-- WE'VE REACHED THE HOSPITAL, DOC! NOW HE'LL FIND OUT THE TRUTH FOR HIMSELF---IF THAT'S ANY CONSOLATION!

"MOVE FAST, BUT DON'T JAR HIM!"

"EMERGENCY! CALL AHEAD TO THE DOCTOR TO HAVE OPERATING ROOM THREE READY!"

MITCHELL AMES' BREATHING GREW MORE LABORED, AND HIS WEAKENED, WEARIED LIDS COULD ALL BUT STRUGGLE TO REMAIN OPEN UNDER THE GLARING ARC LIGHT ON THE OPERATING TABLE! SOMETIME LATER---

"YOUR CHANCES ARE SLIM, AMES. PERFORMING SURGERY WOULD BE A PERILOUS RISK. DO WE HAVE YOUR PERMISSION?"

"Y-YES, DOCTOR-- YES..."

AND PRESENTLY, AS CONSCIOUSNESS STOLE AWAY UNDER THE EFFECTS OF THE ANESTHESIA, THE SINKING PATIENT'S EYES CAUGHT THE COLD GLEAM OF THE SURGEON'S SCALPEL DESCENDING!

"MORE ANESTHETIC!"

"MORE ANESTHETIC!"

THE SHARP FOCUS OF FAMILIAR FORMS WAS BLURRED AND DISTORTED TO MITCHELL AMES AS HE DAZEDLY RECEDED INTO UNCONSCIOUSNESS. THEN--- SUDDENLY--HE FOUND HIMSELF IN A DEEP, SUBTERRANEAN PASSAGEWAY, RUNNING IN WILD PANIC!

MORE ANESTHETIC

MORE ANESTHETIC!

HE'S SINKING UNDER NOW-SINKING UNDER!

SINKING SINKING

MORE ANESTHETIC

"WH-WHERE AM I? AND WHAT AM I FLEEING FROM?"

"T-THIS FIERCE, INSUFFERABLE HEAT! AND EVERYTHING THROBS AND VIBRATES! I-I CAN'T KEEP MY FOOTING! I-I DON'T UNDER-STAND WHAT'S HAPPENING!"

"BUT SOMEHOW I FEEL I MUST KEEP MOVING! GOT TO GET ACROSS THIS RED RIVULET!"

HE SLIPPED AND FELL A DOZEN TIMES, STRUGGLING TO HIS FEET AND PUSHING ON! THE EFFORT TO BREATHE WAS LIKE LIQUID FIRE BURNING INSIDE HIM! AT LAST, HE COLLAPSED EXHAUSTEDLY!

I-I CAN'T GO ANY FURTHER! AND I HEAR SOMEONE COMING!

THAT SHADOW! HUGE AND MONSTROUS! I-IT'S AFTER ME!

QUIVERING WITH FEAR, THE FALLEN MAN BURIED HIS FACE IN HIS HANDS! THEN-- HE FELT A LIFELESSLY COLD HAND GRIP HIS SHOULDER!

NO! NO! D-DON'T TOUCH ME!

--GRANDFATHER! BUT IT CAN'T BE YOU! YOU'VE BEEN DEAD FOR SEVENTEEN YEARS! AND YOU---GREAT-GRANDFATHER! I RECOGNIZE YOU FROM A PHOTOGRAPH!

HORROR-STRUCK, MITCHELL AMES COULD NOT GRASP THE INCREDIBLE COURSE OF EVENTS! THEY HELPED HIM TO HIS FEET ANXIOUSLY, AND---

I-I'M TOO TIRED TO GO ON! WHO IS THAT YOU ARE RESCUING ME FROM?

WHERE ARE YOU TAKING ME? PLEASE ---TELL ME WHAT'S GOING ON!

WHY DON'T YOU ANSWER ME! FOR HEAVEN'S SAKE -- ANSWER ME!

THEY TURNED GRAVELY AND FACED THEIR WEEPING, BESEECHING DESCENDANT! AND IN THAT STARK INSTANT--MITCHELL AMES BECAME AWARE OF A STARTLING FACT!

YOU HAVE NO MOUTH TO SPEAK WITH!

BUT THE STRANGE URGENCY IN THEIR EYES SILENCED HIM! HE MOVED SWIFTLY TO DO THE OLD MEN'S BIDDING--AS THEY GLANCED ANXIOUSLY BACK AGAIN AND AGAIN.

YOU WANT ME TO HIDE IN HERE--! YES, YES -- I UNDERSTAND!

MORE OF YOU! AND YOU ALL LOOK SO MUCH ALIKE! WHY--WHAT DOES IT ALL MEAN?

OUT OF MY WAY, FOOLS! NOTHING WILL DETER ME IN MY PURPOSE! HE IS MINE-- MINE!

THE OLD MEN TRIED VALIANTLY TO BLOCK THE WAY TO THE COWERING, YOUNGER MAN! BUT THEIR FORMIDABLE ASSAILLANT STRUCK OUT WITH A TERRIBLE, PITILESS ONSLAUGHT!

BUT FRANTIC EYES TURNED FROM HIS SOBBING, QUESTIONING FACE--TO THE BLACK SHADOW THAT WAS NOW SO PETRIFYINGLY CLOSE!

HE--HE'S FOUND US!

HE PUSHED HIMSELF UPRIGHT, TO SEE THE MOURN-FUL OLD MEN STANDING OVER HIM WITH A MELANCHOLY HOPELESSNESS!

BUT WHY DO YOU WEEP? HE HAS NOT HARMED ME!

IT IS ALL OVER NOW! EVERYTHING IS FINISHED FOR US ALL!

THERE WAS NO SOUND! BUT ALL AT ONCE, MITCHELL WAS HEARING AN INNER VOICE!

I-I CAN HEAR YOU NOW!--UNDERSTAND YOU! NOW YOU MUST EXPLAIN ALL THIS! YOU MUST!

TELL ME WHERE I AM? GRANDFATHER ---TELL ME!

--IN YOUR OWN BODY, MITCHELL! WE HAVE ALL BEEN RESIDING IN YOUR BODY!

--THE REVELATION GREW IN EVEN MORE FAN-TASTIC PROPORTIONS AS THE YOUNGER MAN LISTENED AND BECAME AWARE OF STRANGE NEW AVENUES OF EXISTENCE!

WE ARE ALL YOUR ANCESTORS! THOSE FROM WHOM YOU INHERITED ALL YOUR CHARACTERISTICS! IT HAS BEEN IN YOUR BODY THAT WE RETAINED A HOLD ON LIFE!

WE TRIED TO SAVE YOU SO WE COULD SAVE OURSELVES! BUT IT IS TOO LATE NOW!

T-THEN THAT WEIRD FORM WAS DEATH!

YES---DEATH HAS CONQUERED YOU! AND SO CONQUERED US ALL---FOR ALL TIME TO COME! YOU WERE THE LAST OF THE AMES' LINE! SOON--SOON WE WILL BECOME AS NOTHING!

IN AWE AND WONDERMENT, MITCHELL AMES GAZED AROUND HIM AT THE FANTASTIC WORLD THAT WAS WITHIN HIS OWN BODY! IT SEEMED ALL TOO INCOMPREHENSIBLE.

--THE NERVES AND ORGANS! THE BONES AND FLESH! THE RIVULET OF RED---THAT WAS MY OWN LIFE'S BLOOD! THE VIBRATIONS ARE THE PULSATIONS OF MY HEART! THEY SEEM ALL TO HAVE STILLED NOW! AND IT IS GROWING COLD!

THEN THIS IS THE REASON YOU HAVE NO MOUTHS! SO YOU CAN NEVER COMMUNICATE TO ANY OF THE LIVING---THE SECRETS AFTER DEATH!

YES---! IT IS ONLY FOR THE DEAD TO KNOW OF THE WAYS OF THE DEAD!

THEN, SUDDENLY--A TREMENDOUS SURGE OF VITALITY PULSATED THROUGH HIM! AND THE STRANGE WORLD AROUND HIM, HEAVED AND THROBBED AGAIN!

SOMETHING IS HAPPENING TO ME! THE NUMBNESS IS GONE!

I FEEL AS I DID BEFORE HE TOUCHED ME!

HIS COLOR HAS RETURNED!

YES--! YES! HE IS ALIVE! IT IS A MIRACLE!

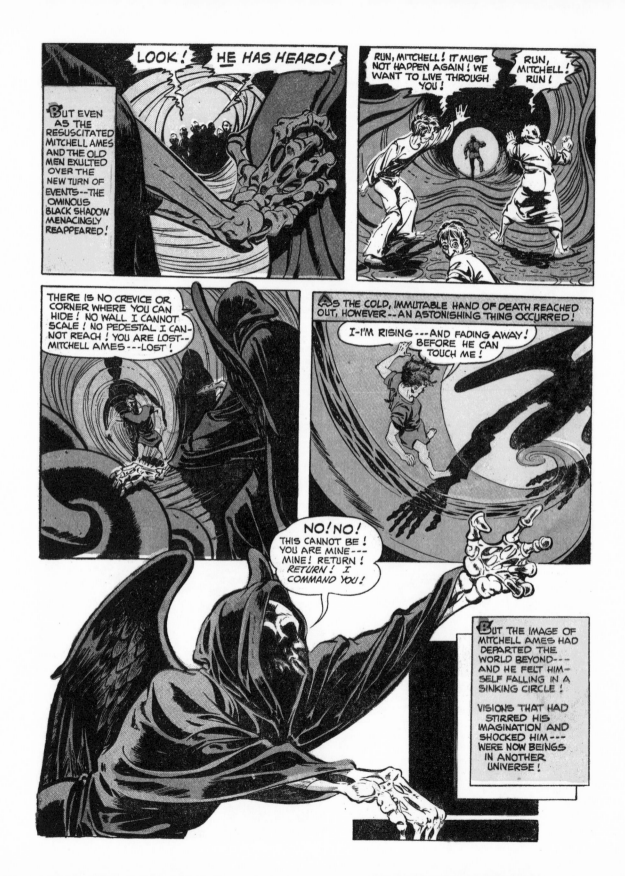

THEN A BRIGHT, GLARING LIGHT PIERCED THE DARKNESS---AND THE PUNGENT ODOR OF ANTISEPTIC TITILATED HIS NOSTRILS! HE WAS ON THE OPERATING TABLE!

DO YOU THINK HE--

LOOK! HE'S COMING OUT OF IT NOW!

AMES! AMES! HOW DO YOU FEEL? YOU'RE GOING TO BE ALL RIGHT!

I-I HAD A--A-- GHASTLY DREAM!

WELL--YOU GOT OFF EASY! DO YOU KNOW, YOU WERE ACTUALLY DEAD--FOR EIGHT MINUTES? IT WAS A MIRACLE WE REVIVED YOU!

WE PERFORMED A RADICAL NEW OPERATION THAT SAVED YOUR LIFE!

I JUST HEARD ABOUT THE ASTONISHING OPERATION YOU PERFORMED, GENTLEMEN! AS MEDICAL DEAN OF THIS HOSPITAL --I'M PROUD TO HAVE YOU ON MY STAFF!

THANK YOU, SIR! THE PATIENT IS ALREADY OUT OF ANESTHESIA!

THE DISTINGUISHED MEDICAL DEAN, WHOSE EYES HAD NEVER WAVERED IN WITNESSING THOUSANDS OF RARE, MAJOR OPERATIONS, LOOKED DOWN AT MITCHELL AMES AND--GREW DEATHLY PALE!

OH, NO! I---I'VE NEVER SEEN ANYTHING LIKE IT!

-- MY LORD!

I-IT'S SUPERNATURAL!

INADVERDENT GASPS BROKE FROM THE TREMBLING LIPS OF THE OPERATING CREW AT THE GHASTLY SIGHT BEFORE THEM!

MITCHELL AMES' MOUTH WAS GONE! THE SKIN WAS SMOOTHLY SEALED AS THOUGH IT WERE NEVER THERE!

A Combat-Happy Joe
by Bill Schelly

The following is an excerpt from Bill Schelly's *Man of Rock: A Biography of Joe Kubert*, scheduled for release in May from Fantagraphics.

Sgt. Rock's creative genesis differed from the beginnings of most comic-book characters. He didn't appear suddenly in a single story in recognizable form. How Rock came to be was complicated, and eventually a source of controversy. That was because someone other than Kanigher wrote one of the early, key stories in Rock's evolution, and most of Kanigher's art staff had a go at Rock before Kubert became the regular artist on the feature.

The story "The Rock!" in *G. I. Combat* #68 (January 1959) was where Kanigher first used the "rock" metaphor as a way of describing a tough World War II sergeant's indomitability. Over the next six months, Kanigher's ideas gradually coalesced in the pages of *Our Army at War* until Sgt. Frank Rock of Easy Company ("where nothing's easy") was fully formed. That key story was "The Rock and the Wall!" in #83 (June 1959). Both "The Rock!" and "The Rock and the Wall!" were written by Kanigher and drawn by Kubert.

As Rock's character emerged, readers found in him an interesting collection of contradictions: brave yet cautious, tough yet sensitive, uneducated but smart, both confident and uncertain. Above all else, was his steely determination to achieve his assigned objectives with the fewest possible casualties. Frank Rock was the kind of leader the men could depend on. He was their rock of Gibraltar—solid, strong and stalwart.

In between those two issues, Rock prototypes were drawn by the team of Ross Andru and Mike Esposito, as well as Jerry Grandinetti and Mort Drucker. Perhaps more significantly, Bob Haney stood in for Bob Kanigher as the writer of "The Rock of Easy Co.!" in *OAAW* #81 (April 1959). Certainly "Sgt. Rocky" in Haney's script is close to the Sgt. Rock readers came to know and love, but, due to the name difference if nothing else, this tough-as-nails sergeant must properly be considered a prototype, or precursor, to the real thing.

Besides, the Andru/Esposito team illustrated "The Rock of Easy Co.!" A good case can be made that the look of Sgt. Rock, which was established by Kubert in "The Rock and the Wall!", is so important, so central, to the character of Rock that he deserves co-creator status along with Kanigher. It was Kubert who established Sgt. Rock's appearance, including the grizzled, perpetually unshaven look, and the sunken shadowy eyes, which other artists were obliged to follow—or it just wasn't Sgt. Rock. Early on, Kanigher was clearly gearing his writing to play into the visual representation fashioned by Kubert.

Nevertheless, Kubert isn't generally given co-creator status for the character, nor does he claim it for himself. "Rock was Kanigher's idea from start to finish, as far as I'm concerned," he stated recently.

What appealed to Kubert about the character was the vision that Kanigher had for Rock. "Bob's intention was to try to do war comics that explored more adult themes, like how we retain our humanity in the face of war," he explained. "That meant something to him, and in turn, it was meaningful to me. It made me do a little bit more and pushed me a little bit more into getting deeper into the kind of stuff—the storytelling, the dramatics—and so on."

Almost from the beginning, Kanigher gave Kubert an extraordinary amount of freedom in interpreting and adapting his Rock scripts. "Bob gave me essentially carte blanche on the stuff. He would give me a script to do, but it was up to me to do anything and everything I wanted. He had that much faith in my ability to do the best on his scripts, and it was great. I had no compunction about making whatever changes I felt were necessary, as long as they were in keeping

with what I felt he wanted."

Kubert succeeded at finding a way to create believable images of war without showing blood. He was able to create the illusion of realism. How? First and foremost, he directed the reader's attention by focusing on details that spoke volumes: a five-day growth of beard, drops of sweat on a soldier's face, the look in his eyes. Second, he created a less-than-pristine environment by impressionistically rendering forests, landscapes, waterways and decimated buildings. He used every trick in the book to induce the reader to forget what he didn't see, such as bloody close encounters with enemy soldiers. Moments of sudden violence were handled quickly, economically, and mostly off-panel.

Irwin Hasen said of Kubert, "He's the most focused person I've ever known." He was able to bring tremendous acuity and concentration to what he was doing on the page, and it showed. Inspired by Kanigher's scripts, which very early on were "narrated" by Rock, Kubert bore down on his storytelling techniques and character delineation. This became important when recurring members of Rock's unit were introduced.

"[Bob and I] felt that each man should look different, walk different, run different, be recognizable from the back as well as from the front," Kubert elaborated. "It was a conscious attempt on my part at all times. I guess I knew we succeeded to some extent when we received letters from readers speaking to and about Rock as if he were a living person." Over the next few years, readers met the men of Easy Company who were a regular part of Rock's unit: Bulldozer, Ice Cream Soldier, Wild Man, Little Sure Shot and Junior, among a number of other regulars and semi-regulars.[1]

Part of the readers' feeling they "knew" Rock was undoubtedly because the sergeant acted as first-person narrator of the stories, beginning with "Ice Cream Soldier" in *OAAW* #85 (August 1959). That story begins, "I'm Sgt. Rock of Easy Company! The best outfit in the army! There's nothin' we won't do! Nothin' we won't tackle! That's why our motto is: When you're in Easy – *nothing's* easy!"

More and more, the focus of the stories was on the inner workings of Rock's head. His shadowed eyes revealed the soul of a man who bore an acute awareness of the struggle to maintain humanity in the midst of war. They show his awareness of what he has seen, and his knowledge that future horrors await. The expression in Rock's eyes sums up Kanigher's whole approach to the strip. Those haunted eyes became a kind of

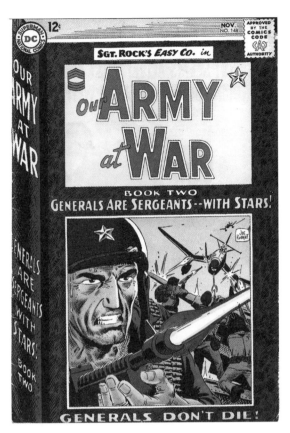

A Joe Kubert cover. [©1964 DC Comics]

trademark of the series.

If *Tor* represented Kubert standing up to his full height as a comic-book creator, Rock showed the artist reaching full maturity. Certainly, this would not have been possible without scripts that were rich not only in ideas and emotions, but in visual potential. Kubert mined that potential beautifully. All his experience was brought to bear in a supremely focused creative expression.

Sgt. Rock as interpreted by Kanigher and Kubert struck a chord. The feature's popularity grew by leaps and bounds. *Our Army at War* became one of DC's best sellers. According to Kubert, during the character's phenomenal three-decade run, Sgt. Rock would outsell every comic book in the company's line-up at one time or another. Many millions of copies of *Our Army at War* were snatched off the newsstands and comic-book racks in drugstores all across America as the adventures of Easy Company unfolded.

In the early 1960s, President Kennedy's New Frontier offered forward-looking vision, while at the same time the nation

1. Crain, Dale, editor, "Introduction by Joe Kubert," *Sgt. Rock Archives, The*, Vol. 1, DC Comics, New York, NY, 2002.

From "Flytrap Hill" in *Our Army At War* #150, dated January 1965, written by Kanigher and drawn by Kubert. [©1965 DC Comics]

experienced an urge to look back to World War II. By then, the Baby Boomers were old enough to take an interest in that global conflagration, and sufficient time had passed for painful memories to heal in the hearts and minds of those who had lived through the experience.

The movies in the late 1940s and 1950s had dealt with the war, with some outstanding results. *From Here to Eternity*, *To Hell and Back*, *Battle Cry* and others had been artistic and box office successes. Then, in 1960, Darryl Zanuck Jr. of Twentieth Century-Fox committed to making the most spectacular war film yet, a star-studded hour-by-hour recreation of D-Day called *The Longest Day*. The Fox film was a smash hit in 1962, and set off a wave of World War II stories in popular culture. The television show *Combat!* made its debut on ABC in October, receiving top ratings. The show would remain at or near the top of the ratings heap through most of its five-year run.

Sgt. Rock benefited from this upsurge of interest in World War II, providing a sort of comic-book equivalent to *Com-*

bat! Sales of *Our Army at War* climbed, and Kubert was Kanigher's artistic linchpin. No sooner had Kubert completed work on the second Hawkman tryout in *Brave & Bold* than Editor Bob Kanigher assigned him to another war comics series, which Kubert would draw along with Sgt. Rock and numerous covers for other war comics.

After Sgt. Rock clicked in *Our Army at War*, Kanigher began introducing more ongoing characters in the other war books. In early 1961, in *G. I. Combat*, Kanigher created a new series that featured a World War II tank named after Civil War General Jeb Stuart and haunted by the dead general's spirit. With #99 (April/May 1963), Kubert replaced Russ Heath as regular artist on the Haunted Tank strips.

Kubert, well pleased by the quality of the scripts, hunkered down and concentrated on constantly improving, constantly developing. The early- to mid-1960s Rock stories in *Our Army at War* are the kind that regular comic-book readers learn to cherish, because they come along so seldom: an ongoing run of

top-flight issues, by a writer and artist truly working together as a team, playing to each other's strengths and backstopping the other's weaknesses — each story reaching for a new level of achievement, constantly raising the bar, breaking new ground.

In comic books, great entertainment involves creators taking the periodic nature of the medium by the horns. Single issues might be praised, but it's the issue-by-issue progression that comics aficionados love most. Greatness in storytelling can only be judged over a run of many issues, though the individual numbers may feature tales that are complete in themselves. The Sgt. Rock and Easy Company stories from 1963 to 1965 are of that ilk; they are certainly comparable to other series peaks, like the Inhumans Saga in *Fantastic Four* (#44 through #60) by Stan Lee and Jack Kirby, or the *Master of Kung-Fu* run in the mid-1970s, written by Doug Moench and drawn by Paul Gulacy. Significantly, even those readers who normally stuck to costumed heroes found themselves adding *Our Army at War* to their stack of purchases. Those issues represented comic-book-making at its finest.

Stories such as "The Four Faces of Sgt. Rock," "One Pair of Dogtags For Sale," "Young Soldiers Never Cry," "Make Me a Hero!" and "A Firing Squad for Easy!" were almost like stanzas in one long, continuing poem — an epic poem recounting the exploits of a determined, common-sensical sergeant and a small squad of infantrymen as they carried out orders from remote commanders to take possession of this or that hill, village, or bridge.

"The End of Easy Company!" (*OAAW* #126, January, 1963) began with Rock's setup lines, "I expected some day to find Easy Company facin' a stone wall — stopped — stumped — but I never expected it in the middle of our attack on Dogtag Hill." Ordered to leave a wounded man for the medics and help take the hill, Infantryman Canary asked, "Why should we get chopped up trying to take a chunk of dirt that nobody wants?" With the platoon's fate on the line, Rock thought, "I'd better come up with an answer — or this is the end of Easy!" Finally, as they wound their way up the hill through a series of Nazi traps, Rock answered Canary, "You're right, Canary! This heap of dirt was worth nothin'! But — the price went up with each Easy guy that fell tryin' to take it!" After a long nightmarish night of battling the enemy, Easy took and held the hill, and Canary was there. "We couldn't let the enemy keep this heap, Rock!" he said. "Not with Buddy's and Sunny's and Tin Soldier's — and all the other Easy guy's names on the price tag!"

This, then, was the difference between Kanigher's approach to war comics, and that of his competitors (who were dwindling in number by this time, anyway): The mission was important, but only insofar as it portrayed the psychological dilemmas and challenges facing men in combat. If combat, by extension, could be a metaphor for any of life's challenges, then these stories offered something to the reader that was unexpected: a series of lessons in problem-solving by a canny, experienced, down-to-earth teacher. Rock didn't have all the answers, but his spirit was resolute, his gaze was steady, and he had the ability to think on his feet and improvise, even in the direst circumstances. Rock had something else: his sergeant's "antenna" — a semi-mystical ability, almost a super power, brought out by long experience — to sense if something wasn't right, if danger lurked in the forest

From "A Penny for Jackie Johnson!" in *Our Army At War #179*, dated April 1967, written by Kanigher and drawn by Kubert. [©1967 DC Comics]

or village ahead. Rock's ability to assess situations was central to the dilemmas faced by the men of Easy Company, and doubtless had readers asking themselves, in their own lives, as they faced the unknown — "What would Rock do?" If a fellow followed Rock's measured approach to problem-solving, he had a better chance of coming out OK.

Native American Little Sure Shot, with a feather decorating his "tin pot," was a respected and long-running member of Rock's Easy Company. But moving from native culture to Army culture was shown to present additional difficulties for the young man in "A Feather for Little Sure-Shot!" in *Our Army at War* #145 (August 1964). In this story, the young Indian enlisted in the U. S. Army from the reservation even though his father said, "My son — you depart before you have won the right to wear the feather of a brave!" Little Sure Shot hadn't fulfilled the traditions of his people, and despaired, "I'll never be able to face my Pop again — unless I win a feather from the enemy!" Finally, he did win the feather, as he battled for his life in the desert against a predatory buzzard, who swooped down for the kill. He'd passed the Indian test to become a brave, and could then fight the enemy with the blessings of his tribe.

Jackie Johnson, the black member of Easy who figured in the 1961 Rock classic "Eyes of a Blind Gunner," had the lead role in "What's the Color of Your Blood?" (*OAAW* #160, November 1965). As the Civil Rights struggle of black Americans heated up on the streets of American cities, Kanigher and Kubert addressed the issue in the guise of a World War II Sgt. Rock story. Jackie was a former world boxing champion, who was haunted by his defeat at the hands of a German behemoth called "Stormtrooper" Uhlan. When the Nazi party member Uhlan was declared the winner, he said, "Blood will tell! Today – we of the Master Race – win your boxing title! Tomorrow – the world!" Coincidentally, the two men met when Rock and Johnson were captured by a Nazi patrol, with Uhlan a member. The fight was restaged by the Nazis, and Uhlan taunted Johnson, "What is the color of your blood? It is black! Say it! Say it – *what is the color of your blood?*" But, when the African-American defeated the German, his own troops fired on him. Wounded, requiring a transfusion, Uhlan finally admitted that the same blood ran through the veins of all men. "I was wrong! Wrong!" Uhlan declared weakly to Johnson. "The color of your blood — is red!"

Kubert's artwork evolved steadily during the early-to-mid 1960s on Sgt. Rock as he worked with great intensity to properly visualize Kanigher's exciting and highly emotional

scripts. Gradually, the brushwork became lusher, bolder and more dominant than that of India ink applied by pen. In the outstanding "I Knew the Unknown Soldier" (*OAAW* #168, June 1966), the art surged across the page, with thick shadows contrasting with explosions, machine gun fire and rifle hits. The story began with a raging storm as Easy rafted across a river, then fought its way up a mountainside to rout a Nazi machine gun nest, and from there stumbled through a fog-bound forest only to have the enemy attack from the tree limbs above. The images brimmed with slashing emotion, like a raging guitar solo. The pictures splashed across the page. Explosions; yelling faces; hurtling bodies. It was an action-packed story full of the usual Kanigher sound effects: WHRAM! WHROOSH! BLAAANG! KRUNCH! RA-TATAT! Bone-crunching hand-to-hand combat followed, and then Easy was plunging into snowy woods, with Rock blinded and helped by an "unknown soldier." Yet even in the midst of the action, so effectively illustrated by Kubert, Rock's inner experience was where the real tale was told.

Some artists find the basic elements of their style early on, and spend their careers perfecting it. "You can recognize [John] Severin's work for decades on end without having to follow him and see the stuff in between," Roy Thomas observed recently. "With Severin, the work looks virtually the same over a forty- or fifty-year period. And it's always good." But Kubert is a different case, Thomas contended. "If you look at early Kubert and at later Kubert, you might have to look at the work in between [to] see the progression, or you might not recognize him as the same artist."[2] With Kubert's art, there's always a sense of progression, of an active creative mind at work, and of an aesthetic coming into sharper and sharper focus.

Along the way, a disquieting darkness became more evident in Kubert's images. Even as the artist himself was more deeply immersed in the work than ever, even as he was stretching the medium by using more long, narrow panels and other unusual page constructs, there was a noir quality that came to bear in the mid-1960s, most notable in the dark, shadowy, haunted eyes of Sgt. Rock.

This new darkness gave Kubert's artwork a downbeat, moody look. One can only speculate what this trend in Kubert's work meant, and where it came from. The mature Kubert seemed to have come to a greater awareness of the capacity for evil in men. Though he had heard of the Holocaust as a teenager, it was only now, when he was working quickly and

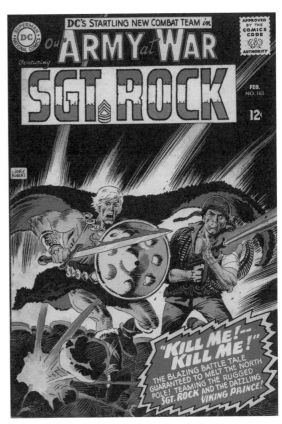

A Joe Kubert cover. [©1966 DC Comics]

tapping deeply into his own subconscious, that his artwork began to reflect this grim awareness. Certainly any mature Jewish artist, whatever the field of endeavor, must admit to or account for the Holocaust in his or her artistic expression. It was unavoidable. Even Kubert's heroic characters share his horror at the awful potential the human race, and his villains who perpetrate horrors also display such awareness.

In the context of the sunny early 1960s, this darkness was highly unusual, and certainly stood out in stark relief against the clean, neat "house style" that could be found in the other DC comics of the era. On the downside, it had cost him acceptance on the Hawkman revival; in the plus column, it lent gravitas to his work, and a generation of aspiring comic-book artists would take that darkness to much greater lengths in the 1980s and 1990s. Kubert became the granddaddy of "comic book noir." In this sense, the man's artwork proved influential for a new generation of comics artists who would emerge by the decade's end. These artists would also create worlds among the dark dominions. ∎

2. Amash, Jim, " 'Roy The Boy' in the Marvel Age of Comics," *Alter Ego* Vol. 3, No. 50, TwoMorrows Publishing, Raleigh, NC, 2005.

Getting *Peanuts* Wrong (or Not Quite Right)
by R. Fiore

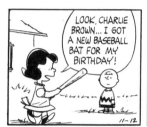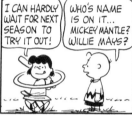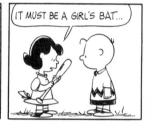

The Nov. 12 1962 strip collected in *The Complete Peanuts 1961-1962*. [©2006 United Feature Syndicate Inc.]

As I don't read 600-page biographies of people I feel I already know enough about, I was unable to participate in the discussion found elsewhere in this issue. I might in the spirit of kibitzing note that if you were raising children in the 1960s and your daughter joined the Mormons as opposed to the Manson Family you would have to consider yourself ahead of the game. I did read Michaelis' biographical essay in the first volume of *The Complete Peanuts*, and there at least he overplays every hand he's dealt. The notion that *Peanuts* represented a "fault line of a cultural earthquake" is patently absurd. If Garry Trudeau and Jules Feiffer saw Schulz as speaking directly to their concerns, then so did the crew of Apollo 10. This is casting a wide net. Michaelis would apparently have it that Trudeau and Feiffer were correct in their belief and Stafford, Young and Cernan were deceived, that *Peanuts* was a "harbinger of '60s activism" that through a fluke became co-opted by insurance companies and bakeries. In reality, it's an aspect of Schulz's particular genius that the cartoonists and the astronauts could each see their personal beliefs reflected in *Peanuts*. Where Garry Trudeau saw "the first Beat strip," the astronauts could see in Charlie Brown the spirit of fortitude in the face of adversity and in Snoopy the spirit of adventure, and neither would necessarily be wrong. It would be more accurate to say that Schulz

stood on both sides of the fault line at once.

It would be more accurate to say that Schulz was one of the many people who came out of World War II believing that the war had changed things. Whatever personal discontents the *Peanuts* characters feel, they abide in the suburban world of peace, plenty and security that their fathers' sacrifices had won for them, and I don't think it's reading too much in to see a sense of pride in that. A useful comparison might be Joseph Heller, who came out of the war with the perception that his commanders had little more regard for preserving the lives of their own men than those of the enemy, that this indifference extended into civilian life as well, and that anyone who believed Milo's assurances that everyone had a share was a fool (though of course Yossarian ultimately wound up working for Milo just like everyone else). *Peanuts* on the other hand addresses the implicit American promise that the door is open for anyone to be anything he wishes, and the reality that no system will overthrow the aristocracy of beauty, talent and charisma. (It's an indication of how little interest Schulz had in material inequities that nobody in the suburban Eden of *Peanuts* has much more than anyone else.) Charlie Brown is struggling with the realization that he is not going to be the great ballplayer, the boy the girls love, the center of attention, or anything other than ordinary. To

refuse to accept the reality will only cause humiliation, and the only rebellion is to make the acceptance bitter.

Even more absurd is Michaelis' contention that Schulz's once-in-a-blue-moon topical references amount to "register[ing] social tremors with seismographic accuracy." Taking the 1961-1962 volume of *The Complete Peanuts* I have to hand here, you do indeed have a passing reference to the hydrogen bomb in one strip, and a reference to Rachel Carson in another. Among the events of these two years not referred to in any way are the first manned space missions, the trial of Adolf Eichmann, the Bay of Pigs invasion, the Cuban Missile Crisis, the Supreme Court ruling banning school prayer, the construction of the Berlin Wall, and any aspect of the civil rights movement. In fact, the contemporary event that gets the most play in *Peanuts* over these two years is the centennial of the Civil War. At the same time, *Li'l Abner* made every effort to appear topical without actually taking a position on anything, and *Pogo* had something to say. Schulz's topical references are better evidence of Michaelis' thesis that the strip closely reflected Schulz's day-to-day concerns; a topical matter that meant a lot to Schulz would find its way into the strip, but he was no bellwether of current events in general.

In the brief biographical sketch at the end of subsequent *Complete Peanuts* volumes, Gary Groth echoes Michaelis when he writes that "[D]uring the 50 years Schulz wrote and drew [*Peanuts*] it remained, as it began, an anomaly on the comics page — a comic strip about the interior crises of the cartoonist himself." It's true that *Peanuts* was personal in a way comic strips had hardly ever been before, but there's a danger here in equating Charlie Brown and Charles Schulz, i.e., Charlie Brown is unhappy because Charles Schulz is unhappy, and if Charles Schulz were happy Charlie Brown would be also. Michaelis and Groth are in a much better position than I to know how happy or unhappy Schulz was,

but it's difficult to see what he had to be unhappy about. His misfortunes seem commonplace, while his success was extraordinary. It's a different thing to have your mother die when you're a grown man (in a time when people grew up faster than they do now) than when you're a child. In his own account, Schulz's experience in combat gave him a confidence he'd never had before. If he struggled professionally, he didn't struggle for long, and early success became mass success and then mega-mass success. But then, the causes of Charlie Brown's unhappiness are pretty trivial stuff — losing baseball games, having bad luck with kites, lacking the nerve to prosecute childhood infatuations, a poor haul at Halloween. He doesn't even seem to be as unpopular as he imagines himself to be. His main problem is that he's ordinary and he wishes to be extraordinary. The causes are trivial because, in Schulz's work, suffering is comic, not tragic.

To have access to old hurt feelings is not the same thing as being in pain. I believe Schulz used those parts of his personality that were useful to him as an artist. Charlie Brown would have been like Schulz if he'd been the musical prodigy instead of Schroeder, i.e., if he had been gifted with a talent that the other children would not value but which would win him fame and fortune in later life. A Charlie Brown who was like Charles Schulz would be a character a mass audience couldn't identify with. The way some people write about *Peanuts* you'd think it was *The Sorrows of Young Charlie.* The very book design of the *Complete Peanuts* series is an argument that the contents are essentially melancholy and autumnal. This is not so much wrong as incomplete. There's disappointment and anxiety in it, but there's a tremendous *joie de vivre* in it, too. I don't think there's anything that captures the 1960s in their most buoyant aspect, the feeling of things being made new and possibilities opening up. It's in the very lines of the strip itself. The psychological landscape of *Peanuts* might have been best captured by Schulz

The Nov. 23, 1961 strip collected in *The Complete Peanuts 1961-1962*. [©2006 United Feature Syndicate Inc.]

himself on the cover of the first Holt paperback collection: Schroeder, (non-Peppermint) Patty and Snoopy are happily playing while Charlie Brown stands aside and apart with a glum look on his face, as if there were a cloud over him. This is the world as it appears to Charlie Brown.

Michaelis makes a point that Schulz was of the last generation to grow up without television. I think this is much less significant than that he was part of the first generation to grow up with comic strips in their mature form. While *Peanuts* was an anomaly, it's not an unprecedented one. Like most popular artists, the comic strip cartoonist saw himself as doing a job of work for the reader, who was not to be burdened with the artist's petty personal problems. Therefore, where the cartoonist's personality was present, it was almost always once or twice removed from the mechanics of the strip. Still, there were significant instances where the rule was broken. Granted, this usually happened when the cartoonist was a little crazy. I think the inner crises of Chester Gould, Harold Gray and, as we've recently found out, Fletcher Hanks, come pretty close to the surface. Lives of quiet desperation find their way into *The Bungle Family*, which Schulz cites as an influence. Another key precedent

would be Frank King. While there were no unhappy characters in *Gasoline Alley*, in the period before the inevitable *deus ex machina* lands — which is to say, for the bulk of any given storyline — there is a pervasive air of yearning when happiness is sought after and anxiety after it's achieved. Something I didn't realize until recently (from reading *Krazy Kat* rather than *Peanuts*) is what a significant influence George Herriman was on Schulz. It took me a long time to twig to this (despite Schulz's own statements) because I always thought of *Krazy Kat* as some sort of fey rarified thing that couldn't possibly inspire a mass-cultural phenomenon or a mass artist. The world of *Peanuts* is Coconino County carried out by other means, except that rather than being a fanciful private world it connects directly to the world we live in, and therefore to readers of all kinds. To ask whether Schulz's characters are children or adults is like asking whether Herriman's characters are animals or people. Charlie Brown and company are in effect anthropomorphic humans. It's not just that there are no adults in this world; there are no children older than Charlie Brown, and after a brief apprenticeship as a baby, none more than a year or two younger. (This might simply reflect the experience of World War II veterans who

The July 14, 1960 strip collected in *The Complete Peanuts 1959-1960*. [©2006 United Feature Syndicate Inc.]

began having children nine months and 30 minutes after discharge and lived side by side in developments of G.I. Bill financed houses.) As in *Krazy Kat*, they create a microcosmic society without societal responsibilities. In growing up with comic strips, Schulz came to see them as a natural means of personal expression and saw no contradiction in expressing himself in a consciously commercial comic strip.

Let me pull back and approach this another way. Rodgers & Hammerstein's *Oklahoma!* started a trend on Broadway of musicals in which the songs were integrated into the plot, which represented a break from the way musicals were done up to that point. People will often express this by saying that *Oklahoma!* was the first integrated musical. This isn't so; there were several examples before that, usually involving either Rodgers or Hammerstein. However, *Oklahoma!* was the one that started the trend, so it's not absolutely wrong to say it was the first, but it's not quite right. Similarly, the unhappiness of Charlie Brown is the engine that powers the strip, in much the same way that Abner's defense of his bachelorhood is the engine of *Li'l Abner*.[1] So it's not wrong to say that *Peanuts* is about unhappiness, but it's not quite right because there's more to *Peanuts* with Charlie Brown. The unhappiness of Charlie Brown makes it possible to portray happiness without being cloying (something that doesn't apply to the merchandise). Based on a close study of Schulz's life, Michaelis concludes that *Peanuts* is a veiled diary of Schulz's day-

to-day life that portrayed his personal suffering. Based on my reading of the strip, I think it's more likely that, though he drew on his personal experience, *Peanuts* is primarily an imaginative work of art. Not having read the book I can't say that there isn't something I don't know about Schulz that would prove Michaelis right, but the objections Schulz's family make do suggest that the intelligence may have been fixed around the policy. The salient point is that *Peanuts* was close enough to life to incorporate his personal experience; Alex Raymond couldn't work his arguments with his wife into *Flash Gordon*. I think his analysis misses what actually makes *Peanuts* a work of art. First and foremost it was the extraordinary comic inventiveness at its peak, but beyond that it was that it created fully dimensional characters in the comic-strip form, characters who were both happy and unhappy, insecure and contented, frustrated and reconciled, all in a naturalistic way and in a world we recognize as our own. It's not merely a four-panel progression to a punch line; there's something in every panel. Making the characters, not only children, but children in a narrow age frame simplified the task immensely by eliminating the complexities of adolescence and adulthood (particularly those that would cause censorship trouble). I'm sure this was fortuitous, but if it had been a calculation, it would have been canny. Schulz's true inheritors are cartoonists like Chris Ware, Adrian Tomine and Dan Clowes, who grew up with Schulz and applied his methods to adult characters. In the final analysis, however, an interpretation that reduces *Peanuts* to a work of autumnal melancholy and the humor to a sugar coating on that unpalatable pill is getting *Peanuts* wrong, pure and simple. ■

1. The difference between these two devices is telling. The problem with Abner's defense of his bachelorhood is that it's perverse. It mockingly exploits the social fiction that a red-blooded American boy has no sexual desire, and even a society determined to give lip service to that fiction can see the perversity of it. Therefore, the device became increasingly difficult to maintain, and eventually broke down, to the detriment of the strip. On the other hand, Charlie Brown is unhappy because he wants things he can't have, and refuses to modify his expectations. Because the device arises organically from his character it can go on forever. Personally I found the device tiresome, but it could endure because it was based on the truth of human character.

Look Alikes
Daisuke Nishijima's Witches, Aliens and Doubles
by Bill Randall

All Comics by Daisuke Nishijima
http://www.simasima.jp

O-son Senso/The Universal ("O Village War")
Pub. by Hayakawa Shobou, 2004
224 pp., 1300 yen ($12.55)
B&W, softcover
ISBN: 978452085566
http://www.hayakawa-online.co.jp

Sekai no Owari no Mahotsukai ("The Witch at the
 End of the World")
Kawade Shobou Shinsha, 2005
192 pp, 1200 yen ($11.60)
B&W, softcover
http://www.kawade.co.jp

Koi ni Shita Akuma ("The Fiend Who Fell in Love")
Kawade Shobou Shinsha, 2006
200 pp., 1200 yen
B&W, softcover

Dien Bien Phu
Kadokawa Shoten, 2005
176 pp., 1000 yen ($9.65)
B&W, softcover
ISBN: 9784048538909

Atomosufia ("Atmosphere"), Vol. 1, 2
Hayakawa Shobou, 2006
208 pp., 1100 yen ($10.60) each
B&W, softcover
Vol. I ISBN: 9784152087119
Vol. II ISBN: 9784152087201

Dien Bien Phu (IKKI serial), Vol. 1, 2
Shogakukan, 2007
282 pp, 714 yen ($6.90)
B&W, softcover
Vol. I ISBN: 9784-091883735
Vol. II ISBN: 9784-09188374-

Which one's the cutest is open to debate. But Como_1, the simplest, also comes with the fewest restrictions. You can pretty much do what you like with him, as long as you mention the author. Como_3, however, has stub legs and a tail, and a restriction against commercial use. He's not as much fun. So choose wisely: You don't want to get stuck with a cartoon companion who's a killjoy.

Actually, these are not companions, but open-source characters created for Commonsphere and Creative Commons Japan. Their author, Daisuke Nishijima, has produced an exciting body of manga in just a few years. He made his debut in 2004 with *O-son War*, though he had a career as an essayist and illustrator well before. His manga look and act like exemplars of the most popular genres, the stories of magic and the future so enjoyed by junior-high-schoolers and high-schoolers. Unlike most artists, however, Nishijima developed outside the manga industry. What's more, he is quite smart. There's more going on here.

Consider *O-son War*. An X-shaped lander has set down in "O" Village. The army shows up, the lander walks. Tokyo —

wait for it – gets flattened. And there are high-school kids. They should have seen it coming.

Yet something is different. For a start, Nishijima finds the locals more interesting than the aliens. He understands small-town life, its isolation and closeness. Mostly, he stays with Ozawa, a high-school senior who has lived in this backwater his whole life. His hometown, whose name literally means "Concave Village," sits in a deep hollow, where not even radio waves can reach. He's been told he has no future. Naturally, the arrival of this craft sets his imagination into overdrive.

Strange, then, that none of the townsfolk share his enthusiasm. His best friends hang around the X too, but don't join him in training with a knife should the aliens attack. Instead, one sits on it and reads a book. Everyone else goes on like nothing's changed. No one but their teacher, a single mother just returned to her hometown, listens to Ozawa. Her ulterior motive may be to get him to apply to college, but he wants to rouse hearts and minds. He mounts the X and rants at his classmates: "We must protect our town!" No one cares. He gets lost in "researching" the aliens. His library, the local Tatsuya video store, offers primary sources by John Carpenter and M. Night Shyamalan. But even the video clerk — who plans to escape their town by watching lots of movies and becoming a director — fails to share the boy's fervor. Perhaps it is the fact that, like the townsfolk, the aliens seem pretty docile.

When the explosions finally start, they mark Ozawa's triumphant hopes, even if a stray one takes out the video store. Nishijima excels at these bombastic moments. He draws smoke trails and frantic motion with still precision and a jinking line. Yet they only work so well because the characters seem so alive. He draws them small and active. Stumpy high-schoolers inhabit the page better than tall adults who barely fit. Furthermore, as he revealed in a brief interview with translator Matt Treyvaud, he considers "the world of junior high and high school [a place] where sensitivities are sharper." Born in 1974, at just the right age when Hayao Miyazaki hit his stride, he knows what he's talking about.

In that interview, Nishijima excludes himself from the camp of "pure manga." An odd assertion, perhaps, from someone whose books offer such pure pleasures. But there is always something else going on. *O-son War*'s points to the difference in a barrage of pop references: *The Prisoner*,

a laugh-out-loud *Rocky* riff and a title that puns on Orson Welles' name. The book's subtitle, "The Universal," comes from the Blur song. Its lyrics serve as an epilogue before the final punch line. A more "pure" manga would only reference manga, I suppose.

Fortunately, these references have a purpose beyond showing off his taste. He points to these works both as catalysts for the characters and frameworks for our reading. He began as a music critic. On one level, he still writes like one. On another, perhaps like all critics, he writes as a fan. He certainly understands how fans use, and are used by, the works they love.

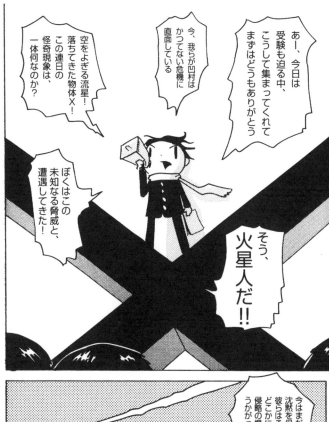

"We have to protect our town, using Rambo as our guide!"

From O-son War. [© 2004 Daisuke Nishijima]

Giant Robot Therapy

On first reading *O-son War*, I did not think of Orson Welles so much as Hideaki Anno. The book seemed a smart gloss on Anno's groundbreaking 1995 television series *Neon Genesis Evangelion*. After reading Nishijima's second book, *The Witch at the End of the World*, I was convinced he was one of the many affected by this show.

Anno, a gifted fan who trumped the pros with the homemade short "Daicon IV," eventually became a key figure in the Japanese animation industry. He and his "Daicon" collaborators co-founded GAINAX, the studio behind the classic drama *Royal Space Force: The Wings of Honneamise*. Their works always married high production values to their *otaku* longing for girls and robots, but *Evangelion* marked their apotheosis.

Its story, a gloss on *Ultraman*, *Space Runaway Odeon* and perhaps even *Alphaville* in later episodes, began as a fan's dream. Alien "Angels" are invading; only 14-year olds in giant robots can stop them. Shinji Ikari, the "Third Child" so chosen, is the son of the robots' architect, a cold, distant man. Shinji's suffocating alienation set the tone, covered with layers of faux-Kabbalistic symbolism, deconstructed archetypes and "service, service, service" (fan-speak for T&A). The first few episodes promised a new classic, on the level of *Gundam*, with animation of a quality not normally seen from television's sweatshops.

Accounts are conflicting, but it appears those early episodes ate much of the budget. Funding comes from toy companies, not patrons of the arts. Add to it that Anno's creative impulse stemmed from a four-year depression, reflected in his characters, each uniquely unhappy and ultimately alone. By the end, with the production running out of money, the PTA complaining about violence, and the staff's morale growing ever more fraught, Anno orchestrated all this chaos on-screen into one honest, raw scream.

As broadcast, the show's last several episodes braided together stock footage, pencil roughs, a full minute of "Ode to Joy" over a single still frame, and a voiceover much closer to therapy than narrative. These episodes seem anxious to fall apart at any moment. But they also reveal a creativity pushing at every limit: personal, formal and financial. The result, if you can bear the flayed storyline, is powerful and unique. Not even artistically daring works of television like *The Singing Detective* approach how *Evangelion* purposes its form to particular ends. Ultimately passionate and personal, Anno directly spoke to those like himself, imploring them to live their own lives, not those of the characters in kids' shows.

This spread: The key six-panel sequence from *The Witch at the End of the World*. [© 2005 Daisuke Nishijima]

But what about the robots? Predictably, some diehard *otaku* felt betrayed. Some sent death threats, deaf to Anno's plea. With the wider audience, however, the show became a phenomenon. It had been moved to a later time slot, and picked up a more mature audience than typical for an anime. If not everyone lived in a tiny room-turned-anime-shrine, they felt empathy with the emotions behind the act. Since then *Evangelion*'s echoes have appeared far and wide. Animators have copied it. Takashi Murakami has made it a cornerstone of his theory of fine art and postwar Japan. Nishijima, too, has named *Evangelion* as a key influence.

She Blinded Me To Science

You wouldn't know it on first glance. *The Witch at the End of the World* did not remind me of *Evangelion* until the end of

out. She's come to help him, but she's awfully chatty as the teeth close in. He starts to scream as she puts her spell together. Even though she has just one eye, she has good aim, and turns the troll into a crumbling mound of stone. Nishijima draws this as a breathless two-page spread, with just six full-height panels filling the pages. He reserves this layout for the most important moments and uses it masterfully.

In this spread, the point of view varies between low-angle and overhead. The full height emphasizes the troll's towering size. The panels also impart a feeling of speed to the witch's spell, like lightning shooting across the ground. He varies close-ups, long shots and medium shots to lead the eye gently through the center of each panel. It can be read panel by panel, alternating top-to-bottom, bottom-to-top, or as one quick sweep. I always read these spreads twice before I realize what I'm doing. It seems to come naturally, especially when he uses the layout for depicting flight. He learned how to do that by studying Miyazaki. The rest is his.

This particular spread serves as a fitting capsule for the whole story. From here, the witch saves him from danger. She explains the nature of the world. (Hint: Things are not quite what they seem.) And she shows him her affection, even if he's too thickheaded to get it any of it.

He starts to get it in Chapter Three when a monster bites off her head. It soon sprouts wings, along with a legion of others just like it, and they begin to tear his world apart. Things had already been worrying — the witch had been talking about shadows, and he had already seen his mentor vanish in a puff of smoke. Then the witches he tries to save dissolve in his hands. The smoke looks marvelously like swirls of ink, a nice reflexive touch. Nishijima has been dropping hints all along. Each chapter opens with a full-page panel of the spires of Devil's Castle. Each has a subtle change; by this point, the tips of the spirals have started to swirl, too.

The book builds to a rousing climax, full of bombastic action in concert with the characters' emotions. Naturally, the world hangs in the balance, but the nature of that world matters much more. The witch tries to explain it to him: "Offshoots, reproductions — copies, imitations — doppelgangers! Those kinds of things." (How delightful that the prequel, *The Fiend Who Fell in Love*, acts almost like a mirror to *The Witch*!)

This world's ontology, in other words, is in question. Much as *Evangelion* made all its foundations fair game, so does *Witch* make its characters' world as contingent as wet ink. As in *Evangelion*, these questions resonate with the key character's emotions and the reader's likely situation. Moreover,

the third chapter. Until then, the two could come from different planets. *Witch* brims with adorable characters suffering far more manageable problems. It even has a cat mascot. *Eva* has a penguin.

The story treads such familiar ground that the jacket blurb could read, "Steampunk *Harry Potter*!" without being too dishonest. It centers on a boy who won't believe in magic because witches fly past all day and make fun of him. He defiantly uses science—magic's archenemy—to put a jetpack on his surfboard. Unfortunately, his maiden voyage rockets him right into the Devil's Castle, a foreboding ruin of black spires. No one ever goes there. Legend has it a powerful witch has been imprisoned there for the last thousand years, ever since the Magic War ended. He doesn't land in her lap, but in a dark forest. Right away a troll hoists him into the air for a snack. Unfortunately, science has no answers, just hypotheses.

Fortunately, a cute witch flies by and sticks her tongue

addresses — eternal adolescence, having transferred one's emotional attachment from parents onto toys, games and movies — are uniquely modern. They stem from a misuse of middle-class wealth and leisure. Nishijima, though, is far more generous than I must sound. He did, after all, create a short comic called "Subculture Vs. Otaku FINAL BATTLE" for the critical journal *Eureka*. It pits two girls in a lightsaber duel, fighting to the finish, a vision both fun and forgiving.

He Saw It (On TV)

Nishijima's first two books hinged on their protagonists acting in the world. His third, *Dien Bien Phu*, puts him in grave danger of being acted upon. This Vietnam war story opens with a quote from Tim O'Brien's "How to Tell a True War Story."

> In many cases a true war story cannot be believed. If you believe it, be skeptical. It's a question of credibility. Often the crazy stuff is true and the normal stuff isn't because the normal stuff is necessary to make you believe the truly incredible craziness.

Nishijima's beautiful sense of flight. [© 2004 Daisuke Nishijima]

O'Brien, saw everything firsthand. Nishijima saw some of it, but only in movies and television. I suspect that is why *Dien Bien Phu* feels like a cute gloss on *Apocalypse Now*. O'Brien would likely be horrified.

Not to say the books have no virtues. He creates a rich world, full of contrasts. It focuses on Hikaru Minami, a Japanese-American photographer just arrived in Saigon in 1965. He's young, impressed by bombs, but stunned by the soldiers. They push him to photograph a local they've posed, a disemboweled corpse holding a sign that reads "Fuck Communism!" Presumably they helped him with the English.

Soon enough Hikaru finds himself at risk of being the soldiers' next model. Staring down their gun barrels, he expects to die. Then one of their heads flies off. A beautiful, almost superhuman killer cuts them all down in a matter of seconds. Stunned, Hikaru tries to snap some pictures when her knife hits him in the middle of the chest. Everything goes black. The chapter ends as he awakes. His Nikon took the knife, but first it took one good picture of her. Their cat-and-mouse relationship, played against the war's grisly backdrop, defines the story.

While it works fine as a fantasy, the epigraph hangs over the book. The fact that Hikaru is a photographer makes it worse. Cameras supposedly capture truth, the "decisive moment" Henri-Cartier Bresson championed. The decisive

the boy in *The Witch* fits into the archetype Anno targeted. He is passive and alone, unable (yet) to make the choice to leave the pains he's grown used to. Though probably better, whatever is waiting could be worse. Best just to suffer here, he has reasoned. The aggressive, cute girl — another *otaku* fantasy — has two models in *Evangelion*, one in *The Witch*, but they all act on the boy, confounding the onanist's fantasy so that he'll act rather than wait to be acted upon.

As always, the context matters most. Like Anno, Nishijima is putting his work into a culture that still has its share of shut-in fans, unreservedly generous to their friends who are cartoons. Never mind the cruelty of those friends who never age, while the fans can neither stop nor slow aging. While not directly aimed at them, *The Witch* undermines its story to make the reader complicit.

It was an old technique when Cervantes used it. But the ends are contemporary. I think the condition Nishijima

May 1, 2008 – June 30, 2008

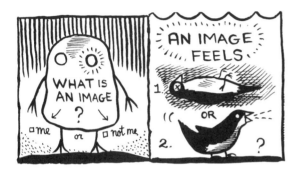

An excerpt from *What It Is* has been released as *Lynda Barry Free Comic Book Day Activity Book Special*. [©2007 Lynda Barry]

ALTERNATIVES

In Dash Shaw's 720-page graphic novel *The Bottomless Belly Button*, the implications of a mother and father's divorce reverberate through their children and grandchild: available in early May from Fantagraphics ($24.99). *What It Is* is a graphic How-To that offers creative-process tips and techniques for cartoonists from *Ernie Pook's Comeek*'s creator Lynda Barry (Drawn & Quarterly, 5/13, $24.95, 208 pp.). Livejournal strips that humorously chronicle the minutia of a young woman's daily life are collected in *Delayed Replays*, Liz Prince's follow-up to her Ignatz-winning, debut graphic novel *Will You Still Love Me If I Wet the Bed?* (Top Shelf, 3/25, 112 pp.). AdHouse Books is putting out Joshua Cotter's *Skyscrapers Of The Midwest* series in one volume. It's about two imaginative brothers and a cat (5/28, $19.95, 288 pp.). Lauded by British comics critics in 2007, Simone Lia's *Fluffy*, which is about a bunny who thinks a human is his father, is being released stateside by Dark Horse in June ($19.95, 192 pp.). According to the Web page at Judenhass.com, Dave Sim hopes to deconstruct anti-Semitism in *Judenhass*, his 56-page "graphic narrative" coming out in May from Aardvark-Vanaheim. A meditation on sex, drugs and ninjas, *Ben Jones & Frank Santoro: Cold Heat* is being published by PictureBox in June ($24.95, 240 pp.).

Alt-comics go all-ages with two June offerings: *Chiggers*, by Hope Larson (First Second, $9.99, 176 pp.) and *Johnny Boo* Book 1: *The Best Little Ghost In The World* by James Kochalka (Top Shelf, $9.95, 40 pp.). In the latter, a little ghost and his pet ghost make friends with monstrous melted ice cream. In the former, two girls form a friendship at a summer camp. In late June, *Pocket Full of Rain and Other Stories* by Jason collects his early work, some of which features humans (Fantagraphics, $19.99, 184 pp.).

CLASSIC STRIPS/COMIC BOOKS

To tie in with this summer's *Iron Man* film, Iron Man's comic-book origins are reissued in early May with Marvel's *The Invincible Iron Man Omnibus* Vol. 1, written by authors such as Stan Lee and with art contributions from Kirby, Ditko and Colan ($99.99, 720 pp.). Fantagraphics collects Jules Feiffer's *Village Voice* strips in *Explainers: 10 Years of Jules Feiffer's Revolutionary Weekly Strip* (May, $19.95, 528 pp.). Dark Horse unearths another Golden Age rarity with its release of Mac Raboy's *The Complete Green Lama* Vol. 1, which concerns what may be the first Buddhist superhero (May, $49.95, 208 pp.). *Jack Kirby's O.M.A.C.: One Man Army Corps* collects *O.M.A.C.* #1-8 and some auxiliary art (DC, 5/21, $24.95, 176 pp.). In late May *Beetle Bailey* Vol. 1 by Mort Walker joins the ranks of complete comic-strip reprints (Checker, $24.95, 200 pp.). In these strips from 1950 to June 1952, Beetle Bailey transforms from a college student into a G.I. Artists like Bernie Wrightson and Frank Frazetta were able to sidestep the Comics Code and do horror comics in Warren publications of the '60s. Dark Horse will release the *Creepy Archives* Vol. 1, which collects issues of the titular magazine from 1964-1965 ($49.95, 240 pp.).

INTERNATIONAL

In May, NBM releases the second half of Manu Larcenet's *Ordinary Victories*, subtitled *What Is Precious*, which won an Angoulême Best Comic Book of the Year award. It's about a photographer dealing with major life changes ($15.95, 128 pp.). For those who have been waiting since the mid-'90s for

Rumiko Takahashi to conclude her romantic comedy about a boxer with a weight problem and a young nun, she finally finished it, so Viz is rereleasing the series in new editions. **One-Pound Gospel** Vol. 1 2nd ed. will be available in early June ($9.99, 240 pp.). PictureBox is releasing a book by "the R. Crumb of Japan": **Takashi Nemoto: Monster Men Bureiko Lullaby** is the story of a radioactive sperm (June, $19.95, 288 pp.). Continuing the trend of having the author's name in the title is Radical Publishing's **Yoshitaka Amano's Mateki: The Magic Flute**, which is the famous illustrator, character designer and cartoonist's take on tale (June, $39.99, 128 pp.). Gemstone is releasing **Donald Duck Family — The Daan Jippes Collection**, which features both original stories by the Dutch Duck artist and his recreations of some of Barks' works (June, $8.99, 64 pp.).

MAINSTREAMY

Matt Fraction, with the aid of Salvador Larroca's art, helps Marvel make Iron Man more user-friendly in light of the upcoming film: In **The Invincible Iron Man #1**, Tony Stark must face his own version of Harry Osborn, Ezekiel Stane (5/7, $2.99, 32 pp.). Joe Kubert has created a new miniseries about his caveman character: **Tor #1** is available May 7 (DC, $2.99, 32 pp.). On May 7, Vertigo releases **House of Mystery #1,** written by Matthew Sturges and Bill Willingham, drawn

Written by Frank Miller, penciled by Jim Lee and inked by Scott Williams, from All Star Batman & Robin, the Boy Wonder #4. This comic will be collected in the trade. [©2006 DC Comics]

by Luca Rossi with guest artists such as Bernie Wrightson. Copping a *Sandman* conceit, it's about five characters trapped in a paranormal watering hole, telling tales while trying to figure out how to escape (5/7, $2.99, 32 pp.). Frank Miller wrote and Simon Bisley drew **Bad Boy**, a strip about a little boy who realizes he's part of an experimental community, for the British *GQ*. It's coming out mid-May from Dynamite Entertainment ($14.99, 52 pp.). As a result of a fan poll at the Marvel website, Chris Claremont has written **Genext #1**, which poses the "what if" … the original X-Men aged in real time and had kids: art by Patrick Scherberger (5/14, $3.99, 32 pp.). Marvel's first joint with Soleil, **Sky Doll #1**, which was written by Barbara Canepa and drawn by Alessandro Barbucci, is about a female cyborg who must investigate her own identity (5/14, $5.99, 64 pp.). **Final Crisis #1**, written by Grant Morrison and drawn by J. G. Jones, kicks in May 28: "the entire Multiverse is threatened" ($3.99, 40 pp.). **Amazing Spider-Man: Brand New Day** Vol. #1, written by Dan Slott and Marc Guggenheim and drawn by Steve McNiven and others, features a newly single Spider-Man, re-secret-identitized (Marvel, 6/4, $19.99, 176 pp.). The first volume of Frank Miller's and Jim Lee's over the top **All Star Batman and Robin**, which collects the first nine issues of the series, will be available June 18 ($24.99, 240 pp.).

ABOUT COMICS

Aline Kominsky-Crumb wrote the intro for Tom Pilcher and Gene Kannenberg Jr.'s **Erotic Comics: A Graphic History from Tijuana Bibles to Zap Comix**, which takes a look at international dirty drawings pre-1970 (Abrams, 5/1, $29.95, 192 pp.). David A. Beronä's **Wordless Books: The Original Graphic Novels** is a scholarly study of woodcut narratives, featuring an intro by Peter Kuper (June, Abrams, $35.00 272 pp.). Gene Kannenberg Jr.'s **500 Essential Graphic Novels** (HarperCollins, $24.95, 528 pp.) will be available June 10. (Kannenberg Jr. runs the Comicsresearch.org website.) Well-illustrated theory regarding metahuman sartorial style comes in the form of **Superheroes: Fashion and Fantasy** by Harold Koda and Andrew Bolton, with an introduction by Michael Chabon (6/28, Metropolitan Museum of Art, $50.00, 192 pp.). On June 30, Fantagraphics will release **Strange and Stranger: The World of Steve Ditko** by Blake Bell, which is a heavily researched character study of the Spider-Man artist ($39.99, 220 pp.). Joel Meadows and others visited the studios of artists such as Mike Mignola and Dave Gibbons, talked to them and wrote a book about it: **Studio Space** (5/31, Image, $29.99, 320 pp.). ∎

Have you recently discovered a new favorite cartoonist and want to read an in-depth interview with him or her? Are you doing research for a book or a paper, or do you just want to catch up with the comic industry's magazine of record? Below is a sampling of *TCJ* back issues available from our warehouse for your perusal. For the full backlist of in-print issues, please visit www.tcj.com.

40: JIM SHOOTER interviewed, Spiegelman's BREAK-DOWNS reviewed. ($3.50)

48: A 140-page partial-color Special, featuring interviews with JOHN BUSCEMA, SAMUEL R. DELANY, KENNETH SMITH AND LEN WEIN! ($6)

72: NEAL ADAMS interview. ($3.50)

74: CHRIS CLAREMONT speaks; plus RAW with SPIEGELMAN and MOULY. ($3.50)

89: WILL EISNER interview; EISNER interviews CHRIS CLAREMONT, FRANK MILLER & WENDY PINI! ($3.50)

124: JULES FEIFFER interviewed; BERKE BREATHED defends his Pulitzer. ($5)

127: BILL WATTERSON interviewed! Limited Quantity! ($10)

131: RALPH STEADMAN interviewed! ($5)

142: ARNOLD ROTH and CAROL TYLER. ($5)

152: GARY GROTH interviews TODD McFARLANE! ($6)

154: DANIEL CLOWES interviewed; HUNT EMERSON sketchbook. ($6)

156: GAHAN WILSON! ($6)

157: BILL GRIFFITH; special KURTZMAN tribute. ($6)

158: ED SOREL; R. CRUMB discusses life and politics. ($6)

162: Autobiographical cartoonists galore! PEKAR, EICHHORN, NOOMIN, BROWN, MATT, SETH! ($6)

169: NEIL GAIMAN and SOL HARRISON interviewed. ($6)

172: JOE KUBERT interview. ($5)

180: ART SPIEGELMAN; R. CRUMB. ($7)

187: GILBERT SHELTON; GIL KANE. ($6)

206: PETER BAGGE and MILLIGAN, SPAIN II, TED RALL interviewed, JACK KATZ profiled. ($7)

209: FRANK MILLER, SAM HENDERSON! ($6)

213: CAROL LAY interview, Kitchen Sink autopsy! ($6)

215: JOHN SEVERIN part I, TONY MILLIONAIRE. ($6)

216: KURT BUSIEK, MEGAN KELSO, SEVERIN II. ($8)

225: MAD issue. JAFFEE, DAVIS and FELDSTEIN! ($6)

227: CARL BARKS tribute, C.C. Beck's *Fat Head* pt. 2 ($6)

231: GENE COLAN, MICHAEL CHABON, ALAN MOORE interviewed; Moore's ABC line of comics reviewed! ($6)

241: JOHN PORCELLINO, JOHN NEY RIEBER! ($6)

242: GIL KANE chats with NOEL SICKLES! ($6)

244: JILL THOMPSON, MIKE KUPPERMAN! ($6)

247: Our 9/11 issue: RALL, RUBEN BOLLING interviews. ($7)

248: STEVE RUDE ! ANDI WATSON interviewed! ($7)

250: 272-page blowout! HERGÉ, PANTER, CLOWES and RAYMOND BRIGGS interviewed! CARL BARKS and JOHN STANLEY chat! NEIL GAIMAN vs. TODD McFARLANE trial transcripts! Brilliant manga short story NEJI-SHIKI translated! Essays on 2002-In-Review, EC, racial caricature, post-9/11 political cartooning, Team Comics, etc. and a rare essay by the late CHARLES SCHULZ on comic strips! ($14)

251: JAMES STURM! Underground comix panel! ($7)

252: JOHN ROMITA SR., RON REGÉ interviewed. ($7)

253: ERIC DROOKER, JOHN CULLEN MURPHY, JASON! ($7)

254: WILL ELDER, Kazuo Umezu interviews! ($7)

256: KEIJI NAKAZAWA; FORT THUNDER! ($7)

257: A suite of four never-before-published interviews with the late, great comix artist RICK GRIFFIN! Hard-workin' writer JOE CASEY interviewed! ($7)

258: A comprehensive look at the work of STEVE DITKO, and a conversation with GILBERT HERNANDEZ and CRAIG THOMPSON! ($7)

259: 2003 Year in Review: Comics and Artists of the Year! Youthquake: A new generation emerges! ($7)

260: DUPUY and BERBERIAN! JEAN-CLAUDE MÈZIÉRES! They're foreign! ($7)

261: PHOEBE GLOECKNER! JAY HOSLER! ($7)

262: NEWFORMAT! ALEX TOTH profiled, with a generous color selection of his 1950s crime comics, plus an interview with STEVE BRODNER! ($10)

263: ED BRUBAKER interviewed! CEREBUS examined! George Carlson's JINGLE JANGLE TALES in color! ($10)

264: IVAN BRUNETTI interviewed, Underground Publishers, Harold Gray's LITTLE JOE in color! ($10)

265: Essays on WILLIAM STEIG, ERIC SHANOWER interviewed, Harry Anderson's Crime Comics in color! ($10)

268: CRAIG THOMPSON! BOB BURDEN! TINTIN AT SEA! WALT KELLY'S "OUR GANG" in color! ($10)

269: SHOUJO MANGA ISSUE! MOTO HAGIO interviewed and her short story "HANSHIN" in english! ($10)

270: JESSICA ABEL interviewed! MARK BODÉ and LALO ALCARAZ! NELL BRINKLEY comics in color! ($10)

271: JERRY ROBINSON interviewed! RENÉE FRENCH! 50 pages of pre-Popeye THIMBLE THEATRE! ($10)

273: EDDIE CAMPBELL interviewed! JUNKO MIZUNO interviewed! ART YOUNG goes to HELL! ($10)

274: MIKE PLOOG interviewed! SOPHIE CRUMB! Early HARVEY KURTZMAN comics in COLOR! ($10)

275: 2005 YEAR IN REVIEW! DAVID B. interviewed! BOODY ROGERS comics in COLOR! ($10)

276: TERRY MOORE interviewed! BOB HANEY pt. 1! Early B. KRIGSTEIN comics in COLOR! ($10)

277: 30 YEARS OF THE COMICS JOURNAL! THE STATE OF THE INDUSTRY! IT RHYMES WITH LUST! ($13)

278: BILL WILLINGHAM interviewed! BOB HANEY pt. 2! ORESTES CALPINI comics! JAXON tribute! ($10)

279: JOOST SWARTE interviewed! JOHNNY RYAN! LILY RENÉE comics! ($10)

280: FRANK THORNE interviewed! CARLA SPEED McNEIL! CRIME DOES NOT PAY comics! ($10)

281: THE BEST COMICS OF 2006! YOSHIHIRO TATSUMI and MELINDA GEBBIE interviewed! ($10)

282: ALISON BECHDEL! FRED GUARDINEER! Andru & Esposito's GET LOST comics! ($10)

283: LEWIS TRONDHEIM! DAVID SANDLIN! THE 39 STEPS comic adaptation! ($10)

284: ROGER LANGRIDGE! GENE YANG! Frederick Burr Opper's HAPPY HOOLIGAN in color! ($10)

285: DARWYN COOKE! ERNIE COLÓN! KEITH KNIGHT! John Buscema WANTED comics in color! ($10)

286: POSY SIMMONDS! GAIL SIMONE! Otto Soglow's THE AMBASSADOR in color! ($10)

287: JEFFREY BROWN! GREG RUCKA! Non-Krazy Kat comics of GEORGE HERRIMAN! ($12)

288: NEW FORMAT! THE BEST COMICS OF 2007! Tarpé Mills MISS FURY in color! ($12)

289: ROBERT KIRKMAN! SHAUN TAN! A gallery of MINUTE MOVIES strips! ($12)

Libraries and Specials:

TCJ SPECIAL I: WINTER 2002: JOE SACCO interviewed! ($24)

TCJ LIBRARY VOL. I: JACK KIRBY: All of The King's Journal interviews! ($23)

TCJ SPECIAL II: SUMMER 2002: JIM WOODRING interviewed! ($27)

TCJ SPECIAL III: WINTER 2003: BILL STOUT interviewed! ($23)

TCJ LIBRARY VOL. II: Frank Miller: All of FM's Journal interviews and more! ($23)

TCJ LIBRARY VOL. III: R. CRUMB: All of Crumbs Journal interviews! ($23)

TCJ SPECIAL IV: WINTER 2004: Profiles of and interviews with four generations of cartoonists — AL HIRSCHFELD, JULES FEIFFER, ART SPIEGELMAN and CHRIS WARE! ($23)

TCJ LIBRARY VOL. IV: DRAWING THE LINE: Lavishly illustrated interviews with JULES FEIFFER, DAVID LEVINE, EDWARD SOREL and RALPH STEADMAN! ($23)

TCJ SPECIAL V: WINTER 2005: Almost half of this volume is devoted to MANGA! Also features Vaughn Bodé, Milt Gross, and a comics section! ($25)

TCJ LIBRARY VOL. V: CLASSIC COMICS ILLUSTRATORS: A full-color celebration of the work of FRANK FRAZETTA, RUSS HEATH, BURNE HOGARTH, RUSS MANNING, and MARK SCHULTZ! ($23)

TCJ LIBRARY VOL. VI: THE WRITERS: Interviews with ALAN MOORE, CHRIS CLAREMONT, STEVE GERBER and more! ($20)

TCJ LIBRARY VOL. VII: KURTZMAN: Interviews with HARVEY KURTZMAN! ($23)

The *Utne* Independent Press Award Winner for Arts & Literature coverage just keeps getting better. Subscribe now to get these issues:

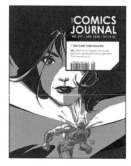

THE COMICS JOURNAL #291

The definitive interview with Eisner-winning artist Tim Sale, house artist of the *Heroes* TV series and penciler on such prestige projects as *Batman: The Long Halloween, Superman Confidential, Grendel, Spider-Man Blue* and *Daredevil Yellow*. Josh Simmons talks about his disturbingly funny minicomics, *Happy* series, *House* graphic novel and forthcoming book *Jessica Farm*. Plus: A color gallery of early comics work by *Flintstones* creator Dan Gordon.

THE COMICS JOURNAL #292

Gary Groth interviews father and son cartoonists Gene and Kim Deitch. The academy-award-winning Gene Deitch talks about directing cartoons such as *Munro* and *Krazy Kat*, and creating his comic strip *Terr'ble Thompson*. Underground comics pioneer Kim Deitch reminisces about the New York-based scene and the evolution of Waldo the Cat. Plus: The innovative Grant Morrison on his X-Men run and how he helped rebuild the DC universe.

"Still the best and most insightful magazine of comics criticism that exists."
— **Alan Moore**

"You ignore it at your peril."
— **Neil Gaiman**

"The good is always in conflict with the better. *The Comics Journal* attempts to explain the difference."
— **Gil Kane**

"All in all, *The Comics Journal* is a stand-out inspiration to me."
— **Kim Deitch**

Read *The Comics Journal* the way the professionals do:

by SUBSCRIPTION.